ART AND HISTORY
OF
EGYPT

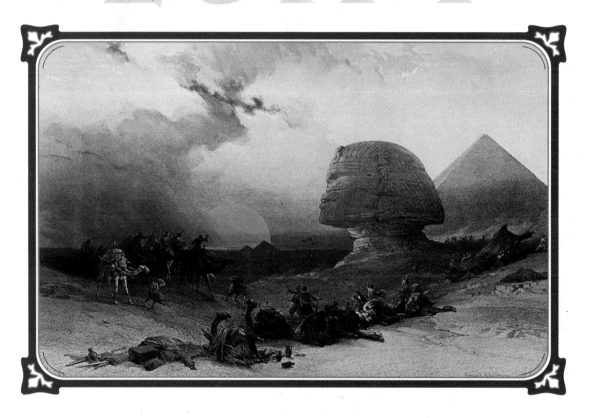

5000 years of civilization

Text and drawings by
ALBERTO CARLO CARPICECI

BONECHI

© Copyright by CASA EDITRICE BONECHI, Via Cairoli 18/b - 50131 Florence - Italy
Tel. 055576841 - Fax 0555000766
E-mail: bonechi@bonechi.it - Internet: www.bonechi.it

Printed in Italy by Centro Stampa Editoriale Bonechi.

Text by A.C. Carpiceci *with additions by* Giovanna Magi.
Translated by Erika Pauli, Studio Comunicare, Florence.
Editorial supervision by Serena de Leonardis.
Editing by Giulia Salvi.
Photographs from the archives of Casa Editrice Bonechi taken by
Marco Carpi Ceci, Luigi Di Giovine, Paolo Giambone.
Color plates and plans by Stefano Benini.
Drawing on page 101 and folder of Nile plan by Stefano Benini.

ISBN 88-8029-086-X

Arte e Storia · Egitto - n° 23 - Pubblicazione Periodica Trimestrale - Autorizzazione del Tribunale di Firenze n° 3873 del 4/8/1989 - Direttore Responsabile: Giovanna Magi

* * *

THE PLANET EGYPT

To modern eyes the peoples of ancient Egypt seem bearers of some higher civilization whose sources lay in another world. While populations elsewhere, still in their infancy, were groping their way out of the stone age, generating cultures that were on more or less the same level in all the regions of the world, the Egyptians seem to have been born adult. They soon broke through the barriers of human possibility, six thousand years ago, almost in virtue of experiences sustained in some other extraordinarily civilized world.

What happened here on the shores of the Nile was unprecedented and unique, an adventure which evolved at dizzying speed, creating works of art and science way beyond the prospects of the time. As yet, the building of the pyramid of Khufu (Cheops), in a period when iron and the wheel were still unknown, remains an inexplicable mystery. We are even more baffled when we realize that even before the Great Pyramid rose, the Egyptians had the technique and organization required to harness the floods of the Nile along thousands of kilometers and turn swampland and the desert itself into a new terrestrial paradise.

The fact that other peoples developed at much slower rates, some remaining in the Neolithic period up almost to modern times, reinforces the feeling that the peoples of the "planet Egypt" anticipated the history of the world by two thousand years, with an impulse of such strength that it can still be felt five thousand years later. The arms used in this colossal conquest were water and fire — the Nile and the Sun. Arms not taken up, but forged, cultivated by this ancient peoples so that the destruction wrought by water and fire should render propitious the fertility of the earth, of the very life of Egypt.

Mankind collaborated with Isis and Osiris to recreate life, to make the land look like paradise once more, a terrestrial paradise which joins anew with the celestial paradise. Egypt is not the Promised Land, but it is the land that man creates by his labor, day by day, year by year, in endless cycles where the Created and Creator fuse into one. No sharp distinctions separate the gods from man; the gods are in the midst of men; their features are those of man, or of the animals which surround him in the sky or on the earth; their hands are invisible and infinite, as infinite as the rays of the sun. Water and cosmic fire, death and resurrection, human essence and divine are present in every clod of Egyptian earth.

Nile and the Sun trace two boundless rings which run throughout the universe of this and of the other world, the path along which the new man of the "planet Egypt" finds his becoming and the reason itself for his eternal course.

Those of us who live now, two thousand years after Christ, can still find that ineffable equilibrium between the way of water and the way of fire by letting ourselves go on a sailboat in Upper Egypt. We can once more discover the invisible bridge that leads us to the sources of our history and feel our hearts throb with the same emotion that touched the hearts of our ancestors of five thousand years ago when at the beginning of the year they listened to the song that accompanied the rising waters of the Nile: "*Come water of life which springs from heaven. The sky burns and the earth trembles at the coming of the Great God. The mountains to the west and to the east open, the Great God appears, the Great God takes possession of the body of Egypt*".

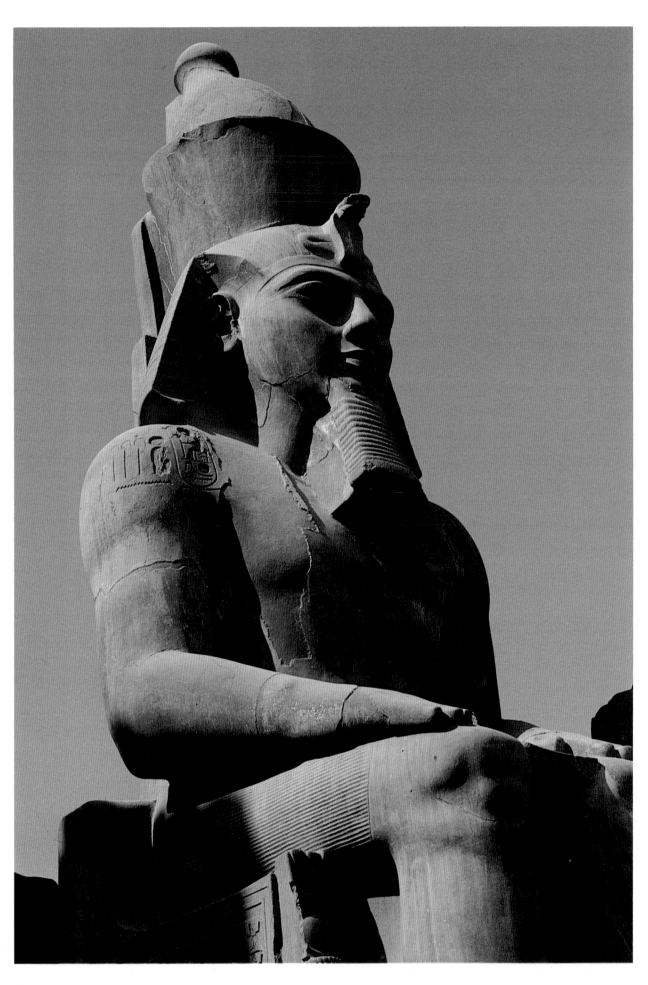

5000 YEARS OF HISTORY
Parabola of a civilization

Before the Pharaohs

In the Paleolithic era, before the explosion of Egyptian civilization, the Mediterranean Sea was cut into two great basins by a tongue of land that joined Tunisia and Italy, passing through the island of Malta. An immense ring of forests surrounded it on all sides and vast lagunas and forests were scattered in a chain over the area later to be identified with the Nile, reaching all the way to the sea. European and North African fauna lived side by side, and Alpine Mediterranean, Somalian and Berber races all intermingled in a sort of boundless Eden.

Then between 10,000 and 8,000 B.C. some kind of cataclysm, which had long been brewing, radically changed the face of this part of the world. The bridge between Tunisia and Italy sank, leaving behind the Maltese islands, a few crumbs; in Northern Africa the immense forests gradually dwindled, the endless lagoons disappeared and were replaced by deserts of rock and sand. As time passed the Nile gradually evolved into its present form, a gigantic serpent that began in the heart of Africa and wound its way, for thousands of kilometers along the Red Sea, until it found an outlet to the Mediterranean.

Between 8,000 and 5,000 B.C. a neverending flow of peoples moved through Upper and Lower Egypt. They came from Asia, from the center of Africa and from the west, perhaps survivors of legendary Atlantis. But as the desert implacably closed in and the flood tide of the great river left behind muddy bogs where there had once been strips of inhabitable land, the land of the Nile became less and less hospitable. Then the 4th millennium witnessed the development of an extraordinary peoples, who mastered the art of regulating the muddy waters along kilometers of shores, of coordinating agricultural activities in an area that covered thousands of hectares, of creating villages and cities, the beginning of the most extensive organized society that had ever existed. Analogous experiences, to be found only in Mesopotamia (Uruk, Ur, Lagash) pale by comparison. The only apparent explanation of their origins would seem to be in the lost continent of Atlantis, dreamed up by Plato three thousand years later.

The Egyptians themselves affirm that their history began with the realm of Osiris, which had been preceded by three great divine kingdoms: the Realm of the Air Shu; the Realm of the Spirit Ra, the Realm of the Earth Geb. The eras preceding ours seem to be adumbrated in these realms and the era of Atlantis in that of Geb. Osiris, god-king and man, is remembered as a king of immense goodness and wisdom, who reunited all the nomad tribes and taught them how to profit from the damage wreaked by the floods, how to keep the destruction of the desert at bay by irrigation and the tilling of the soil and, in particular, how to cultivate wheat for flour and bread, grapes for wine, and barley for beer. Osiris also initiated the nomads in the extraction and working of metals, and with wise Thoth taught them writing and art. After accomplishing his mission, he left his beloved companion and collaborator Isis on the throne, and departed for the east (Mesopotamia) to instruct all the peoples. On his return, his brother Seth lured him into a trap and slew him, usurped the throne and scattered the limbs of the corpse throughout Egypt. Isis, overcome by grief, departed in search of her beloved spouse, and through divine inspiration succeeded in finding his remains and recomposed them with the aid of the faithful Anubis. A miracle occurred thanks to the tears of the inconsolable wife, and Osiris was resuscitated and ascended to heaven after having left a son — Horus. Upon reaching manhood, Horus defeated the usurper after a long and uncertain struggle, and once more took up the task of his father, Osiris.

The Great Sphinx, timeless and unique, testifies to this dawn, in which history and legend mingle with the images of Atlantis or the "planet Egypt". Although attributed to Khafre (ca. 2,550 B.C.), no technical or architectural element, or even any component of logical continuity, ties the Sphinx to the Great Pyramid and the monuments of that pharaoh. The representation of the body of a lion with a human head is the exact opposite of all their visions of the gods, with their human bodies and the head of an animal (lion in the primogenial couple) and makes this colossal ideogram all the more mysterious: a monument raised by the ancient peoples to their first and great king — Osiris? a milestone on the path between life on earth and celestial life?

The chosen people of six thousand years ago inhabited two great zones with contrasting features: Upper Egypt, flanking the Nile as it moved northwards for hundreds of kilometers; and Lower Egypt, which spread out for about 150 kilometers along the countless canals of the Delta.

Upper Egypt, the area that lay south of the Sphinx, had a narrow strip of land that gradually dwindled producing less and less. As the struggle for subsistence was intensified, the people turned their attention to internal problems and shut themselves off from their surroundings in consortiums.

Lower Egypt by contrast was a densely populated generous land in continuous contact with other peoples in any number of ways, favoring a con-

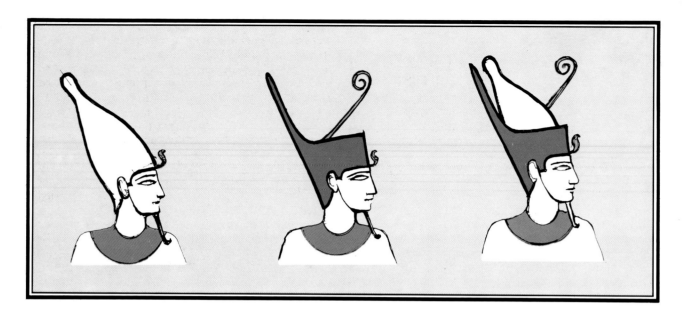

The pharaonic crowns.

*Even in periods when the unity of Egypt was
sound, the pharaohs were often depicted wearing
either the "White Crown" of the South or the
"Red Crown" of the North, as well as with the
"Double Crown", a symbol of the united kingdom.
Thus the pharaohs of an empire that stretched
from the Sudan to the Syrian border were shown
in numerous statues in the temples of Thebes
wearing only the crown of the North or only
that of the South.*

stant growth of trade by land and sea and, as a
result, the flourishing of open self-sufficient com-
munities, in a constant state of ferment.
Productive inhabited centers developed above all in
Lower Egypt, each with its own symbol, almost al-
ways derived from a common animal, symbols
which coincided with the personal vision of the one
god and became the emblems of the ruling family.
The first urban clusters we know of are those to be
found in Lower Egypt, where about twenty-two ci-
ties already had their "anointed one" that is their
king anointed with holy oil and decorated with the
Libyan plume. The first cities whose dominion ex-
tended throughout the Delta were Sais, and above
all Metelis, the great center to which the gold of
Nubia (1500 km. to the south) and the wood of
Syria (1000 km. to the north) flowed.
Leopolis, situated at the base of the Sphinx and
therefore a sort of hinge city between Lower and
Upper Egypt, succeeded them in the strategic and
commercial dominion of Lower Egypt.
The growth of religious power, intimately bound to
all the activities of the time, kept pace with that of
political power. As Leopolis increased in size, the
old sanctuary that lay before it became a holy city.
The Greeks were later to call it Heliopolis (city of
the sun). When it became necessary to unify the
norms and measures for all trading activities be-
tween Upper and Lower Egypt, the unification of
the religious cults, which all Egyptians felt so dee-
ply, also made a comeback and the city became the
fulcrum of religious and social unity.

Originally the divine couple generated by the
primordial mother-earth was worshipped in the an-
cient sanctuary, perhaps witness to the realm of
Osiris. Shu and Tefnut were both represented with
a human body and the head of a lion, in other
words, the reverse of the image of the Sphinx.
The gods of the other "nomes" were then gathered
around this first pair like the scattered limbs of a
single god.
The power axis then shifted towards the city of
Buto, where the first historical nome made its ap-
pearance, that of Andjti "the protector", the new
man who assumed power by popular acclaim.
Andjti was also the first to establish control over
Lower Egypt, by developing the agrarian cult, the
worship of Osiris. The capital took the name of
"city of Osiris". The regality of the sovereign, as
the legitimate descendent and representant of
Osiris, was consecrated in Heliopolis; and it was
put to the test and confirmed with the jubilee fes-
tivities of the sovereign, thirty years after his con-
secration (later this jubilee was to be called the
feast of Heb-Shed). Thus before the end of the
fourth millennium the historical task of legitimiz-
ing, in the form of oracle, the sovereigns of Egypt
fell to Heliopolis.
The Realm of Busiris which followed, expanded
southwards and created new cities, including the
sanctuary city of Abydos, a center dedicated to the
cult of Osiris. With this shift towards Middle and
Upper Egypt, the center of power once more
returned to Leopolis and the new kings were elect-
ed by Osiris himself, in other words by his priests,
and as a result came to be identified with the god
himself. Their emblem was the sacred falcon.
Trade with the Mediterranean brought new wealth
and power and before long the Delta cities became
independent. This dismemberment once more fa-
vored the predominion of Buto which supplanted
Leopolis, eliminated the interference of Sais and
subjected the newborn and weak republics.
The kings of Buto continued to be consecrated in
Heliopolis. Their power became hereditary and
was subject to divine judgement alone; and in this

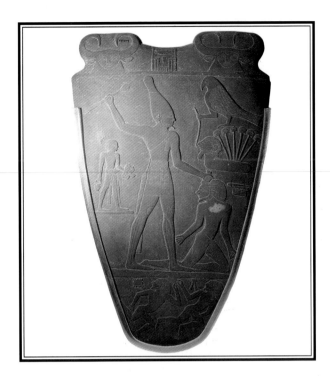

Slate palette in the Cairo Museum showing Narmer, king of Upper Egypt, triumphing over the peoples of the Delta.

way, immune to human judgement, power became absolute. The priests of Heliopolis were called on to sanction the nomination and to judge "post mortem" if the king was or was not worthy of becoming a divinity. With the affirmation of absolute power, the necessary administrative and juridical organizations were also created, particularly those regarding public works and state and financial services, with surveys and censuses of "the gold and the fields" and the consequent institution of a gigantic land survey of the entire kingdom, replete with registers and inventories.

The trade routes in the Mediterranean opened up with the second Kingdom of Buto and real colonies were founded in Crete and Byblos (where a temple dedicated to the goddess Isis was built) and in Upper Egypt, a point of direct contact (at Coptos) both with the caravans from the Red Sea, and with the Nubians who brought in gold, ebony and ivory. Buto became a powerful city, enclosed in turreted walls, with temples and palaces, covered with concealed barrel vaults, from which tall antennas with ribbon banners rose to the sky.

Development in Upper Egypt was slower. The most important cities in the fourth millennium were Coptos, Edfu, Elephantine, Tentiri, Ossirinco. They belonged to a confederation centering on Nubt (Ombos) where the individual princes were consecrated. Their common standard bore the sign of the crocodile, often identified with the god Seth. Strength, aggressiveness and courage were the essential qualities needed to overcome the difficulties encountered every day. Among these was the relationship with their more fortunate brothers in Lower Egypt who provided them with indispensa-

ble products but whose territorial encroachments were a constant source of conflict. The field of battle was the land of Middle Egypt, already the fertile land of all, with an ever growing number of agricultural communities and settlements along the river which obviously looked more to Lower than to Upper Egypt, and created a confederation of their own under the protection of the goddess Hathor, venerated as mother or as wife of Horus. This Hathorian confederation — in which cities such as Assiut, Abydos, Un, Cusai, Kasa prospered — was often subject to attack by Upper Egypt until the powerful kingdom of Buto carried off a memorable victory over the confederation of Nubt, commemorated in the third millennium as that of Horus over Seth. With the victory of the Hathorians, the cities of Panopolis and Coptos rebelled and headed a political and religious revolution of all the feuds of the South, taking the cult of the popular god Min everywhere. The city of Nekhen then became the seat of the sovereign of Upper Egypt, no longer elected by the feudataries but nominated by acclamation of the people and with the support of distant Buto.

This "long hand" of Lower Egypt soon led to a merger of the deities Min and Horus. The princes of Nubt became the vassals of the new king and the new god. The king of Upper Egypt moved down to Heliopolis to be consecrated. Before Nekhen rises the sacred city of Nekheb dedicated to the mother goddess Nekhbet with the symbols of the serpent and the vulture; and the king of Upper Egypt wore the serpent of the goddess on his white crown while her feast was renewed every spring with that of Horus-Min. On this feast the king offered the god the first fruits of the fields and a white bull was sacrificed to ensure the fertility of the land and the rebirth of life.

The original god Seth had by now been definitively ousted; the time was ripe for a political and religious union, after a thousand years of rivalry and isolation, but this great event was not, as everything seemed to indicate, to be realized pacifically by Lower Egypt, but with war by Upper Egypt. In fact the king of Nekhen, urged by the council of "the ten great ones of the South", gradually withdrew from the influence of Buto, once more on the decline on account of the individualistic nature of the Delta cities, and because of the pressure exerted on the borders by the "peoples of the bow", the peoples of western Asia attracted by the wealth of Lower Egypt.

Finally the king of Nekhen moved his capital to Abydos (Thinis), and — with the pretext of freeing it from the grave threat — invaded the Delta lands. Every hotbed of resistence was put out in blood, the ancient city of Mendes was destroyed, Metelis, which attempted to head the last rebellion, was conquered and dismantled, and the ten leading citizens decapitated by Narmer, king of Upper Egypt, who placed on his head the red crown of Lower Egypt, that was also red with the blood of his slaughtered brothers. The fourth millennium had drawn to a close and with the inauguration of the first dynasty what is known to us as official History began.

From 3000 to 2000 B.C.

MESOPOTAMIA — Cultures of **Uruk, Mari, Lagash, Susa**.

PALESTINE — Development of **Jericho**. Development of other inhabited centers and beginnings of painted pottery and working of copper in the eastern Mediterranean.

3000

1st DYNASTY — Capital Abydos (Thinis), Upper Egypt — beginning of absolute power.

Narmer (Menes), king of Upper Egypt, conquers entire Nile valley up to Mediterranean. Unites the two kingdoms and the White Crown of the South is grafted onto the Red Crown of the North. ABYDOS becomes the capital sacred to the god Osiris, seat of the Chancellor of Lower Egypt and the ten Counselors of Upper Egypt. HELIOPOLIS and NEKHEB become sanctuary cities.

Aha founds city of MEMPHIS (Lower Egypt) and consolidates southern frontiers. His tomb is similar to a turreted palace.

Uadji leads an expedition into the Sinai.

Udimu officially proclaims Heb-Shed festival which puts the sovereignty of the pharaoh to the test in the thirtieth year of his reign. Structures in quarried stone with vaulting.

MALTA — Megalithic temples of the Mother Goddess in **Ggantija** and subterranean sanctuary of **Tarxien**

AEGEAN — Ancient Minoan Culture

SYRIA — Founding of **Tyre** and **Byblos** under Egyptian proctectorate

2850

2nd DYNASTY — Capital Memphis, Lower Egypt — Advance of absolute power.

Hotepsekmemwy, Raneb, Nynetjer are first kings in dynasty.

Peribsen puts down insurrection of feudatary princes of Upper Egypt and moves capital to MEMPHIS. Changes deity which identifies it, replacing Horus with Seth. Is buried in ABYDOS.

Khasekhemui proclaims cult of Horus the state religion with seat of highest religious power at HELIOPOLIS. Expedition into heart of Nubia.

MESOPOTAMIA — Beginning of the golden period of the **Sumerians** of **Ur** and **Lagash** — Temples and palaces in brick

2770

3rd DYNASTY — Capital Memphis — Extension of absolute power in field of religion.

Zoser identifies worship of Sun God with worship of king and assumes power of the priest. Imhotep, prince, vizier, high priest of HELIOPOLIS, is first great physician and architect in history, later deified by Greeks as Aesculapius. Construction in SAQQARA of mausoleum-city of Zoser centered on large stepped pyramid. New expeditions to the Sinai and extension of power southwards.

Sekhemkhet begins but never finishes funerary complex with a stepped pyramid. Fortresses and walls built along all frontiers (a 12 km. wall astride the Nile, at height of island of PHILAE).

Sanakhte tries to emulate his predecessors, beginning, among other things, a mausoleum like Zoser's, but his tomb is simply installed where the mortuary temple of Unas was later to rise.

Khaba, last king of the dynasty, probably builds a small pyramid at Zawiyat al-Aryan.

TROY — Development of Troy I

MESOPOTAMIA — First temples at **Ashur**; temple of Ishtar and of Samak at **Mari**. Unbaked brick structures which recall those of the early Egyptian dynasties

2620

4th DYNASTY — Capital Memphis — Consolidation of power.

Snefru is remembered as a humane and kind pharaoh. Defends the frontiers, opens turquoise mines in the Sudan. Builds first smooth-faced pyramid.

Khufu (Cheops) names his sons high priests at NEKHEB, the sacred city across from NEKHEN, and at PE, the sacred city before BUTO (the dismissed priests will curse his memory). Builds first Great Pyramid surrounded by city-necropolis.

Redjedef (Dedefre) briefly usurps power between reigns of Khufu and Khafre. Begins unfinished pyramid of Abu Roash.

Khafre retains centralization of political and religious power. Builds second Great Pyramid with gigantic mortuary temple and granite valley temple.

Menkaure (Mycerinus) restores some of property confiscated by Khufu to priests, is remembered as a just and moderate pharaoh. Builds smallest of the Great Pyramids.

Shepseskaf renews struggle with the power of the priests. New necroplises with mastabas and pyramids built under his reign.

5th DYNASTY — Capital Memphis — Power crisis, flourishing of Solar Worship

Userkaf, grandson (nephew) of Menkaure, builds pyramid at Saqqara.

Sahure digs canal of BUBASTIS joining Mediterranean with Red Sea and creates powerful military fleet. Undertakes first expedition into fabulous Realm of Punt. Builds various pyramids and a solar temple at ABU SIR.

Neferirkare loses juridical and religious power. Builds a pyramid and some temples at ABU SIR.

Nyuserre interrupts series of solar temples at ABU SIR and constructs new pyramids at SAQQARA.

Unas builds pyramid, decorating interior with "The Pyramid Texts" and "Wisdom of Ptah-Hotep", two of the most important extant Egyptian texts.

6th DYNASTY — Capital Memphis — Collapse of absolute power.

Teti attempts to renew the central power with aid of Nubian mercenaries. Great viziers such as Kagemmi and Meri are to all extents the masters of power. Maximum splendor in art. Memoirs of the architect Menipta-Han-Merire, "royal builder of the double palace".

Pepi I witnesses decline of royal power with increase in power of princes, high dignitaries and priests. Uni, first minister, re-establishes dominion over the Sinai and Palestine. A marvelous copper statue of the pharaoh and the striking decorations in the tomb of Uni testify to high level attained by art.

Pepi II, with longest reign in history, from age of six to over a hundred. Nominal reign because it is pacifically divided between the secular and clerical feudatary powers.

At end of 6th Dynasty, central power decentralized by nomarchs (feudatary princes) and the pressure exerted by the neighboring peoples, in particular the Bedouins.

7th and 8th DYNASTIES — Capitals Memphis and Abydos — Dynasties that exist only in name.

HERACLEOPOLIS remains faithful to MEMPHIS as a personal feud of the king. An incessant turnover of princes who claim sovereignty of Egypt. Bands of Asian peoples invade and plunder the Delta cities. Outstanding among powers in the South are: Idi, prince of COPTOS, and Shemai, governor of Upper Egypt.

9th and 10th DYNASTIES — Principal capital Heracleopolis, Middle Egypt — Lack of unified and recognized power.

Neferkare (2130-2120) installs a monarchy as "God given" but not divine, where the king is the "primus inter pares" among the princes. Not all princes recognize him.

11th DYNASTY — Capital Thebes, Upper Egypt — Rebirth of centralized power.

Sehertani-Antef (Sehertowy) (2120-2118) self-nominated king, shifts power from Heracleopolis to Thebes.

Mentuhotep I "The God Montu is satisfied" (2060-2010) extends power of Lower Egypt with support of middle classes who want to restore trade to entire territory. Construction of great mortuary temple with pyramid, colonnade and steps at Deir el-Bahri, Necropolis of Thebes.

Mentuhotep II and III reinstate the office of chancellor vizier and supreme judge. Resumption of maritime trade with Aegean Sea. Important caravan route between COPTOS and Red Sea is equipped with wells, storerooms and a port on the sea.

2500

MESOPOTAMIA — beginning of **Akkadian empire** with king SARGON (2470). The dynasty rules for about two centuries. Development of art in **Akkad, Lagash, Susa, Mari, Ashur** and **Ur**

2350

MESOPOTAMIA — Beginning of the **Gutian** dynasty (2240) — Ziggurat of **Ur**; Nippur; Uruk

2180

TROY — Development of Troy II, III, IV

AEGEAN — Development of ancient Minoan culture

2160

MESOPOTAMIA — Sumerians regain their independence with third dynasty of **Ur**. Golden age for stepped architecture in unbaked brick with ziggurats, palaces and hypogeums at **Eridu, Ur, Uruk, Nippur**.

2120

AEGEAN — Middle Minoan culture

From 2000 to 1000 B.C.

MESOPOTAMIA — End of the third dynasty of **Ur** followed by the dynasties of **Isir** and **Larsa**

AEGEAN — First palaces of **Knossos** and **Phaestos**. Achaean invasion (2000-1750)

1991 **12th DYNASTY — Capital Thebes — Expansion of the Empire.**

Amenemhet I "Amon is at the summit" (1991-1962), former vizier of Mentuhotep III, comes to power, prevails over feudatary princes, with support of people and lower middle classes. Strengthens cult of Amon-Ra. Reclaims 2,000 sq. km. of the Fayyum. Takes confines beyond Third Cataract of Nile, in heart of Sudan. Creates many fortifications in outpost territories.

Sesostris I (Senusret), first pharaoh to introduce co-regency with son in order to ensure dynastic continuity.

Amenemhet II extends empire as far as MEGIDDO, in Palestine, and UGARIT on coast of Syria.

Amenemhet III builds imposing residence in the Fayyum, to be remembered by Greeks as "Labyrinth".

Sesostris III and successors continue expansion and consolidation of empire. Increase along frontiers of fortifications in communication with smoke signals.

BABYLONIA — Realm of HAMMURABI (1792-1750). 1785 Institution of the laws Development of art Construction of gigantic palaces

PHOENICIA — Invention of the alphabet

CENTRAL ASIA — The Indo-Europeans move down towards **India** and **Persia**

MESOPOTAMIA — Beginning of the **Kassite** domination

1785 **13th DYNASTY — Capital Thebes — Dismemberment of power**

Sekhemre marries ruling regent and assumes part of her power. Nubia withdraws from Upper Egypt.

1745 **14th DYNASTY — Almost contemporary with thirteenth**

Neferhotep reconstitutes unity above all in Delta. Carries the protectorate to Byblos in Lebanon. The Hyksos (Canaanites and Ammonites) hard pressed by Indo-European peoples from Central Asia (Hittites and Kassites) invade fertile Delta lands introducing use of wheel and horse — hitherto unknown in Egypt — and the cult of the god Baal.

1700 **15th DYNASTY — Capital Avaris, Lower Egypt — Hyksos Dominion.**

Salitis is first Hyksos "shepherd king: to rule over Lower Egypt. Founds new capital AVARIS.

Apohis, defeated by kings of Upper Egypt, is last "shepherd king".

ASIA MINOR — Beginning of the **Hittite** empire with **Hattusa** as capital and king Hatatushili (1650-1620)

CHINA — **Shang** dynasty and culture

1622 **16th DYNASTY — Capital Thebes — Reconquest of power throughout Egypt.**

Kamose defeats and thrusts back the Hyksos in Middle Egypt.

Ahmose reconquers Nubia up to Abu Simbel. Penetrates Delta, destroys AVARIS and chases the last of the Hyksos as far as Palestine. Upon return, puts down rebellion of princes of the North and re-establishes power over all Egypt.

17th DYNASTY — Phantom monarchy which survives in Lower Egypt during Hyksos dominion.

AEGEAN — Development of Middle Minoan III. Construction of new buildings. Legendary kingdom of Minos in Crete. Linear A and linear B scripts

ASIA MINOR — Great expansion of the **Hittite** empire

MESOPOTAMIA — The **Kassites** conquer **Babylonia**

GREECE — Zenith of **Mycenaean** culture: beehive tombs, Lion Gate

1580 **18th DYNASTY — Capitals Thebes and Akhetaten — Triumph of great Egyptian empire over entire known world.**

Ahmose (1580-1558), brother of 16th Dynasty Ahmose, continues work of consolidation and expansion of power.

Amenophis I "Amon is satisfied" (1558-1530) extends frontiers to Euphrates. First clashes with Hittites and Mitanni.

Thutmosis I (1530-1520) takes cities of THEBES and ABYDOS to maximum splendor. Temple of KARNAK is enriched with gigantic pylons and obelisks; the Great Hypostyle Hall is raised. The cult of god Amon is identified with that of Thoth.

Thutmosis II (1520-1505) marries half-sister Hatshepsut. Puts down internal and external uprisings affirming absolute power.

Hatshepsut (1505-1484), regent for her son, reigns for twenty years wearing male attire and the pharaoh's false beard. Leads important trading expeditions towards mysterious kingdom of Punt.

Thutmosis III (1505-1450) actually reigns only thirty-four years after his mother's death and becomes most famous of pharaohs. In KADESH, behind Byblos, defeats the Mitanni; at MEGIDDO defeats 330 Syrian princes; at CARCHEMISH (1483), in north of Syria, crosses the Euphrates and once more defeats the Mitanni in home territory. With victories of this sort he conquers fertile lands almost as vast as the Delta, and with wealthy trading cities. Extends his dominion over the "islands of the great circle" (Crete, Cyprus and the Cyclades). Generous, pardons even rebels and retains customs and religions of the conquered lands. Egyptian culture and art spread throughout the world.

Amenophis II (1450-1425) concludes peace marrying his son, future pharaoh Thutmosis IV (1425-1408) to princess Miteniya, daughter of Artatama king of the Mitannians.

Amenophis III (1408-1372) maintains peace with his neighbors marrying Tiy (or Tuja) daughter of Sutarna, king of the Mitannians, and the daughter of Kalimasin, king of Babylonia. Tiy strongly influences the pharaoh. First clashes with Suppiluliumas king of Hittites.

Amenophis IV later **Akhenaten** "Pleasing to Aten" (1372-1354) changes his name when he replaces religion of Amon with profoundly mystical and monotheistic religion of Aten, according to which all men are equal in the love of an only God of whom pharaoh is prophet. Creates AKHETATEN "The horizon of Aten", a new capital set at center of Egypt and seat of religious power taken from THEBES.

Nefertiti "the lovely one who comes", a Mitannian princess and bride of Akhenaten strongly influences the renewal of customs, art and religion.

Tutankhaten later **Tutankhamen** (1354-1345) remains in AKHETATEN reigning under regency of Nefertiti; then persuaded by priests returns to THEBES and re-establishes supremacy of cult of Amon. Dies mysteriously at eighteen. **Nefertiti**, marrying the old Ay, succeeds in maintaining power for four more years; AKHETATEN disappears with her death, as do the memory and tomb of the beautiful queen. Egypt falls ever deeper into anarchy and misery.

Horemheb (1340-1314) former friend of Akhenaten and powerful general, repudiates Atonian faith and destroys all traces (even the memory of Akhenaten, the "heretic pharaoh", is cursed). Stipulates peace with Mursili II, king of Hittites, blocked by the plague in Asia. Stems misery by unrelentingly bearing down on administrative corruption.

19th DYNASTY — Capitals Tanis and Thebes — Military power in recurrent states of war.

Ramses I (1314-1312) Former general and vizier of Horemheb, "prince of the entire earth", obtains power. Chooses TANIS as capital of empire leaving THEBES capital of the two kingdoms and seat of the cult of Amon.

Seti I (1312-1298) drives back Muwatalli, king of the Hittites, who had advanced all the way to the Sinai. Takes back Phoenicia and occupies Kadesh despite strong Hittite resistence.

Ramses II (1298-1235) takes the royal residence to AVARIS and fortifies TANIS. In first military campaign once more drives back Hittite army (18,000 men, 2,000 scythed chariots) but prudently comes to a halt at KADESH. In his second campaign drives back rebels of Palestine instigated by Hittites. In face of growing and serious threat from Salmanassar, king of the Assyrians, Hittites and Egyptians, great enemies for over a hundred years, sign first historical international treaty: with god Re of Thebes answering for Egyptians and god Teshub of Hattusa for the Hittites.

Merneptah (1235-1224) scatters the "peoples of the sea": Achaeans, Etruscans, Siculi, Lycians, and Libyans, who once more threaten the Delta. Exodus of Hebrews from Egypt.

Seti II tries to stem economical and administrative crisis. The Delta once more subject to Libyan invasions.

20th DYNASTY — Capital Thebes — Recovery and decadence of central power

Sethnakht destroys the Libyan bands and restores usurped property.

Ramses III (1198-1188) continues work of restoring empire. With his first military campaign puts an end to invasions of "peoples of the sea". Siculi and Etruscans flee into distant Italy, the others into Libya. Those that remain are absorbed as colonies and as mercenaries in the army. Conscription for national defense is established. In his struggle against corruption and treachery, present even in his harem and among his viziers, the great pharaoh is cut down by his enemies. He is followed by seven other pharaohs all bearing the name of Ramses and who come to power thanks to the interminable palace conspirations.

Ramses XI (1100-1085) tries in vain to resist excessive power of the High Priest of Amon, **Amenhotep Herihor**, who becomes vizier and to all extents lord of the empire.

21st DYNASTY — Capitals Tanis and Thebes — Power splits into two branches

Mendes, successor to Ramses XI, governs Lower Egypt from Tanis.

Piankhi, son of Herihor, takes pharaoh's place in Upper Egypt. Succeeded by **Pinudjem I** and his son **Menkheperre**.

A powerful Libyan family from HERACLEOPOLIS which had driven back the army of king Solomon of Palestine as far as MEGIDDO, replaces 21st dynasty.

1450

1314

1200

1085

ASIA MINOR — The **Hittites** invade kingdom of the **Mitanni** allies of Egypt (1420)

ASIA MINOR — SUPPILULIUMAS I, king of the **Hittites**, marches to conquer Egypt (1380)

MESOPOTAMIA — Beginning of the **Middle Assyrian** empire

AEGEAN — Mycenae and Crete are in direct contact with the Atonian culture

AEGEAN — Development of Late Minoan

CHINA — **Shang** dynasty — Bronzes of **Anyang**

TROY — Tradition sets epic Trojan war around 1280

AEGEAN — The Dacians arrive in the Mediterranean

MESOPOTAMIA — TUKULTI-NINURTA I (1243-1207) begins Assyrian empire with capitals **Ashur** and **Nineveh**. Autonomous artistic centers arise at **Tel-Halaf** and **Tel-Alimar** with king KAPARA

AEGEAN — Beginning of Ionian immigration

GREECE — Beginning of protogeometric art

PALESTINE — The reign of **Saul** followed by that of **David**

11

From 1000 to the year 0

<table>
<tr><td valign="top">

PALESTINE — Zenith of kingdom of Israel with SOLOMON who builds temple of Jerusalem and marries an Egyptian princess

MESOPOTAMIA — **Assyrian** Empire ASHURNASIRPAL II, SHALMANESER III, SARGON II destroy the neighboring peoples

GREECE — Beginning of Olympic Games (776)

ITALY — Founding of **Rome**

MESOPOTAMIA — Penetration of **Medes** and **Persians**

CHINA — Beginning of **Chou** dynasty art

GREECE — Beginning of Corinthian art — First Greek philosophers: THALES, ANAXIMANDER, PYTHAGORAS OF SAMOS

ITALY — Beginning of Etruscan art and **Magna Graecia**

MESOPOTAMIA — Destruction of **Nineveh** and end of **Assyrian** empire — Beginning of the **Chaldean** empire (612) — NEBUCHADNEZZAR king of Babylonia; ziggurat and palace with hanging gardens; Gates of Ishtar

PALESTINE — Destruction of **Jerusalem** and the Temple of Solomon (597)

GREECE — SOLON reforms the laws of **Athens** (594)

INDIA — Preaching of BUDDHA

CHINA — Dialogues of CONFUCIUS and Teaching of LAO-TSE

GREECE — **Persian** wars — Defense at **Thermopolis** and victory of the Greeks at **Salamina**

GREECE — Era of PERICLES — Maximum splendor of Greece — Peace with **Persia**, treaty with **Sparta** — Great acropolis of **Athens** built.

</td></tr>
</table>

950

22nd DYNASTY (Libyan) — Capital Bubastis — Attempt to return to ancient prestige.

Sheshonq I (950-929), after death of king Solomon, renews campaign to conquer Palestine.

Osorkon I (929-893), struggle against power of priests of Thebes. Upper Nubia separates from Egypt, joins Sudan, creates new state with capital at NAPATA.

757

23rd DYNASTY (Bubastite) — Capital Bubastis — Dynasty parallel to 22nd, with princes of same capital.

Osorkon III (757-748), resumes relations with religious power of THEBES, instituting function of "divine worshipper of Amon" and attributing it to a royal princess.

730

24th DYNASTY (Saite) — Capital Sais — Brief parenthesis of peace.

Tefnakhte (730-720), king of SAIS, conquers HERMOPOLIS and recovers part of Lower Egypt. Beaten back from South by Piankhi king of NAPATA. Alliance with neighboring peoples to resist frightening devastating expansion of Assyrians.

Bocchoris (720-716) obtains peace with Assyrians. Raises workers and lower middle classes from misery by persecuting rich priestly caste. Is remembered by Greeks as an example of a just and generous king.

716

25th DYNASTY (Ethiopian) — Capitals Napata then Thebes — concurrent with 23rd and 24th.

Piankhi (751-716) annexes Upper Egypt to Nubia.

Shabaka (716-701) brings capital back to THEBES, invades Lower Egypt and draws up friendship pact with Assyrians.

Shabataka (701-689) puts down revolt led by Ezechias king of Judah: later defeated by Sennacherib, king of Assyrians; succeeds in avoiding destruction.

Taharka (689-663) When princes of the Delta rebel, followed by invasion of Assurbanipal, Assyrian king, he takes refuge in far off NAPATA.

Tanutamon (663-655) overwhelmed by the invasion of the Assyrians, who take advantage of the betrayal of the princes of the North and sack THEBES.

666

26th DYNASTY (Saite) — Capital Sais — Resumption of political and social life.

Necho, king of SAIS, treacherously assumes power by accepting the dominion of Assurbanipal.

Psamtik I (Psammetichus) (663-609), son of Necho, conquers Delta with help of the Assyrians and ensures his sovereignty of Upper Egypt by putting relatives and friends in key positions. He frees himself of Assyrians by allying with cities of eastern Mediterranan arc and thus favors the immigration of Greeks into the Delta.

Necho II (609-594) reconstructs Red Sea canal. His ships ply the entire Mediterranean and perhaps even round the Horn of Africa.

Psamtik II (594-588) reconquers Nubia and the gold mines. Spreads culture and morale of the ancient religion throughout Mediterranean. Unsuccessful military campaigns against Cyrene, Greek colony north of Delta. Loses prestige in Asia. The pharaoh is no longer a son of Osiris and his power depends solely on the people.

Psamtik III (526-525) clashes with Cambyses, king of the Persians, who has already taken all his Egyptian lands. Defeated at Pelusium tries in vain for a last stand and kills himself.

524

27th DYNASTY (Persian) — Capitals Sais and Memphis — Continuous struggles for independence.

Cambyses, after conquering Egypt, is crowned at SAIS and consecrated at HELIOPOLIS as pharaoh through maternal descent. Reigns with clemency and generosity.

Darius I (522-484) reorganizes Egyptian economy. Once more opens up the Red Sea canal to join Mediterranean and Indian Oceans.

Xerxes and his successor Artaxerxes put down two great revolts in Lower Egypt.

Darius II (424-404) puts down a third revolt led by Amyrtaeus.

404

28th DYNASTY — Capital Sais — Liberation from Persian dominion

Amyrtaeus (404-398) after the end of the reign of Darius II, frees Egypt and restores much of its power.

29th DYNASTY — Capital Mendes — Struggle for power.

Nephritis I, head of Egyptian army, takes over power.

Achoris (390-378) reconstitutes fleet. Makes alliance with Athens and Cyprus against Persians and Sparta.

30th DYNASTY (Sebennyte) — Capital Sebennytus and Memphis — Loss of independence — Second Persian dominion.

Nectanebo II, prince of SEBENNYTUS takes over the vacillating power. **Artaxerxes II**, king of Persia, with 200,000 men invades the Delta but is stopped by flooding of the Nile.

Nectanebo II, betrayed by Greek mercenaries, flees into Upper Egypt.

Kabbas is nominated pharaoh by the priests of MEMPHIS, but two years later Egypt is reconquered by **Darius III**. Futile attempts at resistence; the survivors invoke Macedonians for help.

Alexander the Great (333-323) drives Persians from Egypt and is received as a liberator and legitimate successor of the pharaohs. Recognized as the son of Ra by the oracle of LUXOR, he founds the new city of ALEXANDRIA (where he will be buried in 323) which becomes the ideal capital and the economic and cultural center of the entire ancient world. He is succeeded by his half brother **Philip Arrhidaeus** who is assassinated and succeeded by **Alexander Aegos**, said to be the son of Alexander and Rossana.

PTOLEMAIC DYNASTY — Capital Alexandria — Return of absolute power — End of Ancient Egypt.

Ptolemy I Soter (306-285), son of **Lagus** (satrap or governor of Egypt at time of Alexander the Great), nominates himself king of all Egypt. Founds the city of PTOLEMAIS, next to THEBES, destroyed by the Assyrians. Reconquers Syria and the Aegean islands.

Ptolemy II Philadelphus (285-246) takes back Cyprus, Tyre and Sidon. Signs a friendship pact with Rome. Once more opens up Red Sea canal. Great development of Hellenic-Egyptian culture.

Ptolemy III Everegetes (246-221) expands frontiers and becomes "Lord of the Mediterranean Sea and the Indian Ocean": ALEXANDRIA becomes most important economic and commercial center from Spain to the Indies; international coinage is Egyptian "stater".

Ptolemy IV Philopator (221-203). His rule marks beginning of loss of dominions and decadence of royal family itself.

Ptolemy V Epiphanes (203-181) obtains Syria as dowry of **Cleopatra I**, given him as wife by king Antiochus. The luxury and dissoluteness of the Ptolemies increases out of all proportion to the social and economic poverty of Egypt, devastated by invasions of neighboring peoples. Rome intervenes as ally and ends up by interfering in Egyptian politics and power.

Ptolemy XII Auletes (80) returns to ALEXANDRIA thanks to Gabinus, Roman governor of Syria.

Ptolemy XIII Neos Dionysos buys power over Egypt from Roman Senate. He has Pompey assassinated to ingratiate himself with Caesar, new absolute lord of Rome. When he comes to Egypt, Caesar marries **Cleopatra VII**, sister of Ptolemy and has himself recognized as son of Amon, descendent of the pharaohs. Caesar and Cleopatra dream of the union of Rome and Egypt and an empire greater than that of Alexander to give their son Caesarion.

Cleopatra VII, on Caesar's death (44) tries to put economy of Egypt back into order and asks help from Antony, Caesar's successor. Antony joins Cleopatra in ALEXANDRIA and **Caesarion** is the new pharaoh. The reconquest of the Asiatic territories begins; but Rome, with Octavianus, declares war on Egypt (32). Egyptian fleet defeated at ACTIUM, Antony and Cleopatra commit suicide.

ITALY — Advance of Roman expansion. Camillus drives back Gauls and destroys Etruscan **Veio**

GREECE — King PHILIP of **Macedon** invades **Greece** (359) — His son ALEXANDER THE GREAT conquers the Persian Empire, Egypt and continues up to the Indus river — Works by SCOPAS, PRAXITELES, LYSIPPUS — Philosophy of PLATO and ARISTOTLE

MESOPOTAMIA — Empire of the **Seleucids**

INDIA — Construction of the first stupas (sacred tumuli)

ITALY — First and second Punic wars between Rome and Carthage — Expansion of Rome in western and central Mediterranean

CHINA — Building of the Great Wall

ITALY — Third Punic war — **Rome** destroys **Carthage**, conquers **Greece**, **Asia Minor** and **Tunisia**

ITALY — **Rome** draws up political and economic relationships with Egypt (80)

The twilight after the year 0

The voice of Ancient Egypt does not die out completely with the Roman conquest. Echoes have spread far and wide throughout the Mediterranean, leaving profound traces in the various civilizations and the land of the Nile is still imbued with its forceful and magical appeal. The Roman emperors themselves have their cartouches in hieroglyphics and honor the gods of Egypt with images in the temples they restore or build. The Osirian cult spreads throughout the empire of the west and to Rome. **Nero** (54-68 A.D.) restores and renovates monuments but also organizes expeditions to find the sources of the Nile. **Trajan** (98-117 A.D.) reactivates the ancient canal leading from Bubastis to the Red Sea, along a route that the Suez Canal now covers in great part. Lastly **Hadrian** (117-190 A.D.) founds the city of ANTINOE in Egypt, visits the "Colossi of Memnon" and the Temples of Thebes, fascinated to the point of attempting an imaginary reconstruction in his gigantic Villa of Tivoli near Rome. These are the last sparks: religious struggles and rebellions to foreign dominion become bloodier and misery and desperation destroy what remains of the cities. Little by little the ancient writing and the art are scorned and forgotten. A thick blanket of sand spreads out over the great past, almost cancelling it from memory.

THE EGYPTIAN RELIGION
Hope and resurrection

We can only hope to retrieve the profound emotion which permeates the great religion of ancient Egypt, and which inspired and pervaded most of the later religions, by freeing ourselves of the preconcepts and commonplaces, so often taken for granted, which make it appear as a tangled wilderness of gods with monstrous animal heads, remote and inhuman and clouded by an anguished terror of the hereafter.

Approaching the religion of Ancient Egypt with prejudices of this sort would be like attempting to judge Buddhism on the basis of the innumerable images that seem coldly remote or grotesquely demoniac on first impact. Or it would be like presuming to penetrate the essence of Christianity by a cursory acquaintance of the rites and traditional iconography. A superficial judgement of this sort, limited to the exterior aspects of a religion, must be replaced by a knowledge of the deep roots from which that religion springs. We must follow in the steps of man as he searches for truth, torn by doubt and anguish, filled with the ecstasy of faith as he attempts to give meaning to apparent reality, to discover the why and wherefore of his own life and that of the universe around him. We must develop an awareness of that range of feelings which swing to and fro between reasoning and pure intuition, and which is why we so often cling to the "visible", the "measurable", in our attempt to understand the invisible and unmeasurable.

And lastly we must realize that the ancient Egyptians were beings whose spiritual problems were much like ours. A comparison of their artistic sensibilities to ours is extremely telling — externally the difference is great, one might even say insuperable, but the difference in substance is irrelevant. Like all great religions that of the Ancient Egyptians was basically monotheistic. And so was that of their ancestors, in prehistoric times, with the cult of the Mother Goddess, the generating force of all things, of gods and man. The religion born with the "planet Egypt", when the great turning point in the history of civilization was achieved, was even more so. All Egyptian cosmogonies are deeply permeated by the feeling of a one and only absolute God, beginning and end of all visible and invisible things: of an eternal creation where the gods have a thousand faces and are the thousand manifestations of the same god, as are all his creatures and all of mankind.

In the Cosmogony of Heliopolis, before creation the Absolute Spirit Ra was diffused in primordial Chaos. At the beginning of time Ra became aware of himself "seeing" his own image (Amon); then, in the Great Silence, he called his double: "Come to me". Ra, light and Conscience of the Universe, "calls" Amon, Spirit of the universe itself. With this call, that is with the word — creative power —

space-air (Shu) and movement-fire (Tefnut) became manifest and in turn they generated and separated the earth (Geb) from the sky (Nut) ending chaos and therefore giving the Universe equilibrium and life. Everything at this point was ready to receive the creative forces of terrestrial and extra-terrestrial life, that is the fertilizing force Osiris — seed and tree of life, water which gives nourishment — and the generating force Isis, love of creatures, fecund power. Later (after the end of the Eden?) the destroying couple made their appearance — Seth and Nephthys, the forces of evil which continuously lose to the life-bearing couple, but also are their collaborators since they provoke the eternal becoming of universal life.

The Cosmogony of Hermopolis in substance furnishes the Heliopolitan cosmogony with images.

Primordial chaos is an immense sphere without light in which the original Tumulus took shape. The primordial egg issued from this conic-pyramidal form, like an incommensurable lotus flower, to let the Sun-Ra (Thoth or Ptah), source of every form of life, come out. Tears which generate all human creatures fall from the eyes of Ra that is from the Light of the Universe. From his mouth, source of the generating Word, are born all the divine creatures, the forces which generate every vital form.

As the centuries passed, the cosmogonies of Heliopolis and Hermopolis were enriched by myths and the divine Forces acquired an even greater consistency in the mythology of the various cities. The religious essence became increasingly occult and was revealed only to a few initiates.

Thus, in imitation of the royal organization of mankind, Amon-Ra was to have his court. The Heliopolitan Ennead consisted of the God and four pairs of gods: Amon-Ra, creator of the universe; 2), 3) Shu, god of air, and Tefnut, goddess of fire; 4), 5) Geb, the earth god, and Nut, the sky goddess; 6), 7) Osiris, god of the afterworld and the fecundating force, and Isis, goddess of divine love and generating power; 8), 9) Seth, god of destruction and Nephthys, sister goddess and aid of Isis.

The Hermopolitan Ogdoad, or group of eight gods, evolved in Hermopolis and was comprised of four joint couples: Nedu and Nenet, gods of the occult world; Nun and Nunet, gods of the primordial waters; Heh and Hehet, gods of spatial infinity; Kek and Keket, gods of darkness.

The basis of the entire system of religious thought and moral rectitude of the Egyptian peoples lies in

Schematic representation of the Egyptian theogony with an indication of the essential symbols.

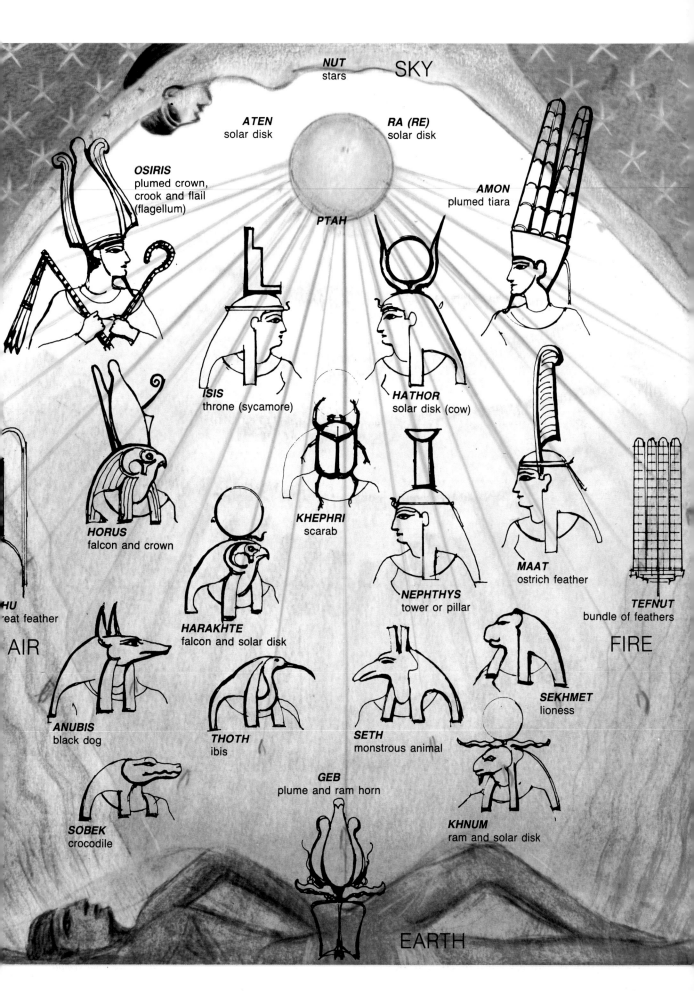

the myth of Osiris which not only mirrors historical events, as noted, but is also the vehicle for a highly spiritual content. With the passing of the centuries it was gradually adumbrated and muddled in the accumulation of fragmentary and contradictory episodes but even so the immense ethical and religious value of its content is still evident even to our modern mentality, hardened by millennia of civilization.

The great Osiris myth can be synthesized quite simply and clearly. After the three divine kingdoms in which the gods Shu, Ra and Geb in turn watched over humanity in the paradisiac Eden, the time came for Osiris and his mission. The Absolute became man that he might reach mankind, lost outside of "Eden", and as a man he suffered and died with other men; man so that he might lead his fellowmen on the hard-won road to self awareness and make them creators of their own life; man to die like the lowest of men, victim of the worst of all injustices. Dismembered by his own brother, he provides the certainty of rebirth to eternal life thanks to the boundless love which joins creator to created. Testimony therefore of love and resurrection as the essential meaning of all creation, testimony that is given by creation itself; by the Sun which disappears and rises again every day, always; by the seed that dies in the dark of the land and is reborn flourishing to the light of the sun and gives new life every year, always. This certainty was the same force which so many centuries later was to lead Socrates serenely to suicide, the same which, united to a moral and spiritual content, was to penetrate the Greek myths and the Roman cults.

The profound love that pervades the Osirian myth was to make the merciful and gentle figure of Isis the goddess the Egyptian people held closest to their heart, and the most human and impassioned being that was ever invented in the ancient world. We will find temples and statues dedicated to her throughout the Roman empire, and still today we can see the remains of a small temple to Isis in Pompeii, built in the first century A.D. While Osiris reassumes the conscience and the experience of resurrection inherent in the forces of nature, Isis is the certainty, the guaranty of rebirth, of the definitive victory over evil and death. The Osirian myth obviously mirrors that of an agrarian world and the primitive concept of the Mother-earth Goddess, in whose bosom the seed-god dies to provide his creature with nutrition and eternal life in a universal agape of love and sacrifice where the mystery of resurrection is perennially renewed.

In the third millennium a cloud obscured the crystalline and manifest substance of the myth of love and resurrection as it became an instrument of power in the hands of a few more or less enlightened priests, but then in the second half of the third millennium the great miracle took place.

It was short-lived, but left a profound mark on human thought. This miracle manifested itself in the attempt of Akhenaten (1372-1354 B.C.) to transform the occult religion into a religion that was revealed to all with the clear vision of an absolute and only god.

Akhenaten himself led the superhuman endeavor to open the seals of religion and let all men partake of the spiritual gifts contained, without the intermediaries of priests and insiders. The first step was to annul the apparent function of all the gods and, in order to avoid confusion, he cancelled the name of Amon and gave the name Aten to the absolute god Ra. The innumerable gods disappeared before Aten and all men were as equal to each other, for He "created every man equal to his brother" and he turned to all saying "thou art in my heart". The universe is synthetized in a single act of love which involved Creator and Creature since "Thou art the flow of life itself and no one can live without thee... Thou dost nourish the child from when he is in his mother's womb, thou calmest him so that he will not cry, thou openest his mouth and thou bringest him what he needeth... thou art the Lord of all, thou who hast taken care of all. Thou who createth the life of all peoples, hast placed the Nile in the Heavens so that it may descend over us and bathe our fields with its floods and fertilize the fields of our countryside".

This love, which creates and sustains the entire universe, manifests itself and is continuously among us, for it is none other than the light of the Sun, giver of warmth and life, its infinite arms laden with gifts. The pharaoh himself, prophet of the Absolute God, and all his family lavish the infinite divine gifts on all. The rite of thanksgiving and offering of his gratitude to Aten-Ra takes place in the open, in the light of the Sun, on a multitude of altars, where all the people celebrate, crowded close around the altars of Akhenaten.

The hold this pharaoh exerted over his people, and the example he and his entire family set, lasted only as long as he lived. Despite the enthusiasm and fanaticism he had aroused, upon his death the old sacerdotal class regained power and cursed the "heretic pharaoh". The temples of Aten were destroyed, his friends now persecuted the revealed religion and Akhetaten, the sacred city, was abandoned to the desert.

Amon and his entire court of gods returned, traditional art took up where it had left off, but the brief experiment of Aten had not passed in vain. In its wake this great mystical ouverture left profound traces and sparks which were fanned to life in the art and religions of other peoples as well as purifying the traditional religion itself. In the latter centuries, despite the various invasions and foreign occupations, Amon-Ra was conceived of as He who "cannot be represented in that He is pure spirit", and in the daily rite "the offerings are in the hands of the priest", that is they became offerings that were substantially spiritual, symbolically reduced to the statuette of Maat: "flesh, soul, nourishment, breath of life" of the Creator. The Osirian mysteries were assimilated in Greece and in Asia Minor, the Egyptian cosmogonic intuitions were acknowledged by Thales and by Pythagoras.

Akhenaten's religious experiences and his pantheism throbbing with love penetrated everywhere, even in such completely different systems of thought as the Greek and Hebrew.

Talismans and sacred symbols:

1) SEKHEM, symbol of authority.
2) UAS, scepter of the gods.
3) UADJ, scepter of the goddesses.
4) ANKH, "Egyptian cross", symbol of eternity.
5) "KNOT OF ISIS", symbol of divine love.
6) EYE OF UDIET, symbol of sanctity, divine grace.
7) "CROOK" crossed with the "FLAIL" or "FLY WHISK", symbol of royal power.
8) ZED, "backbone of Osiris", seat of vital fluid.
9) SCARAB, guardian of the human heart, key to ultraterrestrial salvation.

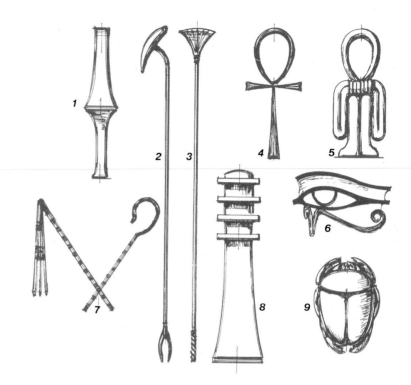

Examples of cartouches and hieroglyphs of the pharaohs; the last one qualifies the Roman emperors as "Kaisar autocrate".

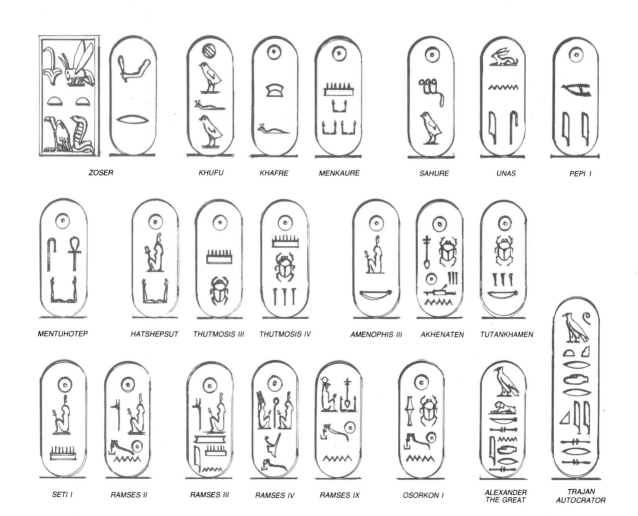

ZOSER KHUFU KHAFRE MENKAURE SAHURE UNAS PEPI I

MENTUHOTEP HATSHEPSUT THUTMOSIS III THUTMOSIS IV AMENOPHIS III AKHENATEN TUTANKHAMEN

SETI I RAMSES II RAMSES III RAMSES IV RAMSES IX OSORKON I ALEXANDER THE GREAT TRAJAN AUTOCRATOR

Sacred script

The Egyptians say that it was the god Thoth who taught them writing during the reign of Osiris, a confirmation of its ancient origins.

In the fourth millennium B.C. the primitive pictographs gradually developed into hieroglyphic characters. As the more or less direct representation of reality became ever more synthetic, it crystallized into the symbol and, with the addition of other elements, soon formed that writing which the Greeks, many years later (210 B.C.) were to call "Hiero-Glyphica", that is "sacred carvings" a reference to the sacred origin of the highly evolved Egyptian writing so many thousands of years before.

In the beginning hieroglyphs were carved in stone and colored. Later they began to be traced, with black or red ink, on interminable scrolls of papyrus, in a form that remained more or less the same for three thousand years. The ancient Egyptian, in fact, felt himself to be at the apex of human civilization and was therefore convinced that he was writing to a humanity that was unchangeable for all times to come.

The pictographic character however continued to be part of the discourse and often the representations to be found on monuments and papyrus scrolls are none other than integrations and illustrations of the writing and therefore subject to schematization and symbolism, giving rise to a clearly pre-established iconography.

As attempts were made to render concepts that became more complex and ample than those carved or painted on the walls, writing on papyrus became more rapid and abbreviated in form, until with "hieratic writing" the signs were reduced to an indispensable minimum. The last form of cursive script, a sort of stenographic version of the first two, was called Demotic.

With the advent of Christianity, as early as the first century A.D. the "pagan scripts" were replaced by the Greek alphabet, and while the sounds remained basically the same, the phrases were now written in a completely different way. The "sacred signs" were soon forgotten and thought of as magic or demoniacal signs whose meaning was no longer literal. It was not until the 19th century that the extraordinary young man named Champollion succeeded in finding the lost key and the deciphering of the hieroglyphs began.

An approximate idea of how this was achieved can be furnished by dividing the sacred signs into three conventional groups which are not distinctly separate but help us in getting an idea of the mechanism that lies behind a script, such as the sacred signs, that has no alphabet. The most important group consists of signs which represent living beings, objects, clearly perceptible actions, including the true ideograms, which indicate the actual object or action represented.

The interpretation and therefore the sounds of these "sacred signs" are known thanks to written translations in Greek by the ancient Copts. A knowledge of the names of many pharaohs, personages and cities of the latter centuries of Ancient Egyptian history has also helped identify the sounds. Once these corresponding sounds are known, a second group of signs or phonograms could be identified whose value was purely phonetic and which confirmed or clarified the sound of the ideogram. Eventually a third and characteristic group in ancient scripts was distinguished whose function was "determinative", in other words which specified the gender or meaning of the ideogram: male or female, plant or animal, concrete or abstract names, noun or related active verb (for example: "eye" or "to see"). Moreover since vowels were not expressed in reading the hieroglyphs, any doubts the listener might have, had to be dispelled by adding determinating signs with a particular sound (for example: if in English we were to read the words without their vowels — mile, mule, male, mole — we would always read m-l for four quite different meanings). As centuries passed the scribes gradually added further phonetic signs, ideograms, determinatives even there where the signs by themselves sufficed. These integrations may very well have been of a poetical and expressive nature, of which the phonetic and literary values still elude us.

This complex script that consisted basically of pictures, graphic rhythms and harmonies enabled the Egyptians to express and preserve for posterity concepts that were both remarkably abstract and highly spiritual: epic poems, lyrics, historical poems, scientific and theological texts. Of particular fame are the "Pyramid Texts" whose sources unquestionably go back to before the third millennium B.C., and which encompass all the cosmic wisdom from earth to sky and the history of Egypt. A great many texts deal with the afterworld, such as the "Book of the Dead", the "Book of Duat" and the "Coffin Texts".

A genre of Egyptian literature to become famous with the Greeks as well was that of moral precepts and teachings. Mention may be made of the "Teachings" and the "Books of Medicine" of Imhotep, the great architect and physician of 2700 B.C.; the precepts of a son of Cheops (2600 B.C.) and the teachings of the great priest Kagemmi (2350 B.C.). The most famous of all surviving literature (preserved in its entirety) is however the "Wisdom of Ptah-Hotep", which dates to circa 2400 B.C., and contains maxims for his son (some of which are cited in this book), a work full of serenity and humanity which came to maturity in a civilization that had been flourishing for more than a millennium.

Texts of great historical interest appeared in the second millennium. A classic is the "Poem of Pentaur", an epic poem that celebrates the battle of Kadesh between the forces of Ramses II and the Hittites (1270 B.C.), found carved in all the pharaonic temples and on the walls of Karnak. In this millennium a work of literature is considered more eternal than the pyramids: "*the book serves better than a stela, more than a solid construction. The book takes the place of the temple, of the pyramid, so that your name will be remembered*

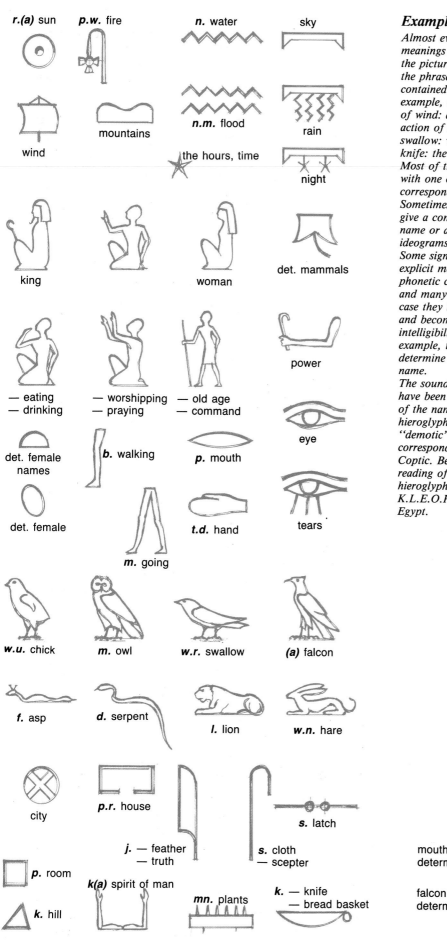

r.(a) sun	**p.w.** fire
wind	mountains
n. water	sky
n.m. flood	rain
the hours, time	night

king

woman

det. mammals

— eating
— drinking

— worshipping
— praying

— old age
— command

power

det. female names

b. walking

p. mouth

eye

det. female

m. going

t.d. hand

tears

w.u. chick

m. owl

w.r. swallow

(a) falcon

f. asp

d. serpent

l. lion

w.n. hare

city

p.r. house

s. latch

j. — feather
— truth

s. cloth
— scepter

p. room

k(a) spirit of man

mn. plants

k. — knife
— bread basket

k. hill

Examples of hieroglyphic signs.

Almost every sign has one or more meanings directly or indirectly related to the picture and defined by the context of the phrase or the determinatives contained. The sign of the sun, for example, can also mean: light, time; that of wind: air, breath; that of the eye: the action of seeing, of crying; that of the swallow: vastness, space; that of the knife: the act of cutting.

Most of the signs have a phonetic value, with one or more consonants corresponding to the picture represented. Sometimes, several signs put together give a composite sound and therefore a name or another thing distinct from the ideograms used.

Some signs, by themselves lacking in explicit meaning, acquire the value of a phonetic confirmation for the reading and many that of determinatives. In this case they lose their phonetic significance and become extremely important for the intelligibility of the script, such as, for example, the sign for woman which can determine the female gender of the name.

The sound and the value of the signs have been arrived at by comparing many of the names and words written in hieroglyphs (or in "hieratic" or "demotic" script) with their correspondents in Greek or ancient Coptic. Below is a classic example of the reading of a name written in hieroglyphs: that of K.L.E.O.P.A.T.R.A., last queen of Egypt.

hill =	**K**
lion =	**L**
feather =	**E (j)**
fire =	**O (w)**
room =	**P (d)**
falcon =	**A**
hand =	**T (d)**
mouth (female determinative) =	**R**
falcon (female determinative) =	**A**

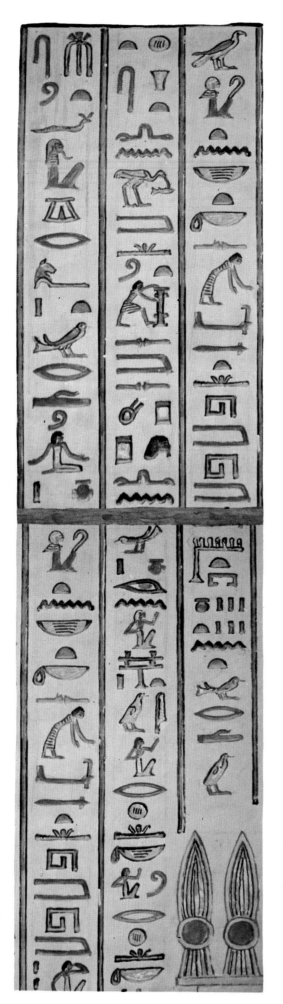

and certainly it is good, also for the afterworld, that your name remain on the mouth of the living".

All the tombs of the notables, of the princes, are full of biographies and chronicles of the time. Various tales also became famous, such as the *"Story of Sinuhe"* which narrates the life of a member of the court of Amenemhet (1991-1962 B.C.), a biography, full of travels and the ups and downs of life, presented with unusual conciseness and efficacy of images. The second millenium is also the golden age of poetry. One of these sings: *"My heart is in harmony with thy heart and I cannot tear myself away from thy beauty....only thy sigh gives life to my heart, now that I have found thee, let Aten make you mine in eternity".* A love poem that may have been danced to and sung by two voices is found in the "Chester Beatty Papyrus" where the lover exalts his beloved as *"Only mistress without rivals — most beautiful of all women — Behold — she is like a star which rises at the beginning of a good year — full of light and perfection she shines in all colors — charms with the light of her eyes — enchants with the sound of her voice...."* and the beloved answers: *"My heart flees from my breast when I think of thee — it tears itself from my breast — it leaves me outside myself — I am unable to make up mine eyes — adorn myself with a fan — ... Be not so wild my heart — repose, be calm — Love comes towards thee — with all my solicitude — Let it not be said — Here is a woman whom love drives mad — be quiet every time you think of him — oh heart of mine, leave me not".*

Detail of six columns of colored hieroglyphs from the tomb of Amun-hir-Khopshef (Valley of the Queens). Many of the signs can be recognized (king, water, hand, mouth, horned viper (asp), etc.) and others can be guessed at in meaning. But all this is not enough to read the text, even partially. Deciphering, in fact, requires a profound knowledge of the mechanism and above all a thorough acquaintance with hieroglyphs. It should in any case be remembered that we have the Frenchman Jean François Champollion to thank for decipherment of the hieroglyphic script. Exceptionally gifted and with a marvelous intuition, he was only twenty-three years old when he succeeded in finding the key which would open the door to an understanding of the meaning of hieroglyphic writing. Merit for getting this world which had remained "mute" for almost a thousand eight hundred years to begin to speak is his, and today we know much more about it than we do about many other, even more recent, peoples.

LIFE IN ANCIENT EGYPT
Milieu and society

The city

About six thousand years ago agriculture and commerce in Egypt were already in an advanced stage of development. Numerous hamlets rose along the shores of the Nile, on the shores of the Lake of Fayyum and along the countless canals of the Delta. The first organized centers, about two thousand five hundred years before the Greek cities, were all more or less square, surrounded by walls, with the houses inside laid out in a grid, close to the palace of the prince and the temple of the tutelary god. The prince's palace was already a citadel with tall rectangular vertically grooved towers, built, in the beginning, with mud-bricks and, from around 2800 B.C. on, with quarried stone.

The inhabited centers on the Delta were the first to develop and become real cities for commerce and seafaring. Instead of enclosing themselves in ever stronger fortified walls, they faced out directly on the long wharves with their shipyards, numerous storehouses and vast market spaces. These cities kept on expanding in times of prosperity, and they were to all extents governed by the ship owners who traded their wares all the way to the distant Black Sea.

On the wharves and on the trading spaces large and middling merchants gravitated with their palaces, banks, storerooms and shops. Around this "city" of five thousand years ago, an ocean of small one-story row houses spread out. This was where the craftsman and worker lived, with premises for the small and large industries which worked gold, glass and produced cosmetics, textiles and an infinity of other objects to send throughout Egypt and the known world. Outside the city, conspicuous suburbs of garden-villas sprang up for the merchants and the well-to-do.

The most important temples generally constituted an autonomous center next to the prince's palace, or developed into sanctuaries which became real sacred cities as opposed to the political commercial centers. Ancient cities famous as centers of trade and marine commerce included Atribi, Mendes, Buto, Sais, Tanis and finally Bubastis, on the canal which joined the Mediterranean to the Red Sea. In 1500 B.C. the city of Far, on the site Alexandria was to occupy more than a thousand years later, already had a breakwater (2100 m. long and 50 wide) thrown out into the sea, providing the port with 60 hectares of basins, piers 14 meters long, and an enormous network of storerooms and market zones to back them up.

The cities of Upper and Middle Egypt generally developed at a slower rate, a result of their historical rather than commercial vicissitudes, and they needed higher and thicker city walls. Almost always built of crude bricks, they were square and occasionally rounded at the corners, ten or more meters high and sometimes even thicker than they were high. Long ramps led from the roads inside and the main gates to the wide guard walks which crowned all the walls. The city was a large grid, almost half of which was occupied by the governor's palace and the city temple, with the residences of the nobles and other minor temples all around. The other half of the city consisted of a vast agglomerate of houses, shops, workshops, all only one floor high which opened onto side roads that branched off from the few main arteries.

In those cities which became capitals of the Kingdom, the complex of the pharaoh's palace and the city itself were almost one and the same, in a great conglomeration of temples and government buildings and court residences. Independent agricultural and commercial activities found little outlet, for the mastodontic urban organism was solely in the service of the government and the divine majesty of the pharaoh. A few scattered ruins are all that is left of Memphis, the capital created in the third millennium, but an idea of what the residential quarters of the nobles, the monumental squares and the palace fortress of the pharaoh must have been like can be furnished by careful study of the necropolises around the Great Pyramids and the monumental complex around Zoser's Pyramid.

The remains of Tell el-Amarna tell us much about Akhetaten, the capital built for the "heretic pharaoh" Akenaten which lasted not much more than a score of years. Although the entire city has not been brought to light, what has been found is sufficient to arouse great interest in the urban layout which differs from the traditional grid within a square. The new city stretched out freely, like a great long band which followed the windings of the Nile.

In the time of Thutmosis III (1505-1450 B.C.), the population of Egypt numbered seven million inhabitants, and in the 5th century B.C. there were about 20,000 inhabited centers. Practically nothing is left of all these towns and villages and blame for the destruction of even such imposing cities as Thebes and Memphis is to be laid to man, particularly in later times, more than to time. But an idea of what life was like in the more crowded and active parts of the ancient cities and hamlets can be had by wandering through the old quarters of the oriental cities of today, where time seems to have stopped, or by observing what has remained and what we know of the villages built for the makers of the necropolises. Of particular interest from this

point of view is the village that lies between Akhetaten and the necropolis at Tell el-Amarna. Unlike the city, this hamlet was rigidly laid out along traditional lines, with an orthogonal network in a perfectly square plan, and thus seems to have been the first housing center to be built in the area for those who were to construct the city, according to the pharaoh's plans, and then the necropolis. The village is enclosed in a wall of unbaked bricks with a single entrance on the south, which opens into a rectangular square out of which five perfectly orthogonal and parallel roads lead off. Six rectangular blocks of single-story housing units open off these streets.

The units are all so similar that they seem to have been built in series on a single project type. The system is in fact extremely simple: long rectilinear and parallel walls divide rectangular bands into three strips where each housing unit occupies a three-room section, with a single entrance on the same street. These are all of equal size and can be considered a true modular unit, upon which the planning and realization of the entire town was based. In view of the modular units also used for the small temples in the necropolis of Zoser, the numerous cities created from nothing, and lastly the same grid layout, it seems likely that as early as 2700 B.C. the Egyptian cities were the fruit of a well thought-out and rational urban program, including the construction in series of different types of buildings.

The village of the necropolises of Thebes in Deir el-Medina, which may have been begun by Thutmosis I (1530-1520 B.C.), had a traditional orthogonal scheme, with standard housing in series, similar to that of Tell el-Amarna, but later changes and enlargements turned it into a long lozenge with a principal bayonette artery which cut through a chaotic wilderness of houses of all sizes and shapes. Of particular interest is the social organization of Deir el-Medina, which must have been much like that of the other artisan, industrial and agricultural villages. The population was organized under two mayor-directors flanked by a council of artisans and laborers with autonomous administrations. Experts in architecture, sculpture, painting, drawing were flanked by scribes, specialized workers, laborers, diggers, small entrepreneurs, expert master masons and finally those employed in common services such as water carriers, for the desert zone had only cistern wells; the guardians who led the livestock to pasture in the valley; hunters, launderers, etc. All were incorporated in small homogeneous communities, with their own priests and individual chapels built around the citadel. They were well paid for their important work and able to afford tombs that were richer than those of the nobles and were situated around three sides of the hamlet on convenient sloping squares. A path laid out in the rocky desert, and equipped with shelters and deposits of water, took the workers to the various necropolises. In the Valley of the Kings the shelter became a sort of hospice where groups of artisans working in continuous shifts could be housed in case there was urgency in consigning the work.

Two axonometric models of cities that existed around 3,000 B.C.
Note the grid layout of the residential area, enclosed in the more or less square shape of the turreted walls and the L-shaped layout around the citadel of the royal palace.

The work was contracted between the director-mayors, assisted by the council, and the commissioner. The delivery dates and compensation for specific well-defined projects such as decoration were specified in the contract and were then executed by the artisans themselves. The council also saw to the programming, with the distribution of the tasks and wages. The master mason of each group had a work book where he kept note, among other things, of the reasons for absence from work, which could be for illness and even for the birthday of the worker's mother or because he had had a fight with his wife! There were many days off, for each "week" (composed at the time of ten days) had two days of rest, and to these were added special leaves of absence for holidays; the

Plan of the city of El-Lahun.

The city was begun by Sesostris II (1897-1878 B.C.) on the occasion of the great land reclamation project of El Fayyum around the ancient Lake Moeris. The city was situated next to the great regulatory apparatus of the waters which flowed into the great lake and the irrigation network for the 2000 square kilometers of land from a basin in the Nile, the Bahr Yussef. The urban layout of the city is basically what it was a thousand years earlier, perfected and adapted to meet the new requirements. The nature of the city walls which enclose a square of 350 meters per side is no longer defensive. The residential zone of the officials of El Fayyum develops between the king's palace and the housing for artisans and reclamation workers. The former area has its own entrance from the outside, and enclosure walls of its own, and includes about a dozen large residences of about 2500 square meters each with dwellings of about 70-80 square meters set in between. The royal residence was fortified and stood on a rise, like a small acropolis, set midway between the two areas. The artisan zone also has an external entrance; it has an L-shaped main artery, circa 9 meters wide, from which secondary streets circa 4 meters wide branch out on either side. These small blind streets give access to long blocks of modest one-story identical housing units. This capital of El Fayyum, which contained a maximum of 3000 inhabitants, could certainly not compare to the Delta cities with their 40-50,000 inhabitants, but it undoubtedly reflected the basic layout.

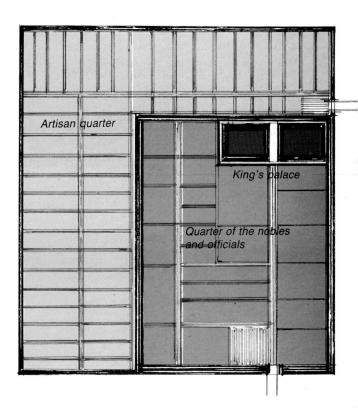

Artisan quarter

King's palace

Quarter of the nobles and officials

Plan of the village of Deir el-Medina.

Planned exclusively for the workmen of the Necropolis of Thebes, the layout, above all inside, has been altered by the numerous successive restructurations that were necessary as the number and importance of the family nuclei varied. Taken as a whole, it gives us an idea of the changes that took place in the urban fabric over the centuries, with disorderly housing ensembles much like those still to be seen in some of the old suburbs of the Egyptian cities.

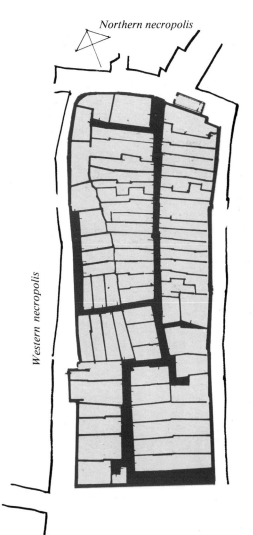

Northern necropolis

Western necropolis

"royal" holidays, for example, lasted four days permitting everyone to reach their distant relatives.

Payment was calculated on the basis of a "liter" of fat converted into commodities such as beer, legumes, clothing, sandals and even unguents and perfumes; and what was not paid in kind was settled in copper coin. If the lodgings were no longer sufficient, the workers "lay down", that is they went on strike; and there is no doubt that their demands were immediately satisfied, in view of the importance and outright indispensability of their work.

Controversies or sanctions, if needed, were decided by a court of workers presided by the master mason. The case was first discussed with the

Council and the sentence was decreed in the name of the King. A second and final appeal was also possible with the vizier or the Pharaoh himself. The latter also intervened in questions of great importance or high surveillance.

The basic diet included the flesh of oxen, pigs, gazelles, antelope and even hyena (livestock was bought or captured and fattened), followed by roasted or boiled birds, onions, beans, lentils, fruit such as dates, figs, apricots, pomegranates and carobs. Sweets were mainly made with honey. Drink was milk, water, wine and above all beer.

The castle palace

Around the end of the fourth millennium B.C. the complex of buildings destined for the housing and exercise of the central power, the Palace of the Pharaoh or prince, acquired a distinctive architectural form, which it maintained for most of the third millennium. A good idea of what these beautiful monumental complexes looked like is provided by the representations on sarcophagi from the late Fourth Dynasty (2620-2500 B.C.).

Constructions of the First Dynasty such as the tomb of Aha and in particular that of Udimu (circa 2900 B.C.) even furnish us with an idea of the layout of the rooms and internal courtyards.

In appearance this palace archetype, which lasted about 500 years, was a rectangular parallelepiped whose walls were articulated externally by a continuous series of towers set so closely that the projection equalled the recession: the internal mass was hollowed out by courtyards and rooms set at right angles. The external faces were also embellished by tall closely set pilasters joined at the top and often crowned by a rich cornice and by decorative panels.

It should be noted that this architectural solution was later to be found in the buildings of Ugarit, Uruk and Mari in Mesopotamia, in the stepped ziggurat and in the Babylonian palaces; the analogies of the early Sumerian palace-temples with the tomb of Udimu are particularly striking, as is that of the gigantic palace of Sargon in Khorsabad with the older complex of Zoser in Saqqara, analogies which would seem to indicate a common model dating to earlier than 4000 B.C.

The pharaoh's palace, vertex of the city and the kingdom, had to meet the requirements of administration as well as those of the king, and the rooms were therefore laid out in two large sectors. One of these included the rooms for the official abode of the king and his family, the great audience hall, the throne room, and, lastly, premises for the use of the "*master of the palace*", the "*custodian of the crown*", the "*master of the two thrones*", and the "*chief of the regal ornament*" who directed the complex ceremonies and the entire royal court, including numerous ladies of the court and the pharaoh's harem, to which must be added an army of servants, palace laborers, artisans, artists, physicians and hair-dressers. In direct contact with this official part were the "*Royal Court*", and the "*House of Works*", the latter presided over by the

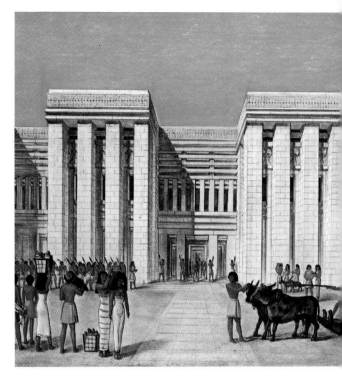

Reconstruction of a royal palace in the Old Kingdom (third millennium B.C.)

This reconstruction is based on bas-reliefs and architectural decoration on Fourth and Fifth Dynasty sarcophaguses. The architecture consists of projecting and receding structures, with vertical pilasters on the avant-corps and a regular interlacing of vertical and horizontal beams on the walls in the back. In this reconstruction: scenes of the changing of the guard and the arrival of gifts and supplies for the palace storerooms.

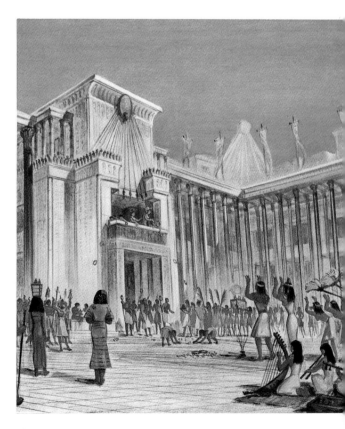

"*palace architect and constructor of the royal fleet*".

The second sector included: the "*White House*" (Ministry of Finances); the "*Red House*" or of "*Eternity*" (Ministry of the Regal and National Cult); the "*House of the Seal*" (Ministry of Taxes) with a highly equipped land survey and national registers of property; the "*House of the Director of the Armed Forces*" with annexed the barracks for the royal army.

The royal court had a chancellery and archives. The procedure was divided into three stages: written and documented petition; judicial inquiry; sentence based on the conclusions of the parties. Punishment consisted in terms of imprisonment, flogging and, rarely, in a death sentence by beheading or hanging.

Naturally as the power became stronger, the palace added on more rooms and satellite buildings. Often various offices were held by the same person. In the time of Zoser, for example, the High Priest Imhotep, an exceptional man, covered the offices of physician, royal architect and vizier.

With the Fourth Dynasty, this palace-castle achieved its greatest splendor. We believe that these monumental buildings developed in a technical and artistic ambient of architectural experiences completely unknown to the rest of the world. The central portion in particular was characterized by a play of solids and voids, accentuated by projecting elements and vertical stringcourses which, compared with the walls of the mausoleum of Zoser, reveal an exceptional architectural and technical-constructive evolution, all in less than two hundred years.

The palace temple

At the end of the third millennium B.C. the splendid palace-castle seems to have disappeared, both in terms of an aesthetic-architectural solution and as a volumetric solution of a single block containing the functional units for the pharaoh's residence and government. In the second millennium requirements became increasingly complex: the growing empire necessitated greater prestige and more complex directive instruments. The entire palace was now occupied by the official head-

Ideal reconstruction of the state court in the Royal Palace in Akhetaten (1360 B.C.).

The reconstruction is based on bas-reliefs and paintings dating to the period of Aten (second half of the 14th century B.C.). To be seen is one of the largest courts of Akhetaten's Royal Palace, surrounded by painted wooden columns, with the great loggia surmounted by Aten, the Solar Disk. The pharaoh and his family, appearing on the balcony, throw garlands of flowers to the festive crowds which come from all parts of the empire (scene taken from a painting in the tomb of Eie in Tell el-Amarna).

Examples of furniture to be found in the palace or in the upper class house:

1) *Throne. In both carved and painted representations, the throne is already to be found in the third millennium and was used both by gods and pharaohs. It consisted of a cube set on a footrest platform; a long flat cushion completely covered the seat and the low backrest.*
2) *Table. The circular table top is supported by a single bell-shaped leg.*
3) *Chair. The seat and the back are covered with a cushion and the legs are in the form of lion feet. There was usually also a footrest.*
4) *Folding chair. This pincer shape is still currently in use.*
5) *Small rectangular table. Set on a latticework frame with four legs, it was used as a gaming table, perhaps checkers and chess, and it probably had small cubby holes.*
6) *Small latticework support for vases and amphoras.*
7) *Tall latticework support for amphoras.*
8) *Headrest. It was in use as early as 3000 B.C. as an alternative to the pillow.*
9) *Bed. Composed of a horizontal webbing of strips of leather or canvas attached to a framework. In our example the side elements are two stylized lion figures, a motif quite common in the second millennium.*
10) *Coffer for jewels and personal objects.*
11) *Trunk for clothing. Sometimes more than a meter high and with skids on the feet to facilitate moving it from one room to another.*

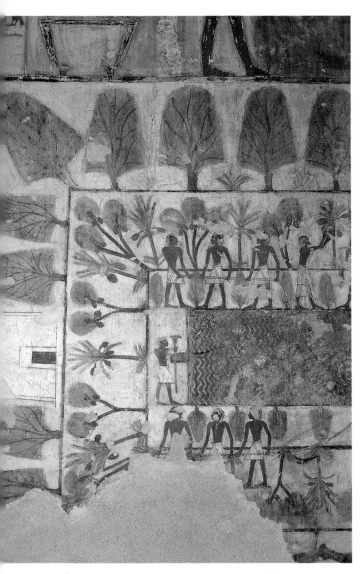

The garden of an Egyptian house.

An essential part of an Egyptian dwelling was the garden, which had to have a fish pond. Many paintings show the open-air area of the house and the example above comes from the tomb of Reckmire in El Qurnah. In this bird's eye view of the garden the water in the central pool is rippled by the wind and full of flowers and fish; on either side shady flowering plants; around it an embankment lined by a row of fruit trees, and then another strip of green, bounded by other shade trees alternating with flowering shrubs. The facade of the house crowned by a cornice and with a large portal that is set amidst the greenery overlooks the short end.

quarters of the king and his court. Seat of the powerful lord of the world, the god on earth, the dwelling was equivalated to a temple. The central hall was now a hypostyle hall, crowded with gigantic columns that led to the throne room which was also columned. The "Festival Hall", and the accessory rooms for the court and the services, were situated at one side, in front of a large vestibule, also colonnaded or with pilasters. All the wealth and monumentality of the complex was centered along the axis leading from the entrance atrium to the throne room. Basically it was like the temple, the throne room taking the place of the chapel of the god. Practically the only thing left of the palaces of the second millennium were the interesting ruins of the "royal palaces" which accompanied the funerary temples, as at Medinet Habu and at the Ramesseum. Just how magnificent and rich these enormous abodes of the lords of the world in 2000 B.C. must have been can be seen in the temples they raised in all of Egypt.

The porticoed palace facade appears in the temple of Seti I in Abydos; the internal and external colonnaded porticoes in the court of Amenophis III in Luxor; the hypostyle audience hall, the feast hall and the throne room, in the analogous rooms of the temple of Karnak. An idea of the imposing circle of walls which bounded the center of world power, in addition to the external facades of the palaces, can be found in the walls and in the Great Portal of Medinet Habu.

In the reign of Akhenaten (1372-1354 B.C.) an outstanding period for art and religion, the architectural idiom applied to the construction of the governative center and the pharaoh's residence also changed drastically. As seen in the city of Akhetaten in Tell el-Amarna, the palace was no longer a mass imprisoned within a square or laden with gigantic columns, like a temple, but was transformed into a villa set at the center of other buildings and open spaces. The long zone occupied by the official residence stretched out between the principal artery (the "King's Avenue") and the Nile. The complex moved from a spacious peristyle, with a throne room, to a series of courtyards and gardens with the guest house, the harem, the royal offices and the service rooms. A gallery that passed over the Avenue of the King, joined the palace to the abode of the pharaoh and his family. The dwelling was modest in size, but rich in exquisite paintings of flowers and birds, even on the floor, and surrounded by loggias with columns or small pilasters in painted wood, embellished by hanging gardens which sloped towards the great artery. Governmental buildings surrounded the complex which was flanked by the private temple and the higher school for future collaborators.

To the north of the city lay the Hat-Aten Palace ("Castle of Aten"), probably the first to be built in the new capital, since it still seems to be enclosed in a square and divided into six orthogonal and symmetric spaces. Two large courtyards occupy the central space connected to the only entrance: the first courtyard provided access to the private sanctuary, on the left, and the service and

storeroom zone, on the right; the second courtyard, heart of the entire complex, was in the form of a tree-shaded garden with, on the right, the apartments of the king and his family, and, on the left, the zoological garden with housing for the animals that came from the far corners of the empire. In the back the hypostyle hall with the throne room stood at the center with the festival hall on the right and the private garden with flowers, fountains and surrounded by cages for exotic birds on the left.

Meru-Aten, the vast summer residence of the pharaoh, lay to the south of the city. Included in this residence were two great rectangular enclosures, set side by side. The smaller one was meant for religious meditation with numerous chapels and small cells at the sides, a small covered temple and a sacred enclosure or open air temple; at the center, pavilions and altars lay scattered throughout the grove with its sacred lake. The buildings were also prevalently distributed on the short sides in the larger enclosure so that a large open area remained in the center: the residence itself with three small temples and a garden with pergolas, fountains, canals and waterworks was on the right and large stables for the horses, the chariot house and the king's kennels, on the left; the central park had a vast navigable artificial lake, with a pier, small islands and pavilions.

Even so the palaces, hanging gardens and well-equipped parks of Akhenaten, splendid and original as they were, could not compare with the monumentality and vast size of those that were to come a hundred years later with Ramses II and Ramses III, lords of the entire known world and great constructors. Certainly the fame of their gigantic dwellings and their immense gardens were still alive in the first millennium when Nabucodonosor — five hundred and more years later — built his palace and the famous hanging gardens of Babylon.

Lastly it is to be noted that while in the third millennium the palace competed with the "house of the hereafter" of the pharaoh, in the second millennium the tomb could hardly compare with the funerary temple and the palace where the pharaoh received the powerful of the entire world.

The palace house

Normally the houses of the nobles and upper-class Egyptians were much smaller than the dwelling of the pharaoh, and not nearly as richly decorated or furnished. In the prosperous cities of the Delta those who had princely houses were shipowners and merchants, while in the cities of Upper Egypt the more conspicuous dwellings belonged to princes and government officials. During the third millennium B.C., the princely dwelling of the living is much like the princely dwelling of the dead, so that the houses of the notables in ancient Memphis, the capital of Upper and Lower Egypt, were basically similar to the "mastabas" still to be seen around the Great Tombs of the pharaohs, in the necropolises of Giza and Saqqara.

These palace-houses were more or less in the shape of a rectangular parallelipiped, with only one story and a single entrance. There might be a small garden in front, enclosed in a low wall, while the entrance might be set back and form a covered vestibule which in the wealthier houses had one or two pillars. Numerous rooms of varying sizes and one or two open courtyards were "dug out" of this building block. Generally air and light reached the rooms from the courtyards and internal small courtyards rather than from outside.

The rooms were not arranged around an axis or symmetrically, but mirrored the requirements and means of the owner. Normally a small room that served as porter's lodge opened off the vestibule, with the official rooms, the family living room, the study and the private rooms of the owner of the house all arranged around the peristyle of the main courtyard, on the right, while the smaller halls and the rooms of the children and the private apartments of the wife with her own small courtyard lay on the left. In between were the various service areas — the kitchen, the larder, the storerooms. Depending on the office the owner held, the reception hall had an alcove in the back where the husband and wife, seated on two small thrones, received the guests and subordinates, and took part in the festivities. A cistern-well contained the water brought by donkeys or servants. Various cellars were excavated under the kitchen or other rooms and were used to store food or various objects and household furnishings.

At the end of the third millennium and throughout the second millennium B.C. the palace house grew in importance and autonomy, with a tendency to imitate, naturally in a decidedly minor tone, the pharaoh's palace. The number of rooms increased and their distribution became more orderly and axial; the building was enriched by columns, at times in painted wood, in the vestibules, the porticoes and inside the halls. The garden became much more important and larger, and was completed with ponds, fountains, pergolas, trees, flowers and, lastly by pavilions for sojourns and meals in the open.

In the city of Akhetaten, two small garden cities developed on either side of the city center — that is the Great Temple and the Palace of Akhenaten. They consisted of rectangular lots of equal size, each with its villa and well-equipped garden, all so similar that they must have been the result of a single project model — houses with a number of small rooms, occasionally on two floors, with light vestibules, verandas and balcony porticoes in wood. The houses were profusely painted, even on the ceiling and on the floor while the gardens were modest in size but all full of flowering greenhouses, aviaries, shady pergolas, pavilions, ponds and, outside the house, always present, the chapel dedicated to Aten-Ra.

After Akhetaten, the dwellings of the nobles once more grew enormously around the palaces of Thebes or in the wealthy cities of the Delta. There were many more rooms for the lords, with antichambers, bathrooms, rooms for massage and oiling of the body, and for make-up. The bed of

the husband and wife was set inside a baldachin with a double wall to keep it cooler. A consistent number of rooms with services was destined for the guest quarters. Every member of the family had his own servants and rooms. There were no slaves in the service of the palace-house nor in the pharaoh's palace. Prisoners of war were used for work in the state-owned fields and it was not until 1500 B.C. that they were given as remuneration to the army officers and became private property. The prisoner-slave was not however treated as a beast of burden; on the contrary, at times he might even become a member of the family such as the case of the rich barber who acquired a prisoner slave, taught him the craft, gave him a niece as wife and finally freed him of all bonds, making him a shareholder in his property.

The furniture in an Egyptian house was small in size and limited to the indispensable, for larger objects were put in the basement and clothing was kept on the various shelves in the closets built into the walls, or in numerous baskets or small chests. Jewellery and toilet-sets were kept in precious coffers. There was an abundance of tables of all types and uses: with one or two levels, with a single bell-shaped foot, or with four legs; tables for flowers, for vases, for food and specifically designed for playing chess. There were also many chairs, armchairs, stools and portable chairs, all small in scale and light, often with precious trimming and always of extremely fine make, with no basic difference between the furniture used by the pharaoh or that of the notables and craftsmen who created and built them. After 3000 B.C. the bedroom contained a pavilion-alcove in painted and gold lacquered wood in which the bed with sides and worked feet was kept. Below the pavilion-alcove of the queens there was also a small drawing room; in the richer families a trestle headrest was used for cooler sleeping.

Cushions for the chairs, the footrests and also for sitting on the ground abounded, with a profusion of carpets, animal skins, embroidered textiles. The windows, which at the most could be closed by shutters, were protected by curtains. In the beginning, the doorways also had curtains which were pulled up and down thanks to a roller set on the lintel. The sets of pottery, copper and later bronze were of very fine make, with bowls for washing hands, vases and phials for perfumed oils, mirrors and dryers. Knives with large blades and a curved handle were used, as well as spoons of varying size and form, highly decorated. The richest menus included: ten courses of different meats; five of poultry and birds; ten of fruit; fifteen types of bread, cheeses, cakes and rolls; six types of wine and beer, innumerable honeyed sweets.

Both men and women, in some periods, shaved their head completely and wore wigs. Not even the pharaoh had a beard for the one he wore was fake. Normally men wore kilts (generally reaching to the knees) and the women a fitted garment that reached to the ankles and was held up by a strap. For festivals men and women wore rich necklaces, bracelets, ornaments on full pleated and semitransparent garments. Children were almost always

naked even if they wore bracelets and earrings; a favorite among their toys was the doll of painted wood, dressed in lively colors and sometimes with jointed arms that were moved by strings.

Feasts and receptions were common and frequent, and before long rules of etiquette were formulated which influenced civil behavior ever after. The vizier Ptah-Hotep (ca. 2500 B.C.) in his "Wisdom", a model for all of ancient Egypt, advises as follows: "*When you are invited to supper by an important person, you will accept what is offered thanking him profusely. Turn to him but without insistence and not too often. Do not speak to him unless he speak to you. Since you do not yet know what might cause him displeasure, speak when he invites you to and your speech will be pleasing to him.....do not question until you have given him time to reflect. If he reveals his ignorance and he gives you the occasion, do not shame him, but treat him with delicacy. Do not speak too much, do not stop speaking to him, do not attack him with your discourse, do not tire him so that another time he will not avoid your conversation.....*"

Garden Festival in the villa of a high official of the Middle Empire (second millennium).

The entertainment takes place around the pool in the garden, with the porticoed facade of the large house in the background. On the left, the wooden pavilion where the owner and his wife, their small children and personal counselors are gathered. On the edge of the pool two groups of girls are performing acrobatic dances to the rhythm of the clapping of hands of a third group and to the music played by an orchestra next to the pavilion. The various scenes are based on paintings in the tombs of Theban nobles; those of the dance from the tombs of Saqqara: tomb of Ankh-ma Hor and of Kagemmi.

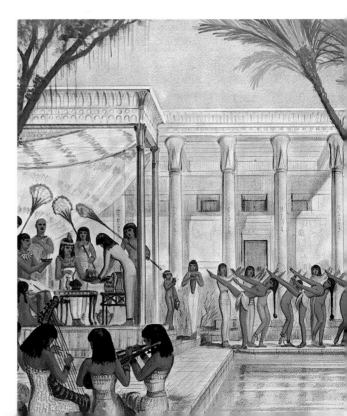

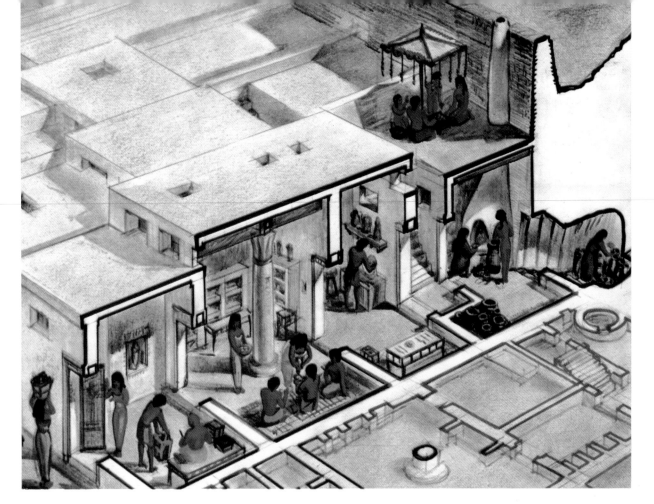

The minimal house

Just as there is a great difference between the palace of the pharaoh and the house of a nobleman or of the upper classes, so was there an even greater difference between the latter and the house of the middle and lower middle classes, that is the house of the artists, artisans, small entrepreneurs and merchants who lived outside the palace of the king, in full economic autonomy.

The minimal house, seen as a module basis for the entire urban development, was, above all at the beginning of the creation of the city, an element of about eighty square meters per family unit and was divided into three successive zones: entrance, repose, kitchen. The first zone could be divided into two distinct spaces for the vestibule and the living room, and sometimes the alcove for the parents was also inserted; the second could also include the workshop; the third included the larder and storeroom for supplies and furnishings. The kitchen often was furnished both with a corner oven with a fireplace, and a stone brazier at the center. Cellars were situated under the kitchen and elsewhere for the preservation of the foodstuffs, the water supply, the storeroom for objects. Often, a smaller or larger internal courtyard, with a staircase, led to the flat roof, furnished for open-air living. A single door opened onto the street and openings for air and light were off the small courtyard or in the ceiling. The shrine for the religious cult of the family was always to be found in the entrance hall.

In the houses of the more well-to-do, the central room had one or two pillars bearing the name of

Interior of the house of a rich artisan.

The axonometry gives an idea of the uninterrupted succession of houses along the sides of the street in an artisan quarter. The roofs vary in height and are pierced by skylights to illuminate and provide air for the internal rooms. The cross section indicates the succession of rooms from the street to the external boundary wall or to another symmetrical row of houses. First comes the antechamber with an alcove for the husband and wife with the shrine for the tutelary god set in the wall. Then comes the living room with a central column on which the name of the owner is written, the workshop, and then the small staircase which leads to the terrace where an umbrella pavilion permits an open-air sojourn. Lastly the kitchen with the cupboard, the oven and the stone brazier. Underground cellars were accessories to the kitchen and the workshop (the reconstruction was based on a typical example of dwelling in El Lahune and the village of Deir el-Medina).

the owner. The walls in unbaked brick were plastered inside and outside and decorated to varying degrees by the owner himself. The floor was in beaten earth, sometimes plastered and painted red. Presumably each unit was inhabited by a single family and the cases where the surface available was doubled so as to include another housing unit are rare, which seems to indicate that life inside the house was very limited. On the other hand, needs were very modest even when economic conditions improved, limited to a few articles of clothing, furniture, furnishings and even foodstuffs. As a result of the specific moral and religious education of the ancient Egyptians, the dominant ambition was that of having a large and lovely house for the afterworld, as can be seen in the village of the builders of Deir el-Medina.

The family

While there was a considerable difference in the housing of the upper and lower middle classes, this did not apply to the family.

Monogamy was the rule in Ancient Egypt. Only the pharaoh had one or more harems (in later centuries this was also the case with princes and those in positions of power) but this did not in the least undermine the husband-wife relationship.

All were based on deeply felt family ties, even when the paternal authority gave way to an equality of rights and duties of all the members of the family. In fact, in 2700-2500 B.C. when, for the first time in history, the patria potestas and the right of primogeniture were replaced by an equality of all rights, the mother never lost her position of goddess of the hearth, in other words the "goddess Isis of the house", reciprocal affect was reinforced, and "*respect for the father*" and the filial affection for the mother were the cardinal virtues which were to remain throughout the centuries to come.

Aside from individual faults and moral defects which have always characterized humanity, these were the ideals and moral principles shared by all, even by the pharaoh, and which all had to account for when the soul passed judgement in the hereafter, a belief firmly held by all.

The husband is reminded: "*if you are wise, remain home, love your wife tenderly, nourish and clothe her well, but also heap caresses on her and comply with her desires. If you turn her away your family will fall apart, instead open your arms, call her, show her all your love*".

In painted scenes, as early as 2400 B.C. the wife is always shown next to her husband, with all their children, even when the lord receives his subordinates, when he takes part in feasts and dances, and when he goes fishing with the harpoon along the Nile or hunting with the boomerang in the swamps and at the edge of the desert. The couple are shown playing chess together at the end of the day. Even there where tribal power prevailed and the wife was not as influential, husband and wife were joined by a bond of tender affection and partook of that great love which tied Isis to Osiris.

With the revelation of Akhenaten the heights of humanity were achieved. Together with his family he provided an ideal example, the visible proof of the universal love of Aten located in the family, a divine bond which joined each family to the other and to that of the pharaoh.

Five hundred years later this sense of spirituality diminished and family unity was primarily a matter of economic and opportunistic interests. Marriage became a simple contract between the father of the bride and her future husband and then between the directly interested parties, a preliminary contract in which the clauses for indemnity in case of divorce were also stated. On his part, the husband stated: "*I have taken you as wife, you have brought me a sum in silver, if I leave you and I hate you I will restore this sum to you plus a third of what I will have earned with you*".

The times when the man saw his bride as "*the fer-

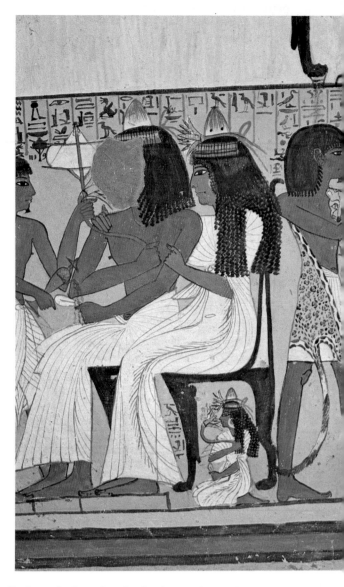

In the early dynasties, the dominant subject, above all in the tombs of the nobles, was already the family. In the latter half of the third millennium B.C. the husband and wife are often shown of equal size and practically identical, surrounded by their children. Le us compare two examples taken from the paintings of this period and specifically from the tomb of Sennedjem of circa 2700 B.C. and from the tomb of Inherka of circa 2600 B.C. In the first, the man is bare chested; both husband and wife have garlands on their heads; the daughter is tiny but is still dressed and ornamented like her mother; a servant brings a sail-shaped fan and pours perfumed oils; all the men have short beards, quite rare in ancient customs. In the second, the husband and wife are dressed alike (the husband is heavier in build); the children are in natural proportions, entirely nude with the typical hairdress of locks braided into a curled tress at the side; in front of them, a circular table with a game, probably some sort of checkers; the children are also playing with tame birds; a servant brings a coffer and a statuette of Osiris. These two scenes evidently depict two moments of household life: the first, ceremonial; the second, relaxation in the intimacy of the family.

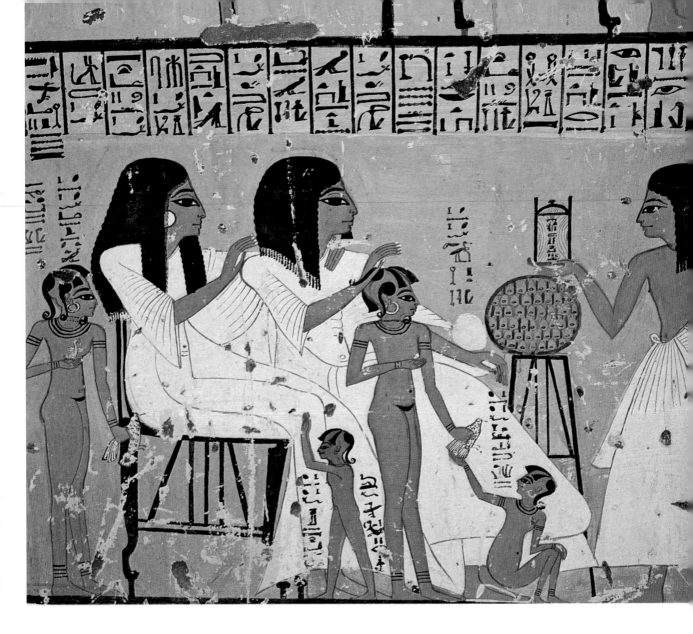

tile field, the blessing of the house" (Ptah-Hotep, 2500 B.C.) lie in the past; respect and courtesy remain, but the life-giving love of Isis and Osiris becomes ever harder to understand and impracticable even in the land of the Nile.

All the paintings of the brief Atonian period show scenes of the "heretic pharoah's" family life. Over and over he is shown with his wife Nefertiti, the "beauty who comes here", and his daughters (in order of birth: Meritaten, Maketaten, Ankhsen-paaten, Neferaten, Neferre, Setepenre). The dominant figure in art is no longer the pharaoh but the royal couple itself, bearer of the same divinity and bound to their family by continuous affection.

These feelings are evident in the overpowering realism of the new art where they are shown conversing, receiving, playing, on their chariots, adoring the One God, always together. This love propagated to all and when the First Family stepped out on the loggia to dispense gifts, it incarnated the message of divine love of the universal family which joins every creature to God. On the death of its prophet, this universal bond quickly disappeared. The person of the king once more became inaccessible and detached even from the members of his own family. With the first signs of the final collapse, foreign customs and social and religious crises all helped to diminish the family bonds of affection and religion.

The land and the sea

The fertile land, the river and the sea were the source of life for Ancient Egypt, truly the flesh and blood of Egypt.

The fundamental occupation for most of the population was undoubtedly agriculture and power, both in politics and religion, was based on the ownership of land. The first pharaohs were tillers of the soil. Amenemhet I (1991-1962 B.C.) in the presence of his son gloried in the fact:

"I cultivated wheat, I worshipped the god of wheat in every valley of the Nile. No one suffered the pangs of hunger or thirst during my reign".

When it was their turn to appear before the divine judge for entrance into the heaven of Osiris, among their good deeds the nobles numbered the irrigation works they had carried out to improve the conditions of the fields and the well-being of the farmers. The essence of Egyptian ethics and of its highest spiritual thought, to be found in the myth of death and resurrection of Osiris, springs from the agricultural world. The exceptional intellectual potential of the Egyptian peoples was started on its way by the fertility of the fields, the annual flooding of the Nile.

With the passing of winter, identified with the months of drought that killed off all life in the fields, the star Sirius — the primordial Mother — rose on the horizon, and with it the North wind, and a great tear shed by Isis fell from heaven causing the Nile to rise at its unknown source, beyond the pilasters of the world. For four days the *"Green Nile"* full of silt ran down and then for fifteen more, the *"Red Nile"*, full of fertile mud.

By August all land was covered with water and only the cities and towns emerged like islands from an immense boundless swamp. With the winter solstice (our winter) the immense lagoon withdrew and disappeared, men returned to the good earth and work was once more taken up with indescribable gaiety, for life was reborn in the wake of desolation. Even in the hereafter, these moments in the life of man were recalled as something paradisaic — plowing the soft black earth with wooden plows drawn by small long-horned oxen; sowing from arm-born baskets full of seed; reaping with sawtooth sickles; gathering the sheaves on the farmyard court, threshing with three oxen moving around in circles, and finally winnowing to separate the seeds from the chaff. Unforgettable hours of work lived as a continuous celebration with games, songs, jests and above all the chatter of a happy people in communion with a generous land that had come back to life to provide security for tomorrow.

These moments in their lives, the most memorable for millions of people who lived four thousand years ago, were in a sense "filmed" and kept for eternity in almost all the most important Egyptian tombs.

Another great festival, after that of the cereals, was the grape harvest, with the treading of the grapes in large masonry tubs, as was that of taking the animals to pasture in the good season. Then came the harvesting of barley and millet, which grew wild, and the gathering of the papyrus, the precious sedge used in making ropes, sandals, and boats, and which provided paper and brushes for painting and writing when cut into fine strips, woven and beaten.

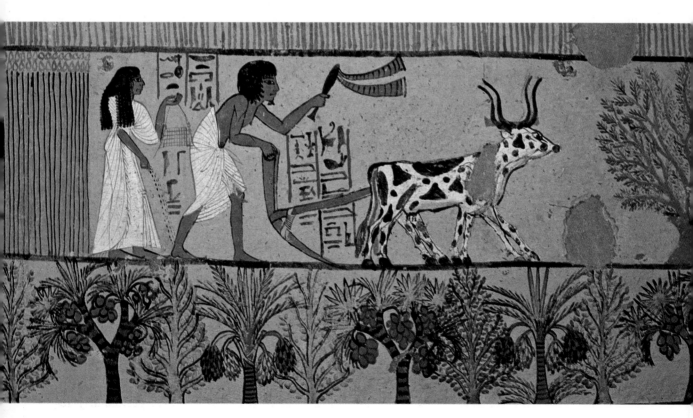

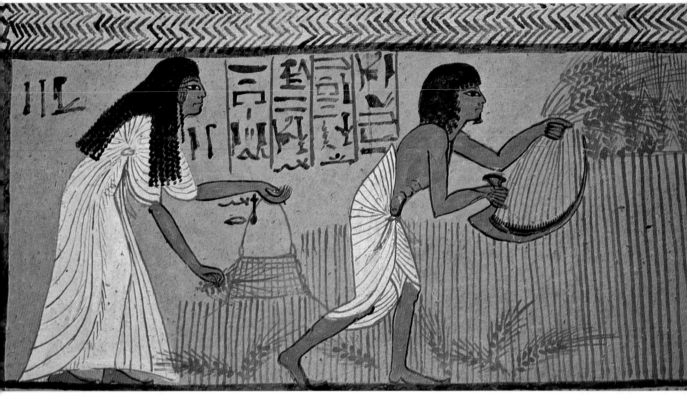

Two details taken from the large scene of life in the Fields of Yalu (the Egyptian Paradise) painted in the tomb of Sennedjem in Deir el-Medina. In both scenes we see the husband and wife together plowing, sowing, reaping and gleaning the grain.

Much more complex and demanding were the works concerned with regulating the flooding of the fields and which involved skills that were unique at those times, requiring knowledge in a variety of fields: astronomy, land surveying, trigonometry, hydraulics, construction, as well as the capacity to program and organize exceptional operations to be carried out over thousands and thousands of hectares of land. It meant an acquaintance with the astronomical calendar, an understanding of instruments for measuring and levelling, of how to excavate canals, construct dykes, dams, bridges, regulate and lift water. And all this in a period dating back to four thousand years before Christ when the other peoples were still groping their way out of the Stone Age. Works of this sort obviously required a catena of cooperative efforts along the entire course of the Nile, a catena which undoubtedly always formed the backbone of the union between Lower and Upper Egypt.

The knowledge of the astronomical calendar was the result of ancient observations and study of the sun's course in relationship to the fixed stars. Every year was divided into three seasons: the flood season, Akhet (from June 15th to October 15th); the sowing season, Peret (from October 15th to February 15th); the harvesting season or of the great heat, Shemu (from February 15th to June 15th, the end of the Egyptian year).

In mathematics the Egyptians were familiar with the principal operations, some types of fractions, the calculation of surfaces and volumes as well as those principles of trigonometry which permitted them to develop great networks of canals and agrarian lots; their instrumentation was obviously advanced enough to eventually permit them to build the Great Pyramids.

One of the machines to be found painted in a tomb in Deir el-Medina is a device which is still used in the Egyptian countryside, called "shaduf". It consists of a long pole balanced over a support in wooden beams or in masonry, maneuvered by hand. The pole acts as a great pivoted lever with a pail to lift water or other weights at one end, and with a counterweight on the other consisting of a block of mud or stones. The utility of this machine in irrigating fields and lifting any kind of weight is obvious: a device therefore which could also have been advantageously used in lifting the blocks of the pyramids and the temples in the absence of pulleys and hoists.

The progress of agrarian science led in 2000 B.C. to the reclamation of El Fayyum south of Memphis, and a large region around Lake Moeris (five times larger than it is now at that time) was made arable by canalizing and reclaiming thousands of hectares of marshy sterile land. This great work also included the construction of villages and the constitution of ideal cooperatives: in the village, in fact, every worker of the land had a house of his own with a garden of about 1,500 square meters, and he belonged to a team of five workers with their own head worker; workers and master builders formed a jointly responsible community which annually discussed the programs with the delegates of the state property for the consignment of the products and regulation of remuneration.

Navigation on the Nile was also particularly fa-

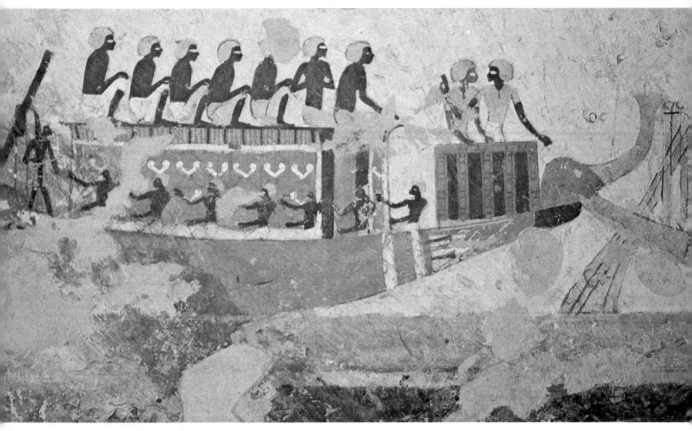

Detail of a boat, with the forebridge on the prow, taken from the tomb of Userhat in El Qurnah.

vored by nature: while ships plying the river from south to north, that is towards the sea, were aided by the current, those going upstream from Lower to Upper Egypt had an almost constant north-south breeze to help them along. The Nile not only fertilized the land but also became the lifeline and the communications network for all of Egypt. On the south this immense artery joined it to Nubia, the land of gold and ivory; on the north to the Mediterranean and therefore with Lebanon, the land of the precious cedar wood; in the center with the caravan route which led from Coptos, through the Uadi Ham Mamat, to the Red Sea and then to the mysterious land of Punt (Abyssinia? Pakistan?) the source of myrrh, incense, spices, electron (yellow amber) and white gold, products of such importance for ancient Egypt that Sahure (2500 B.C.) undertook a great expedition, assembling and dismantling the boats needed to cross the Red Sea. Later the route along the desert was equipped with stopovers, deposits of water continuously refurbished and a naval yard on the Red Sea.

It was in the Sixth Dynasty (2350-2180 B.C.) that the ancestor of the Suez Canal was built, joining the Red Sea with the city of Bubastis and the Mediterranean. It seems that during the 26th Dynasty (609-524 B.C.), when Rome and Athens had barely seen the light, Egyptian ships were circumnavigating Africa, rounding the Pillars of Hercules and returning via the Canal of Bubastis.

Ships of all sizes sailed the Nile: boats built of papyrus rushes, or bundles of palm, the ten-meter-long feluccas, and enormous rafts more than thirty meters long capable of carrying the heavy obelisks for hundreds of kilometers.

The ships that connected Byblos and Memphis as early as 2620 B.C. in the time of Snefru, founding father of the Fourth Dynasty, were already built in a particular way and were of large size. A fleet of at least forty ships, fifty meters long, and another sixty of smaller size, transported enormous loads of cedars of Lebanon.

By the beginning of the fourth millennium, the shipbuilding technique must already have been based on centuries of experience. There is evidence of sail boats even before the pharaohs, and the image of Ra-Sun who navigates with the "*two barks of the sky*" goes far back. The building of boats went hand in hand with the making of sails. As early as the year three thousand fine linen sails, large in size and perfectly regulated by ample rigging, made it possible for fully loaded ships fifty meters long to sail the Mediterranean.

The mast was often a high tripod of trunks; and a large cabin stood on the central part. The oars were in the shape of lances and the rudders like two great blades in equilibrium on the sides or on a special trestle. Often the helmsman was protected by an awning. The colors and the decoration were always brilliant and to be found everywhere.

The boat, essential in daily life, was also an integral part of every religious festival, and was therefore jealously preserved in the heart of every temple. It was the vehicle *par excellence*, both in this and in the other world, for men as for gods: the vehicle of Life along an endless Nile.

5000 YEARS OF ART
The Egyptian Museum in Cairo

The imposing building which presently hosts the Cairo Egyptian Museum at Midan el-Tahir, was designed by the French architect, Marcel Dourgnon, winner of an international competition.

Today the Museum hosts the most important collection of Egyptian art in the world.

There has been European interest in Egyptian antiquities since the beginning of the eighteenth century: the Napoleonic campaign of 1798, the discovery of the Rosetta Stone the following year and above all the publication of the 18 volume «Description de l'Egypte» between 1809 and 1816, not only gave a rigorously systematic definition to the study of Egyptian civilization but increased the appetite of those who had already begun to collect ancient objects like sarcophagi, statuettes and scarabs. There were, in fact, numerous persons living in Egypt at that time who by no means looked down upon the gifts bestowed by over-generous Pashas on their guests. Amongst the first to start collecting these antiquities were the consuls of various European countries. These collections were then sold in Europe and made up the original nucleus of Egyptian collections in various European museums such as those of Turin, Paris, London and Berlin. The artistic and archaeological heritage of Egypt thus suffered serious losses: the situation was, in fact, so serious that in 1830 a scholar of the Champollion school, asked the Pasha Muhammad Ali to set up a service to safeguard the preservation of the monuments. The former leniency seemed to have come to an end in 1834, when a museum was founded on the banks of Lake Ezbekiah where all the objects were catalogued. These first origins were soon transferred to a more suitable site in the citadel of Cairo: there were still so few items that it was possible to fit them all into one room! The Archduke Maximilian of Austria saw these objects during a visit to Cairo in 1855 and asked the Pasha Abbas to give him some items: the Pasha gave him everything in the room and so the first original Cairo Egyptian Museum can today be seen... in Vienna! Fortunately, on the 1st June 1858, Auguste Mariette, one of the directors of the Louvre Museum, also sent out to Egypt to collect antiquities, was able to get himself appointed «Mamour», that is Director of Excavations. The numerous pressures on Khedive Said to preserve Egyptian monuments, allowed Mariette to be granted use of the former headquarters of a river navigation company at Boulak, a small port near Cairo. Mariette moved there with his family and began what would become the first national museum of the whole Middle Eastern area: the official opening was on the 18th October 1863.

In 1891, the collections were moved to the Giza Palace and finally in 1902 to their present location.

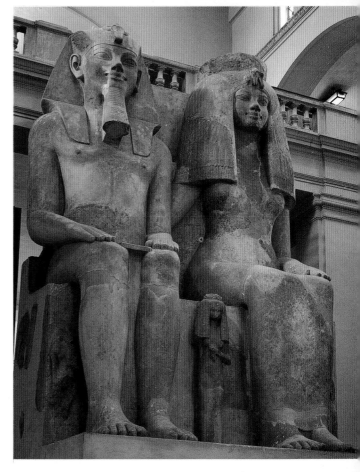

Colossal statue of Amenophis III with his wife Tiye: over ten meters high, it comes from Medinet Habu.

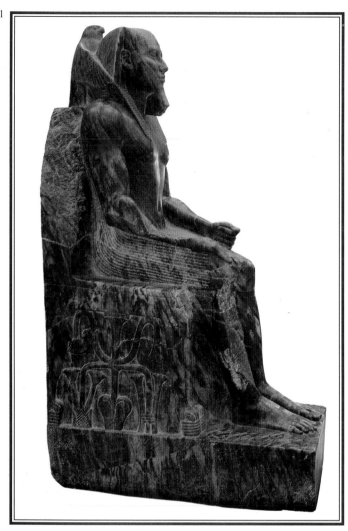

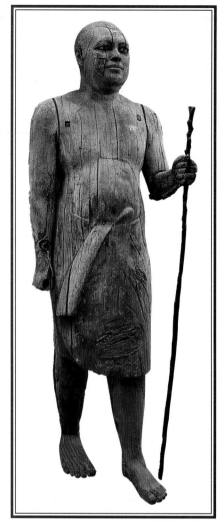

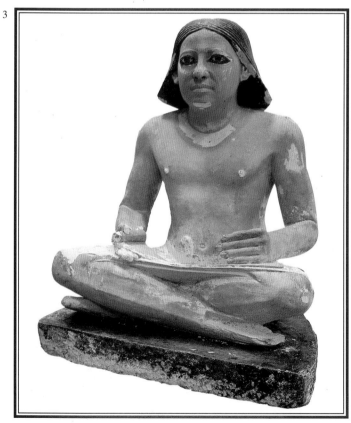

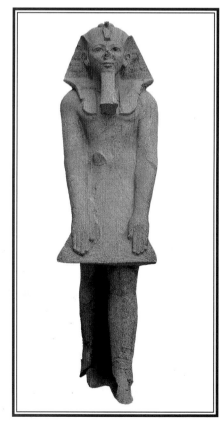

1. Black diorite statue of Khafre (Chephren): the falcon god Horus is perched behind the king's nape.

2. Wooden statue of Ka-aper, «chief lector-priest» who lived in Memphis; it is also known as the statue of Sheikh el Beled, which means headman of the village.

3. Seated scribe: from a tomb in Saqqara, it is in painted limestone with inlaid eyes (4th Dynasty).

4. Granite statue of the queen Hatshepsut shown as a pharaoh, in male attire and with the false beard (from Deir el-Bahri).

5. Rahotep and Nofret, from Maydum, not far from the pyramid of Snefru. Rahotep was Director of Expeditions and High Priest.

6. Offering bearer, in stuccoed and painted wood from Deir el-Bahri (11th Dynasty).

7. The dwarf Seneb and his family, a small but perfect group in painted limestone (6th Dynasty).

5

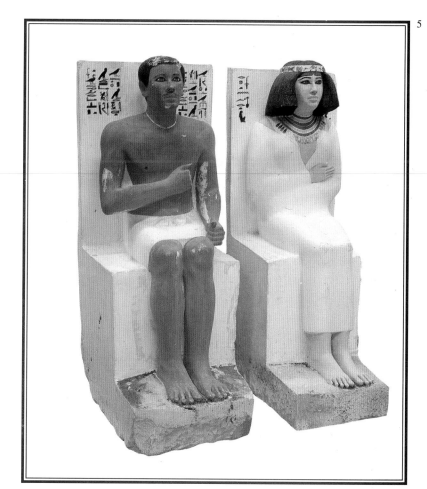

6

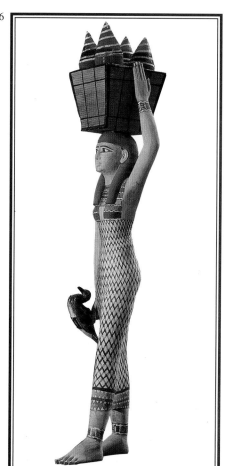

7

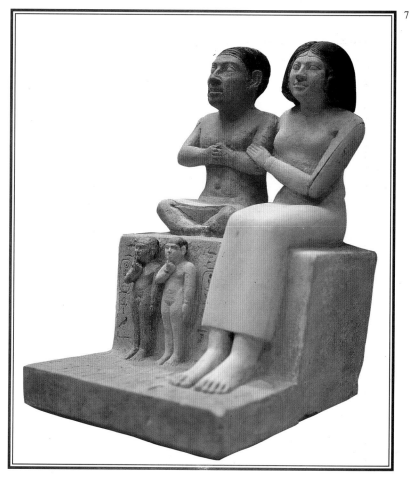

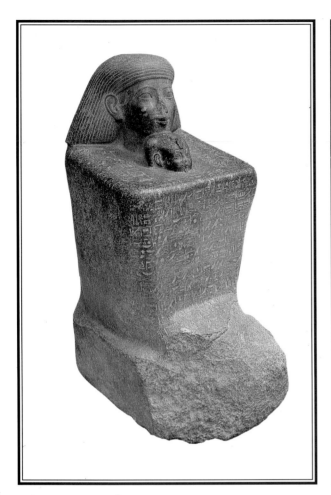

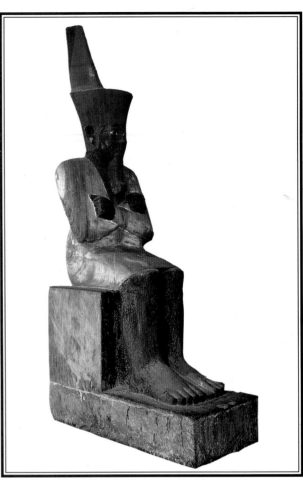

Block statue of Senmut and Princess Neferure, in grey granite from Karnak (18th Dynasty).

Statue of Mentuhotep I, in painted grey sandstone, from the funerary complex of Deir el-Bahri (11th Dynasty).

Model figures of soldiers marching four abreast, from Assiut (Middle Kingdom).

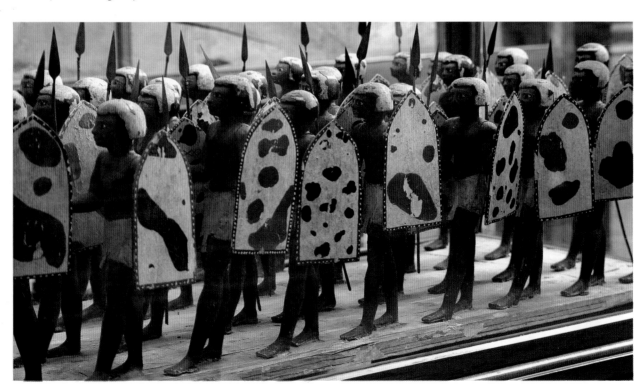

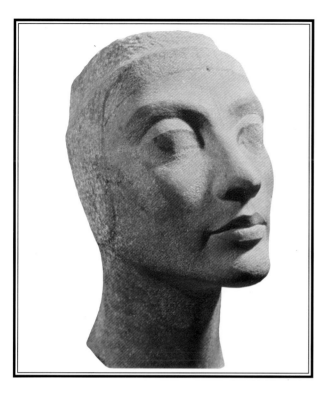

Quarzite head of Nefertiti, wife of Akhenaten, from the atelier of Tuthmosis in Tell el-Amarna.

Architectural colossus in sandstone of Akhenaten, from Karnak.

Domestic altar with the family of Akhenaten, from Karnak.

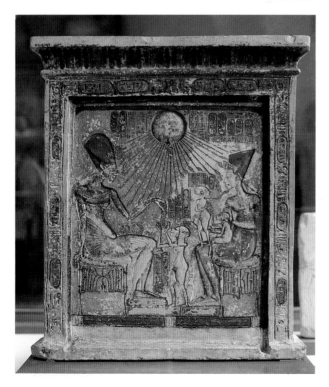

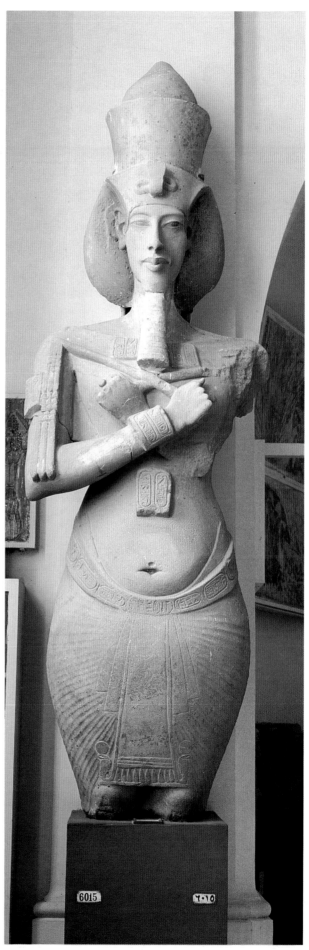

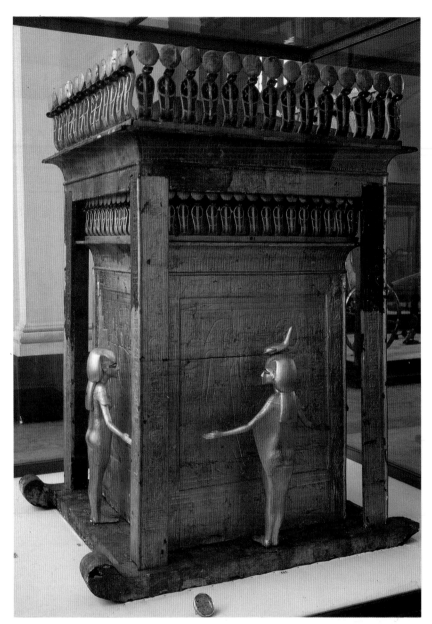

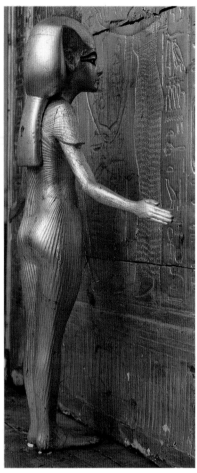

Tutankhamen's treasure.

«*Canopic Naos*»: *the gilt wood shrine with the goddesses Isis and Selket to protect the canopic urns inside.*

The goddess Isis, her eyes and eyebrows painted black.

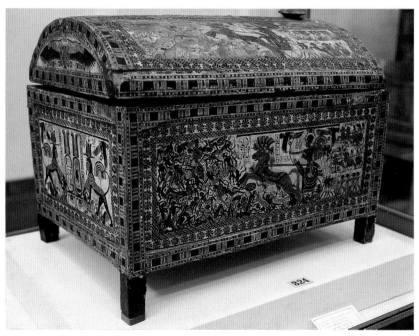

The small wooden "hunting" coffer. Both sides are painted with battle scenes in which Tutankhamen defeats hordes of ennemies.

The gilt throne and a detail: the gold-plated wood is inlaid with semi-precious stones and glass paste. In the detail, Ankhesenamun anoints her husband.

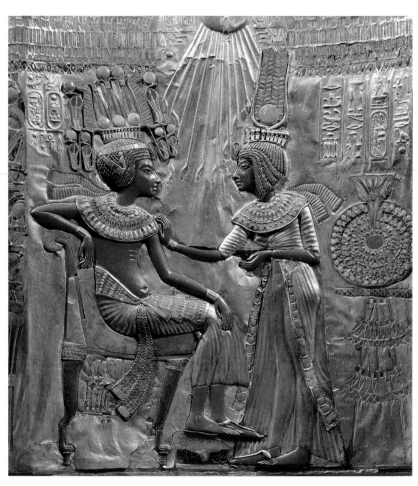

The royal «Ka» of Tutankhamen, about 1 meter 73 cm. high; it represented the pharaoh's double which at the moment of his death left the body to follow him into the afterworld.

Funeral couch, with cows' heads at the head bearing the solar disk between their horns.

The god Anubis, in wood stuccoed and painted black: ears, eyes and collar are gilded.

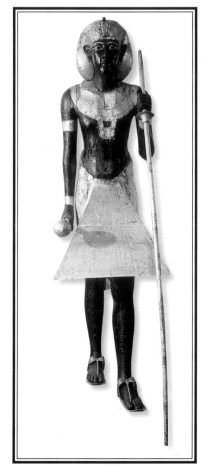

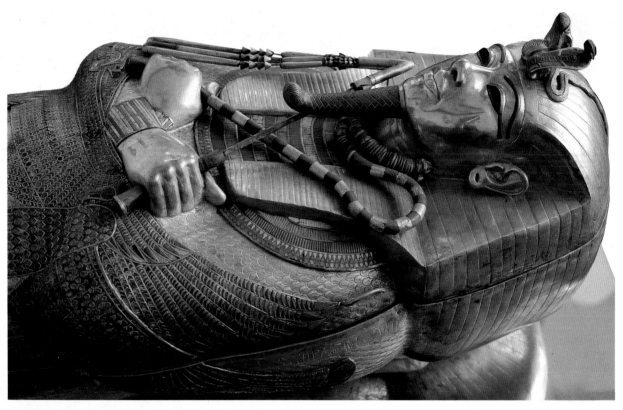

Detail of the third mummiform sarcophagus in beaten gold: the sovereign holds his insignia, the flail and the scepter.

Some of the pharaoh's ceremonial batons.

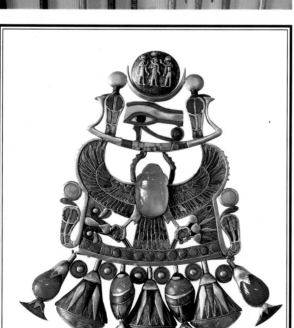

Pectoral with emblems of the sun and the moon: the central part of the jewel consists of a calcedony scarab which also forms the body of a falcon with spread wings.

Funerary mask of Tutankhamen, in gold and precious stones, an exact likeness of the king. Particularly elegant is the heavy nemes headdress in blue and gold stripes with the royal symbols on the forehead, inlaid with lapis lazuli, turquoise and carnelian.

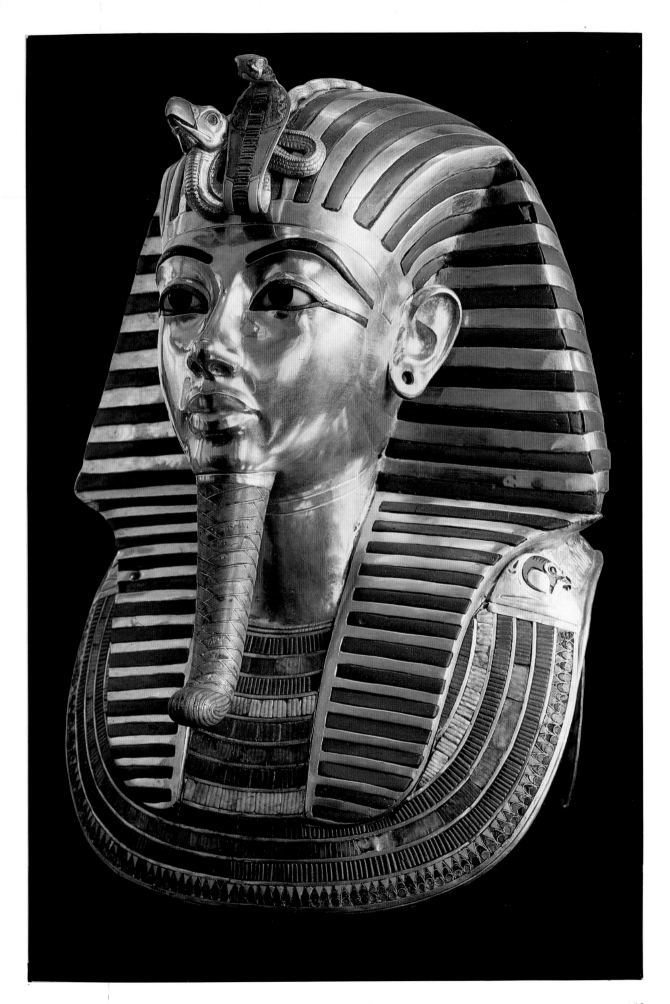

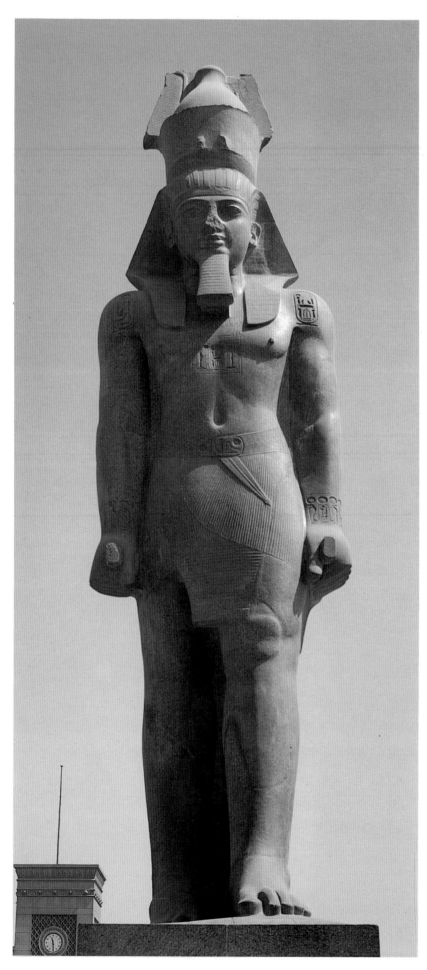

Statue of Ramses II.

It was found in Memphis, then was taken to Cairo in 1954, to be exhibited in the station square. It is 10 meters high and the double crown represents the unity between the North and the South. On the back of the statue there is a stanchion bearing the Pharaoh's titles, one of which is «The Strong Ox» which is the symbol of fertility. Between the statue's legs is a relief of Ramses' wife (Bent-Anath) who was, at the same time, one of the 200 sons and daughters and one of his three daughters who were given this title. A replica of this statue stands now on the road leading to Cairo Airport.

The Bab al-Muzayyinin (The Barber's Gate) is the most important of the eight gates of the Al-Azhar Mosque.

THE NEW CAPITAL
The great monuments of Cairo

The predynastic period in Egypt is characterized by confederations with political heads or kings who resided in a capital. That of Lower Egypt was Buto, that of Upper Egypt was Nekhen, and then with the union of the Two Lands under Narmer, the city of Memphis became the first capital of the unified Egypt. In the course of the centuries the capital was moved more than once until 332 B.C. when, with the arrival of Alexander the Great, it was transferred to Alexandria, west of the Delta, where it remained throughout the Ptolemaic and Roman periods. With the introduction of Islam in Egypt, other capitals were founded in turn, each one clearly of a military nature, which in the end joined to form a single city. In 969 the new city of Al-Qahirah (The Victorious), now known as Cairo, was founded, which thereafter became the capital of Egypt and center of Islam. The new city developed rapidly: during the Ayyubid period the Citadel was built and the construction of a great wall to surround Al-Qahirah was begun. Building and urbanization flourished in Cairo under the Mamluks (from 1250 to 1517), and was kept up by the Ottomans who also favored important trading

activities. During the reign of Muhammad Ali and his successors the city continued to develop. After the revolution of 1952, the economic boom of the 1960s resulted in a sharp rise in the population. At present the great city has over twelve million inhabitants, and is the most populous of the African cities and also a great political, cultural and economic center of the Middle East.

The Mosque of Sultan Hassan (left) and the Al-Rifa'i Mosque (right). The former is one of the most famous and beautiful mosques in Cairo, built between 1356 and 1363. It is one of the outstanding examples of Islamic architecture, and covers almost eight thousand square meters. The Al-Rifa'i Mosque was built by a woman, the Princess Dowager Khushyar, and was terminated in 1912. Inside are the tombs of the royal family of Egypt, from the Khedive Ismail Pasha to Faruk.

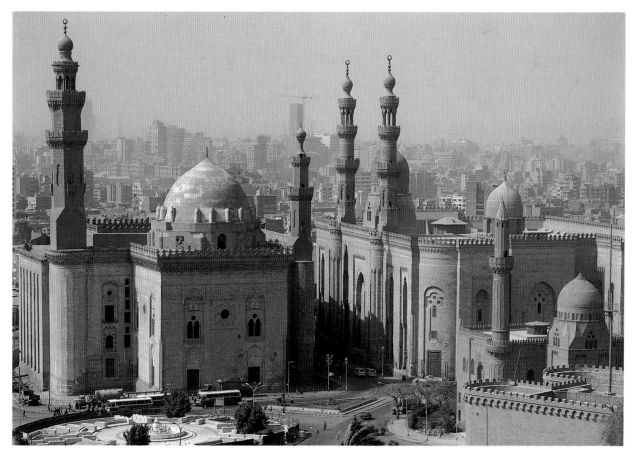

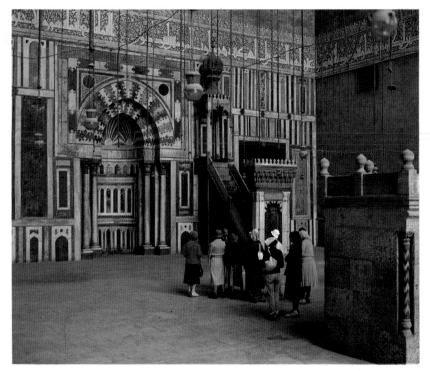

Two pictures of the rich architectural decoration in the mosque of Sultan Hassan and one of the slender minarets of the Al-Rifa'i Mosque.

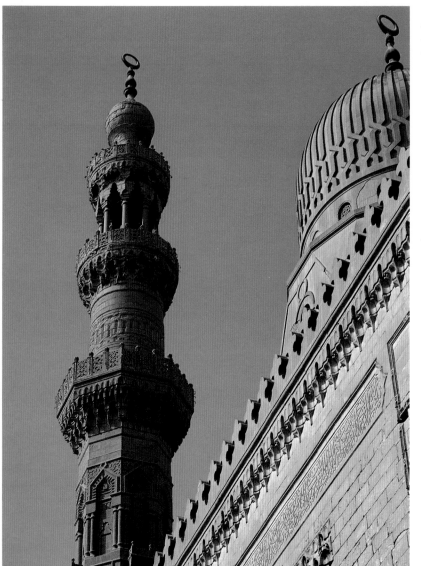

Muhammad Ali Mosque.

Built in 1830, this mosque has become the emblem of Cairo. It consists of two parts, the mosque itself and the court, at the center of which is the lovely ablutions fountain. The mosque was designed by the Greek architect Youssef Bochna, who lived in Turkey and who took as his model Hagia Sophia in Istanbul. Square in shape, it has a central dome 21 meters in diameter, and 52 meters high, resting on four square pillars. Alabaster abounds and a multitude of concentric crystal chandeliers hung on chains provide the illumination.

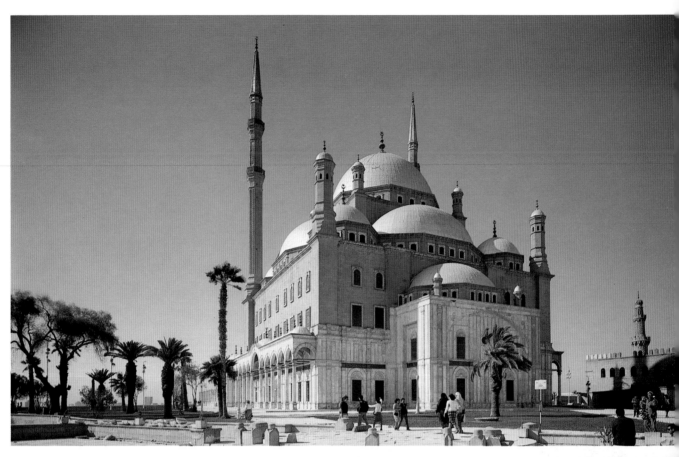

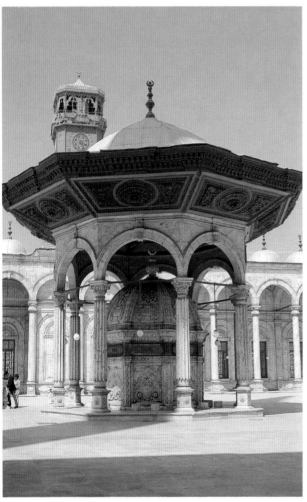

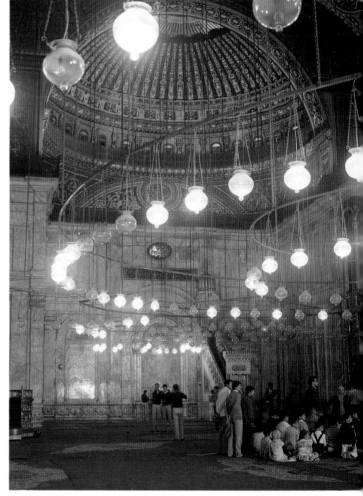

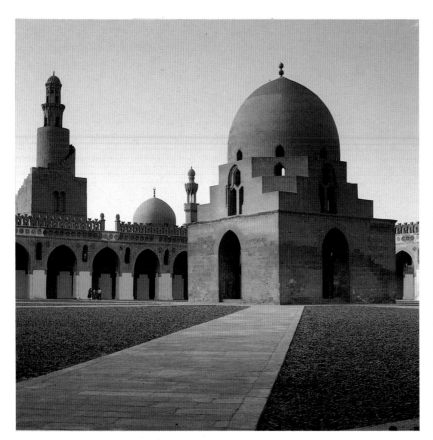

Mosque of Ibn Tulun, built between 876 and 879. The design follows the plan of the mosque of Samarra in Iraq.

The minarets of the Mosque of Al-Azhar.

The modern Cairo Tower, on the island of Gezira.

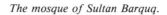

The mosque of Sultan Barquq.

A view of the Nile from the Nile Hilton.

A room of the Museum of Islamic Art, inaugurated in 1903, and on the right, a picture of the Coptic Museum, with a fountain covered by a wooden dome set on four marble columns; a chandelier with 366 lamps representing the days of the year hangs from the center of the vault.

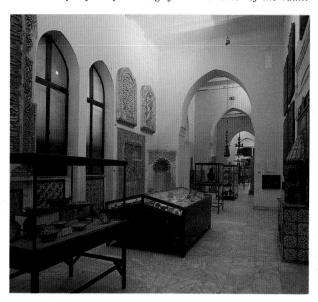

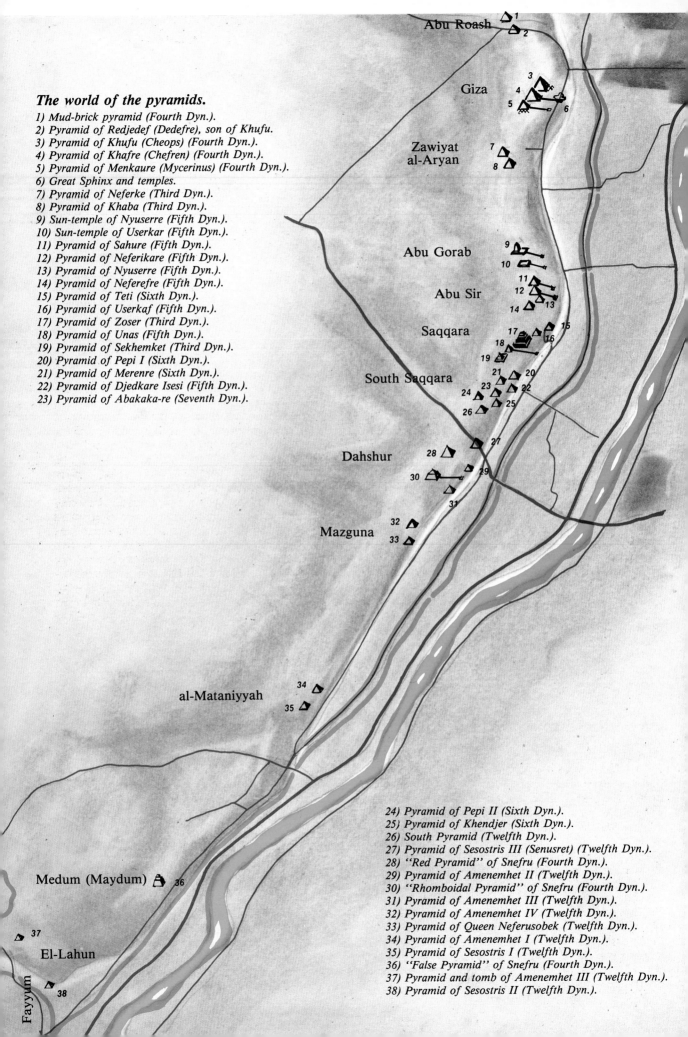

The world of the pyramids.

1) Mud-brick pyramid (Fourth Dyn.).
2) Pyramid of Redjedef (Dedefre), son of Khufu.
3) Pyramid of Khufu (Cheops) (Fourth Dyn.).
4) Pyramid of Khafre (Chefren) (Fourth Dyn.).
5) Pyramid of Menkaure (Mycerinus) (Fourth Dyn.).
6) Great Sphinx and temples.
7) Pyramid of Neferke (Third Dyn.).
8) Pyramid of Khaba (Third Dyn.).
9) Sun-temple of Nyuserre (Fifth Dyn.).
10) Sun-temple of Userkar (Fifth Dyn.).
11) Pyramid of Sahure (Fifth Dyn.).
12) Pyramid of Neferikare (Fifth Dyn.).
13) Pyramid of Nyuserre (Fifth Dyn.).
14) Pyramid of Neferefre (Fifth Dyn.).
15) Pyramid of Teti (Sixth Dyn.).
16) Pyramid of Userkaf (Fifth Dyn.).
17) Pyramid of Zoser (Third Dyn.).
18) Pyramid of Unas (Fifth Dyn.).
19) Pyramid of Sekhemket (Third Dyn.).
20) Pyramid of Pepi I (Sixth Dyn.).
21) Pyramid of Merenre (Sixth Dyn.).
22) Pyramid of Djedkare Isesi (Fifth Dyn.).
23) Pyramid of Abakaka-re (Seventh Dyn.).

24) Pyramid of Pepi II (Sixth Dyn.).
25) Pyramid of Khendjer (Sixth Dyn.).
26) South Pyramid (Twelfth Dyn.).
27) Pyramid of Sesostris III (Senusret) (Twelfth Dyn.).
28) "Red Pyramid" of Snefru (Fourth Dyn.).
29) Pyramid of Amenemhet II (Twelfth Dyn.).
30) "Rhomboidal Pyramid" of Snefru (Fourth Dyn.).
31) Pyramid of Amenemhet III (Twelfth Dyn.).
32) Pyramid of Amenemhet IV (Twelfth Dyn.).
33) Pyramid of Queen Neferusobek (Twelfth Dyn.).
34) Pyramid of Amenemhet I (Twelfth Dyn.).
35) Pyramid of Sesostris I (Twelfth Dyn.).
36) "False Pyramid" of Snefru (Fourth Dyn.).
37) Pyramid and tomb of Amenemhet III (Twelfth Dyn.).
38) Pyramid of Sesostris II (Twelfth Dyn.).

"The World of the Pyramids" is an apt name for the series of cemeteries which lie along the western bank of the Nile, stretching from the ancient city of Leopolis almost as far as Heracleopolis.

Over eighty pyramids, a continuous chain fifty kilometers long, lie to the north and south of Memphis.

Surrounded by a myriad of mastabas, or oblong shaped flat-topped tombs with sloping sides, a great many of the pyramids are smooth faced while a few are stepped. Almost at their head stand the monumental pyramids of Giza.

The oldest pharaonic tombs resemble the palace-castles of the First Dynasty, next come the stepped pyramids, and lastly, those with smooth faces. While it may be easy for us to see how the palace of the living pharaoh could become the "palace" of the deceased pharaoh (just as the house of the living prince became, with the mastaba, the house of the deceased prince), it is more difficult to grasp the correlation of the pyramid with the world of the living and with the afterworld.

The origins of the palace, the turreted residence of the king, date back to before 3000 B.C., and at that time the regal tomb may also have had the same formal features. Clear examples are provided by the tomb of Aha (circa 2900 B.C.) and by the slightly later tomb of Udimu (Den). While the former is of the empty type — in other words it is similar to a real dwelling where the central hall has been turned into a mortuary chapel (that is the "king's chamber") — the latter is of the solid type, or a dummy, and can be compared to an imposing coffer, the simulacrum of the king's house, which protects the mortuary chapel excavated in the rock. What we have in both cases is the prehistoric rite where the relatives preserved the deceased inside or under their dwelling.

With the arrival of the pyramids, the simulacrum of the house was swept away and all ties with the real world or with tradition were abolished. It was in Zoser's time (2700 B.C.) with the works designed by the great architect Imhotep that this sudden, apparently inexplicable, leap ahead took place. Indeed, that marvelous architectural complex at the center of Saqqara consists of three basically different structural types: the beautiful enclosure wall which echoes the architectural traditions of the royal palaces; the stupendous massive buildings and the colonnaded vestibules, which furnished the entire ancient world with completely new perspectives of architecture; the hermetic mass of the stepped pyramid which looms up in the center of the complex, and for which no reference to traditional architecture nor with the architecture invented by Imhotep himself can be found. What explanation can be found for the conceptual abyss between Imhotep's most important work and the others, apparently disavowing whatever architec-

tural forms and ensembles the same architect had previously attempted or invented? The overturning of tradition comes clearly to the fore in the construction of the pyramid. Initially the structure was a "mastaba" with a square ground plan (almost twice as large as the tomb of Udimu). The pharaoh's burial chamber lies under the massive mastaba, at the end of a shaft sunk in the rock. The two enlargements of the house-tomb were all in line with tradition. While the second enlargement was in course, the program was abandoned for no apparent reason and the first pyramid with four steps — a great protecting bell — appeared on the mastaba, then to disappear in turn on three sides under the final six-step pyramid.

Why, we wonder anew, was the traditional tomb, simulacrum of the dwelling of the living, "swallowed" up by a form that was completely new, even for the inventor himself? This is all the more problematical in view of the fact that barely a hundred years later the stepped pyramid was replaced by one with smooth faces. On the whole, the stepped pyramid is the sum of a superimposition of mastabas of ever smaller size, and this concept took on concrete architectural form, not many centuries later, in the stepped temples (known as ziggurats) of the Sumerians, a concept which was then perfected in the Babylonian temples of two thousand years later. While these expressions are basically diverse they can indirectly be referred architecturally to the pyramid of Imhotep. But what reference can be found for the smooth-faced pyramids begun only one hundred and twenty years after Zoser?

The leap from the stepped pyramid to the smooth pyramid is to be found in Medum (Maydum), "written" in the original structures of the pyramid built by Snefru, founder of the Fourth Dynasty. In terms of construction, the difference is not great. Indeed it seems almost natural that a stepped pyramid should end up protected by a continuous surface coating so as to resist the wear and tear of time: moreover the concept of a continuous face is an integral part of all the great pyramids, to begin with Zoser's, where the construction developed with a series of sloping smooth walls around a central core (the core of the pyramid of Khufu (Cheops) seems to be a giant obelisk 146 meters long without a point). The leap in form is however quite something else, for from a silhouette which displays at least some faint rapport with current architectural concepts, one passes to another where all contact with reality is lost. The fact that this latest "novelty" was not the result of a momentary caprice, but remained until the end of the Sixth Dynasty, is also to be kept in mind. An exciting example is found at the end of the third millennium. The golden period of the stepped pyramids lasted not much more than a hundred years, while that of the

Monumental pyramid complex.

Cross section and ground plan of a typical layout.

A — Pyramid built of sloping sections of stones and faced with fine stone from the quarries of Turah.

B — Subsidiary pyramids for the pharaonic princesses.

C — Mortuary temple for the cult of the deified pharaoh.

D — Causeway.

E — Valley Temple for purification and initiation.

1) *Pyramid precinct.*
2) *Access gallery inside the pyramid with the opening on the east.*
3) *Treasure chambers and burial chamber.*
4) *Sanctuary with seven shrines for the gods and antechamber for the worship of the pharaoh-god.*
5) *Colonnaded court for the priests and initiated members of the family.*
6) *Storerooms for the offerings and cells for the priests.*
7) *Small temple for offerings and prayers for the queen.*
8) *Vestibule of the mortuary temple.*
9) *Buried sacred barks.*
10) *Room for the "Guardian of the Threshold".*
11) *Storerooms and cells for the priests.*
12) *Shrine for the "opening of the eyes and mouth".*
13) *Vestibule for the purification and completion of the mummy.*
14) *Landing stage on the canal coming from the Nile.*

geometric pyramid lasted five hundred years!

Whatever it was that caused Khufu (Cheops) to attempt this "architectural absurdity" — a macroscopic pyramid even further from reality than Zoser's, a costly undertaking at the limits of human possibility — must have been extremely deep and powerful. Since we have absolutely no precedents for this extraordinary "model", no hint at what the stimulus might have been, the answer must be sought for in the world of religion and in experiences that go back beyond history. "Spiritual pyramids" are to be found in Egyptian theology and cosmogony, in that "science" of the world before and after the "land of the Nile". These pyramid-shaped mysteries are mirrored in the primordial tumulus that rises from Chaos, the source of the great egg-lotus which opens to give birth to the sun. There is a strong formal analogy in the pyramid of rays of light, a great road which diminishes to a point in infinity, and transports the elect to a true Egyptian Nirvana, achieved by crossing the bridge that unites heaven and earth.

Over and over this pyramid of infinite arms which descend from the sun to benefit all men, none excluded, arms widespread almost as if to embrace mankind as a whole and take it back into heaven, appears in the art of Akhenaten, the prophet pharaoh of the revealed religion.

The "Pyramid Texts" themselves, which transcend history, tell us "*I have walked on thy rays as if on*

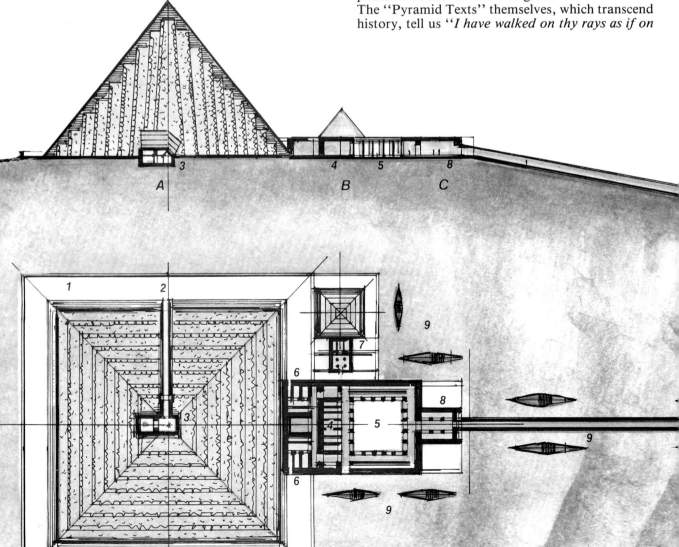

a stair of light to ascend to the presence of Ra....heaven has made the rays of the sun solid so that I can elevate myself up to the eyes of Ra....they have built a staircase leading to the sky by which I can reach the sky".

The Great Pyramid (as well as the Sphinx) is then none other than a gigantic ideogram exhumed from the past, in which "we read" the staircase which *par excellence* leads to eternity. It is the world which manifests itself, the voice of the Eternal who materialized when at the beginning of Time he said to his image: "Come to me". This gigantic talisman of stone became the confirmation and concrete certainty of the rebirth of the chrysalis-mummy, the base and the end of the ascent to Paradise.

In our search for the "model" of this unprecedented gigantic talisman, it seems only natural to turn once more to that mysterious reservoir for origins which Plato called Atlantis. According to Plato memories of Atlantis were transmitted to Solon (600 B.C.) by a priest of Sais, an ancient city in Upper Egypt, who described Atlantis as an ideal kingdom founded nine thousand years earlier by Poseidon, god of the sea (for the Egyptians too the primordial earth is born of water). An important fact was that the kingdom of Atlantis — submerged by the sea from which it had risen when the good wise men who lived there fell prey to corruption — had stretched all the way to Egypt.

And one last thing to be kept in mind is that according to Plato these Egyptian priests, custodians of the memory of Atlantis, numbered Imhotep, the great priest who had initiated the ascent to heaven with the first great stepped pyramid, among their illustrious ancestors.

The function of the pyramid

The urban complex of the smooth-faced pyramid differs greatly from that of the stepped pyramid, as revealed by a comparison of the architectural ensembles of Giza and Abu Sir with that of Zoser's mausoleum.

The smooth-faced pyramid develops eastwards with an unbroken series of three monuments: the "mortuary temple" at its base; the "valley temple" on the bank of the canal, the long "causeway-gallery" which joins the two temples. The entire complex began functioning as soon as the funeral of the deceased began.

When the pharaoh died, the long rites of his "embalming" and burial began at the temple-dwelling of the pharaoh. Once the body had arrived with the procession of sacred barks, the "purification" ceremonies began at the Valley Temple and the preparation of the mummy was also completed. The principal ceremony was the purifying washing

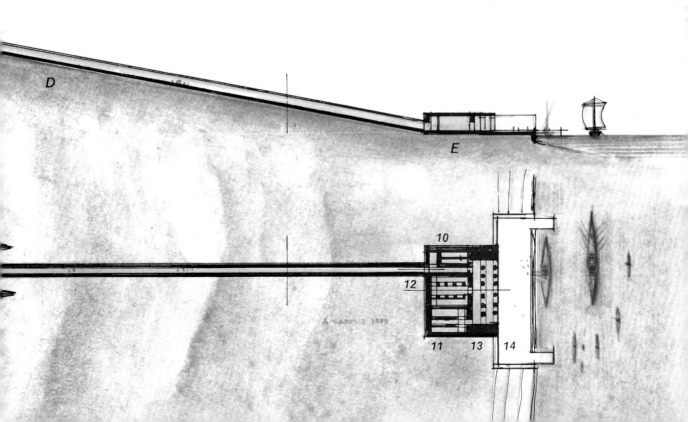

comparable to that of the Sun which is reborn every morning from the "*Lake of the Lily*". Purified, covered with propitiatory amulets, the mummy passed by the "*Guardian of the threshold*", then began his journey of ascent, hidden from profane eyes in the gallery, and reached the temple further up for the "consecration". As the body proceeded from one columned hall to the next, the number of initiates and purified who accompanied him (consisting of priests and relatives) dwindled. When it reached the great central court only the great initiated and the pharaoh's heir continued into the "sancta sanctorum" of the mortuary temple, where the fundamental ceremony of the "*opening of the mouth and eyes*" took place. The royal heir presided over this rite which "opened" the communication of the deceased with the afterworld, before the five chapels, in other words, the five statues of the god-king, one for each attribute given to the pharaoh when he had received his royal "consecration".

Officially reunited with the gods, the deceased was taken through secret ways to the subterranean chapel. Once sealed, the precious sarcophagus was set in the midst of his dearest possessions and treasures, after which the worker-priests retraced their steps, closed the marble portcullises and obstructed every passage so that no one might disturb the pharaoh as he waited for his final ascent to the sun. The last secret ceremony was that of placing the statue of the pharaoh in the sirdab, the masonry cell in the heart of the mortuary temple, from which the simulacrum of the king would "see" for all times to come the ceremonies and offerings made in his honor.

"Purification" took place in the outer vestibule and continued under a temporary pavilion erected on the roof of the mastaba. The sarcophagus was then lowered into the shaft which led from the roof down to the subterranean chamber. Once the sarcophagus had been installed and surrounded by treasures and memoirs, the burial chamber was sealed and the shaft filled with stones and sand and walled up at the top. The funeral ceremonies and the offerings were resumed in the small external vestibule, in front of the false door where the deceased was represented as if he were taking part in the rites executed in his honor.

A series of rooms were hollowed out in the "empty mastaba" which more or less echoed those of the house of the deceased, in other words rooms for the deceased and rooms for the members of his family. The ceremonies of purification and the opening of the eyes and mouth were therefore fully carried out inside the tomb-house before the sarcophagus was lowered into the shaft opened under the floor and definitively sealed. The funeral rites and banquets could also be more fully carried out afterwards in the varying internal rooms, with the participation of the deceased in the form of his image looking out of the "falsc door" or magically present from the interior of his sirdab. The family link between earth and heaven thus remained intact, and the colloquium between the living and the dead continued after death.

Mastaba tombs

Dignitaries and nobles were commonly buried in tombs set around the pyramid and known now as mastabas, after the Arab name meaning "bench". They were rectangular in plan with slightly sloping walls, a cornice molding all around and a single entrance door or "false door" with or without an exterior vestibule. Just as the palace of the deceased pharaoh was similar to the palace of the living pharaoh, so the mastaba was similar to the house the owner of the tomb had lived in previously. But while the palace tomb turned into a solid structure, the mastaba started out as a "solid" and was gradually modified into an "empty" structure. This probably depended on the fact that initially the courtiers were buried in simple pits, marked by stone tumuli, around the chapel of the king. As the royal chapel evolved, the tumulus was constructed in stone until it became an actual palace-house around the great pyramid.

Since the "solid mastaba" contained no rooms above ground, the "mummification" process was carried out entirely in the city, in the "*palace of life*".

Ideal reconstruction of part of a mid-third millennium necropolis.

The "mastabas", arranged on a grid plan, look like the residential quarter of the nobles and high officials surrounding the palace of the king. The cross section shows the interior of two mastabas of different type. Above on the right is the older type, which looks like a house from the outside only, for the interior is solidly filled with blocks of stone and sand — like the lovely mastabas built around Zoser's pyramid. In the lower central portion is a mastaba of the type used above all during the Fifth and Sixth Dynasties: the close analogy to the houses of the living is apparent in the interior as well.

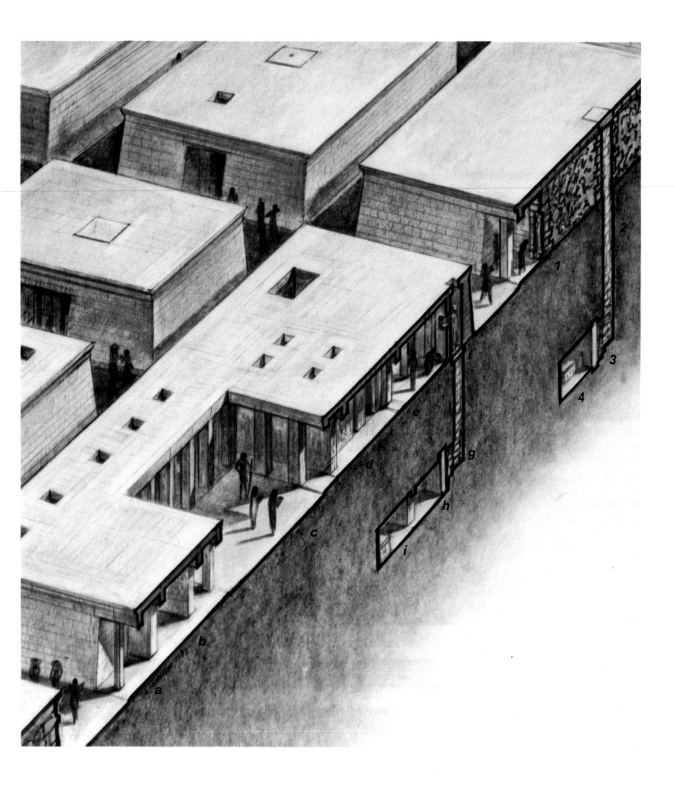

Solid or dummy mastaba:

1) Vestibule chapel with stela in the back: the "false door" with the "appearance" of the deceased is sometimes to be found on the stela.
2) Shaft which leads from the terrace to the subterranean chambers.
3) Antechamber of the "treasure" with walled-up entrance.
4) Burial chamber.

Mastaba reproducing the house:

a) Vestibule.
b) Entrance hallway leading to the inner rooms (of the parents and their children).
c) Internal courtyard or central hypostyle hall.
d) Access to storerooms.
e) Small hall for funeral rites and banquets.
f) "False door" and closed cell containing the simulacrum of the deceased. In the mastabas this cell, called sirdab, was always on the western side; that is on the side of the realm of the dead.
g) Shaft leading to subterranean chambers.
h) Chamber for gifts and furnishings of the deceased, with a walled-up entrance.
i) Burial chamber.

Giza

Reconstruction of the Necropolis of 2500 B.C.

Giza is the name currently given to the gigantic burial grounds of ancient Letopolis (now Cairo). They cover an area of two thousand square meters on a plateau. An escarpment on the southeast edge slopes down for forty meters. A canal brought in from the Nile and separating the desert zone from the fertile land once ran along the base of the bluff. The Sphinx Abu el-Hol, the "terrible one", and the Great Pyramids are the principal monuments. They are the only one of the seven wonders of the world exalted by the Greeks in the 2nd century B.C. still extant (the other six wonders, practically all gone, were: the Lighthouse of Alexandria of Egypt, the Mausoleum of Halicarnassus, the Temple of Artemis in Ephesus, the "Colossus" in the port of Rhodes, the hanging gardens of Babylonia, the statue of Zeus by Phidias in the Temple of Olympia).

The pyramids lie along a diagonal (those of Khufu and Khafre on the same base diagonal) running from northeast to southwest, so that none of them ever hide the sun from the others. The first two are practically the same height at their summit, since that of Khafre which is actually smaller is set higher on the plateau. All three have a burial chamber excavated in the rock and set almost in the center of the main body of the construction; other superimposed chambers are found in the pyramid of Khufu (Cheops) and in that of Menkaure (Mycerinus). Each one had a complete monumental complex consisting of a mortuary temple, a causeway and a valley temple; while that of Khafre is mostly still extant, that of Khufu has been almost completely destroyed. The only one of the three that is arranged on an axis with the pyramid is that of Menkaure; that of Khafre deviates considerably to the south (beyond the Sphinx) and that of Khufu deviates to the north. Three subsidiary temples stand to the east of the pyramid of Khufu and three to the south of that of Menkaure. That of Khafre probably had a single subsidiary pyramid to the south.

A — *Funerary complex of Menkaure (Mycerinus).*
1) *Pyramid (66 m. high by 108 m. long).*
2) *Three subsidiary pyramids.*
3) *Sacred enclosure.*
4) *Mortuary temple.*
5) *Causeway.*
6) *Valley temple.*

B — *Funerary complex of Khafre.*
7) *Pyramid (136.50 m. high by 210.50 m. long).*
8) *A subsidiary pyramid.*
9) *Sacred enclosure and rock cut storerooms and shelters for the worker-priests.*
10) *Causeway.*
12) *Valley temple.*

C — *Funerary complex of Khufu (Cheops).*
13) *Pyramid (146 m. high by 233 m. long).*
14) *Three subsidiary pyramids and solar boats.*
15) *Mortuary temple.*
16) *Causeway.*

D — *Burial grounds east of the rock tombs.*
E — *Necropolis to the south.*
F — *Necropolis to the west.*
G — *The Great Sphinx (21 m. high and 73.5 m. long).*
H — *Temple of the Sphinx.*

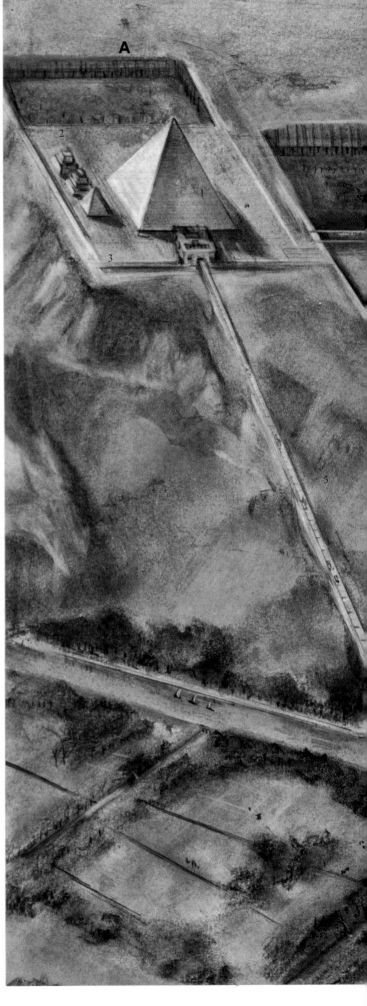

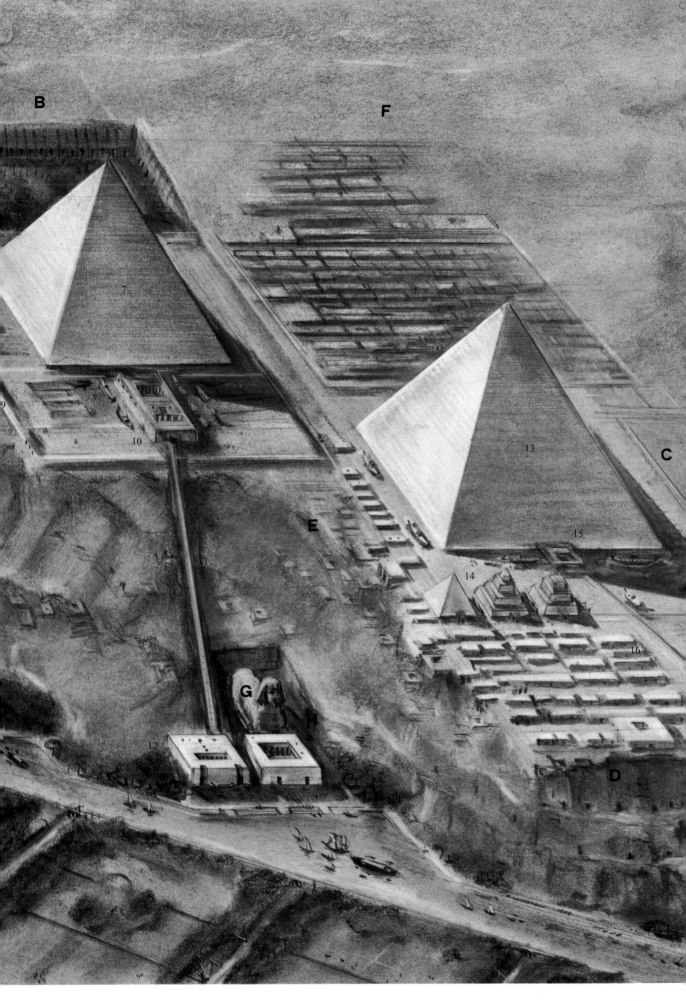

B

F

7

9

10

13

C

E

11

15

14

G

16

H

12

D

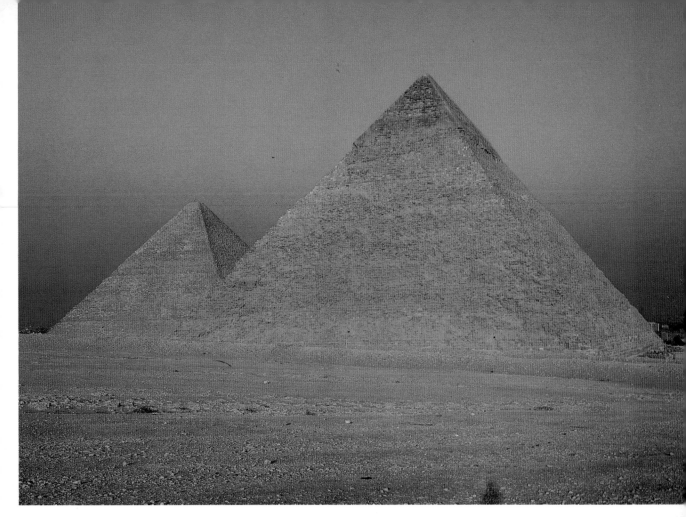

The Pyramid of Khufu (Cheops).

The pyramid, seen from below, gives the impression of an immense flight of stairs which leads to infinity. The impression is heightened by the total absence of the facing so that the internal blocks, arranged like a giant's staircase, are revealed. Originally 146 meters high, it now measures 137 and a plaza ten meters wide lies where the summit once was; the original 2,500,000 cubic meters of stone blocks are now only 2,350,000, which means that by the early 19th century 150,000 cubic meters of fine cut stone had been removed for the construction of Cairo. The perfection achieved by this parameter, now vanished, can be gauged by the internal walls of the Grand Gallery, 46 meters long and with a maximum height of eight and a half meters, inside the pyramid, which leads to the "king's chamber".

The Great Pyramids of Giza.

Note the almost intact point of the pyramid of Khafre in the foreground faced with limestone from the Turah quarries, and the ruins of the great mortuary temple on the right. While there is no great difference in size between the two pyramids (originally that of Khufu was 9.50 m. higher than that of Khafre), they vary considerably in internal organization. In fact, while Khafre's pyramid is quite normal and was conceived as a gigantic "tumulus" above the burial chamber, that of Khufu protects a pseudo-monument built into the heart of the pyramid itself, which contains the "king's chamber" connected to a gallery causeway of great size and noble make in addition to the burial chamber dug deep into the rock and the "queen's chamber" situated only a few meters from the foundations. This "monument" is about 20 meters high and stands 40 meters above the floor of the pyramid. It can be described as a tower of granite blocks weighing between 40 and 60 tons, which in cross section strongly recalls the Zed, the "backbone of Osiris", an image of prehistoric origins (read the highly interesting hypothesis of M. Pincherle: "La Grande Piramide" Filelfo, 1977).

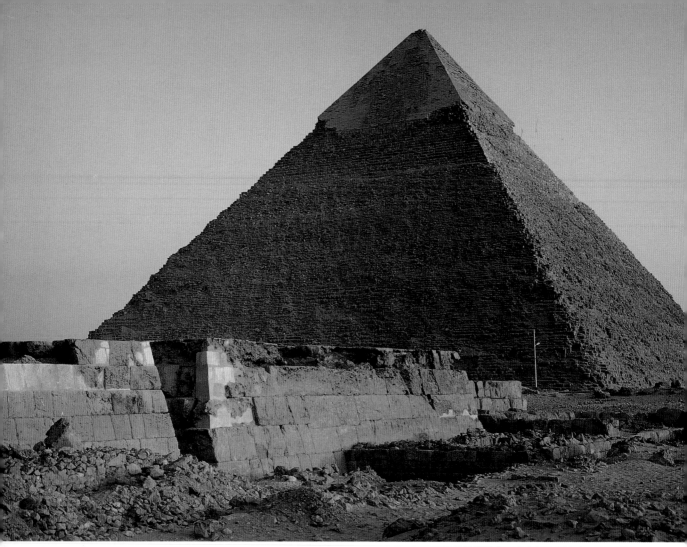

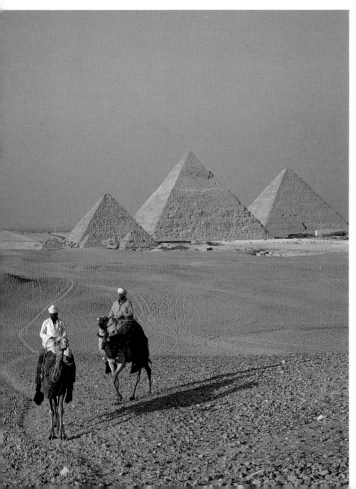

Pyramid of Khafre seen from the south.

The granite blocks in the foreground were once casing for the pyramid of Menkaure at the base up to about a fourth of its height. Behind stands the pyramid of Khafre with its characteristic hood, the last remaining portion of the external casing. The pyramid is 136.5 meters high and 210.50 m. wide. The angle of the sides is about 50° and the volume amounts to about 1,660,000 cubic meters. The facing of the base was in pink granite. Two galleries which leave from the pyramid and from the north level lead to the burial chamber, half of which is cut out of the rock. All the pyramids were violated, this one in 1200 A.D. by the son of Saladino, Ali Mohammed.

Entranceway of the Mortuary Temple and view of the Pyramid of Menkaure.

This pyramid is considerably smaller than the other two giants, barely 66 meters high and 108 wide. In 1500 it still had its fine facing, practically all of which has now been removed. Only a few ruins remain of the mortuary temple, still intact in the 18th century and built of blocks weighing up to 200 tons. The beautiful basalt sarcophagus, decorated with the typical "Palace facades" was lost at sea on its way to England. In its time the complex of Menkaure (Mycerinus), a "just and pious" pharaoh, also seems to have been under an unlucky star. Perfectly built, it had to be terminated hurriedly and various parts were completed in mud brick and soon deteriorated.

The three subsidiary pyramids south of the Pyramid of Menkaure.

In all likelihood, only the first pyramid was smooth faced and coated in pink granite. This pyramid may have been built for the queen Khamerernebty II, wife of Menkaure.

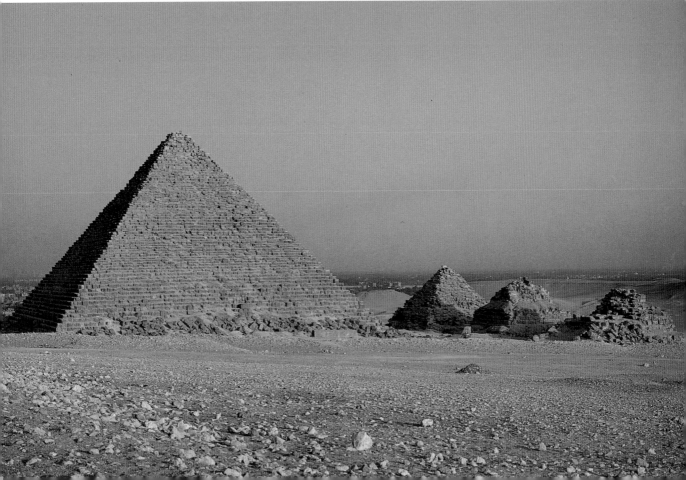

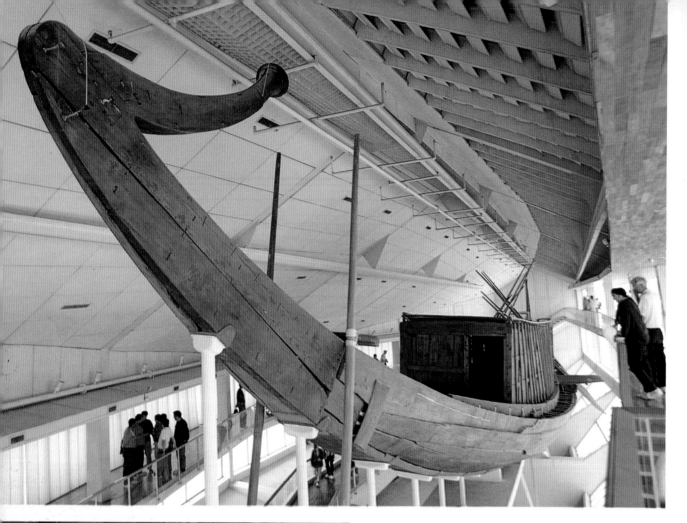

The solar boat.

In May of 1954 the Egyptian archaeologist Kamal el Mallak brought to light, after almost 5000 years, a «solar boat», to the south of the pyramid of Khufu (Cheops), perhaps the very bark which had accompanied the body of the pharaoh to Giza. In cedar, sycamore and jujube wood, the vessel is 46 meters long and about six meters wide in the middle and terminates fore and aft in papyrus-shaped poles. A covered cabin about nine meters long is at the center of the boat, which also had six pairs of oars.
In this ideal reconstruction the great boat is shown fastened to a sledge drawn by oxen, while a procession of priests and priestesses brings the sacred offerings.

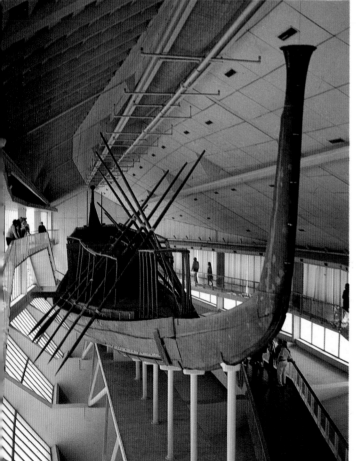

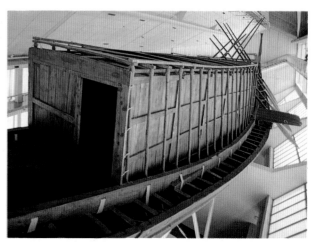

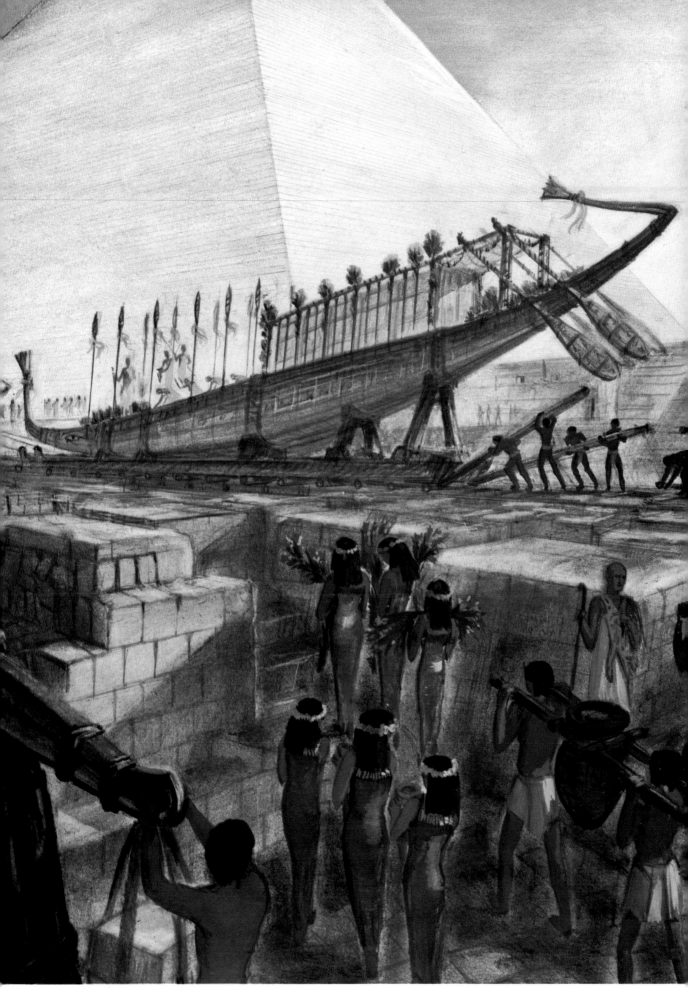

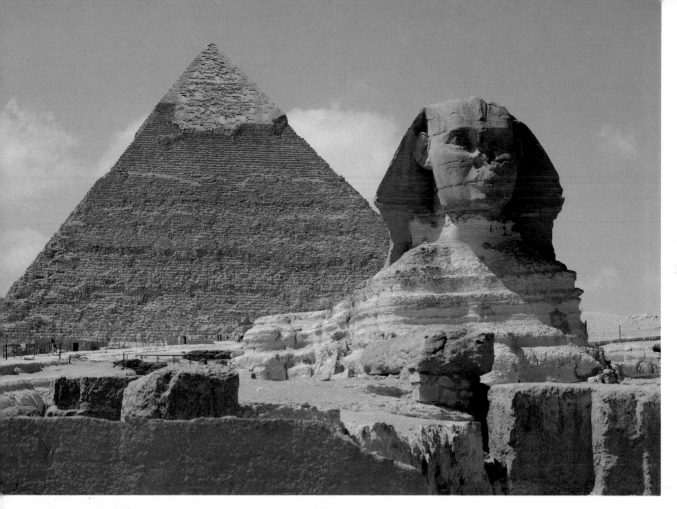

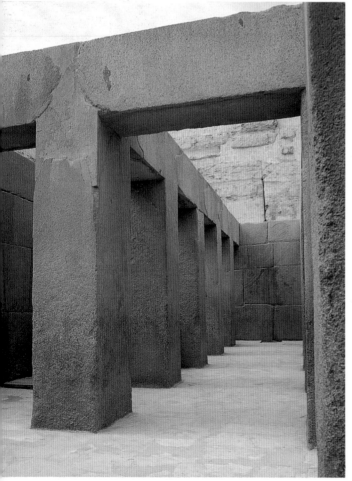

The Sphinx, in the likeness of the king Khafre (Chefren) whose tomb looms up majestically in the background, and a picture of the temple of the Sphinx, with the two aisles separated by six granite pillars.

Reconstruction of the temple of the Sphinx (third millennium B.C.).

This temple differs substantially from those of the Fourth Dynasty and from those that were to follow. A comparison of the plan of the temple of the Sphinx with that of Khafre's temple, next to it, clearly reveals the basic difference in the underlying concepts. In fact Khafre's temple, like all subsequent temples, was symmetrically laid out along the vertical axis beginning at the entrance, and the rooms were "excavated" in the solid body of the construction. The temple of the Sphinx, however, is symmetrical at the center, that is in line with the vertical axis and the longitudinal axis passing through the center, and the walls are not as solid. This layout is closer to the royal mastabas of the First Dynasty than to the temples of the Fourth and later dynasties. In consideration also of the material and construction technique, this temple seems to have older origins than that of Khafre.
The reconstruction of the interior shows this ancient temple as it might have been after the restoration of Thutmosis IV (1505- 1450 B.C.).

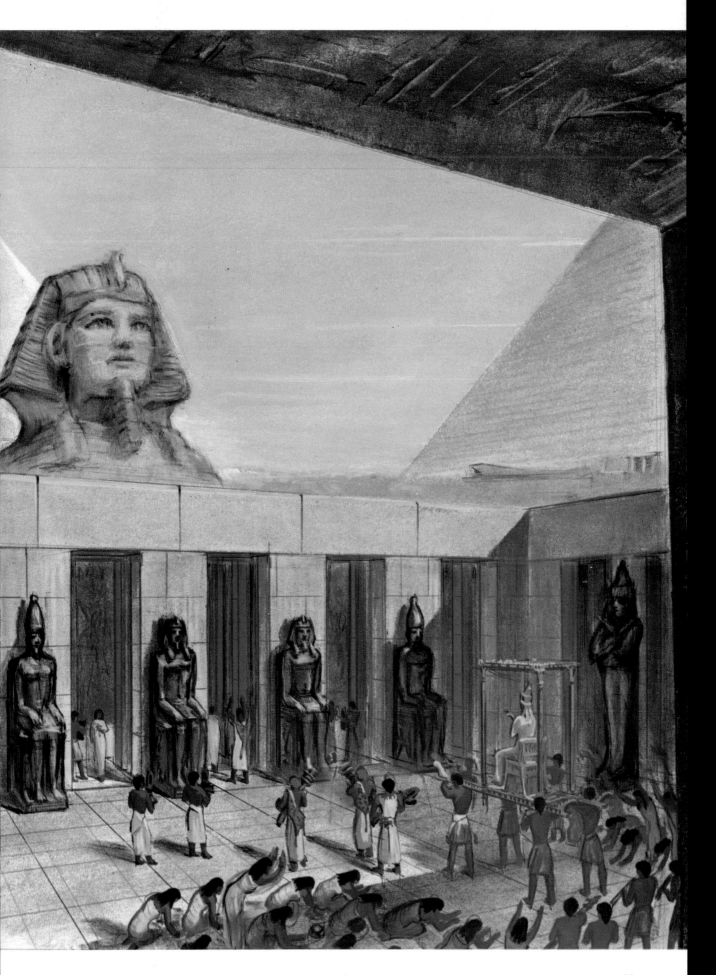

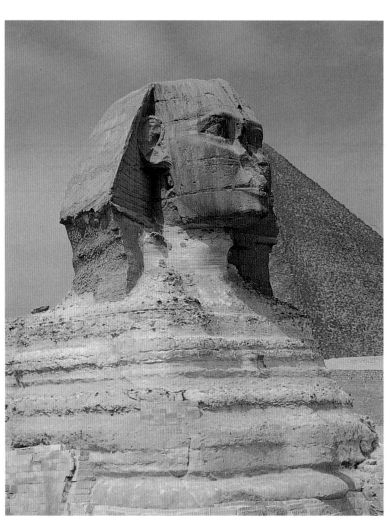

Side of the Great Sphinx of Giza.

This gigantic human-headed lion, entirely carved out of rock, is 21 meters high and about 73 meters long. According to the Greek Herodotus, there is a rock-cut temple underneath the Sphinx connected via a long tunnel to the lake and island of the sarcophagus, hidden in the bowels of the rock on which the pyramid of Khufu stands. The monument has been repeatedly restored and the sand has repeatedly buried it anew up to its neck. The most famous restoration was that of Thutmosis IV to whom the god of the Sphinx Horem Akhet, that is the "Horus of the Horizon", appeared in a dream as he was resting in the shade of the colossus, urging him to this pious undertaking, as is noted in the stela between the lion's feet. The restoration in stone blocks dates to the Ptolemaic period. The Romans also tried to free it of the sand and set an altar in front of the prestigious monument. The last removal of sand dates to 1926 and restoration is still in progress.

Profile of the Sphinx.

The defacement, due in this case also more to man than to time, is clearly visible, for the head emerging from the sand was even used as a target for the Mameluke cannons. The head is five meters high, the stump of the nose almost two meters. The false beard, added by Thutmosis IV, is in the Cairo Museum.

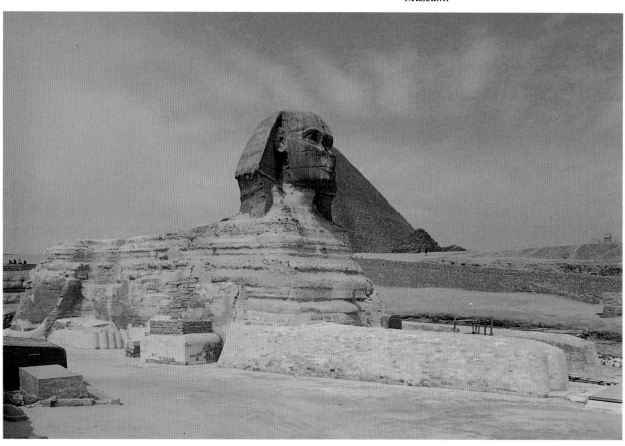

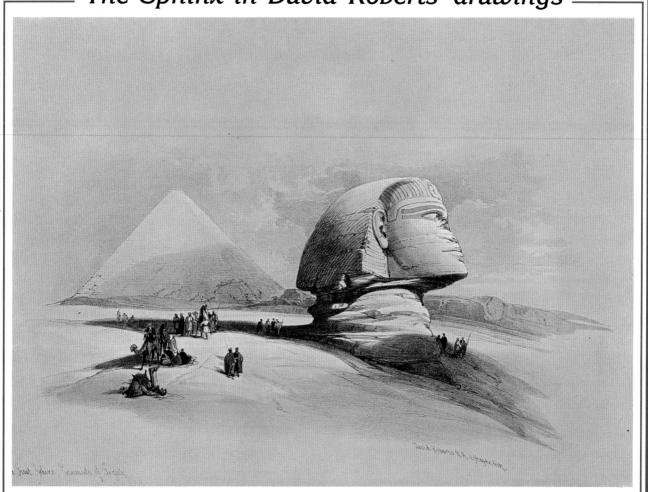

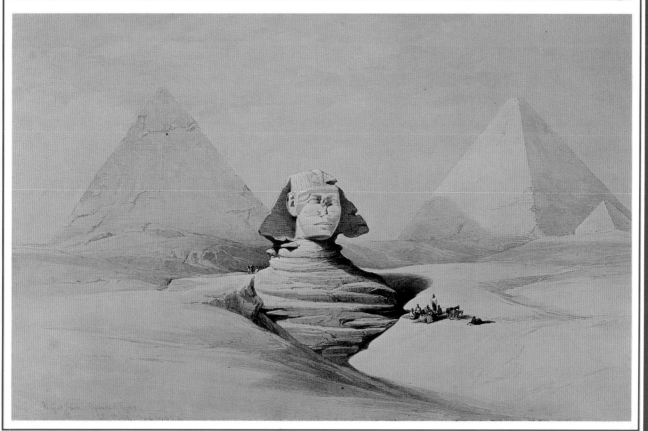

ARCHITECTURE AND ENGINEERING IN ANCIENT EGYPT
Construction of the pyramid

While it may be difficult to solve the problem of that "architectural absurdity", the pyramid, tracking down the building techniques employed presents no less a challenge. Obviously this means the pyramids of Giza and in particular that of Khufu (Cheops).

The emotion that wells up within us as we approach these mastodons in stone — so far removed from the world we know — is indescribable, suscitated not so much by their superhuman mass as by the interrogatives that impetuously crowd into our minds — where are we to find a "logical" explanation for this mountain that seems to have risen from a void, an overwhelming reality devoid of visible roots, unless we fall back on images of gods and semigods?

Attempts have been made for over a hundred years to find the answer to the "mystery of the pyramids" and rivers of ink have flowed in trying to explain how they were built, how, in other words, something impossible became reality.

The problem first and foremost concerns the method by which almost three million cubes of stone, weighing at least two tons apiece, were transported and installed in a structure almost one hundred and fifty meters high, in a period when neither iron nor the wheel and much less the capstan or pulley were yet known.

The most commonly accepted theory is that of a great provisional ramp built along one side of the pyramid which kept pace with its height so that the blocks could be dragged, one by one, by hundreds of slaves, to the top. It seems odd that so many still accept this theory for a ramp of such height, capable of bearing up under the traffic of so many heavy blocks, could only have been built in stone, and as the dry wall masonry settled, the escarpment slope would have been practically the same as that of the pyramid. It must also be kept in mind that if teams of 25-30 men were employed on the ramp, the slope had to be kept to a minimum with a causeway at least three-four meters wide. In view of all this, the theory of the temporary ramp built along the exterior is acceptable solely in the case of heights of but a few meters. It seems self-evident that any kind of ramp employed in transporting material to a height of 140 meters would have to be a masonry structure about a kilometer long and that when it reached the required height it would be equal in cross section to the pyramid against which it rested! In other words, in line with the hypothesis of the external ramp, a mass of masonry three times as large as the pyramid itself would have to be built, without taking into account the fact that as it rose a ramp of this size would have made the

work ever harder and slower until it became practically useless.

Another erroneous belief concerns the hordes of slaves, tied to endless ropes, who supposedly dragged along the blocks. This belief can be traced back to depictions of the transportation of colossal statues and makes absolutely no sense where the transportation of loads weighing various tons is concerned. And the Egyptians of 3000 B.C. were certainly not lacking in common sense. Since this was a period of internal conflict alone, there were no hordes of prisoners of war, nor even slaves, as is sometimes popularly maintained.

Furthermore the employment of such an enormous amount of manpower to drag thousands of hundredweights over long distances, is practically impossible and counterproductive. Paintings however often document the use of animals for the transportation of heavy loads and employed in other laborious tasks — asses laden with burdens, pairs of oxen pulling plows or sledges laden with baldaquins, gifts, household goods and heavy sarcophaguses. On the other hand, there are any number of pictures of long rows of men and women who individually, or in pairs, carry objects that are anything but heavy. The logical conclusion is therefore that for loads that weighed various tons the Egyptians of 3000 B.C., like all those that were to follow, availed themselves of whatever beasts of burden or draft animals they had at hand. While interesting theories regarding the construction techniques used in the pyramids have recently been formulated, they still suffer from various defects rooted in the commonly accepted theory, or provide only partial answers to the problem. All in all, the most reliable and complete hypothesis is what can be deduced from the oldest extant references, as cited below, taken from the "Histories" of Herodotus, dating to 455 B.C. *"Some were ordered to transport the stones from the quarries to the Nile — others to transport them along the river with great rafts — shifts of 100,000 men replaced each other every three months, working uninterruptedly — It took ten years to build the road along which the blocks of stone were moved, a work by no means inferior to that of the pyramid, made of ashlars decorated with figures and animals. Ten years to build this road and the chambers dug out of the rock that serves as base for the pyramids....Twenty years to build the Great Pyramid....cased in cut stone, smoothed and perfectly joined.*
This is how the Pyramid was made: first, as a stepped structure with a series of levels....then, as soon as the levels were finished, the remaining stones were raised with machines built of small

beams (short timbers). The machines took the stones from the ground to the first level, here they were loaded on other machines that were waiting and raised to the second level and from this to the third, and so on for there were just as many machines as there were levels to the stepped structure. It might also have been a single machine that could be easily handled that was transported from one level to another after having unloaded a stone..... The uppermost parts of the pyramid were finished first and then the next and finally the lowest parts and those at the base".

Herodotus, two thousand years after its construction, could not have been clearer; and it is therefore hard to understand why this evidence should not have been taken more into account. Herodotus writes of a pyramid that is first built in stepped form; and we know that under the thick outer facing the pyramid is stepped; Herodotus writes of machines to lift the stones from one level to another; in a tomb in Deir el-Medina we see pivoted lever machines to lift weights without winches or pulleys. "Machines" of this sort are still in use, and they certainly were employed in the time of Khufu to raise stones from one level to another. Temporary ramps for dragging material were certainly built up to a modest height, outside of a building and as a normal accessory, and traces have been found in the unfinished step pyramid of Sekhemket in Saqqara, prior to that of Khufu; but for exceptional heights and constructions of another type, such as those of the Great Pyramids, Egyptian technology must have certainly have had much more highly evolved resources than those numerous scholars of today seem to think.

The construction machine

Herodotus was the first to cite this prodigious "machine", ancestor of our crane, used almost five thousand years ago to raise the material from one level of the Great Pyramid to another.
As we have said, even today the weight lift called "shaduf" in Arab can be seen on the canals in Egypt where it serves to raise water and is basically identical to examples painted four thousand years ago in the tombs of Deir el-Medina. There is no reason to doubt that this type of machine was already employed in the early dynasties and that the machines for raising building materials were constructed along the same lines.
The principle is moreover extremely simple and is currently still exploited in many countries. In its original version the machine looked rather like a large "steelyard" or pivoted lever set on a saddle pilaster or timber trellis, free to rotate horizontally and diagonally as well. The pail or barrow was hooked to one end while the counterweight of mud or stones was attached to the other. In my reconstruction the system emjoys a maximum rotation field by reducing the saddle fulcrum to a conical fulcrum which penetrates the opening of the lever

Side and top view of the "pivoted lever machine" in action.
A-B Initial position of the arm:
A) attachment of the block to be raised;
B) attaching the net with small counterweight stones.
C-D Position of the arm at the halfway point.
E-F Position of the arm upon arrival:
E) unhooking of the block;
F) unhooking and unloading of the counterweight.
Wooden levers are used to give the machine its original impetus, guided during the maneuver with ropes from below and from above.

The machine is built of wooden beams and palm trunks tightly lashed together. The oscillating arm had a hole in the middle so that it could rotate around the pivotal support of wood or stone. The trellis tower was anchored or had ballast at the base, so as not to oscillate during the operations.
The machine was constructed so that it could be disassembled, transported in several pieces, and reassembled. The reconstruction shown is of a "pivoted lever machine" capable of raising blocks weighing from 200 to 300 hundredweight up to a height of ten meters from the base.

arms, so that they can swing completely around on the point of contact. The entire machine is built of short logs, lashed together. At the base of the support a basket, filled with ballast, ensures the stability of the machine during the movement of the arms. A net at one end of the lever facilitates loading and unloading of the ballast, and at the other end another net serves to fasten the limestone blocks.

The principal positions assumed by the machine during use, seen from the side and from the top, are shown in the illustration. In position A-B the counterweight is prepared at the upper level while the weight is attached at the lower level. In the position C-D the lever is in equilibrium and parallel to the steps. In E-F the counterweight has dropped to the lower level and the block has been raised to the upper level. The machine is constantly maneuvered and guided by ropes and levers. Once the load has reached destination, it is unloaded, the ballast is taken off below and brought back up to the upper level, by hand and on donkeys. At that point a new block is ready to be attached at the bottom and the operation repeated.

Obviously the machines were differently built according to the varying heights involved and the weights to lift. For blocks of around two tons that had to be lifted to a height of six meters, a machine eight meters high at most might need not much more than half an hour, so that it would take a block six hours to be hoisted to a height of a hundred meters. The series of machines set on each side could then unload about two hundred blocks a day on the uppermost workyard.

Series of machines were not required for the relatively limited number of monoliths weighing forty or fifty tons and one or two specially built pivoted levers sufficed, aided by levers and counterweights like those used later to erect the obelisks.

These particular pivoted levers used for heavy loads certainly were built accordingly, and beams of Lebanon cedar, like the masts of the boats, measuring up to fifty meters in length, were employed.

The pyramid construction yard

A valid picture of what the enormous construction yard that ranged from the stone quarries to the Giza plateau was like in 2600 B.C. can be had by integrating the accurate description of Herodotus with what we know of the structure of the Great Pyramids.

The materials used, in particular for the Great Pyramid of Khufu (Cheops), fall into two distinct categories: granite monoliths and blocks of limestone. The differences in number and weight resulted in two types of construction yards which we will call "monolith construction yard" and "block construction yard". It should be kept in mind that the technique was dry joint masonry, without mortar or binder of any sort, in which the

blocks were simply set or "mounted" on top of each other.

The "monolith construction yard" stretched over more than 800 kilometers from Giza to the granite quarries of the Island of Elephantine and can still be seen near Aswan. This stone is much harder than limestone and the blocks weigh up to fifty or sixty tons, but there were only about seventy of them in all and they were installed at heights of between forty and sixty meters above the base of the pyramid.

The granite in the Aswan quarries crops out on the surface and the rocky crust which covered the more compact seam was removed by building great fires and then cooling the red hot surfaces with cold water. The abrupt temperature changes caused cracking and facilitated removal. Continuous pounding with large balls of dolerite (a blackish crystalline stone from the Red Sea, harder than granite), either by dropping or hammering, freed the upper part and the outer side of the monolith, after which the inner side and lower face were freed by creating wide trenches in which the stone cutters could work as they detached and rough hewed the piece, using stone or wooden mallets and chisels of dolerite or some unknown copper alloy. Wooden wedges were forced into the notches and cracks. When wetted, they expanded and split the stone open, which when properly coordinated helped to detach the monolith from the bed rock. The block had previously been attached to a sled and, once freed, it was lowered with ropes and counterweights down a ramp that led all the way to the Nile. It seems likely that advantage was taken of the flood to abbreviate the distance between the quarry and the river, but both when it was loaded and when it was unloaded the barge would have had to be propped up so that the float remained level with the pier until the operation had been completed to keep the monolith — above all in the case of long and heavy obelisks — from splitting. With its heavy load, the barge, guided by tow boats and by long ropes from the land, went downstream with the current of the Nile. In the zone of Memphis, the large barge was deviated into the canal that led to Giza. Here the pier of the valley temple and the paving of the long gallery were ready and waiting. Launched and purified with holy water, the monolith began its strenuous ascent towards the pyramid, forty meters higher up. Numerous teams of oxen were attached to the block, and many men, both in between the oxen and at the head and sides, directed the endeavors of the animals and lubricated the rollers with milk water. A rigorous organization and perfect training meant that the actions were carried out as if by a single organism.

At the top of the ramp the large group that was dragging the granite monolith encountered the sizable interior steps of the pyramid that had already been built up to the level of the "King's Chamber" (forty meters above the level of the plateau) and, on the north, the sloping stone pavement of what was to be the Grand Gallery. This new ramp was 25% shorter, but steeper than the first, so that other teams of oxen were added on, and at the

sides men and machines joined in to help the animals and balanced levers pushed at the base so that there would be no backsliding. Suitable machines were used to set up the vertical monoliths at the top, capable of handling blocks weighing various tons and raising them another twenty meters.

There were no serious problems regarding weight (two tons as compared to the forty or more of the monoliths) or mass in the limestone "block construction yard", but it did have to deal with quantity (almost three million blocks) and the relative heights to which they had to be taken. For instance, for the sixty meter level alone, about 2000 blocks had to be raised and perfectly installed at a height of sixty meters from the base.

The extraction and transportation of the blocks from the limestone quarries of Mokattan and Turah, opposite Memphis, was relatively easy, as was that of the masonry filling which came from quarries near the pyramid itself. But the major problem involved getting most of the material there as quickly as possible and consequently meant organizing thousands of specialized workers in the quarries, for transportation and construction. It was therefore a matter of assembly line work in the quarries, on the routes and canals, in getting the pieces to the construction yard at the base of the pyramid.

At this point the principal phase, that is the actual construction, can be dealt with. The pyramid mentioned by Herodotus was initially stepped, that is in the beginning it was set up without its external casing, and each new step became in turn the level used by men and machines to raise the material to the next level. The pyramid itself acted as support for the construction yard which was building it (as is the case in any multi-story building).

The carrying skeleton of Khufu's pyramid has about twenty steps, each tread five meters wide and with risers six meters high — ideal dimensions for the functioning of a pivoted lever machine which could take and raise blocks of about a cubic meter in size.

Assembly lines of machines were at work on each side of the pyramid in construction: about ten at the base and diminishing in number as the structure narrowed until there were five on the tenth level and one, of large size, on the topmost level.

A host of men, women, boys, mules, thronged around the teams of workers at the machines. They brought water, food, stone for counterweights, timber and sand for leveling, rollers for dragging and beams for raising. Projecting stones or steep ramps built on the step itself between one level and the next permitted this army to move continuously from the base to the topmost level (even now an agile boy can climb up to the top of Khufu's pyramid in not much more than a quarter of an hour).

The highly important task of adjusting and installing all the material required to create the subsequent step took place over and over again on the topmost level. The operation was highly technical and required great precision for blocks weighing many hundredweight had to be maneuvered into position and perfectly installed, over distances of hundreds of meters on a level and in elevation. The points of departure for these operations were precisely determined according to the cardinal directions, and instruments such as plumb bobs, squares with the sides in a 3-4-5 relationship, wires, rods, pickets, in other words all the instruments that had been perfected in hundreds of years of experience in land surveying were employed. The greatest experts under the direction of the high priest-architect and with the direct participation of the pharaoh himself, oversaw the execution of each level, and all did their part in bringing these mastodons in dry masonry to a perfect realization, and finishing them off with sloping faces (after 4,500 years the errors found are on the order of millimeters).

The external casing, for which the best stone from the quarries of Turah was employed, began as soon as the topmost block had been set in place. This was the only pyramid-shaped stone in the entire construction, dovetailed into the ones below with a pin, plated in gold and incised with sacred signs. The casing was carried out by filling in each step — until it coincided with the next one, continuing the smooth face of the pyramid — with cut and perfectly polished stones, separated by joints that were never more than half a millimeter wide. For the finishing touches expert stone cutters used temporary scaffolding in wood, which rested on the lower step and was taken down and reassembled ever lower. In the end we have four triangular faces of about twenty thousand square meters each, perfectly smooth and oriented to the four cardinal points.

With the pyramid of Khafre, almost as large as that of Khufu, the problems of the "block construction yard" were about the same while those of the "monolith construction yard" did not exist.

With the pyramid of Menkaure (Mycerinus) the structure was about a third smaller, in height, and therefore the difficulties encountered were far fewer.

The subsidiary pyramids of Giza, stepped, with high steps, and with smooth faces, are of modest size and the same holds for almost all the other pyramids scattered between Giza and Fayyum (the famous pyramid of Unas at Saqqara is less than twenty meters high). There was no need to employ complex and specialized techniques in these, as in the Great Pyramids, and in the circumstances the use of a temporary external ramp must have been useful. They were in any case modest constructions, in execution as well as size, and have not withstood the wear and tear of time.

The Great Pyramids seem more and more to represent a rare parenthesis in the art of building, mastondons made by men, from the most humble of workers to the high priest-architect, designer and director of the works, extraordinarily gifted and experienced. So much so that once the generations of 2700 to 2500 B.C. had passed away, no further marvels of this sort were made, almost as if that magnificent instigating force that sprang from the past had come to a head in this last formidable statement and then run dry.

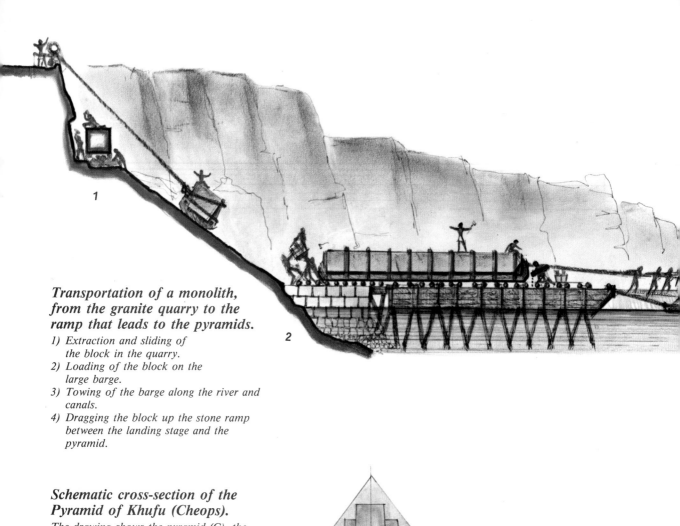

Transportation of a monolith, from the granite quarry to the ramp that leads to the pyramids.

1) *Extraction and sliding of the block in the quarry.*
2) *Loading of the block on the large barge.*
3) *Towing of the barge along the river and canals.*
4) *Dragging the block up the stone ramp between the landing stage and the pyramid.*

Schematic cross-section of the Pyramid of Khufu (Cheops).

The drawing shows the pyramid (C), the hypothetical inner pyramid (A) and the Zed-shaped monument (B).
1) *Burial chamber.*
2) *"Queen's Chamber".*
3) *"King's Chamber".*
4) *Grand Gallery.*
5) *Monoliths being hauled into position.*
6) *Raising of the monoliths.*

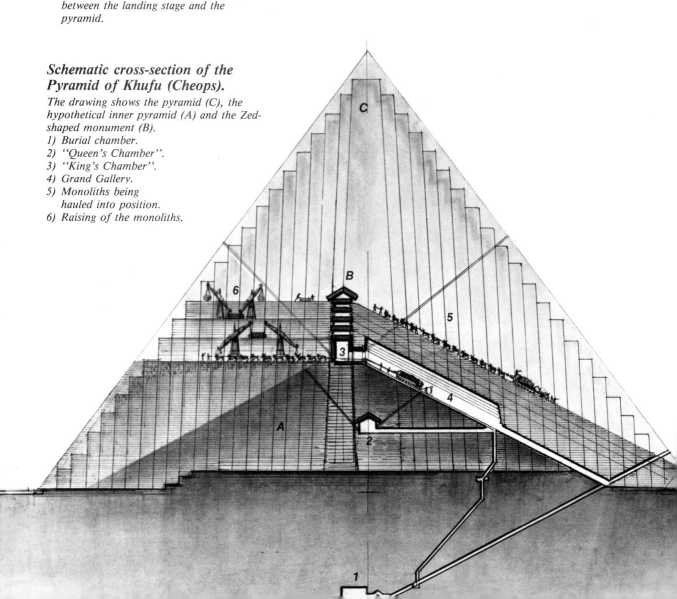

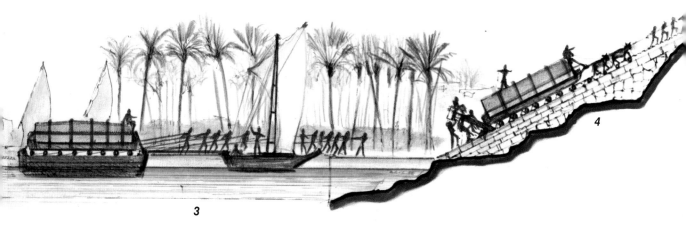

3

4

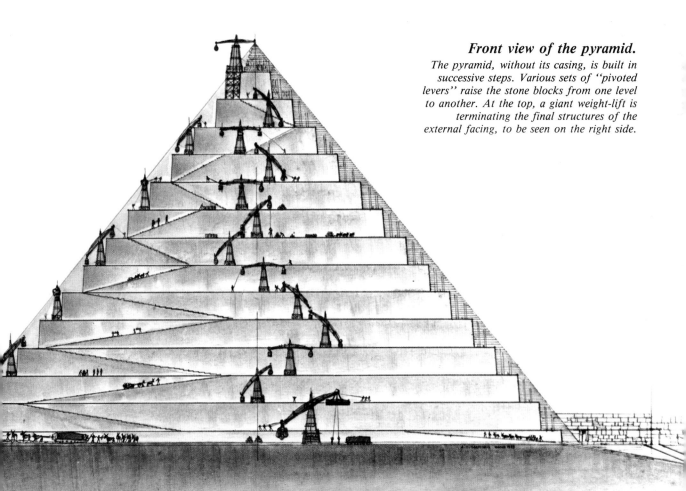

Front view of the pyramid.

The pyramid, without its casing, is built in successive steps. Various sets of "pivoted levers" raise the stone blocks from one level to another. At the top, a giant weight-lift is terminating the final structures of the external facing, to be seen on the right side.

Saqqara

The great necropolis reconstructed in its entirety.

The necropolis is about 8 kilometers long and one kilometer wide.

All the principal dynasties are present here, from the First (with the famous tomb of Aha) to those of the Saite, Persian and Ptolemaic periods.

The ideological center is the funerary complex of Zoser which rises up like a citadel with the pyramids and mastaba tombs of all periods clustered around. On the north, between the pyramid of Teti and the Serapeum a series of fine tombs fans out. On the south are the remains of the funerary complex of Sekhemket.

S — Serapeum: Hypogeum of the Apis bulls, animals sacred to Ptah, god of Memphis.
E — Semicircle of statues of Poets and Philosophers (including Plato, Heraclitus, Protagoras, Homer, Pindarus) built by Ptolemy I.
1) Mastaba of Ptah-hotep and Akhet-hotep.
2) Mastaba of Ti.
3) Baboon Gallery.
4) Ibis Gallery.
5) Hesi Re.
6) Horus Udimu.
7) Horus Ada.
8) Horus Zed.
9) Queen Merneith (First Dynasty tombs).
10) Mastaba of Ankh-ma-hor.
11) Mastaba of Kagemmi.
12) Mastaba of Mereruka.
13) Mastaba of Ka-em-heset.
T — Pyramid of Teti (first king of the Sixth Dynasty) with the mortuary temple and subsidiary pyramids.
O — Complex of Userkaf (first king of the Fifth Dynasty) with mortuary temple and two subsidiary pyramids.
Z — Step Pyramid Complex of Zoser (first king of the Third Dynasty).
14) Court with altar, storerooms, and dwellings for priests.
15) Mortuary temple with the pharaoh's sirdab.
16) "House of the North".
17) "House of the South".
18) Heb-Shed Court with buildings and altar.
19) Small temple and temple with fluted columns.
20) Entrance of the Sanctuary and entrance "colonnade".
21) Facade of the "Cobra Palace".
22) Top of the South walls.
23) Storerooms and portico.
24) Court in front of the Great Step Pyramid with the three main altars.
U — Pyramid of Unas.
25) Mortuary temple.
26) Monumental Gallery Causeway.
27) Sacred barks buried in large stone basins.
28) Valley temple and landing stage.
29) First row of mastabas south of the walls of Zoser: Ha Ishu Ef, Vizier Unefert, Unas Ankh, Princess Idut, Vizier Mehu. Second row: Queen Khenut and Nebet.
30) Mastaba of Mehu-ka-irer.
31) Mastaba of Nefer-her-ptah.
32) Tomb of Ptah-iru-ke.
K — Funerary complex of Sekhemket, successor of Zoser (complex reconstructed as if it had been finished).

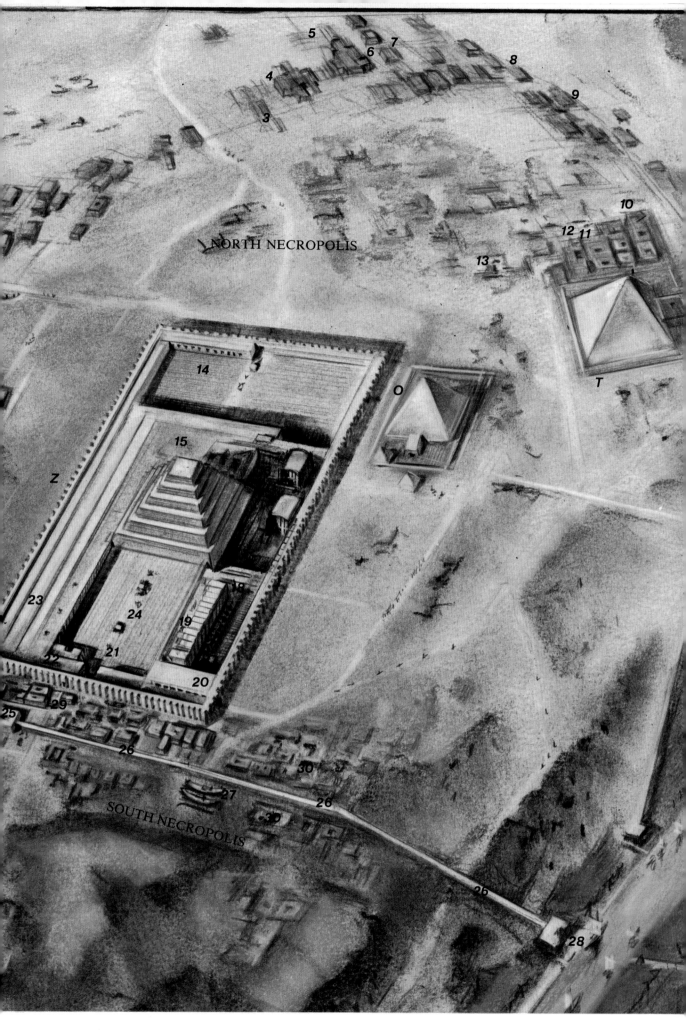

NORTH NECROPOLIS

SOUTH NECROPOLIS

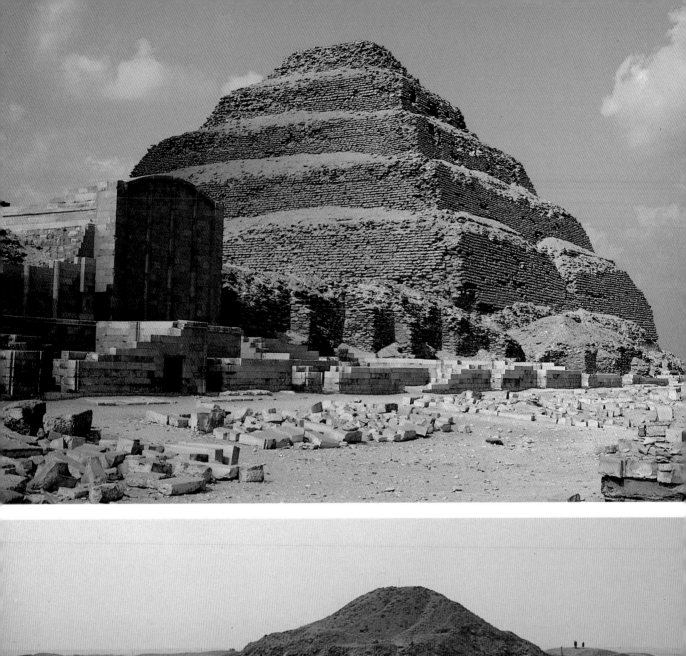

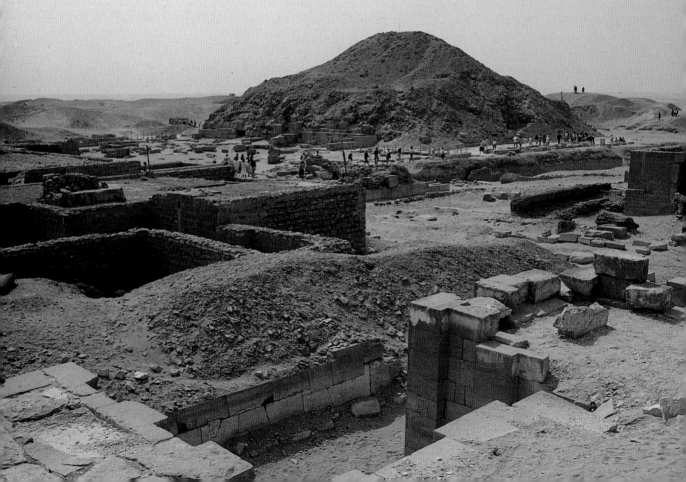

The funerary citadel of Zoser.

Zoser's pyramid is the first large structure finished in stone ashlars (height m 62.50, base m 125 x 109). The pyramid was built in three principal stages: the first was limited to the raising of a large mastaba; the second developed this into a four-stepped pyramid; the third set the final six-stepped pyramid over the east facade of the mastaba. An extraordinary number of galleries, tunnels and rooms has been discovered under the pyramid. At the base of the enormous central shaft, isolated all around, is the tomb of the king, in granite, surrounded by beautiful blue faience tiles. With entrances of their own, further down, are the galleries with tombs of the royal family.

The pyramid of Unas.

The mortuary complex of the last pharaoh of the Fifth Dynasty included the pyramid, the temple and the causeway leading to the Valley Temple. The pyramid is of modest size and was already in ruins in 2000 B.C. when Ramses II had it restored.

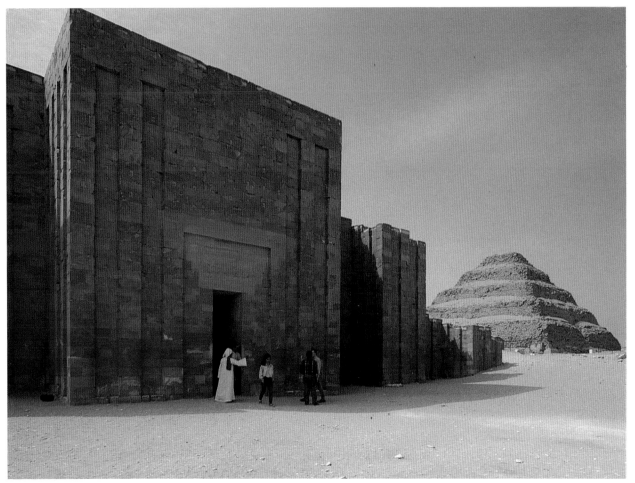

Mastaba of Mereruka.

The princely house of Mereruka also known as Meri is probably reproduced here. The house was complete and included quarters for the owner, for his wife Har-watet-khet and his children, as well as the one which was for official use.

The decorations are particularly lovely, and the usual themes are treated in an original way. Above is shown a procession of offering bearers. Below, the detail of a hunting and fishing scene in a magical atmosphere full of animals and plants.

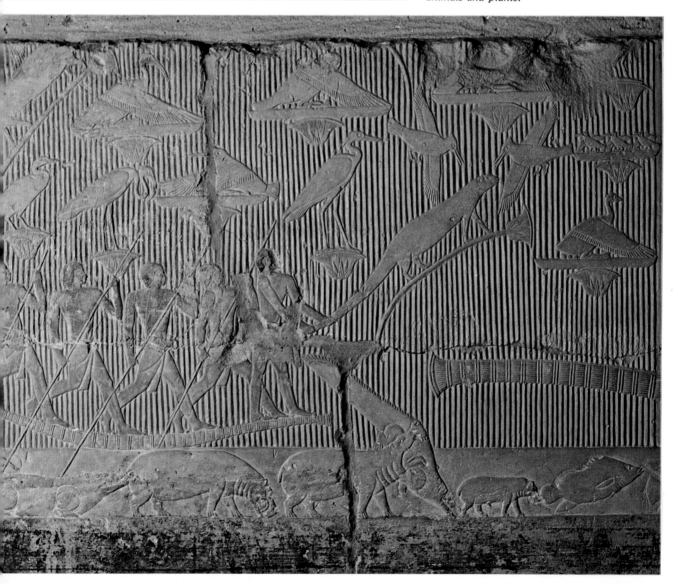

Mastaba of Ti.

This is one of the finest tombs both in the high level of artistic expression achieved and in the fine synthesis of the modelling and the beautifully balanced composition. Ti was an important figure in the Fifth Dynasty: "sole friend", "head of the secrets", "chief of the king's workers", "director of the pyramids" of Neferikare and Nyuserre. His wife, Nefer-hotep, was a princess.

Scenes of family life and of hunting and fishing decorate the great court with its twelve pillars and inner chambers. These lively depictions were the work of outstanding artists, as can be seen in the two examples shown here. Above: detail of a procession of men bearing offerings; below: detail of a procession of women, also bringing offerings. The figures are treated with solemnity and inimitable delicacy, and the series runs along before our eyes giving us a feeling of movement as these noble creatures of human genius slowly advance.

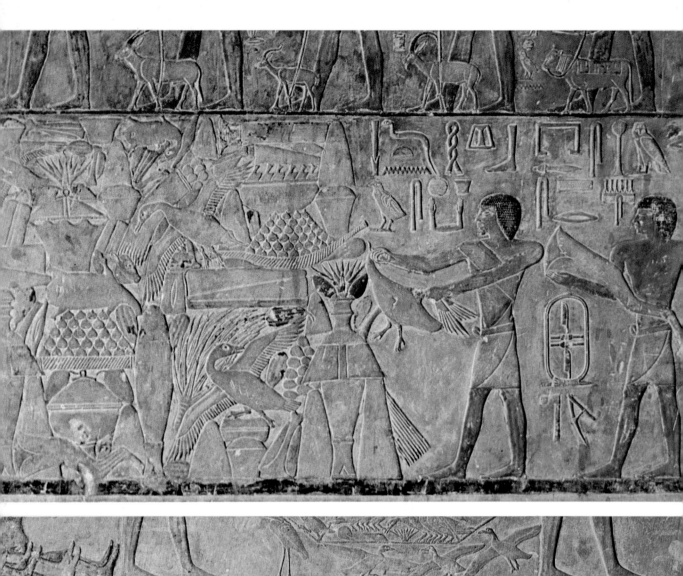

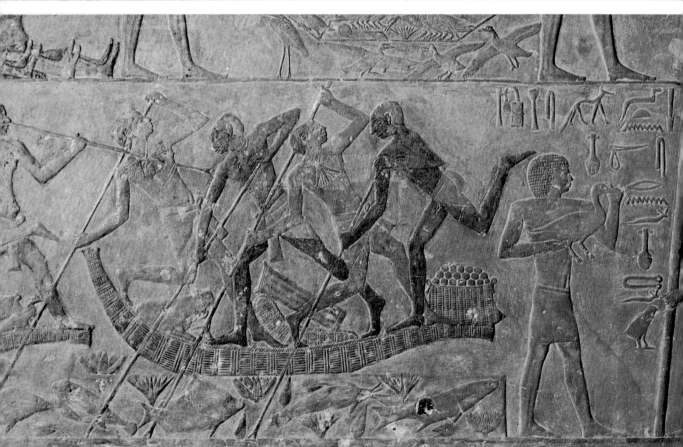

Mastaba of Ptah-Hotep.

The tomb communicates with that of his son Akhet-Hotep who added on the rooms to the right of the tetrastyle Hall. The chapel of Ptah-Hotep in particular contains another series of lovely painted bas-reliefs, once more with offering scenes where original details can be noted (such as that of the whippets under the owner's chair, and that of the servant who massages his legs). In the scene of water sports we have the figure of Ankhen-Ptah, probably the principal artist and designer of the whole.

On the facing page are shown details of an offering scene and of rowers who seem to dance on their boat.

Mastaba of Kagemmi.

This tomb belonged to another powerful and wise High Priest of Teti who was also supervisor of the pharaoh's pyramid. Half of the construction is solid, like the original mastaba, and half is occupied by pillared halls, chambers and storerooms. The decorations of the accessory rooms are even finer than those reserved for the funerary chambers which lead to the sirdab. The fishing scenes and those of offerings at the entrance are particularly lovely as are the bas-reliefs in the pillared hall depicting games and dances, agricultural scenes and a sentence passed in Teti's court.

Detail of a servant pouring seeds for the birds in an aviary. The aviary is shown in its ground plan while the animals and men are shown from the side.

Offering scene with men bearing papyrus and birds and leading gazelles on cords.

Bas-relief with a row of dancing girls. The short-haired dancers have a sort of small cape hanging down from their necks and are bending their bodies backwards almost as if they were about to make a somersault. The dance in the tomb of Ankh-ma-hor is the same but the dancers wear different costumes and their hair is in a long braid that ends in a ball.

Mastaba of Princess Idut.

This Sixth Dynasty princess occupies the tomb of a previous Fifth Dynasty owner. Many of the chambers are decorated with scenes of everyday life, dedicated to activities on the canals and rivers, and two entire rooms with scenes of nautical sport. Above, a controller is taking inventory of property: below, two scribes are seated on the ground and make note of the supplies. Note the boxes for carrying brushes and colors, the scrolls of parchment and the scribe with two spare brushes stuck behind his ear.

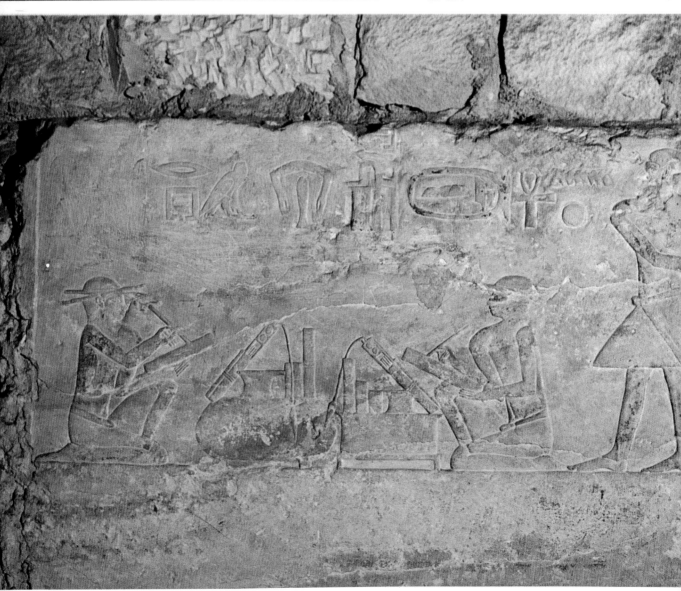

At the side: the butchering of a bull. Two servants armed with long knives are preparing to carve up the animal. Below: a boat carrying a rower, an offering bearer and a cowherd is followed by a herd of cows and bulls wading the river. The water is full of fish and a crocodile is watching from the shore. Particularly lovely is the figure of the calf which looks back at its loving mother as a sailor holds its forefeet up.

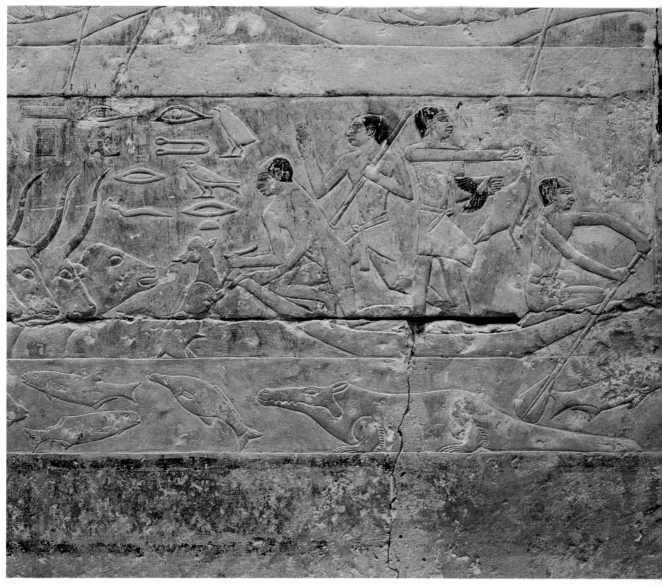

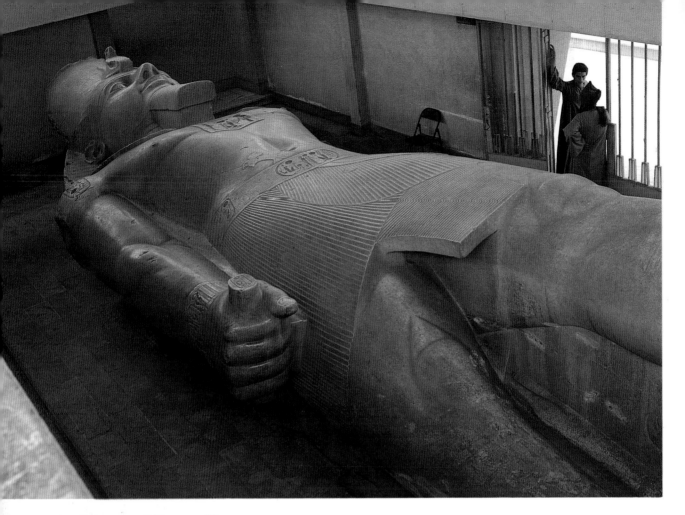

The Colossus of Ramses II.

Colossal statues of Ramses II stood in front of a pylon of the temple of Ptah. One of the two figures, originally 13 meters high, is now in the square of the railroad station of Cairo. Numerous fragments of another two colossal seated statues have been found near the pylon.

Alabaster sphinx of Amenophis II.

This is the largest of the extant sphinxes carved from a single block (4.50 m high and 8 m long) and it once flanked the entrance to the Temple of Ptah.

Memphis

Very little remains today of the ancient capital of Menufer, called Memphis by the Greeks, which extended for fifteen kilometers from Giza to Saqqara, with at its center the citadel of the "white walls" — perhaps begun by the great architect Imhotep and with a wealth of temples and sanctuaries dedicated to all the gods of the ancient world — the city where Phoenicians, Judeans, Armenians, Greeks, Libyans and Sudanese each had their quarter. The decline began with the creation of Alexandria. By the fourth century A.D. it was already a sea of ruins. With the rise of Cairo the few temples left standing because they had been used as Christian churches were demolished and it all became a workyard for the new city. Today nothing is left but a few ruins that came to light in the excavations that began in the 19th century. The most important are those of the famous temple of Ptah, where the pharaohs were crowned, and a chapel of Seti I, all not far from the present village of Saqqara.

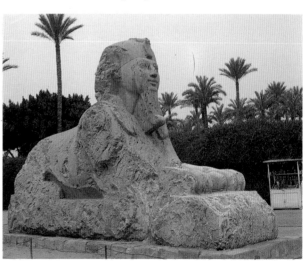

Dahshur

The site lies 2 km from the South Saqqara pyramid area and contains five pyramids. The first is that of Sesostris III (Senusert) (1840 B.C.), built in mud brick once cased with ashlars in Turah stone. Further south, the stone pyramid of Amenemhet II (ca 1900 B.C.) follows that of Amenemhet III in mud brick; after that the two pyramids of Snefru, predecessor of Khufu: one known as the "red pyramid" and over twice as wide as it is high (m 100 × 215 in width), the other the famous "Rhomboidal Pyramid" or "Bent Pyramid" shown in the picture. It is the best preserved in this necropolis and owes its name to its singular shape: almost halfway up the face the angle of the slope passes from 50°40' (which was more or less maintained in the pyramids of Giza) to 43°. Another singularity is the fact that there are two entrances which lead to two chambers with corbelled vaulting like the Grand Gallery of the Great Pyramid of Khufu. The "Rhomboidal Pyramid" had a subsidiary pyramid on the south, originally 26 m high, a shrine with a mud brick wall on the northeast, which served as a mortuary temple, and a causeway which connected it with the Valley Temple.

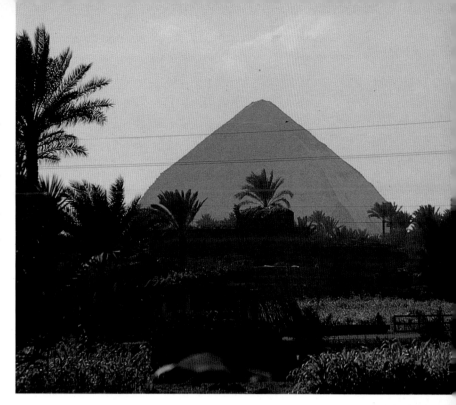

Maydum

Almost on a level with El Fayyum, towards the Nile, stands the "false pyramid", another highly original work attributed to Snefru, the first king of the Fourth Dynasty. At present it has the form of a high step from which two smaller steps rise. Its present aspect might lead one to believe that it was a solar temple, but the great quantity of debris around the base reveals that it looked quite different originally. Other steps must have jutted out from the faces of the present base, so that the entire structure was in the form of a sharply pointed eight-step pyramid. The summit may have been somewhat like the sun temples of Abu Gorab, built a hundred years later, with a third obelisk emerging from the truncated pyramid. It is also thought that an outer casing had been planned to turn it into a true smooth-faced pyramid but that work had come to a halt shortly after its beginning.

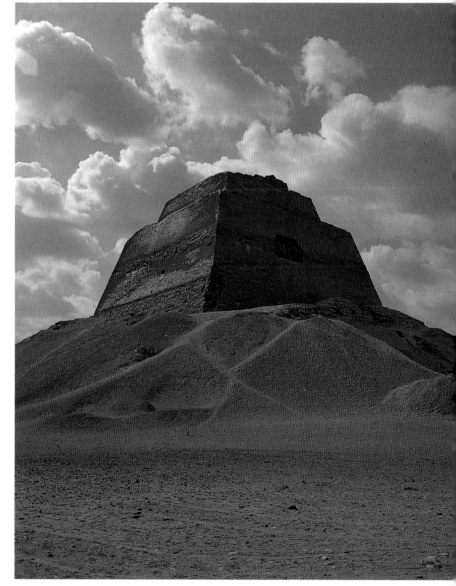

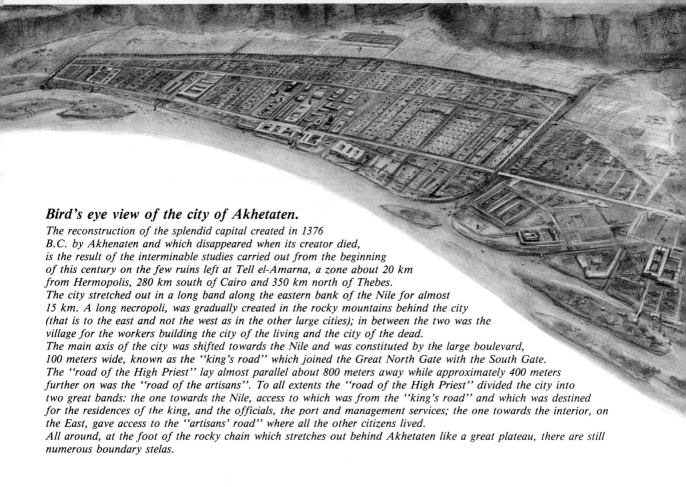

Bird's eye view of the city of Akhetaten.

*The reconstruction of the splendid capital created in 1376
B.C. by Akhenaten and which disappeared when its creator died,
is the result of the interminable studies carried out from the beginning
of this century on the few ruins left at Tell el-Amarna, a zone about 20 km
from Hermopolis, 280 km south of Cairo and 350 km north of Thebes.
The city stretched out in a long band along the eastern bank of the Nile for almost
15 km. A long necropoli, was gradually created in the rocky mountains behind the city
(that is to the east and not the west as in the other large cities); in between the two was the
village for the workers building the city of the living and the city of the dead.
The main axis of the city was shifted towards the Nile and was constituted by the large boulevard,
100 meters wide, known as the "king's road" which joined the Great North Gate with the South Gate.
The "road of the High Priest" lay almost parallel about 800 meters away while approximately 400 meters
further on was the "road of the artisans". To all extents the "road of the High Priest" divided the city into
two great bands: the one towards the Nile, access to which was from the "king's road" and which was destined
for the residences of the king, and the officials, the port and management services; the one towards the interior, on
the East, gave access to the "artisans' road" where all the other citizens lived.
All around, at the foot of the rocky chain which stretches out behind Akhetaten like a great plateau, there are still
numerous boundary stelas.*

*A small head in granite of one of
Akhenaten's daughters, sculptured in
the Amarna style characterized by an
intensive search for reality.*

Tell el-Amarna

The Palace of Akhenaten.

Between the world of the pyramids and the world of the temples and sanctuaries, including that of Thebes, is inserted the world of Akhenaten, the "heretic pharaoh", not only in a geographical sense, but also ideally and in terms of style.

This world which passed so fleetingly in the history of Egypt — a few decades compared to more than three thousand years — was certainly the product of the transcendental impulse which began with the Sphinx, matured in the experience of Imhotep, and finally reemerged in the pyramids. This yearning for the God-Man which flashed into the collective conscience was the same which intermittently surfaced, throughout the centuries, in the intuition of the few initiates and in particular the creators of the world of the pyramids.

Akhenaten's revelation took on concrete form in the cuy of Akhetaten "Horizon of Aten" in Tell el-Amarna and more specifically in the House of the Pharaoh. Like all the structures in the city, the house lacks both colossal size and structures capable of defying time and the elements. Its scale is human and it communes with the environment, for it was conceived for the temporal and spiritual life of the man and his family. The dwelling stands on a rise above the "king's road", with three tiers of hanging gardens around it and a carriageway with a pedestrian stairease joining it to the road. The area is taken up in great part by a small park, 3500 meters square, covered with plants and flowers.

Husband and wife have their quarters, composed of a room with an alcove, a bathroom and a wardrobe. The pharaoh also has a painter's study where brushes in palm fibers and fishbone "pencils" have been found. The daughters have six rooms around a court of their own. All the walls, the ceiling and even the paving are decorated and painted with domestic animals and birds.

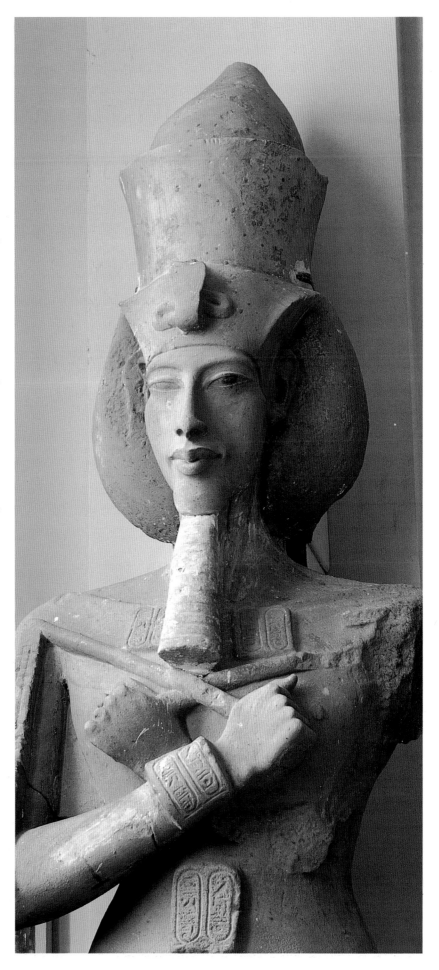

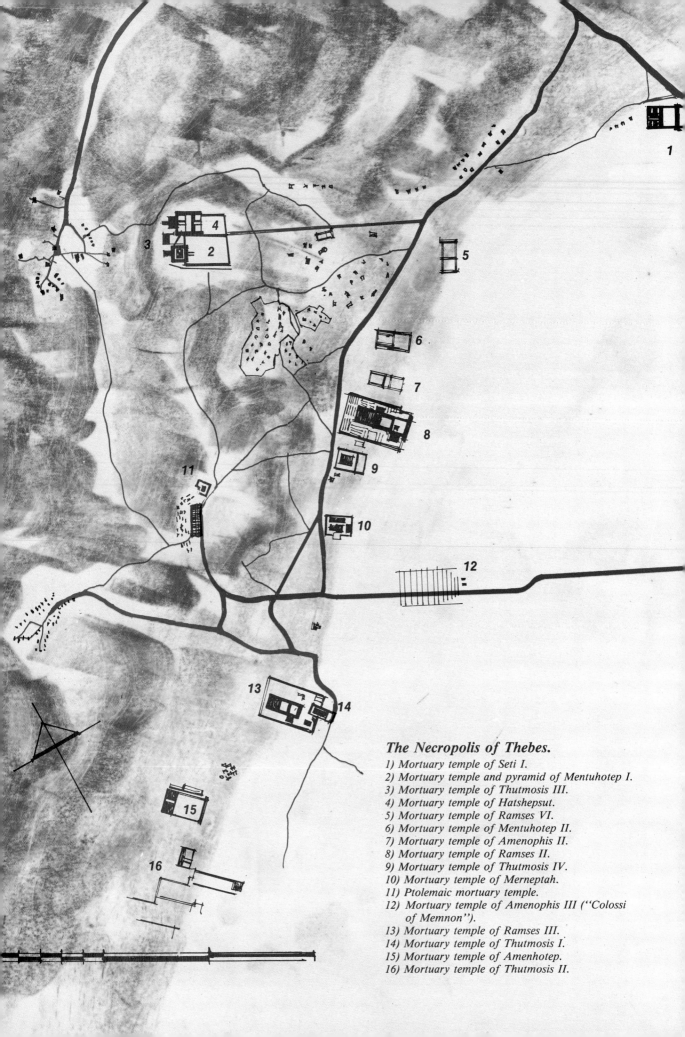

The Necropolis of Thebes.

1) Mortuary temple of Seti I.
2) Mortuary temple and pyramid of Mentuhotep I.
3) Mortuary temple of Thutmosis III.
4) Mortuary temple of Hatshepsut.
5) Mortuary temple of Ramses VI.
6) Mortuary temple of Mentuhotep II.
7) Mortuary temple of Amenophis II.
8) Mortuary temple of Ramses II.
9) Mortuary temple of Thutmosis IV.
10) Mortuary temple of Merneptah.
11) Ptolemaic mortuary temple.
12) Mortuary temple of Amenophis III ("Colossi of Memnon").
13) Mortuary temple of Ramses III.
14) Mortuary temple of Thutmosis I.
15) Mortuary temple of Amenhotep.
16) Mortuary temple of Thutmosis II.

THE AFTERWORLD
The necropolis of Thebes

In view of the extraordinary development in the fields of art, technology and religion, it seems only logical that the minds of the Egyptian peoples should have turned to the problems of who they were as Egyptians and what their relationship with the universe was. Egyptian thought was based primarily on a dualism which sprang from unity and ended in trinity.

As early as the third millennium all creation was conceived of in terms of varying degrees of matter and spirit, with the world of inert matter at one extreme and that of pure spirit at the other. The realm of the earth therefore is the direct opposite of the realm of the sky, and every "encounter" between man and the other realm determines the actual entity and vitality of each individual. Every creature, every thing, is therefore a manifestation of the Ka, the divine breath, which the great god Ra infuses in all inert matter, none other than the eternal repetition of the moment in which the Absolute became aware of his own image and pronounced the sacred words "*come to me*". Every stone, every mountain, the Nile, the sea, Egypt itself, differ and partake of divinity through their Ka, through the god who is cause and manifestation of their very being.

The same universal process is played out in man, fulcrum of creation, microcosmos between earth and sky. When the god Khnum made the human race, he modelled two identical figures — Khet or inert matter, the human body, and Ka or the divine breath, the spiritual body. Their superimposition endows every human creature with life and gives rise to the Ba, the individual soul, in other words man's awareness of himself, his individual will as opposed to that of the creator. The miracle of creation returns, as an act of conscience in man, who thus becomes the only creature gifted with a will and conscience of his own and therefore responsible for his actions.

In this immanent and transcendental relationship, the Egyptian point of view is that the life, the actions of the individual are not detached from the whole, for the work of the soul is paralleled by that of the Ka, his divine double, the "*witness who is in the boat of truth*", and therefore his actions constantly participate in universal life.

In this cosmic order the Ka, man-spirit, also determines the field of action, the type of life to which the man-soul must give his contribution and therefore develop his own personality according to divine design.

The peoples of Egypt as a whole can therefore be equated with an immense pyramid where every step is the field of action of the single individual and the summit is that of its king. What each person does becomes the cause and the support of the achievements of the pharaoh who in turn becomes the link between the finite and the infinite worlds.

There is no break in the continuity of universal harmony between life in this world and in the next. For the Ka of the Egyptian peoples is not provisional but eternal, just as the terrestrial "pyramid" is continuous with the celestial "pyramid", and the society formed on this earth is a design of divine reality which has its conclusion in heaven. The pharaoh stands surety for this total redemption and his actions as absolute father and protector continue even after death, so that addressing all those who still live in suffering and misery, he calls in a loud voice: "*stretch out your arms, oh creatures born of the word of God, for he who falls will I raise, he who weeps will I comfort....I will do all that the Lord who is good has conceded to me*". In the third millennium the concept that the terrestrial society was the direct expression of the divine design predominated. Therefore the Ka of the pharaoh became a compelling force leading to immortality, for the terrestrial "pyramid" was a reflection of the divine pyramid. In the second millennium, the importance of the Ba increased for the pharaoh as well, and divine judgement was gradually extended to all men. Life was no longer a ritual mystery but took on the aspect of a mission to be fulfilled. Moral treatises were no longer rules for getting along in life but became conditions *sine qua non* for overcoming the great trial, credentials that would guarantee the afterworld. As social cohesion fell apart and economic tranquillity vanished, the search for moral credentials, the vision of a possible award for one's actions, became increasingly uncertain and distressing, for the final victory of good over evil was no longer guaranteed even to the powerful. The pharaoh became only one of the many men tormented by the doubt that the mummy was no longer the chrysalis from which eternal life was born, but the only bond to the larva of an unknown life. "*The tombs of the great builders* - says the discouraged Egyptian — *have disappeared. What has happened to them? I have listened to sayings of Imhotep and Hergedef which have become norms and counsels that will never pass, but what has happened to their tombs? The walls have fallen and the tombs exist no more as if they had never existed. There is no one who comes from the afterworld to speak to us of them, to soothe our hearts until we too reach the world to which they have gone. Rejoice my heart, only oblivion will give you serenity*".

With his religion of equality, of love and a direct contact with God which gave all men faith in a universal redemption, Akhenaten provided a brief parenthesis to this uncertainty. Six hundred years later, in the Saite period (666-524 B.C.) this lofty Egyptian spirituality still pulsed in the individual conscience that had been achieved, in the equality of men before god and in a renewed faith in divine providence.

House of the dead house of life

When the Ka and the Khet are separated, that is when the divine spirit abandons the body, the vital support fails and death arrives. While for all things created death corresponds to the destruction of the individual, for man it also brings about the release of the Ba, his soul, and the beginning of life in the hypersensitive afterworld of the terrestrial kingdom. Since there was no break for the Egyptian between the realm of earth and the realm of the sky and the actions of the living and the dead were in direct contact, the funeral rites and the cult of the dead assumed maximum importance.

In the funeral rite the first thing to be done was to mummify the body, the material "model" willed and inhabited by the divine Ka, and therefore often indispensable to the deceased as the element through which he could continue to be aware of himself and of his identity until it was identified with the God-Ra.

In prehistory, and subsequently among the common people, the corpse was curled up in a fetal position (as if it were returning to the bosom of the Mother Goddess), sewn into animal skins, closed in a large clay jar and then buried in the desert. The body quickly dehydrated in the hot dry climate and its preservation was assured for a long period of time. If the deceased was sufficiently important and family means permitted, a burial chamber was created at the bottom of a shaft where the tools used by the deceased as well as models and seeds were deposited around the body. A tumulus of stones was then erected on the closed shaft. Rites with offerings of food and drink were carried out at the tumulus, accompanied by evocations such as: "Arise and partake of this food which we offer you".

As early as the Fourth Dynasty mummification had become a specialized art and therefore depended on the financial resources and political power of the family. Herodotus refers to three procedures used. The most economical was accessible even to the less well-off and consisted in a violent washing of the body cavity and drying in the sun as of old. The most expensive procedure, which succeeded in maintaining the aspect of the deceased most closely, lasted many months and could be afforded only by few for the cost was 26 kilos of silver, a fabulous sum in those days.

Mummification took place in the "House of life" (a name that was also extended to the tomb, highly indicative of Egyptian religious thought). For the more well-to-do, the continuous washings were followed by surgical removal of the viscera — intestines, lungs and liver — as well as the brain. Mummified separately, they were placed in four vases (canopic jars) consecrated to the four children of Horus.

The complex operations were guided by a thorough knowledge of anatomy and medicine. It should be kept in mind that the "higher physicians" and the "palace physicians" were acquainted with such things as castor oil, enemas, various types of contraceptives and an analgesic based on hellebore. The well-known Twelfth Dynasty (2000-1800 B.C.) treatises on surgery, external therapeutics and anatomy were based on much older studies. The fame of the school of Sais (600-500 B.C.) and its "chief physician" had spread throughout the Greek world. It must also be recalled that the Greeks identified Imhotep with the god of medicine Aesculapius and that Hippocrates made ample reference to an Egyptian text in composing his treatise on gynecology.

Lastly the mummified body of the deceased was wrapped in long marvelously plaited linen wrappings, into which amulets of all kinds and sizes were inserted as the ritual with its prayers and consecrations was followed point by point. Special priests, members of a powerful class and in great demand thanks to the secret skills and magical knowledge they were heir to, were in charge of every phase of the funeral rites. The mummy was continuously purified with lustral water and prayers and after being completed with a sculptured or painted image of its Ba, was enclosed in one or more cases which were later to take on the form of the mummy itself and were painted with the image of its Ka.

The funeral procession set out from the "House of Life". At its head came the precious sarcophagus under a flowered baldachin, followed by the relatives with the "hired mourners" (women and children who wept loudly and strewed their heads with earth). Then came the long procession of funeral furnishings, which included the furniture, clothing and jewels of the deceased, "models" of his boats, his houses and his shops, filled with "ushabti" figures, "small models" of his followers, a sign that they were continuing their task in the afterworld. When they reached the Nile, the procession continued on the sacred river, the source and life of Egypt, and ideally also the beginning of the journey along the celestial Nile. If possible, the procession stopped at Abydos, the greatest Osirian sanctuary, where every Egyptian desired to have at least a symbolical burial, that is a stela next to the great reliquary of the God King of the living and the deceased.

Once at their cemetery, the procession continued on to the tomb. Purification rites of the mummy with water and incense were performed in the chapel or vestibule after which began the final and essential ceremony of the "opening of the eyes and mouth". A priest at their head read the magical formulas of the "Book of the Dead" to the relatives and the mourners. The mummy was in front of the sacred stela, ideally sustained by the God Anubis, while the daughter and wife wept inconsolably. The "Kher-Heb" in his leopard skin, the heir to the deceased as priest, besprinkled the mummy with perfumes and incense. Two auxiliary priests poured unguents and proceeded to open the eyes and the mouth with a pointed flint instrument and the ancient sacred silica adze. On an astral level, the effect of this magical function was that the Ba of the deceased could finally "see" and "speak" in the afterworld, for the ceremony itself referred to

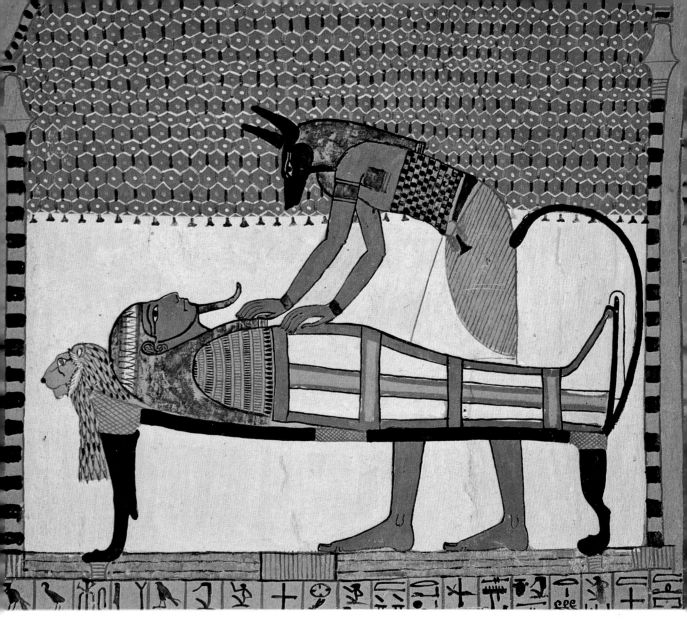

the two fundamental acts of creation: the birth of the human and divine creatures, respectively, from the "eyes" and from the "mouth" of Ra.

The preparation of the deceased for the great journey was now complete. The sarcophagus with its furnishings was lowered into the subterranean chamber, everything was sealed, and the shaft filled in and walled up. Then another important phase of the relationship between the living and the dead began: the cult of the dead.

This cult was based above all on prayer and on the offerings which constituted the "spiritual nourishment" not only of the deceased but also of the celebrants. Through prayers the Ka of the living communicated with the Ka of the deceased while through entreaties and manifestations of affection the Ba of the living communicated with the Ba of the deceased. Prayers and entreaties ensured the support of the family Ka, therefore the integrity of the Ka of the living, and helped the soul of the dead to fuse with his spirit. The offerings have the same magical power since they nourish the Ka of those partaking of the funeral banquet as well as of the traveler in the afterworld. Fig milk, bread, beer, wheat (symbol of resurrection) nourish the body of the soul; while water, saltpeter and incense nourish

The god Anubis shown touching the heart and stomach of the mummy, gazing steadily in its eyes, so as to wake it and accompany it in its journey through the afterworld. This is a perpetuation of the rite, performed by Anubis when he helped Isis to recompose the scattered members of Osiris and bring him back to life. The scene takes place under a canopy with the curtains half drawn, similar to the one under which the deceased is transported. Note the lovely "anatomical bed" in the form of a lion with a long curling tail.

the spiritual body. The more the presence of each individual Ka is felt, the more complete is the communion between the living and the dead, and in this "encounter" requests for help, advice, even complaints and thanks, alternate with the prayers and magical verses, so that the contact is continuous and the family remains united to him who is traveling on the bark of the sun.

This continuity of life comes to the fore in the paintings which are an integral part of the "*House of life*" of the deceased. Many are the tombs in which the owner, depicted on the door jambs, seems to be coming to usher us into his house, to present us to his dear ones, to tell us of his daily life, his travels, his deeds, show us his glory in the service of the pharaoh and his works as paternal

benefactor for friends and employees. This marvelous spectacle of a serene and happy life unrolls before our eyes with its all-pervasive joy of living both here on earth and in the paradisiac life of the afterworld.

Journey in the afterworld

At the beginning of history, it was the pharaoh who guided his people, patterned as in an immense pyramid, to rejoin the astral pyramid. The route to be followed was dictated by sacred texts, the sum and substance of knowledge of the visible and invisible universe. An echo of this ancient knowledge is to be found for the first time in the "*Pyramid Texts*", carved on the walls of the burial chambers in the pyramid of Unas (2400 B.C.).

When the pharaoh eventually became the guide only for himself, the number of "*Books of the Dead*", "*Coffin Texts*" and "*Books of Duat*", intended for every soul on his way to the afterworld, multiplied. These texts presuppose a knowledge of the realm of the dead through religious faith, and contain rules of behaviour, magic formulas, sacred rituals, secret prayers, all aimed at helping the traveller overcome the innumerable trials awaiting him. As the power of the ancient faith waned and the individual conscience evolved, these texts varied, ranging from an extreme synthesis of the relationship between the soul and the universal spirit to an increasingly intricate casuistry which complicates relationships, filling them with demoniac images, infernal visions. Even the equilibrium and continuity between terrestrial and ultra-terrestrial life varied and oscillated between two extremes: the one taking refuge from an increasingly incomprehensible immortality by clinging desperately to life on earth, and the other exalting ultra-terrestrial life as liberation from the torments and limitations of life on earth.

A touching example of contempt for life and admiration of the afterworld appears in the song of a poet of about 1790 B.C. "*Behold, death is before me like the healing of the sick, the going outside after a long illness. Today death is before me like the perfume of myrrh; like rest under the sail in the hours of breeze....*".

The last great journey begins when the spiritual Ka is separated from the material body. The Ba, the soul of man, liberated from earthly life, hovers disoriented near the corpse. The merciful goddess Isis receives it under her great loving wings and entrusts it to the wise god Anubis who will comfort, guide and sustain it until the moment of divine judgement.

The two make their way to the ends of the world, towards one of the four mountains which support the sky, the one to the west of Abydos, the sacred city of Osiris. Once over the high mountain, the soul, with Khephri's barge, descends into the "*Gallery of the night*" through which the river of the Underworld flows. Anubis succeeds in guiding the boat through the endless swirling rapids of the river furrowed by the spires of the gigantic serpent Apophis (chthonic animal which penetrates the subterranean Amenti). At last the barge enters the heart of the Underworld, that is the reign of the "secret things".

The banks and the waters of the river teem with monstruous beings who hurl themselves at the travelers. Gigantic baboons try to capture them with a great net; serpents armed with long sharp

1 2 3

Transporting the mummy to the Necropolis.

1) The corpse is mummified in the "House of Life". The viscera are prepared separately and placed in four canopic jars.
2) A priest reads the ritual. The mummy is wrapped in linen bindings, in which amulets are placed, and covered with the sacred mask.
3) The procession bearing the mummy under its pavilion and the funeral furnishings moves down to the river.
4) The procession continues on boats to the sanctuary of Abydos.
5) Landing of the procession on the shores of the necropolis.
6) The mummy with the boat and the precious furnishings is carried up the steep rock-hewn staircase.
7) The final ceremony of the "opening of the eyes and mouth" is carried out. The female mourners together with the wife and daughters embrace the feet of the mummy and send out their final lamentations.
8) Entrance gallery to the tomb.
9) The tomb has been prepared and some of the furnishings have already been brought into the offering chamber.
10) The treasure has been placed in the treasury.
11) As soon as the gifts and the mummy have been arranged in the burial chamber, the rooms will be walled up and the entrances, filled with stones and sand, will be sealed.

5

6

7

8

9

10

11

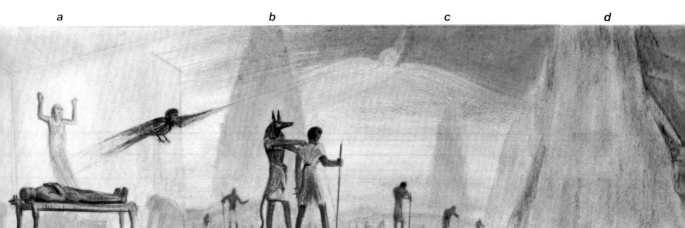

a b c d

The journey in the afterworld.

a) *Separation of the Ka (spirit) and the Ba (soul).*
b) *Anubis lovingly guides the deceased.*
c) *Beginning of the journey under the protection of Isis.*
d) *Arrival at the western mountain, gate to the Netherworld.*
e) *Descent to the river in the "gallery of the night". Journey in the gloomy realm of Seth.*
f) *Gigantic baboons attempt to snare the boat.*
g) *The "enemies of Osiris" lie in wait for the boat.*
h) *The serpent Apophis tries to block the way.*
i) *Trials of the Seven Gates of exit.*
l) *Trials of the Ten Pylons of entrance.*
m) *Ascent of the "Staircase of Justice". All the Ka Gods of Creation are present.*
n) *Final judgement before Osiris. Anubis weighs the heart against the feather. Thoth and the monster Ammut keep watch.*
o) *The redeemed soul purifies itself in the "lotus lake".*
p) *Eternal life in the paradisiac "Fields of Yalu" (Fields of the Blessed): hunting, fishing, working along the "celestial Nile".*
q) *Union with the immortal Ka, ascent and identification with the Supreme Being — Ra.*

knives, fire-spitting dragons, reptiles with five ravenous heads, continuously emerge from the earth and the water. The air resounds with cries, terrible threats, heart-breaking lamentations of wandering shades, of beings rejected by the spirit, of headless human larvas and enemies of Osiris. Luminous divine beings help Anubis as he comforts and defends, clustering around the weak soul of the deceased, practically overcome by fear.

At last the two arrive at the farthest reaches of the gloomy realm of Duat. In order to leave they must go through seven gates; and to enter into the great Hall of Osiris they must pass ten pylons. Each gate is guarded by three divinities: the magician god, the guardian god, the questioner god. The soul, in order to pass, must know the proper magical words and the secret name of the Guardian of the threshold, after which it can say: "*Open the gate for me, be my guide*". Once through the seven gates, the passage of the ten pylons begins and the tutelary god of each pylon reveals his "secret name" for eternity.

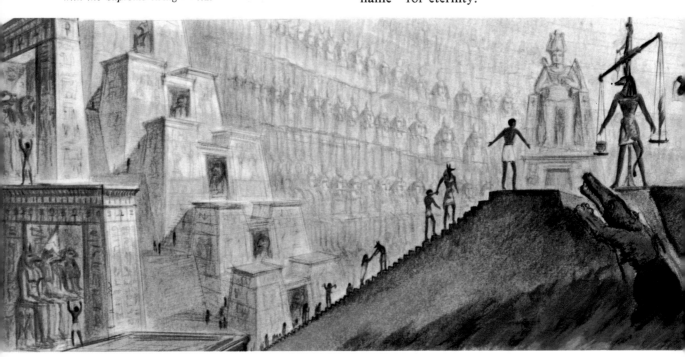

i l m n

After the last pylon, the soul enters the *"Grand hall of justice of Osiris"*. All around are the gods of the universe, the cosmic Kas, images of the absolute god himself in whom they are reflected with a thousand colors like a gigantic kaleidoscope (in the tomb of Thutmosis III 741 gods are represented). At the center rises a stepped pyramid which the soul, exhausted by the long trial, must climb, helped once more by the good Anubis. On the plateau at the top of the pyramid are the four high judges, that is the couples who gave origin to creation: Shu and Tefnut (air and fire); Geb and Nut (earth and sky). These judges, pure expression of divine creation and therefore of Justice and Truth, are present with Osiris, god king of the afterworld at whose feet are the gigantic scales for the *"weighing of the heart"*. The culminating moment has been reached, the soul is alone before the supreme god and must show that it has *"never done evil to anyone"*.

Throughout his life clear and lofty ideals have guided him who is now being judged. *"If thou art great after having been small, if thou art rich after having been poor be not miserly with thy wealth for this has fallen on thee as a gift of God....If then it fell on thee as a gift from God...if then thou cultivatest thy fields and they give thee fruit, fill not only thy mouth, but remember thy neighbor, for abundance is given thee by God..."* In his maxims, repeated for two thousand five hundred years, Ptah-hotep warns: *"Sow not dread among men for God will give thee battle in equal measure, for whosoever pretends to conquer life by violence, God will take the bread out of his mouth, he will take away his riches and he will reduce him to impotence. Sow not dread among men; give them a life of peace and with peace thou wilt have what thou wouldst obtain with war, for this is the will of God"*.

But the greatest "monument" which ancient Egypt left to world ethics is to be found in the words of Nefershem-Ra at the Last Judgement: *"I have given bread to the starving, I have given drink to the thirsty, I have given clothes to the naked, I have*

made him who had no boat cross the river, I have buried him who had no children". Note well that these cornerstones of human virtue are repeated in many "mastaba tombs" and were thus an integral part of the ideals that prepared the way which three thousand years later was to lead to the Kingdom of Heaven. To get back to the journey in the afterworld, once the soul has revealed its actions, the heart — in which they are contained — is "weighed". Anubis himself places the jar with the heart on one plate and the counterweight, the feather of Maat goddess of truth, on the other before unblocking the scales.

The god Thoth takes note of these operations, while the monster Amenuit, crocodile-lion-hippotamus, lies in wait and raises his head, ready to swallow the losing soul and drag it down into the gloom of Sokaris.

If the heart is lighter than the feather, the soul is "justified" and the spiritual Ka returns to make it live for eternity. In some papyruses this charming moment is depicted with the image of the mummy stretched out at the top of a step pyramid, contemplating infinite space, while eight white stars seem to descend and slowly penetrate it.

At this point life in Paradise in the "Fields of Yalu" begins: first the soul purifies itself of all earthly dross by bathing in the "*lotus lake*". Newly pure and young as in the womb of the Mother Goddess Nut, it grows and works blissfully in the paradisiac fields, reunited with its dear ones, hunting and fishing along the celestial Nile. The solar realm of pure spirit gradually filters into this enchantment of life and nature, this return to the golden age of the reign of Osiris on earth; the purified souls climb higher and higher along the staircase of luminous rays of Aton-Ra until they reach the "*Bark of truth*".

There are three important points that come to the fore in this last stage of the Great Journey towards Eternity. The first already appears in ancient thought, where the human personality, once regenerated and "justified", continues to act as part of the whole and of divine will, joining the army of Horus in its battle against evil and suffering on earth. The second, in which the soul loses itself in the Egyptian Nirvana, is beautifully expressed in the "*Tales of Sinuhe*" "*...he was carried off to heaven and thus found himself united to the solar disk and his body returned to Him who had generated him*". The third, the rediscovery of one's Being in the Absolute, is sung by the beatified soul: "*I am yesterday, I am today and I know tomorrow... I am Ra and Ra is myself...the Being is in me, the non-Being is in me ...I am the master of the soul of God who embraces me in his bosom*".

The boat of the god Khnum brings the spirits of the pharaoh's predecessors to protect his journey in the afterworld.

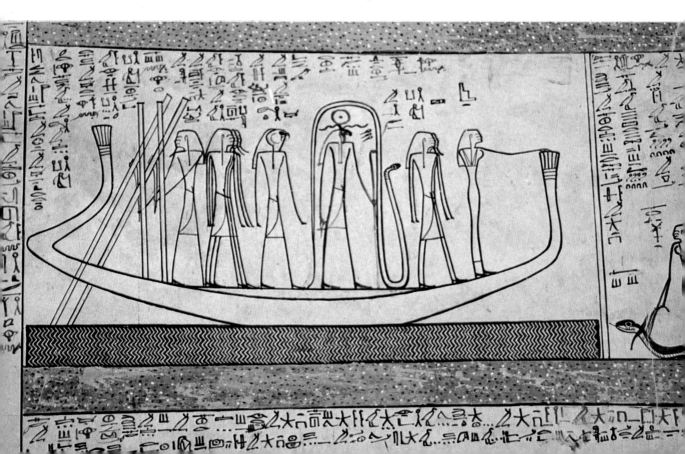

The Valley of the Kings

In times past this terrifying gorge stood as a place apart from life on earth, set in the midst of sun-burnt rocks. Yet the images man left in its depths are still there, testifying to a world where dignity and respect reigned, and which gives us food for thought. The hypogeum structures in themselves, the decorations on the walls, are treasures in the way of art — even though the precious furnishings they contained were mostly carried off long ago when the tombs were violated. In Ptolemaic times many had already been opened and traces of the ancient "tourists" who visited them can still be seen today. But even so there is still magic in the tombs of the great kings of the 19th and 20th Dynasties with their imposing architecture and their paintings. The arrangement of the monuments that characterized the funerary complexes of the Theban dynasties differed from those that had come before. In the period of the pyramids the tomb itself, coupled with the mortuary temple, had been the focal point. With the Theban kings the imposing mortuary temple rose up at the edge of the desert and the tomb itself, now also a temple but of smaller size, was jealously hidden in the heart of the desert. Their plan was generally that of the traditional temple arranged around a longitudinal axis. A long gallery, divided into two or three sections, leading to the subterranean temple, composed of one or more pilaster halls surrounded by sacristies and offering chambers, with the burial chamber and the treasury chapels at the end. Some tombs have lateral deviations, such as that of Amenophis II and Ramses II (gigantic and unfinished) and some several levels, as in the fine tomb of Seti I. The tomb of Hatshepsut has an extremely long corridor that bends around almost in a half circle as it descends about 30 meters underground with a few rooms at its end. The iconography of the royal tombs does not linger on the continuity of life in the afterworld but concentrates on the continuity of the life of the pharaoh in contact with the gods and his victory over death as a demonstration of his divinity. Therefore it once more takes up and illustrates what was begun with the pyramid texts in the tomb of Unas, with the glory of his earthly life stressed in the mortuary temple and that of his divine life in the hypogeum temple. It is therefore in the latter that all the secret bonds with the extra-sensorial world are concentrated, represented and divided according to the sacred texts (books of the "opening of the mouth", "of that which is in the Am-Duat", "of the Gates") and the occult cosmogony, so that the passage from the external world to the burial chamber turns into an initiatory route leading to identification with the Sky, with Ra, the Supreme Being.

1) Ramses VII.
2) Ramses IV.
3) Ramses III (tomb never occupied).
4) Ramses II.
5) Menerptah II.
6) Ramses IX.
7) Tutankhamen.
8) Ramses VI.
9) Amenophis II.
10) Horemheb.
11) Ramses III.
12) Amonmes.
13) Ramses I.
14) Seti I.
15) Sethnakht.
16) Merneptah I.
17) Thutmosis I.
18) Seti II.
19) Thutmosis III.
20) Thutmosis IV.
21) Prince Montukhopechef.
22) Queen Hatshepsut.

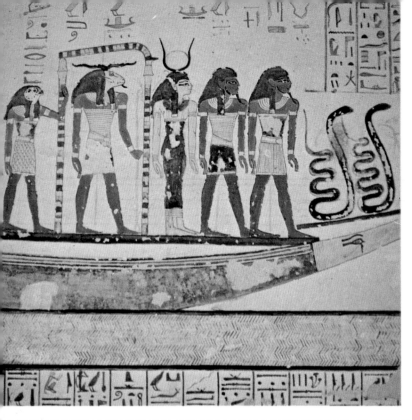

Ramses IX.

The entrance to the tomb is preceded by a flight of steps hewn out of the rock, with a central ramp for lowering heavy objects. The gallery and the two small chambers at the sides are decorated with scenes taken from the "Book of the Dead", from that of the "Litanies to the Sun" and finally from the "Book of the Duat". Astral scenes decorate the ceiling of the burial chamber.

Detail of the walls of the corridor. Above: the sun boat of Khnum guided by the benign serpents, the ancestors and the gods Hathor and Horus. Below: two protecting genii with the serpent Sokaris and the Scarab of the Rising Sun.

Ramses VI.

In this tomb too, as in the preceding, a long corridor is divided into three sectors. The hypogeum consists of two chambers: the first holds the granite sarcophagus (circa 3 meters by 2 by 2.80) and has scenes from the "Book of the Gates" on the walls and astral scenes on the ceiling; the second is cruciform and is decorated with scenes from the "Book of Caverns".

Detail of the lovely ceiling in the burial chamber, where the gigantic figure of Nut, the goddess of the sky, predominates (repeated twice), enclosing the western and the eastern spheres. The two hemispheres are filled with a great procession of stellar gods following the sun boats as they ply the celestial Nile.

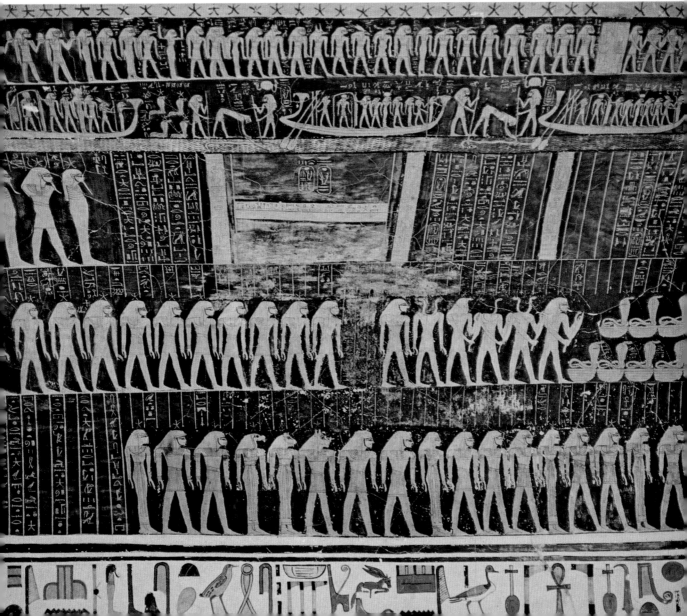

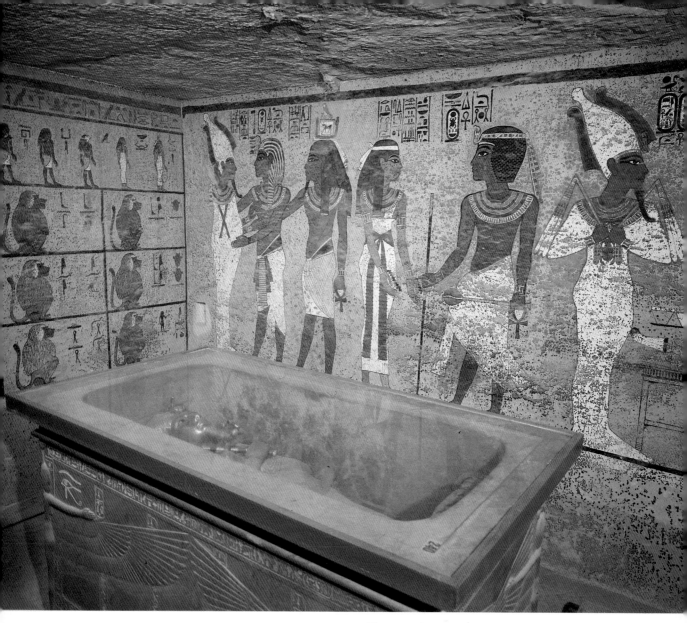

The sarcophagus chamber as it is seen today by visitors to the Valley of the Kings and as Carter saw it, with the enormous catafalque which occupied almost the entire burial chamber.

Section of Tutankhamen's tomb.

Tutankhamen.

In its structure and decoration the tomb is one of the least impressive but the immense treasures of art and archaeology it yielded have made it the most famous. The tomb, discovered in the early part of the 1900's, was hastily prepared for a pharaoh of secondary importance, who died very young. Tutankhamen (1354-1345 B.C.) lived in that troubled period of political-religious struggles that followed the death of the great "heretic pharaoh" Akhenaten (1372-1354 B.C.), disorders that were put down a few years later by the powerful Horemheb (1340-1314 B.C.). A short corridor led to an antechamber which gave onto the burial chamber and the treasury on the right, while opposite was another room for the offerings and the furnishings.

The only room to be decorated was the burial chamber. The decorations show Ay, the second husband of Nefertiti and successor to Tutankhamen, performing the "opening of the eyes and mouth" ceremony on the mummy in the guise of Osiris. The tomb had no sooner been filled with its furnishings and sealed than it was "visited" by thieves. They were evidently disturbed and succeeded in making off with only a few objects. Summarily reordered and sealed anew by the priests, it was buried a hundred years later by debris when the tomb of Ramses IX was built higher up. The waste material cancelled all traces and it was forgotten for almost three thousand years, until it was brought back to light in 1922 thanks to Howard Carter's experience and intuition.

The discovery of the tomb in a valley that had already been thoroughly "excavated" brought the archaeologist great fame, but also the bitter realization of just how much had been lost to mankind when the tombs of pharaohs as great as Amenophis III, Seti I, Ramses II, and Ramses III were looted. The unbelievable treasures found are now in the Cairo Museum.

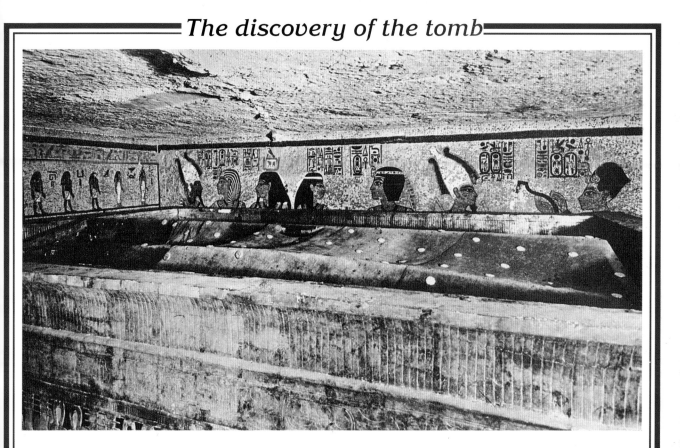

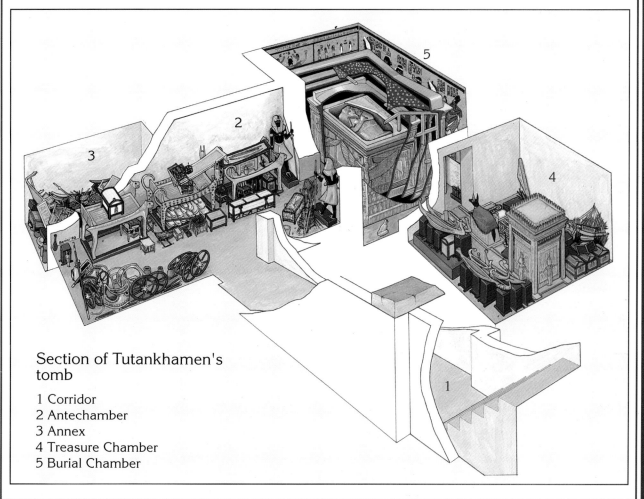

Section of Tutankhamen's tomb

1 Corridor
2 Antechamber
3 Annex
4 Treasure Chamber
5 Burial Chamber

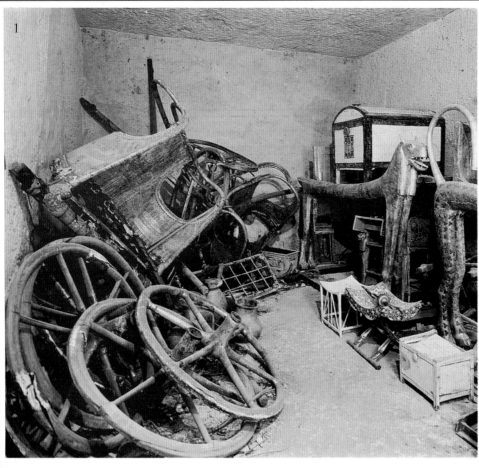

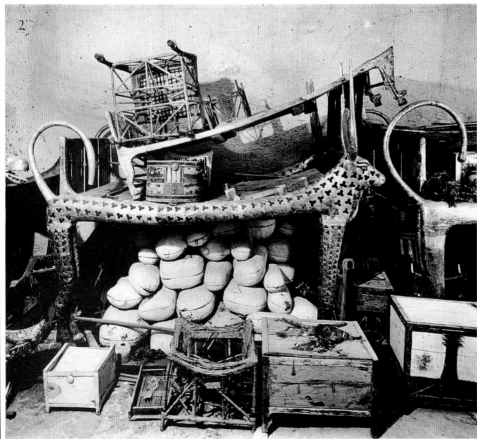

1. A corner of the antechamber, as it appeared to the astonished eyes of Howard Carter on November 26, 1922: on the left the dismantled chariots of the pharaoh can be identified and on the right two of the three zoomorphic funeral couches.

2. Part of Tutankhamen's funeral furnishings piled up in the antechamber of the tomb: at the center of the photo, the finest of the three funeral couches, the one with cows at the sides whose lyre-shaped horns enclose the solar disk.

3. The two statues which represent the pharaoh's «Ka» (his «double»), none other than sentinels set to guard the funerary chamber: through the hole in the wall a glimpse of the gilded wooden sarcophagus which occupied practically the entire room can be had.

4. A view of the inner chamber of the tomb of Tutankhamen: the statue of Anubis, wrapped in cloth and with garlands of flowers round his neck, protects the king's treasure. At the back can be seen the «canopic naos», the wooden shrine covered with gold which contained the pharaoh's canopic jars.

5. The breath-taking moment when Carter and his assistants find themselves before the pharaoh's sarcophagus, after having opened the four shrines, which were set one inside the other like Chinese boxes. It took 84 days of hard work to take them apart.

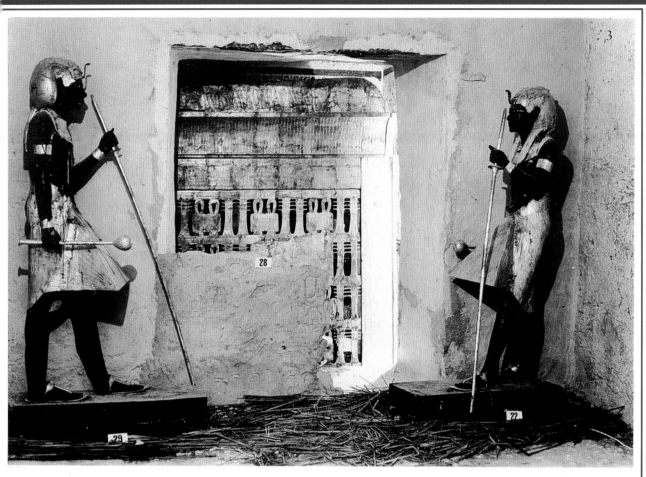

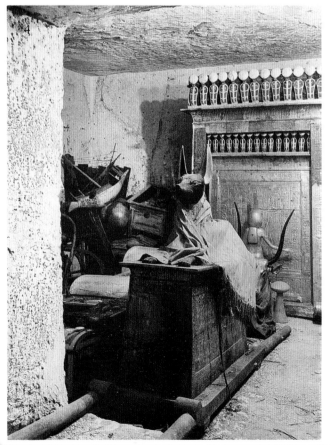

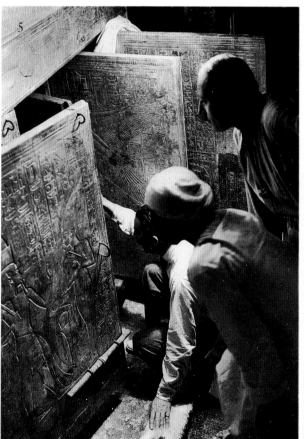

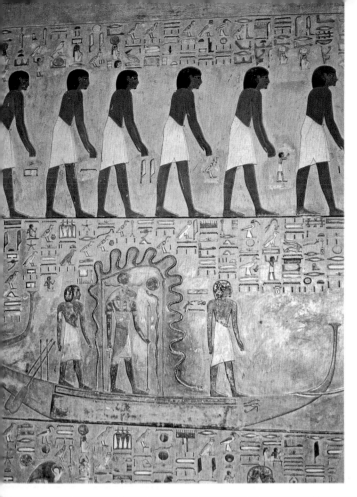

Seti I.

This is one of the largest and finest of the royal tombs. Long flights of steps and corridors lead to the hypogeum — a complex organism consisting of various pillared halls, arranged on different levels, with an obstruction pit in the vestibule. Apparently work was brought to a halt by the death of the pharaoh.

Detail of the cortege of sacred barks showing the bark of the god Khnum and the tabernacle protected by the great serpent.

Detail of the long row of walls and gates (with their relative guardians) which divides the realm of Duat, protected by the serpent Apophis, from the realm of Osiris, protected by an interminable catena of genii and gods.

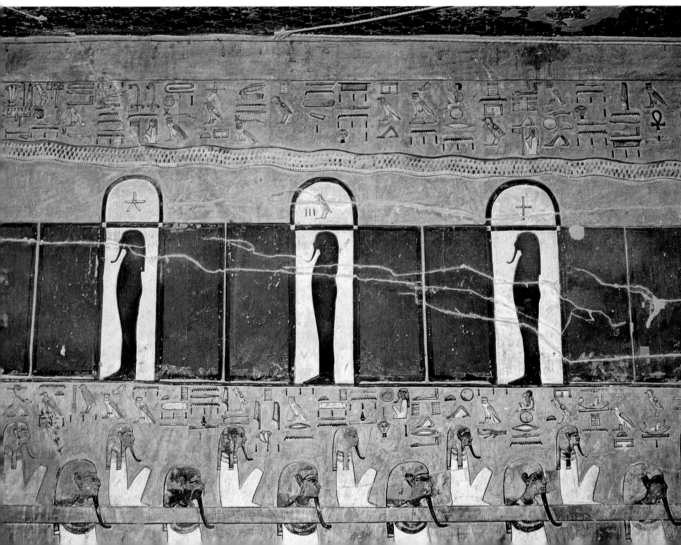

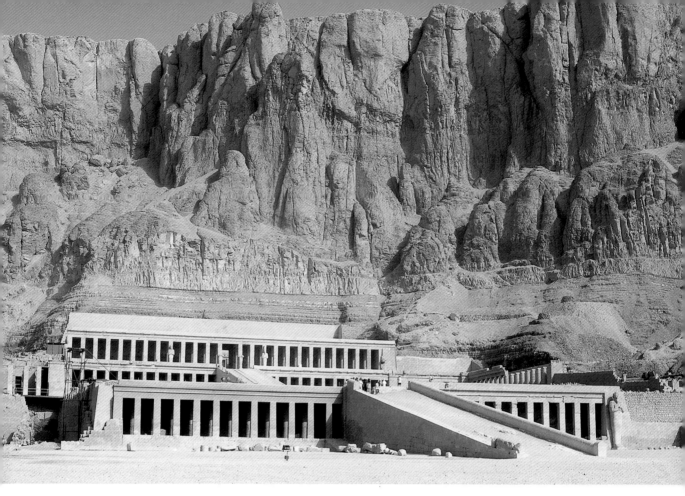

The monumental complex of Deir-el-Bahri in its present state.

Deir el-Bahri

The name, ''Northern Monastery'', comes from a complex which had been set into the ruins of the temple of Hatshepsut, saving it from total destruction. As early as the Eleventh Dynasty the entire valley was consecrated to the goddess Hathor and used as a necropolis; it was then abandoned and reached its highest splendor five hundred years later under the queen Hatshepsut.

Reconstruction of the monumental complex of Deir el-Bahri.

The entire zone to the left is occupied by the monumental necropolis of Montuhotep I. The great temple of Thutmosis III stood near the mountain. The facade was completely colonnaded, with a great hypostyle hall with a raised body at the center and, finally, a tetrastyle sanctuary; all that remains now are the foundations and fragments of the fine painted bas-reliefs, now in the Museum of Luxor. The entire zone to the right was occupied by the temple of the queen Hatshepsut. Two enormous terraces precede a third on which the actual temple stands. In the reconstruction the two top terraces are shown. The first court was once surrounded by pylons and had an entrance avenue of sphinxes and obelisks. At the rear of the first court is a portico of pillars and columns; on the wall in the back scenes of the transporting and erection of obelisks. A ramp leads to the second level where on the right and at the corner is a fine portico of proto-Doric columns. Still further back a portico with two rows of pillars and on the walls scenes from the life of Hatshepsut, from her birth to her expeditions to the mysterious land of Punt. At the northeast corner, the small perfectly preserved temple of Anubis, with a hypostyle hall and three chapels. Towards the southwest, internally, the small temple of the goddess Hathor with two contiguous hypostyle halls and with Hathor columns; the second hall is decorated with the representation of the festivals in honor of the goddess. At the back, excavated in the rock, the chapel with scenes of the queen worshipping Hathor in the form of a cow. In some scenes the great architect Senmut, creator of the great temple, appears. On the last terrace, more pilastered porticoes and a fine portal at the center, practically intact. Next comes a large court with a double row of columns all around. On the right, the solar temple of the god Harakhte; on the left the chapel dedicated to Thutmosis I, father of the queen; at the center, the hypogeum of Hatshepsut with beautiful painted bas-reliefs showing the sacrifice of the bull and the antelope.

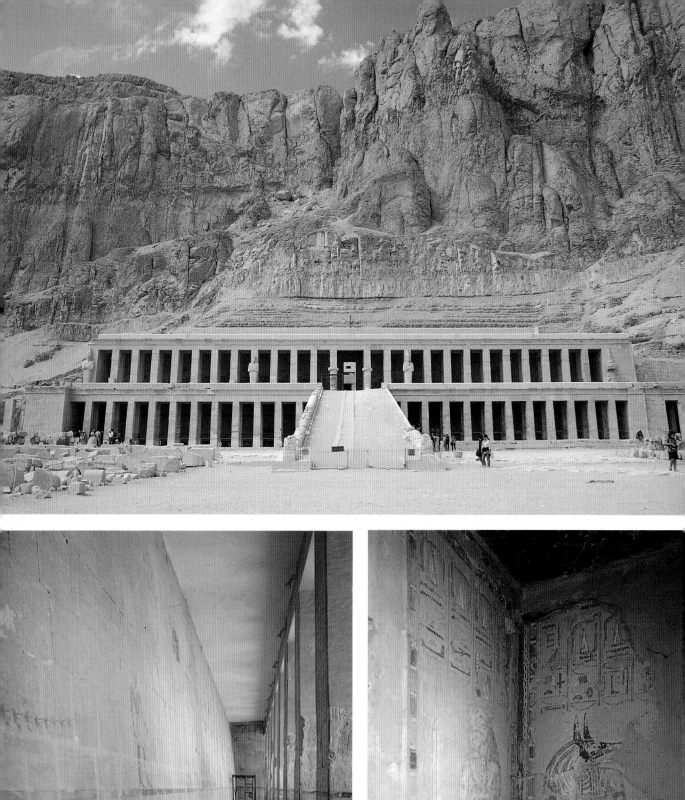

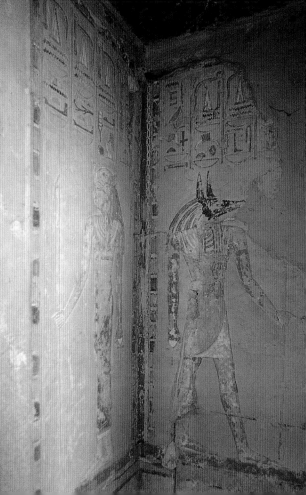

The Temple of Hatshepsut.

This marvelous complex can be seen easily thanks to the restoration works still in course. Created by the architect Senmut, a worthy heir to Imhotep who had lived one thousand two hundred years earlier, it is of great importance in the story of human achievement. The gigantic temple was dedicated, in part, to the Ka of Thutmosis I (1530-1520 B.C.), father of Queen Hatshepsut (1505-1484 B.C.) and to her Ka; this confirmed her right to regality despite the fact that she was a woman.

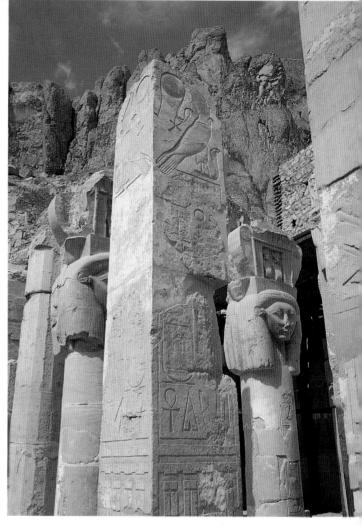

Detail of the fine capitals of the Hathor temple. To be noted are the volutes around the shrine with the sun cobras, which seem to anticipate the Ionian capital by a thousand years.

Above, four details of the temple.

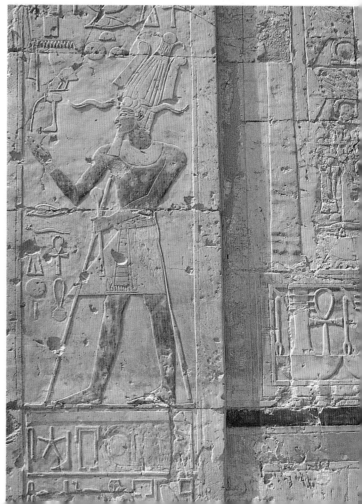

The Valley of the Nobles

The tombs of the great dignitaries of the Middle Kingdom stretch out over three contiguous fields today called Asasif, Khoka and Sheik Abd al-Qurnah. They clearly differ from the royal tombs both in the simplicity of their architecture and in the subjects illustrated with great vivacity and unusual realism.

The fields of Asasif and Khoka are practically level, and therefore the chambers dug out four meters below the surface are preceded by open courts and steep flights of steps which go down into the rock. The Qurnah area has a hilly part reserved for the principal Theban officials; the tombs, which went deep into the rock, were preceded by a small terrace on the east and the entrance was topped by a small pyramid. Steles with inscriptions and biographical scenes were set around and in the vestibule. In some tombs, the statue of the deceased, sometimes together with his wife, "looks out" from the niche at the back.

While they may not always be of great importance, these tombs are of interest in that they give us an idea of the high offices and functions that existed in ancient Egypt.

The examples illustrated here, as in other cases, were chosen to give an all-over view of the stupendous range of works of art contained in the Theban necropolis.

1) Pnim Ra "Second prophet of Amon".
2) Neferhotep "Chief scribe of Amon".
3) Amenemhet Surer "The King's Steward".
4) Nebamon "Scribe of the treasury".
5) Neferonpet keuro "Scribe of the treasury".
6) Mose "Scribe of the treasury".
7) Pabasa "Steward of the Divine Votaress".
8) Aba (Ibi) "Steward of the Divine Votaress".
9) Montu Emhat "Fourth prophet of Amon".
10) Kheruef Senaa "Steward of the Great Bride of the King".
11) Kiki "Royal steward".
12) Diar "Guardian of the royal harem".
13) Zoser-karaseneb "Steward-scribe of grain".
14) Amon Mose "Commander of the troops".
15) Uah "Majordomo of the king".
16) Toi "Royal scribe".
17) Miu "Prefect of This ".
18) Paser "Governor of the city".
19) Nakht "Scribe, astronomer of Amon".
20) Neferhabef "First prophet of the royal Ka".
21) Nediemge "Inspector of the gardens of Amon".
22) Menna "Scribe of the fields".
23) Nebamon "Royal scribe, inspector of the king's granaries".
24) Huy "Sculptor of Amon".
25) Ramose "Vizier and governor of the city" (Thebes).
26) Userhat "Royal scribe".
27) Khaemhet Mahu "Royal scribe, overseer of the granaries".
28) Amenhotep Sise "Second prophet of Amon".
29) Amenemhet "Scribe and steward of the granaries of Amon".
30) Amenemhet Mahu "Commander of the Army".
31) Rekhmire "Vizier and Governor of the city".
32) Ineni "Overseer of the granaries of Amon".
33) Horemheb "Royal scribe and of the recruits".
34) Neb Amon "Standardbearer in the Bark of Amon".
35) Sennufer "Prince of the city of the South".
36) Kenamen "Chief steward of the king".

Kiki.

In the subject matter and the vivacity of the scenes, this tomb (half abandoned and once used as stables) clearly reveals what the basic differences between the royal tombs and those of the nobles were.

Scenes of family life and work in the fields are depicted on the walls. Scenes of the journey of the body to Abydos and the necropolis. Details showing the hired mourners and the bearers of offering tables.

Kiki with a small beard, is followed by his wife holding a sistrum.

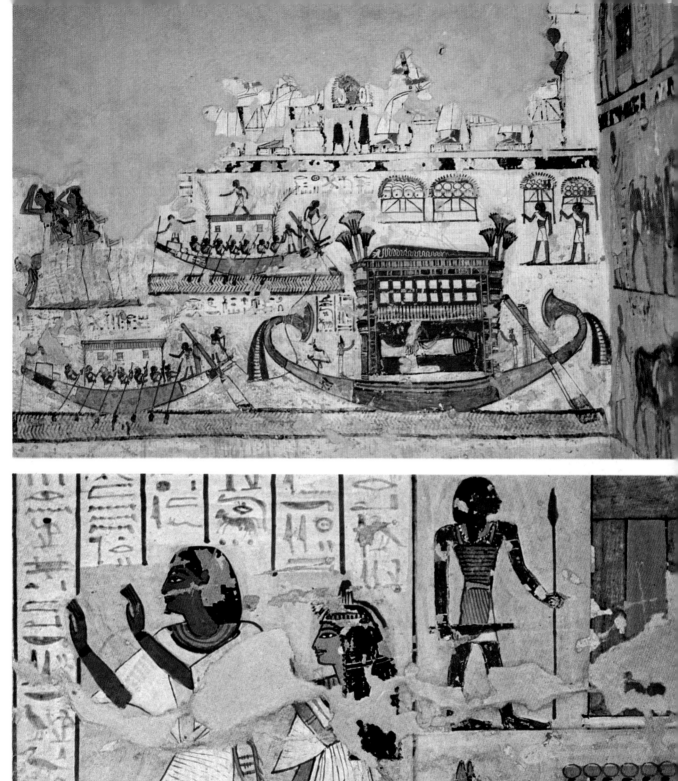
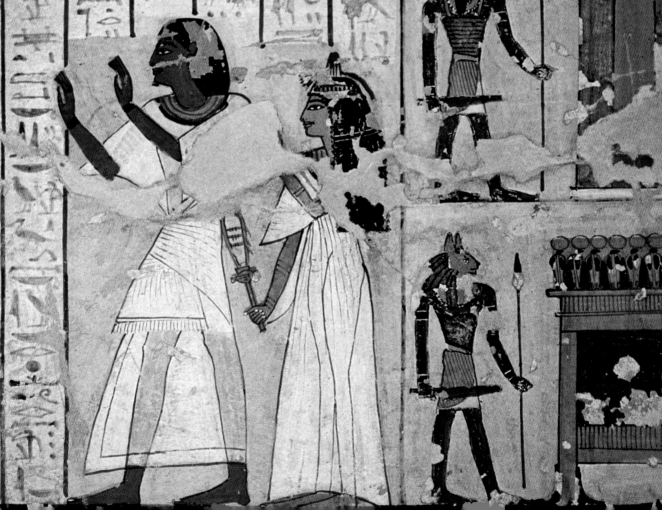

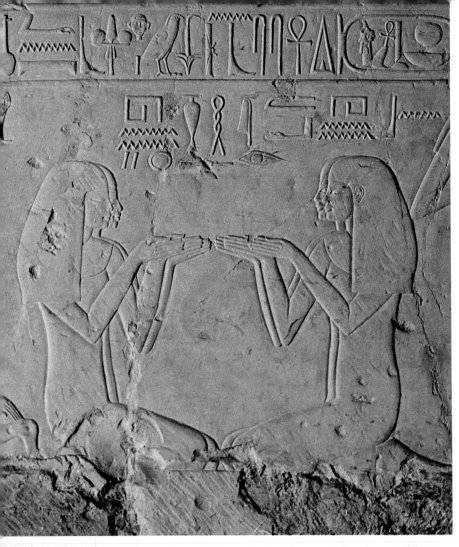

Kheruef Senaa.

Tomb of the "Steward of the Great Bride of the King" for Amenophis III and Amenophis IV who then became Akhenaten. A spacious wall presents us with scenes of dances, banquets, offering processions and also shows the erection of the Zed, both in honor of the "Steward" and of the pharaoh and the queen Tiy. Two details of these lovely bas-reliefs are shown here on these two pages. Above, four girls seated on the ground converse while others move on to the ritual dance. Below, two dancers. Note the flowing hair and the short skirts with interlacing straps tied in front.

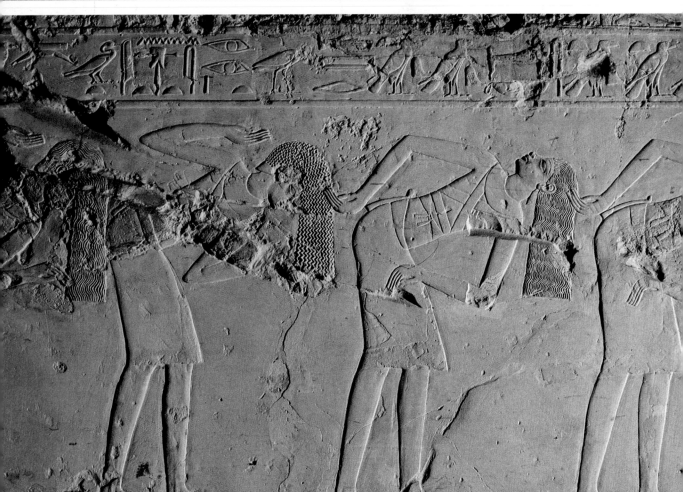

Nakht.

Tomb of the "Scribe and astronomer of Amon" in the time of Thutmosis IV, in Qurnah. Beautiful scenes (from which the name of Amon was scraped away during the Atonian "heresy"), above all those of the cultivation of grain, the grape harvest, hunting and fishing.

Kneeling offering bearer: in his right hand he holds a bunch of flowers, in his left a branch with bunches of grapes and a tray with sweets, vegetables and fruits.

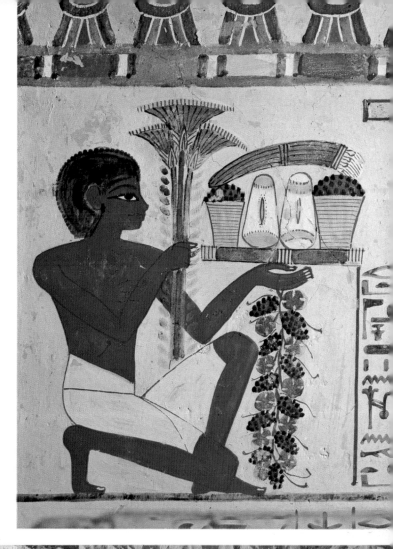

Nakht hunting in the canebrakes of the lagoon: detail of his daughter, seated, and his son, standing, as he gives his father the boomerang; his wife "Chantress of Amon" can be seen behind the "astronomer scribe". The slender green colonnade of lagoon reeds in the background recalls the motive in bas-relief in the mastabas of the third millennium.

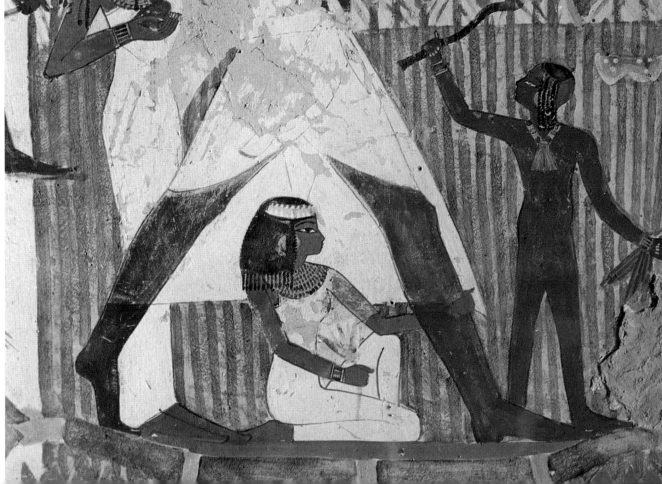

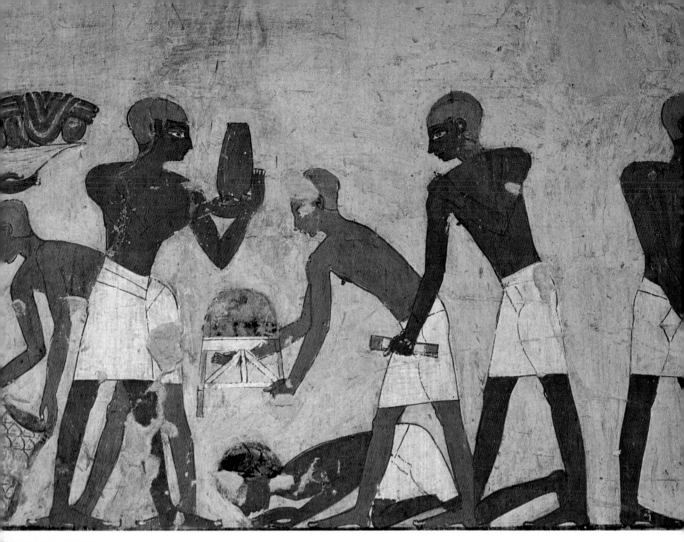

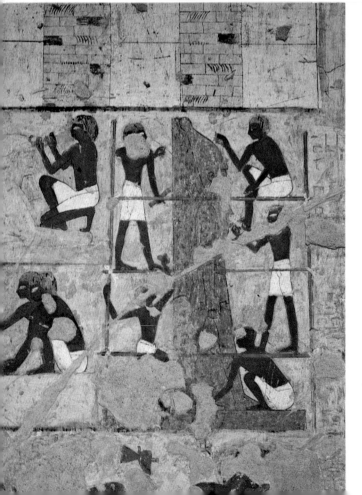

Rekhmire.

The tomb of the "Governor of the City", vizier of Thutmosis III and Amenophis III, is one of the largest and best preserved. Of particular interest are the scenes which show the envoys of the land of Punt, of the land of Keft (perhaps Crete), of the Negroes of Kush and finally the envoys from the land of Ratenu (Syrians and Assyrians). Even more interesting the scenes in the chapel with the "Governor" directing the works for the temple of Amon, including all the artisan trades, as well as painting and sculpture.

Supervisors inspecting the offerings brought on trays, baskets and tables by bearers.

Artists busy sculpturing a sphinx and painting and engraving a "colossus" of the pharaoh.

Menna.

Tomb of the "Scribe of the Fields of the Lord of Upper and Lower Egypt", in the time of Thutmosis IV. The "Scribe" used and enlarged a pre-existing tomb. The colors of these scenes, among the most elegant and refined in the necropolis, are also well preserved. Of particular interest scenes of life in the fields and a pilgrimage to Abydos.

Two girls in diaphanous linen tunics. The one on the left holds a perfume vase and two bunches of flowers.

Sennufer.

Tomb of the "Prince of the City of the South" at the time of Amenophis II, in the zone of Qurnah. It is at the bottom of a rock-hewn flight of stairs and consists of a transverse vestibule and a chamber with four pillars. The walls of the antechamber are decorated with offering scenes showing Sennufer, his wife, Seth-Nefer "Royal nurse", and the daughter Mutahi. Grape vines are painted on the ceiling. In the burial chamber: the couple, "who come out of the earth to see, every day, the course of the sun".

A corner of the vestibule with a detail of the purple grape arbor: below, the profiles of the wife and daughter of the "Prince".

The husband and wife travelling on the Nile, seated under a canopy, in front of a laid and purified table.

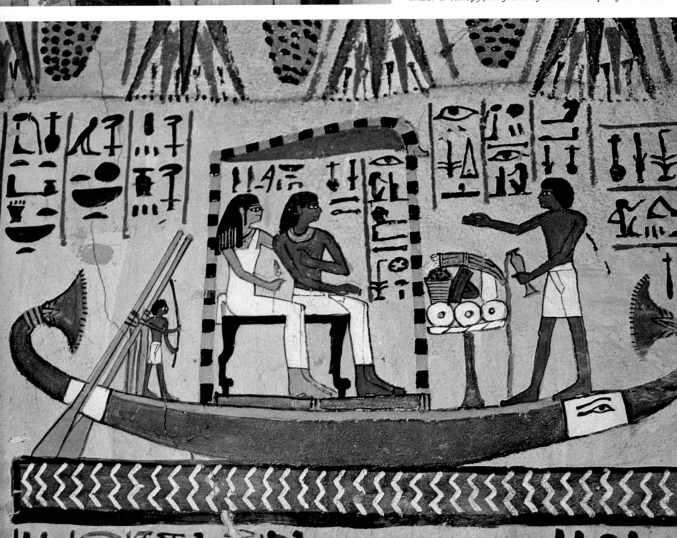

Ramose.

Tomb of the "Governor of the city and vizier" of Akhenaten in the zone of Qurnah. When the pharaoh died, Ramose abandoned the tomb begun near Akhetaten and began all over again in Thebes. The corridor and part of the hall contain fine bas-reliefs while other scenes are painted. The refinement and naturalism of the mixture of Atonian and classical features is outstanding.

Procession of carriers bearing furnishings. Among the objects is a table, a chair, several coffers and a bed with a headrest.

Procession of flower bearers. At their head is a bearer carrying a "pair of scales" on which vases of perfumed oils have been hung and "censers" for the "opening of the eyes and mouth" ceremony.

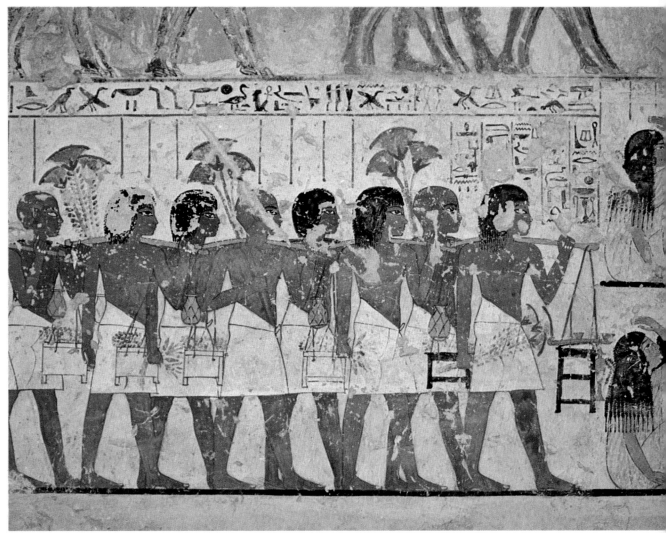

The Valley of the Queens

The valley, currently called Biban el-Harim
("The gates of the Queens"), moves back into
the desert like the valley of the Kings, which
is one and a half kilometers further north. It
is somewhat wider and is closer to the
workmen's village, Deir el- Medina, to which
it is still joined by the original track that
crosses low hills. The ravine at the entrance
contains various steles commemorating the
deeds of Ramses III and prayers to Osiris and
Anubis can still be seen incised on the rocks.
Some of the 80 tombs discovered in the valley
are incomplete or were seriously damaged,
blackened by smoke from the campfires of
the desecrators, or used as stables.
Almost all the tombs date to the 19th and
20th dynasties, in other words to between
1300 and 1100 B.C. circa. The most
important are those prepared for the wife and
three of the children, who died young, of
Ramses III.
In their size and arrangement, the rock-hewn
chambers recall the structure of the tombs of
the princes more than the great hypogeums of
the pharaohs. In subject matter the paintings
on their walls are the same as those found in
the royal tombs but they are not as formal or
solemn. This is particularly evident in the
tombs of the princes, where the paintings even
appear to have been executed by the same
kind of artists who worked in the tombs of
the nobles. The tombs of the princes are also
characterized by scenes depicting the offering
rites to the gods. The prince may be alone or
is shown with his father Ramses III, who
presents him to the god of the afterworld. It
should lastly be noted that the tombs of
prince Khaemweset and of Queen Nefertari
are the most complex, and that while they are
notably smaller than the royal tombs, they are
similar in structure.

1) Prince Amonher Khopechef, son of Ramses III.
2) Queen Tyti, probably wife of Ramses IV.
3) Prince Khaemweset, son of Ramses III.
4) Prince Praher Umenef, son of Ramses III.
5) Queen Nefertari, wife of Ramses II.

Prince Amonher Khopechef.

The colors in the decorations of this tomb are unusally
intense and lively, in particular the ultramarine blue. In the
first chamber the king is shown presenting his son to
Thoth, to Ptah and to the four sons of Horus; in the
second chamber there are scenes taken from the "Book of
the Dead". The frieze in the architrave, with the winged
solar disk flanked by cobras, is of great beauty. In the
lower register, at the center, are the symbols of the reign of
the pharaoh, with a winged cobra, sign of great protection,
next to each one.

Above, the prince Amonher Khopechef and the god
Khnum.

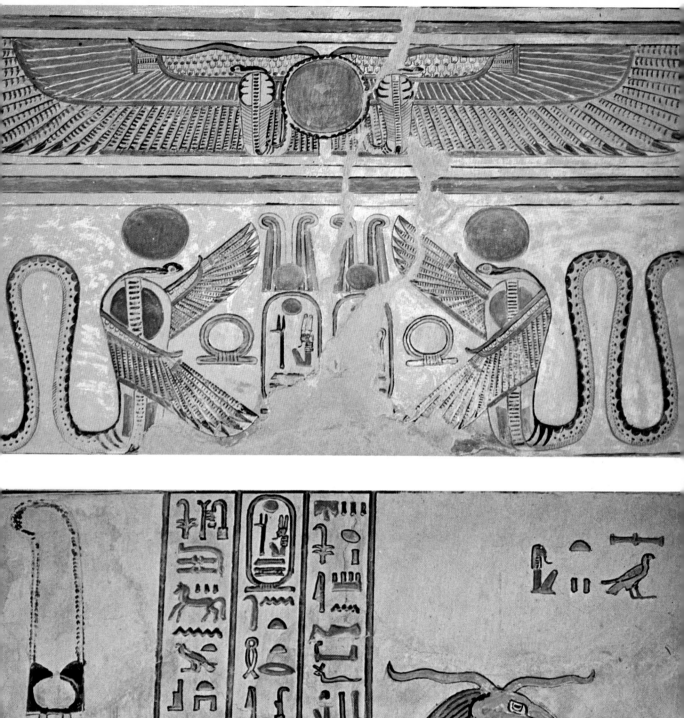

Prince Praher Umenef.

The more important subjects to be found in the tombs of the other two brothers also appear here: the prince shown alone before the gods, or encouraged and protected by his father Ramses III in the presence of the gods (Thoth, Ptah, Maat, Osiris, and other guardians of the gates of the Afterworld). The prince resembles his father except that he is smaller and has braids over his ear. Sometimes the queen is also present in the ceremonial scene.

The colors used in this tomb, particularly in the scenes derived from the "Book of the Dead", are not as lively as those in the tombs of Praher-Umenef's two brothers. The yellow ocher, which predominates in the backgrounds and in the skin tones of the goddesses, tends to delicate hues, which almost recall the decorations in the nearby tomb of Tyti, probably painted a few decades later.

Gates of the world of the Duat with three guardians armed with long knives. Above; a guardian seen frontally, a singular position in Egyptian iconography and reserved for the child sun, that is the rising sun. Next to him is the crocodile-headed god Sobek followed by the vulture goddess Nekhbet, protectress of Upper Egypt.

Queen Nefertari.

The tomb of Nefertari, the wife of Ramses II (19th dynasty) was discovered by the archaeological team headed by Ernesto Schiaparelli, Director of the Egyptian Museum, Turin, in 1904

Nefertari offering two jugs of wine to the goddess Hathor.

Queen Tyti.

Despite the fact that it was abandoned and used as stables, this tomb contains paintings that are exceptional in their originality and in the delicacy of the hues dominated by purplish pinks. Probably the queen shown with her hair worn in a braid (a hairstyle generally associated with youth) died very young.

On either side of the doorway the queen making offerings to the four Genii of the afterworld. To be noted her high feather headdress and the full bell-shaped skirt, through which her rosy body can be seen.

Prince Khaemweset.

The tomb of this prince is the largest one of the sons of Ramses III. A corridor divided into two sectors leads to the hypogeum comprised of a hall and two side chambers. The paintings are perfectly preserved and the colors, even delicate ones such as greens and blues, are still as bright as if they had been painted only yesterday. In the scenes on the walls of the corridor the prince is shown accompanied by his father in the offering ceremony and being presented to the gods, while in the side chambers only the prince is present at the rite. The gods include Thoth, Ptah, and the four sons of Horus, protectors of the canopic jars (Amset, Hapi, Kuamutef and Kebehsenuf).

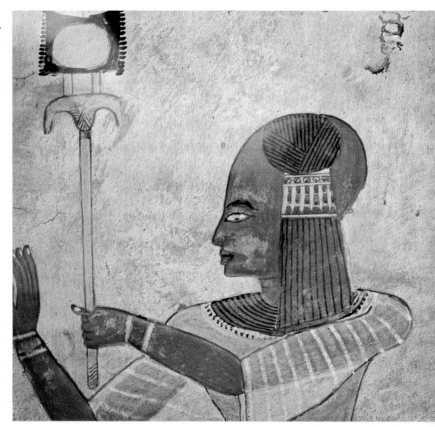

Khaemweset offering a large feather to the gods: the scene is almost identical to the one on p. 119, but here the prince is wearing a braid over his ear, with the rest of his head shaven. Probably Khaemweset was younger than his brother Amonher Khopechef. Also to be noted is a greater fidelity in the portrait of the boy.

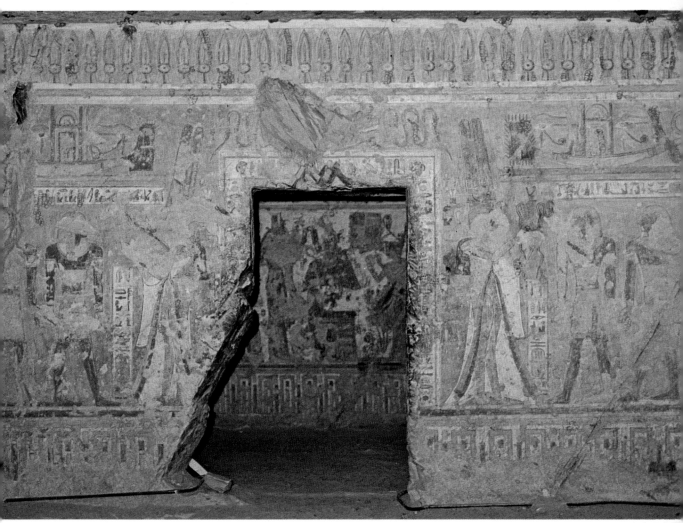

The Valley of the Workmen

The valley, with the village and the necropolis of the workmen, artisans and artists who built and decorated the tombs of Thebes, is now known as Deir el-Medina, that is "Monastery of the town", for this region too was occupied by Coptic monks. The town was active for five centuries (from 1550 to 1000 B.C.) and the number of inhabitants increased from an original nucleus of about 250 to more than a thousand. Of these, a tenth worked on the royal necropolis; the rest were engaged in the other subsistence activities (many women were employed in preparing grain for bread and barley for beer). Those who worked on the royal tombs called themselves "servants of the Place of Truth". They were first-rate experts, from the quarrymen and stone cutters, to the masons, sculptors and painters. The latter two almost always worked in two teams: one on the "left hand wall" and the other on the "right hand wall". These teams were directed by architects or artists and protected by special guard services. Every day a storeroom-scribe distributed and collected the wooden and copper tools.

The craft and the art were transmitted from father to son. Painting and writing required special skills in drawing. Writing in particular, always under the guidance of an expert scribe, was constantly connected with the highest administrative offices. Amon Ra above all was worshipped at Deir el-Medina and one of the prayers of these workers says: "Thou who givest succour to the poor let the supreme Court be prepared to give him justice, and let him who has corrupted life be defeated". The entire slope west of the village is taken up by the necropolis. The great number and variety of tombs, often larger and more complex than those of the nobles, range in type from chambers dug out of the rock to others equipped with superstructures, of considerable technical and architectural importance, built externally. It hardly needs saying that the latter are the most interesting and the richest, but very few are now still extant. The richest had a spacious court set in a precinct and a small entrance pylon. The chapel at the back was surmounted by a small pointed pyramid in brick with a small window on the east. A porch with columns stood before the chapel and inside, dug out of the rock, were one or more chambers on a level, with the niche and the simulacrum of the deceased at the back. The vertical shaft which led to the subterranean chambers was under the court or the chapel. Some tombs had chambers on the surface, with vaulted roofs and brick or ashlar fittings.

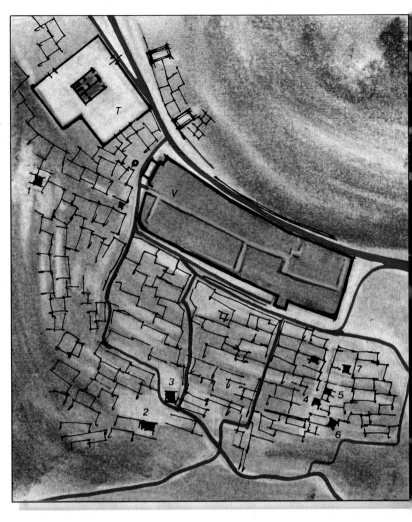

T Ptolemaic temple.
V Village.
1) Tomb of Neferabet "Servant in the Place of Truth west of Thebes".
2) Tomb of Ipy "Sculptor".
3) Tomb of Pashedu "Servant of the Place of Truth west of Thebes".
4) Tomb of Sennedjem "Servant of the Place of Truth".
5) Tomb of Khabekhet "Servant in the Place of Truth".
6) First tomb of Inherka.
7) Second tomb of Inherka "Vice master of the Double Land in the Place of Truth".

Sennedjem.

Nothing but the main chamber of the tomb of the "Servant in the Place of Truth", or official of the necropolis in the 19th Dynasty, remains. Numerous offerings of the products of the land are presented to the god Osiris. Scattered on the floor and on a table with three bell-shaped legs one can identify jars of wine on tripods, vegetables, a duck, jars of milk, a bunch of flowers, and also onions, sweets and baskets of fruit including one with a bunch of purple grapes.

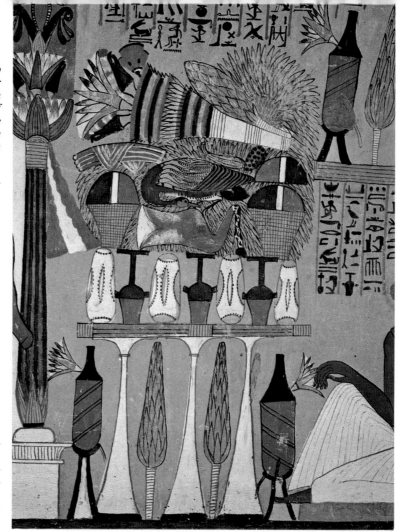

Back wall of the room where the "plan" of the Fields of Yalu is depicted; Sennedjem and his wife move on from the adoration of the gods to work in the fields. The bark of Ra-Harakhte, "Sun of the Morning", moves out to travel on the Celestial Nile which bathes the Fields of Yalu.

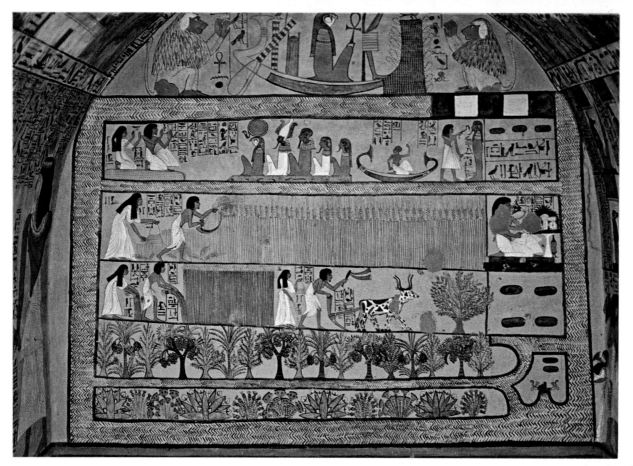

Inherka.

This "Vice master of the Double Land in the Place of Truth" in the time of Ramses III and Ramses IV, had commissioned two tombs at one and the same time. The one further up is less interesting; it contains a long list of kings and princes and what is probably a portrait of the owner shown as a scribe painting. In the valley tomb, close to the village, the paintings of animals and the decorations are unusually elegant and imaginative. A few details from this tomb are shown here. On this page: a large scarab with the "Hathor necklace"; four elegant walking Anubis figures, and finally a detail of the lovely ceiling, decorated with spirals and other motives (that of the sacred bull Apis can be identified) which prelude Mycenaean and Corinthian designs of many centuries later.

Two details of the solar barks with the deceased at the helm. In the one below, the goddess Isis followed by Thoth and Khephri, scarab-headed god, another personification of the rising son, are towards the prow.

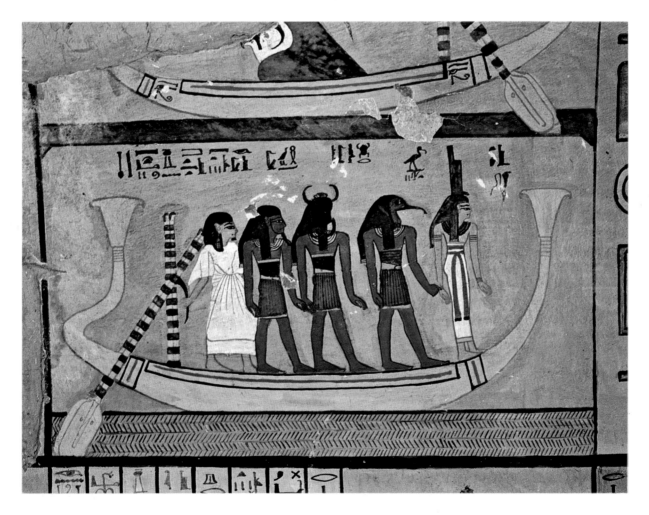

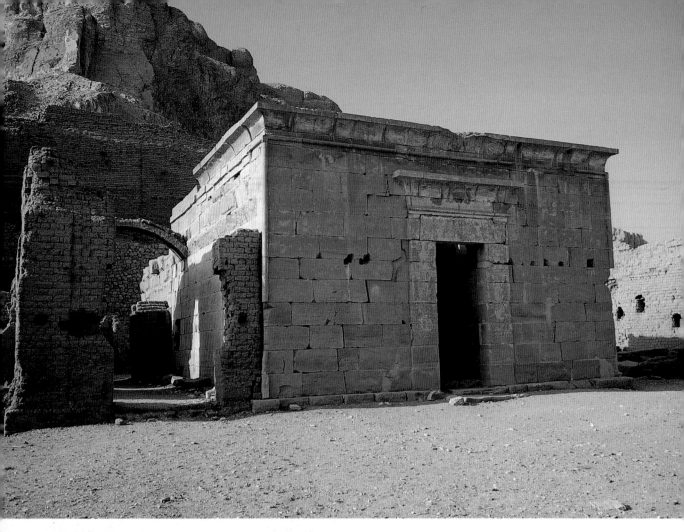

The Ptolemaic Temple.

This is the only temple which still has its storerooms and where the mud-brick enclosure walls are almost intact. It stands to the north of the Village of the Artisans and was begun by Ptolemy IV Philopator (221-203 B.C.) in honor of Hathor and Maat, the goddesses most venerated in the necropolis, and the great high priest-architect Imhotep, deified. Work on the temple continued under the successors of Ptolemy IV with decorations still being added by the last king of the Ptolemaic dynasty, brother of the Great Cleopatra VII. In the early centuries of our era, it was occupied by the Christian Copts. This was the "Monastery" — Medina — from which Deir el-Medina took its name and thanks to which the temple and its annexes were preserved. The building is of modest size with a court of about 50 meters set against the mountain, and a sanctuary of 15 meters by 9.

Of particular interest inside, in addition to the usual scenes of adoration and offering, is that of the judgement of the souls in which Philopator, Evergetes II (Ptolemy VIII) and Cleopatra II are depicted.

View of the temple facade from the portal of the enclosure wall.

Ramesseum

Ever since the 19th century, the temple complex built by Ramses II between Gurnah and the desert has been known by this name. The Greek historian Diodorus Siculo (80-20 B.C.) marveled at this gigantic and famous temple which is now no more than a few ruins. Oriented northwest southeast, the temple itself was preceded by two courts. An enormous pylon stood before the first court, with the royal palace at the left and the gigantic statue of Ramses II looming up at the back. Only fragments of the base and torso remain of the syenite statue of the enthroned pharaoh, 17 meters high and weighing more than 1000 tons. The scenes of the great pharaoh's army triumphing over the Hittite forces fleeing before Kadesh, represented in line with the canons of the "epic poem of Pentaur", can still be made out on the pylon. Remains of the second court include part of the internal facade of the pylon and a portion of the Osiride portico on the right. Scenes of war and the rout of the Hittites at Kadesh are repeated on the walls. In the upper registers, feast in honor of the phallic god Min, god of fertility. On the opposite side of the court the few Osiride pillars and columns still left can furnish an idea of the original grandeur. Scattered remains of the two statues of the seated pharaoh can also be seen, one in pink granite and the other in black granite, which once flanked the entrance to the temple.

Twenty-nine out of the forty-eight columns in the great hypostyle hall (m 41 x 31) still stand in the central rows. They are decorated with the usual scenes of the pharaoh before various gods. Part of the ceiling decorated with gold stars on a blue ground has also been preserved. The sons and daughters of Ramses appear in procession on the few walls left. The sanctuary was composed of three consecutive rooms, with eight columns and the tetrastyle cell. Part of the first room, with the ceiling decorated with astral scenes, and a few remains of the second room are all that is left.

Vast storerooms built in mud bricks stretched out around the temple. Traces of a school for scribes were found among the ruins. A temple of Seti I, of which nothing is now left but the foundations, once stood to the right of the hypostyle hall. It consisted of a peristyle court with two chapel shrines. The entire complex was enclosed in mud-brick walls which started at the gigantic southeast pylon.

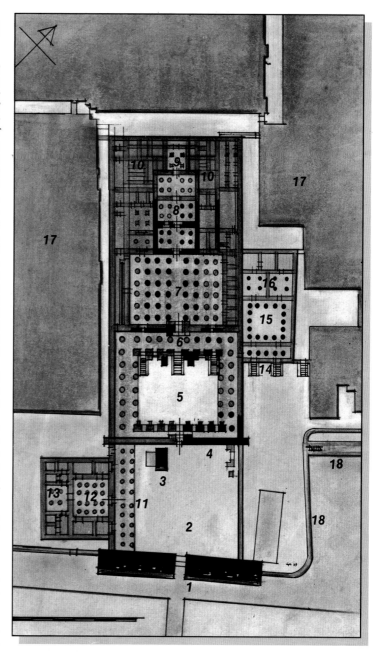

Temple of Ramses II.
1) Great entrance pylon to the "Ramesseum".
2) First court.
3) Gigantic statue of the seated pharaoh.
4) Second pylon.
5) Second court with portico of Osiride pillars on the transversal sides.
6) Vestibule of the temple higher up.
7) Hypostyle hall with a higher central nave.
8) Three lesser hypostyle halls.
9) Tetrastyle sanctuary.
10) Chapels, sacristies, and cells for the priests.

Palace of Ramses II.
11) Facade with double colonnade.
12) Hypostyle hall of the palace.
13) Throne room.

Temple of Seti I.
14) Portico of the facade higher up.
15) Temple court.
16) Double sanctuary.
17) Storerooms of the "Ramesseum".
18) Mud-brick walls and earth bastions.

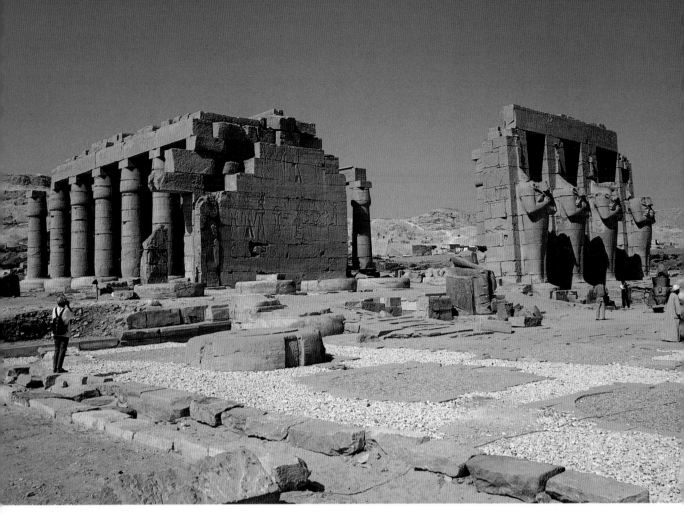

Partial view of the Ramesseum, which Diodorus Siculo called the «Tomb of Ozymandias», referring to one of the names of Ramses II, Usermare. On the right can be seen the four Osiride pillars of the facade vestibule of the hypostyle hall. The term Osiride is used to indicate the pillars against which statues of the pharaoh in the guise of Osiris are set.

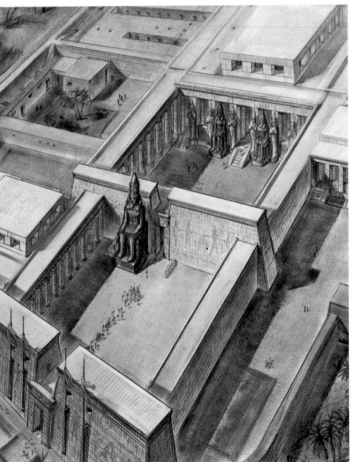

Reconstruction of the Ramesseum.

The gigantic statue of the pharaoh is set in the first court while the facade of the royal palace can be seen on the left. Next comes the second court with the temple vestibule and the two statues in pink and in grey granite. On the right, part of the temple of Seti I can be glimpsed.

Remains of the colossal statue of Ramses II: despite its enormous size, the colossus was worked with extraordinary attention to detail. It must have been 18 meters high and weighed about 100 tons: the fingernail by itself was 19 centimeters long!

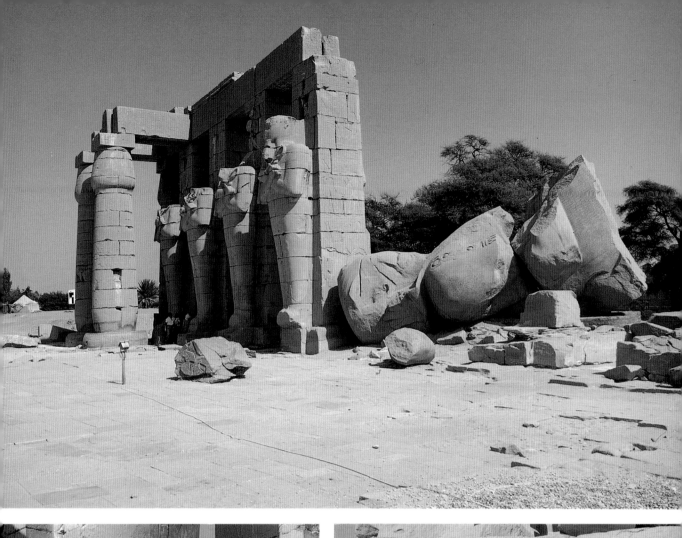

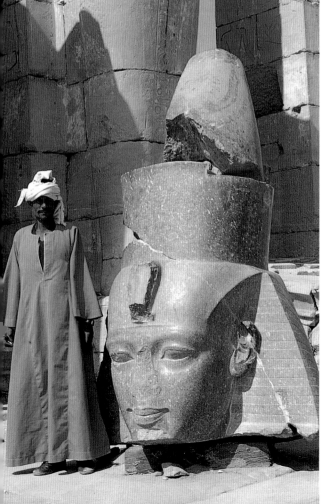

Medinet Habu

Temple of Ramses III.

The temple, together with other monuments of minor importance, stands in a zone called Medinet Habu after a village of the Christian Coptic period, most of which stood within the monumental complex. In this case too the new utilization of the temple saved most of the ancient vestiges, despite the fact that at various times parts were dismantled in attempts at recuperating the building stones. The complex consisted of the great temple of Ramses III surrounded by two sets of walls — the outer one simply a low wall — with fortified entrance gates to the south and north. In front of the great temple stood the small temple of Thutmosis I and the chapels of the Divine Votaries.

1) Landing stage.
2) Bastions of the low walls, "guard houses". Scenes with the king making offerings to Amon.
3) Circle of low crenellated walls.
4) Great South gate ("Royal Pavilion"). Scenes with battles and prisoners being offered to the gods.
5) High crenellated walls.
6) Great North Gate.
7) Nilometer.

Great Temple of Ramses III.
8) First pylon.
Scenes with battles and Asian captives being offered to the gods.
9) First court with Osiride pillar portico (right).
10) Second pylon with ramp flanked by statues.
11) Second court with Osiride pillars and colonnades (at the sides). Religious scenes with processions of boats.
12) Monumental vestibule with ramp, statues and Osiride pillars.
13) Vestibule colonnade. Scenes depicting the king and his children making offerings to the gods.
14) Great hypostyle hall.
15) Lesser hypostyle halls.
16) Sacristies and treasuries.
17) Sanctuary.
18) Enclosure wall of the temple decorated with scenes of the hunt, religious scenes, military expeditions and a religious calendar.
19) Enclosure wall of the temple with scenes of naval battles against the confederated peoples and the wars against the Libyans and the Syrians.

Palace of Ramses III.
20) Facade of the palace with the colonnade, entrance and "window of appearances".
21) Hypostyle hall.
22) Throne room.
23) Temple storerooms and dwellings.

Chapels of the Divine Votaress of Amon
I — Chapels of the princess Bhepenupet, daughter of Piankhy, of the queen Mehetenusekhet, wife of Psamtik I and of the daughter Nitocris.
II — Chapel of Amenardis, daughter of Napata.

Temple of Thutmosis I.
a) Roman forecourt of Antoninus Pius.
b) Ptolemaic pylon.
c) Colonnade of Nectanebo.
d) Pylon of Shabaka.
e) Court of the last of the Ptolemies.
f) Sacred cell of Hatshepsut.
g) Sanctuary of the three Thutmosis pharaohs.

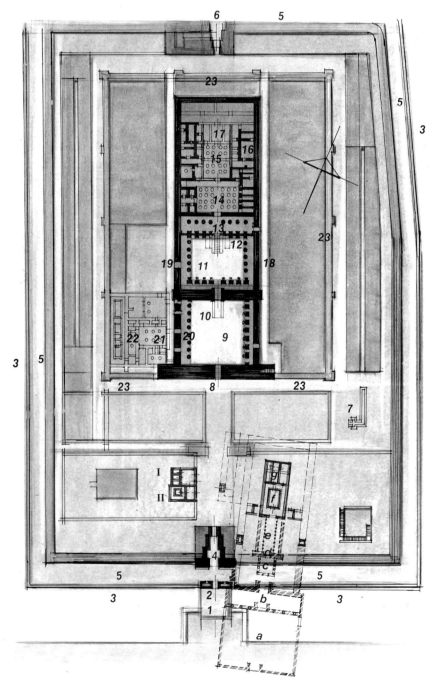

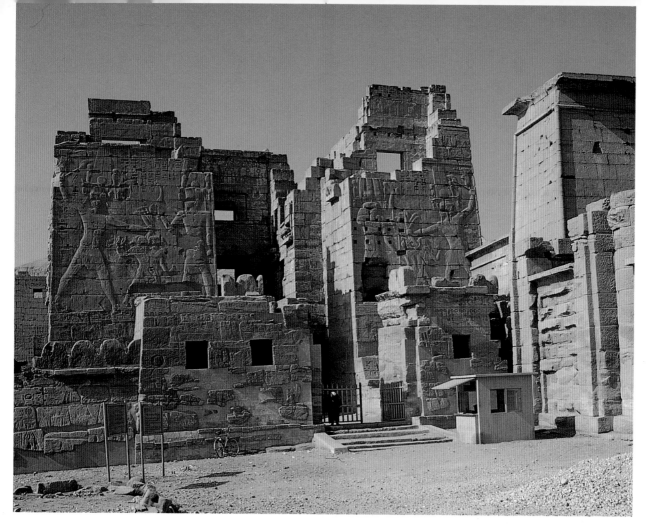

The Guardian Gate and the imposing South Gate, or Royal Pavilion, with the usual scenes of battles and prisoners being offered to the gods.

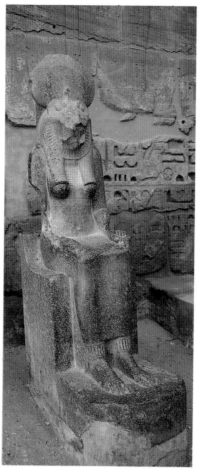
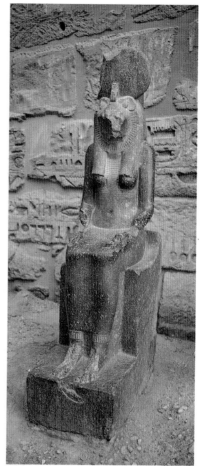

Two representations of the goddess Sekhmet, the bride of Ptah, the lion goddess whose name means «The Powerful»: the lion head is surmounted by the solar disk and uraeus.

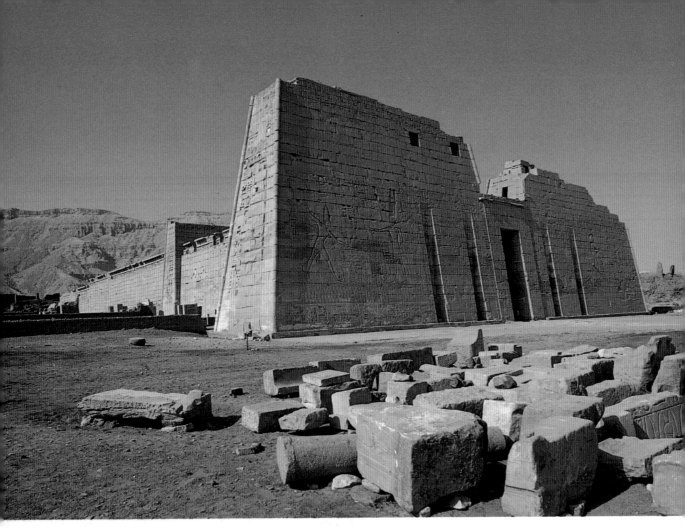

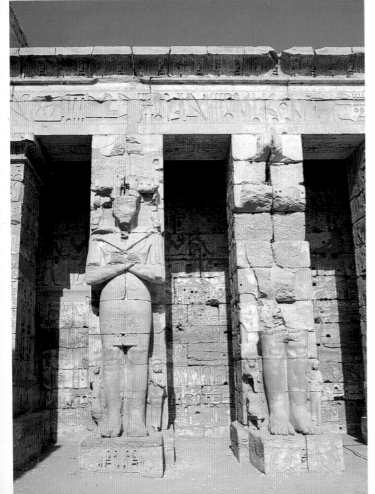

The victories of the pharaoh are sculptured on the first pylon of the Temple of Ramses III. The four grooves in which the flagstaffs were inserted can still be seen.

Osiride pillars in the first court.

Reconstruction of the monumental complex in the time of Ramses III. Moving upwards from the bottom: the landing stage on the Nile; the Guard Gate with the low crenellated walls; the great South Gate with high crenellated walls; on the right, the small temple of Thutmosis and the sacred lake; the first pylon and the temple walls; the first court and, on the left, the Royal Palace; the second pylon; the second court; the vestibule of the great hypostyle hall; the Sanctuary; the Great North gate.

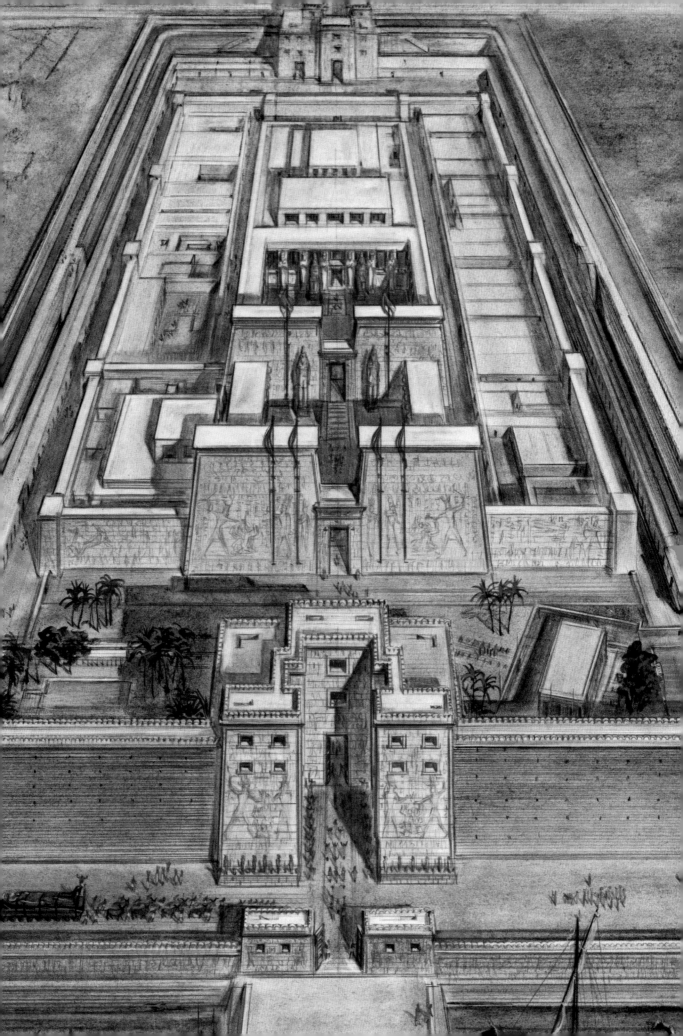

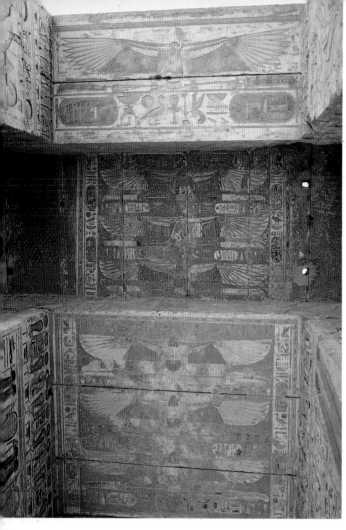

Details of the decoration inside the temple of Ramses III: to be noted on the lintel is the vulture goddess Nekhbet protecting Upper Egypt, and symbolically, the entire imposing temple complex.

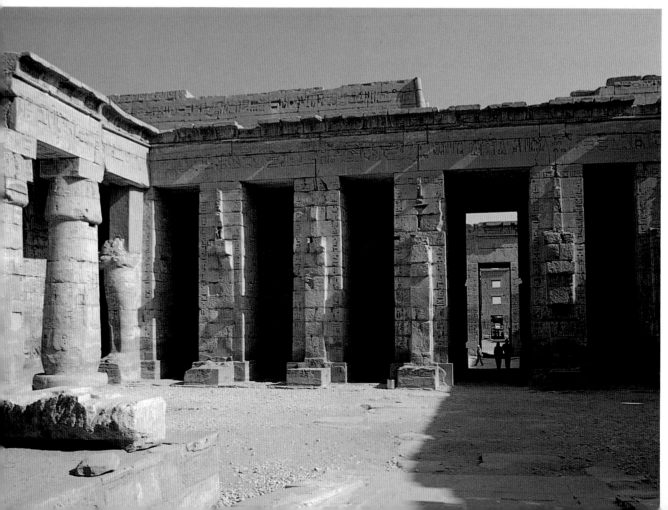

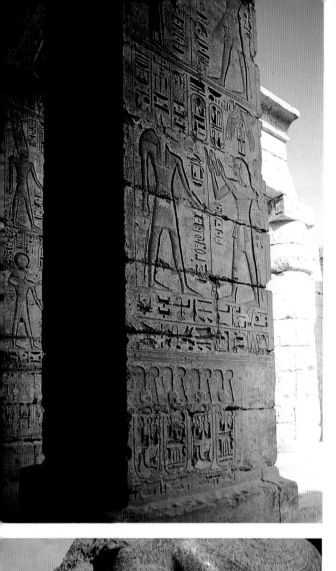

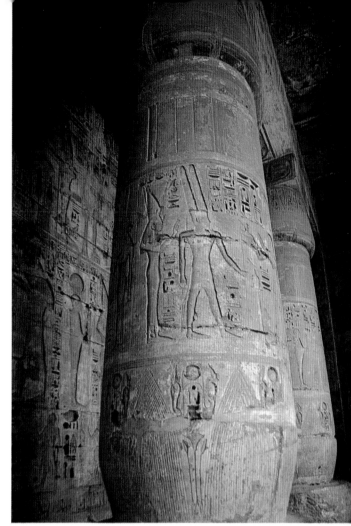

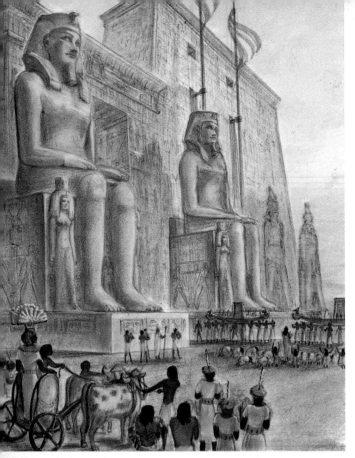

Colossi of Memnon.

This is what the famous statues of Amenophis III (Amenhotep) are called. They are the last remains of the immense mortuary temple built at the beginning of the 14th century B.C., a sort of outpost in fertile land of the necropolis which lay behind. Unfortunately the state of preservation of these monolithic sandstone statues, 18 meters high (the equivalent of a modern six-story building), a meter higher than the giant of the Ramesseum and weighing almost 1,300 tons, is very poor.

Strabo, the Greek historian and geographer, reported that most of the temple fell in the earthquake of 27 B.C. while the Colossi cracked from their shoulders to their hips. From then on the two statues began "singing" when the sun rose. This led to the creation of the "Oracle of Memnon" (for the Greeks Memnon was a mythical king of Ethiopia, son of Aurora) and soon became a pilgrimage site for Greeks and Romans, including the emperors Hadrian and Septimius Severus. When the latter, in the hopes of finding favor with Memnon, had the statues restored, they stopped speaking.

The "Colossi of Memnon" guarding the gigantic entrance pylon to the mortuary temple of Amenophis III, as they were three thousand years ago. In this imaginary reconstruction the procession of solar barks is entering the temple.

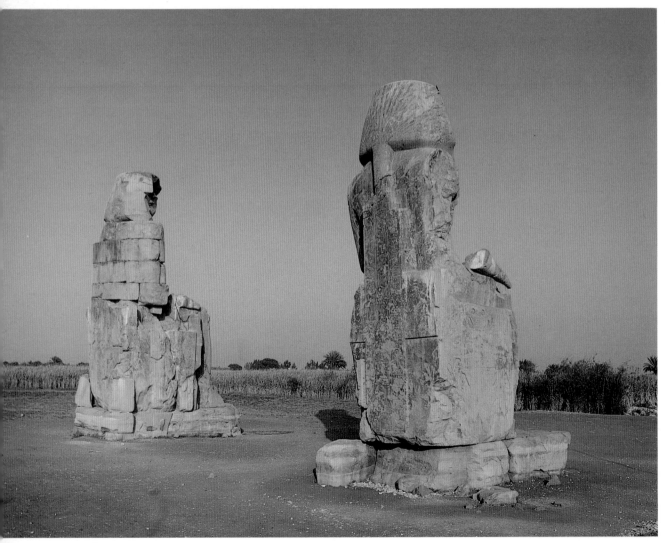

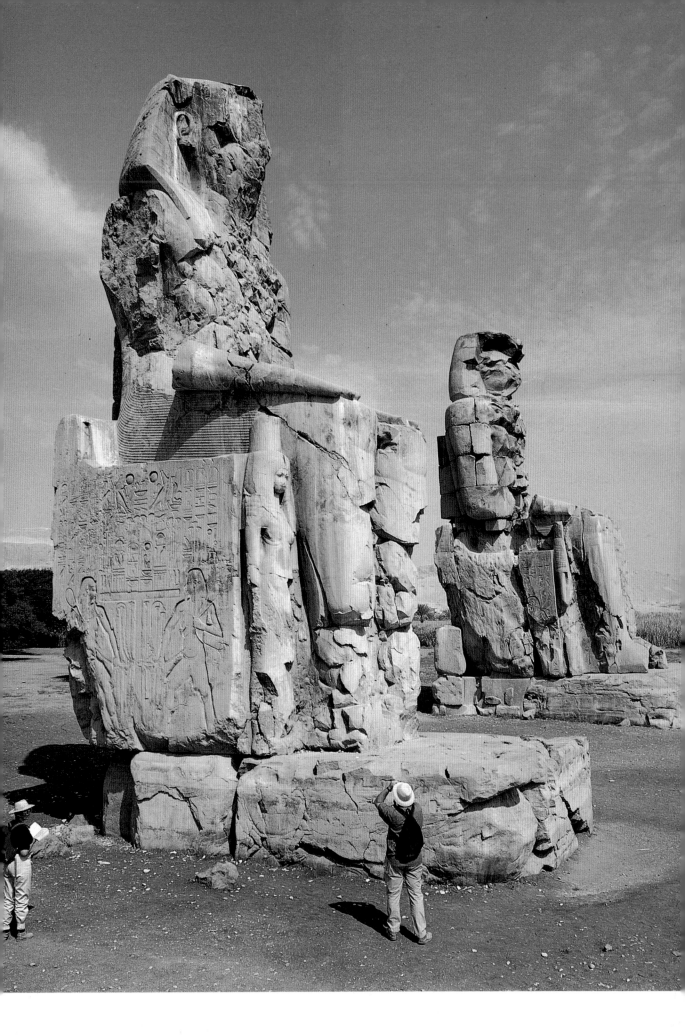

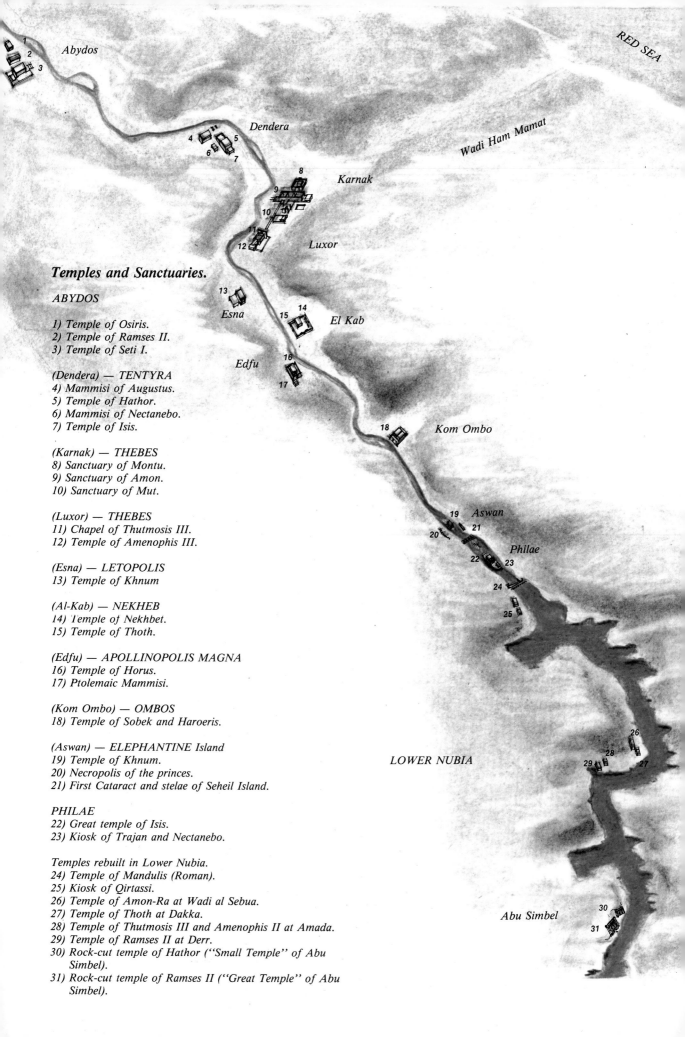

RED SEA

Abydos

Dendera

Wadi Ham Mamat

Karnak

Luxor

Temples and Sanctuaries.

ABYDOS

1) Temple of Osiris.
2) Temple of Ramses II.
3) Temple of Seti I.

(Dendera) — TENTYRA
4) Mammisi of Augustus.
5) Temple of Hathor.
6) Mammisi of Nectanebo.
7) Temple of Isis.

(Karnak) — THEBES
8) Sanctuary of Montu.
9) Sanctuary of Amon.
10) Sanctuary of Mut.

(Luxor) — THEBES
11) Chapel of Thutmosis III.
12) Temple of Amenophis III.

(Esna) — LETOPOLIS
13) Temple of Khnum.

(Al-Kab) — NEKHEB
14) Temple of Nekhbet.
15) Temple of Thoth.

(Edfu) — APOLLINOPOLIS MAGNA
16) Temple of Horus.
17) Ptolemaic Mammisi.

(Kom Ombo) — OMBOS
18) Temple of Sobek and Haroeris.

(Aswan) — ELEPHANTINE Island
19) Temple of Khnum.
20) Necropolis of the princes.
21) First Cataract and stelae of Seheil Island.

PHILAE
22) Great temple of Isis.
23) Kiosk of Trajan and Nectanebo.

Temples rebuilt in Lower Nubia.
24) Temple of Mandulis (Roman).
25) Kiosk of Qirtassi.
26) Temple of Amon-Ra at Wadi al Sebua.
27) Temple of Thoth at Dakka.
28) Temple of Thutmosis III and Amenophis II at Amada.
29) Temple of Ramses II at Derr.
30) Rock-cut temple of Hathor ("Small Temple" of Abu
 Simbel).
31) Rock-cut temple of Ramses II ("Great Temple" of Abu
 Simbel).

Esna

El Kab

Edfu

Kom Ombo

Aswan

Philae

LOWER NUBIA

Abu Simbel

THE HOUSE OF GOD

In 3000 B.C. the temple looked like a gigantic "mastaba", in other words a large parallelepiped with slightly sloping walls and a large crowning cornice. The vast spaces inside echoed those of the "king's house", arranged along the main axis, and included audience halls and rooms for official ceremonies as well as for the Lord of the house. In the temple, the large halls which served as vestibule and offering places were followed by the sanctuary or shrine itself with the chapel of the titular god at the center flanked by four or six sacred chapels and all around sacristies and oratories.

Large pillars divided the main halls into two or three aisles. Sometimes open to the sky, they might be defined as courts surrounded by pillared porticoes (see Temples of Khafre and Pepi II). In its structural features the temple remained basically the same throughout the centuries. Those dating to the third millennium, however, are distinguished by the fact that the rooms along the axis seem to have been "dug out" of the parallelepiped block, in other words the walls do not follow the perimeter of the rooms, as was to be the case later, but fill the entire space between the rooms and the external rectangular perimeter.

Various unique features also appeared in the architecture of the third millennium B.C., with the work of the architect Imhotep (2700 B.C.). Zoser's mausoleum was marked by the invention of fluted tapering columns with capitals, a rudimentary hypostyle hall where the ceiling was supported by numerous columns, and, to judge from the monuments at the base of the pyramid, it also seems likely that the temple at the time was vaulted and had a colonnade on the facade.

At the end of the third millennium another extraordinary innovation took place with Montuhotep I (2060-2010 B.C.). In his imposing complex in Deir el-Bahri, the pyramid once more became the culminating point of the composition, and the temple was furnished with a huge hypostyle hall with 80 columns before which stood a court with a portico on four sides. Internal and external and frontal porticoes also made their appearance with triple rows of columns and double rows of pillars. It was not until four hundred years later that this concept turned up again in the temples built for Thutmosis I (1530-1520 B.C.) and Hatshepsut (1505-1484 B.C.), the pharaoh queen, by the architect Senmut, priest and lover of the queen: the temple to the Ka of the pharaoh and the queen at Deir el-Bahri and the temple to Amon-Ra at Karnak.

At Deir el-Bahri, Montuhotep's old solution was developed into a complex of porticoes and small temples which faced out onto spacious hanging gardens which sloped down towards the valley.

The principal features of the temple that then became the canon for all future times were defined at Karnak. The new temple differed from those of the preceding millennium in the grandeur of the halls which led to the sanctuary, the preciousness of the tabernacle (sometimes replaced by the solar bark) and the number of chapels, oratories and sacristies which occupy all available space, replacing the massive walls of the old temple. But the most obvious variations were the wealth of paintings which overflowed onto the ceiling and the outer walls and the architectural setup in front of the temple, which became an integral part of the "house of God".

The decorations stress the purpose of each area of the temple and on the whole illustrate the temple as a synthesis of the cosmos which receives the god. As such the pavement represented the earth, the ceiling, the sky (which was therefore painted with stars while great sacred birds hovered on the architraves); the capitals were like immense flowers which open and close as day follows night. The sacred mystery enacted in each room is shown on the walls: thus in the large entrance hall the god is shown in his various manifestations as he goes forth to meet the pharaoh, while all the regions of the Nile bearing flowers, fruit and food for the cult, with the pharaoh hunting animals to take as sacrifice, appear in the offering room. Around the "sancta sanctorum", the tabernacle of the god, the sacred barks carried in procession are shown. The various cults, including that of the divine birth of the pharaoh, are depicted on the walls of the chapels all around. The rooms to the north present the Osirian mysteries with the chamber of primordial water, that is the world prior to and after creation and the rooms to the east bear the realm of the vital spirit Ra, with the chamber of fire and that of the festival for the new year. Externally and in the rooms where the people were permitted to enter, the deeds of the pharaoh, accomplished for the glory of the absolute god and the greatness of his people, are represented, including the consecration of the temple, the processions and the festivals of the god and of the king.

The architectural elements added to the temple in 1500 B.C. consisted of one or more courts with imposing colonnades on the sides, where the worshippers participated in the life of the temple. Two broad massive towers on either side of the entrance, their facades and ends sharply sloping, created the typical entrance structure known as a pylon. Two or six colossal statues of the king and two obelisks, taller than the pylon, were set next to the monumental portal.

Statues of the king filled the courts and the inner halls almost as if they were ensuring his presence, indispensable in all the religious rites.

The sacred avenue, flanked by a long row of sphinxes and chapels, began before the last pylon; all around the temple were gardens, sacred lakes, vast storerooms, living quarters for the priests and the royal palace which overlooked the most impor-

tant court. The entire complex of buildings was enclosed in walls, sometimes with towers, and with monumental gates.

In the temple plan as defined by Senmut what strikes the eye most is the obelisk, the extremely tall pointed monolith in granite. As was the case with the pyramid, the obelisk too seems to appear out of nowhere, with no apparent cause or practical or artistic point of reference despite the fact that even the first true obelisk (Sesostris III of circa 1970 B.C. in Heliopolis, 24.5 meters high and weighing 121 tons!) must have required exceptional skill both in the making and in its erection. It must also be kept in mind that this architectural *"absurdity"* is not the whimsy of a single circumscribed period in history, for 200 years later Seti I was called "he who fills Heliopolis with obelisks".

A thousand years later we still have obelisks with Psamtik II and Nectanebo II, last king of the Thirtieth Dynasty. Obelisks without inscriptions may still have been made in Roman times. The most famous is the one taken to Rome and set up in St. Peter's square in 1586, an ingenious undertaking that went down in history. How much greater must Hatshepsut's enterprise of 3000 years earlier have been.

In seeking for a valid model one is again induced to turn to that fund of experiences and memories whose roots are lost in the mists of time, that mysterious archetype which generated the so-called

Construction and decoration of the Temple.

1) *Weight-lever raising a rough-hewn capital to the second level.*
2) *Weight-lever setting into place the drum of a column.*
3) *Weight-lever setting in place a rough-hewn capital.*
4) *Gigantic weight-lift positioning a monolithic covering element.*
5) *Trimming the beams and the covering.*
6) *Trimming and painting of the capitals. Removal of fill-in begins.*
7) *Trimming and painting of the columns begins. Fill-in continues to be removed.*
8) *Columns and internal walls of the temple are completed. Fill-in is completely removed.*
9) *External decoration is terminated and remaining material is carried away.*

menhirs, those first votive monuments in the form of enormous slivers of stone standing upright in the ground. To arrive at the cause that prompted the idea of the obelisk, it is necessary to penetrate Egyptian thought and its all-embracing solar cult. An important indication is provided by the solar temple of Niuserre (2500 B.C.) in Abusir, where a gigantic obelisk can be seen issuing forth from a truncated pyramid on the main part of the temple. This petrified image takes us back to the primordial tumulus from which the sun rises. It must also be recalled that the Temple, in other words the "House of God" itself, was, from 2000 B.C. onwards, the concrete expression in architectural terms of the solar myth: the Sanctuary of the temple is the dwelling where the sun rests during the night; the uppermost part of the hypostyle hall is the zenith of the sun's course, and the flower capitals of the taller columns are "open", while those of the lower columns are "closed" because they find themselves in the zone oriented towards the sun's nadir (the hall itself is called the "*green papyrus hall*" for the papyrus symbolizes the life-giving force of the sun); the pylons facing east and the two great towers symbolize Isis and Nepthys, "*the two goddesses who hold high the solar disk when it shines high in the sky*". Lastly the two obelisks in front of the towers recall the horns which frame the sun on the heads of the goddesses, and can once more be interpreted as another gigantic ideogram, made of stone, which rises skywards like the arms of the Ka. This time it is not the sun which descends with the pyramid of its infinite rays of light to take all creatures into its embrace, but it is each of the creatures which stretches forth its arms to be joined to infinity.

The temple which had taken form by the middle of the second millennium was to remain fundamentally the typical temple throughout ancient Egypt

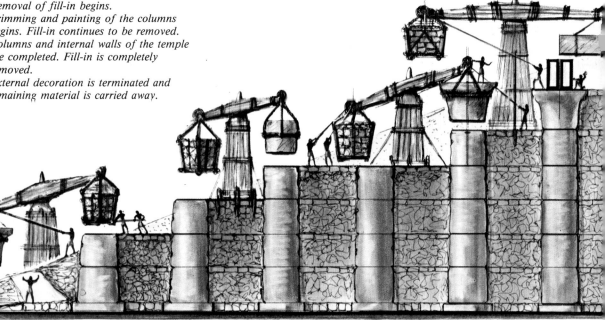

and the only exception to these canons was introduced by Akhenaten (1372-1354 B.C.). The "heretic pharaoh" radically changed the "house of God" in deference to the religion of Aten revealed to all. The building was limited to a modest shrine surrounded by vast courts where countless altars stood scattered around the pharaoh's altar to receive the offerings of the people.

The hypostyle hall became particularly important during the reign of Amenophis III (1408-1372 B.C.) but it was above all with the work of the great builders Seti I and Ramses II (from 1312 to 1235 B.C.) that the columned hall became a gigantic organism set before and sometimes even separated from the temple. With Seti I we have the affirmation of the porticoed facade and the succession of courtyards of diminishing size. Great temples were also realized by Ramses III (1198-1188 B.C.) but after him new constructions were few and the subsequent pharaohs often simply restored or enlarged the old temples.

In the Ptolemaic period construction of "houses of the gods" was taken up anew and the old canons were rigidly respected and simplified in finely balanced works of architecture.

From the third millennium on there were no basic changes in the rites performed in the temple except for a gradual increase in the participation, albeit still outside the temple, of the masses. Only initiates and priests together with the pharaoh were admitted within. Most of them awaited the "rising of the god" in the large vestibule. And only "those who were pure" could enter the "hall of the rising", in other words only the "Vab" priests who prepared the offerings and initated the secret rites. At the back, in the heart of the sanctuary only the high priests and the pharaoh entered. Only they had access to the sacred bark, which "bears the beauties of god", and to the "mysterious places"

where the sacred objects were kept, and then they removed the seals and opened the doors of the tabernacle: god was finally "visible". New songs rose in the air: "Oh wake great god, reawaken in peace. Full of serenity is thy reawakening". The statue was washed, ornamented with linen wrappings, sprinkled with perfumed oils and the eyes and mouth were painted. Then came the offering of food perfumed with flowers. Every action was accompanied by a sacred dialogue addressed to the statue.

The announcement that the god was once more awake was first given in the offering hall, then in the hypostyle hall filled with dignitaries and the pharaoh's courtesans, and lastly in the large courts where all the faithful were gathered. The sun had once more returned to illuminate the earth and give life to all.

In addition to the daily ritual, there were numerous feast days for the pharaoh and the gods on those days which were most important in agriculture. As early as 4000 B.C. every city celebrated its patron god repeatedly, at the beginning of every month and of the year, which coincided with the end of the great drought.

As Thebes developed, the most important feast of the year became the "Opet" which took place between the sanctuaries of Karnak and Luxor. The culminating point was when the sacred bark of Amon-Ra left the temple of Karnak. Carried by thirty priests, the bark of the almighty god was followed by that of Mut (Amon's bride, spiritual queen of all Egypt and therefore wearing the double crown) and by that of Khonsu (Amon's son, the lunar god destroyer of evil). Behind the Theban triad came the pharaoh with his court and the priests and priestesses singing ancient chants. Then came musicians and dancers flanked by rows of soldiers from all parts of the empire.

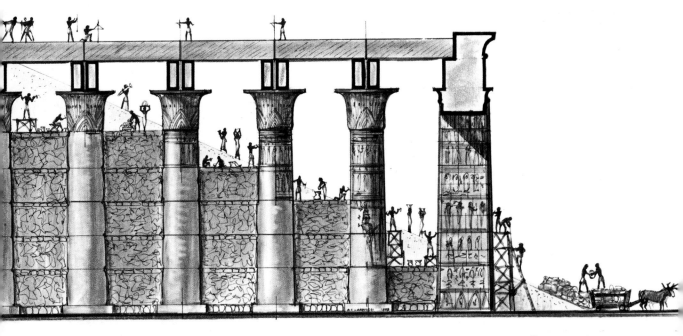

The procession moved along the avenue of sphinxes, halting before the chapels along its way to recite prayers and make particular offerings. When it reached the Nile, the procession continued on sacred barges drawn along by the festive crowd on the banks. Upon their arrival at the temple of Luxor the barks with the tabernacles were placed in the sanctuary for a few days and then amidst rejoicing, prayers and song and music, began the journey back surrounded by the joyous crowd in communion with its God.

Construction of the temple and erection of the obelisk

In the second millennium many problems inherent in the construction of the temple could be solved by applying the techniques acquired in the periods of the pyramids; but there were also others not to be slighted.

The construction of the pylons presented no particular problems since it was simply a matter of building massive walls with ashlars on the outside and an inner filling of rubble.

In "mounting" the ashlars and for the "dry joint masonry" (it pays to recall that the masonry was still without any kind of binder or mortar) the usual kind of wood scaffolding and weight-levers could be used since weights of less than ten or twenty hundredweight were involved. The construction of the hypostyle hall and the erection of the obelisk however posed new and arduous problems.

How to mount the numerous gigantic columns (composed of cylindrical blocks and heavy capitals) as well as the roofing consisting of even heavier beams and monolithic slabs was the principal difficulty encountered in building the hypostyle hall. The closeness of the numerous columns, the fact that the solid and empty spaces were almost equal, the horizontal repetition of all the blocks comprising the column suggested the use of the system, at the time the most practical and sure, of mounting the blocks level by level, filling in, one after the other, the spaces between the columns with orderly rows of stones so as to have a solid flat working level at all times. The efficient lever-machines raised the heavy cylindrical sections of the columns and the great capital from one level to another; and more powerful machines (like those which had made it possible to mount the "King's chamber" in the pyramid of Khufu (Cheops) a thousand years earlier) set the high beams and broad roofing slabs in place. Once the process of mounting had been terminated, the work of decoration and finishing began — from top to bottom — and the covered hall was emptied level by level, while most probably the filling material was used in mounting another sector of the temple or to fill in

the pylon towers. As the interspaces were gradually emptied, the capitals and the columns were completed by expert stone cutters and at the same time — with the help of temporary movable scaffolding — the finished areas were sculptured and painted For the obelisk, the problem was how to set a monolithic tower — from 20 to 30 meters high and weighing from a hundred to three hundred or more tons — upright on a pedestal, in other words three or four meters above ground level. At the time it would have been difficult to build suitable wooden cradling and a weight-lever of suitable size (remember that in 1500 B.C. neither pulleys nor winches were known). On the other hand, the usual hypothesis that a provvisory ramp was also used for the great obelisks (a hypothesis I have already discarded with regards to the pyramid) is unacceptable above all because it would have been impossible to govern the monolith in the last phase of sliding and setting it upright on its base.

I maintain, more simply, that the presence of the great pylon provides the key. In fact the massive structure seems to have been created purposely to provide a valid support behind the Great Obelisks: a support not for an impossible weight-lever but for a system of ropes and counterweights that would initially have served to drag the mastodontic monolith up to the upper edge of the base, and then to turn it into the right vertical position.

It is also probable that the ancient method of levers applied alternately on the right and on the left with wedges inserted in the underlying part were used to raise the horizontal block short distances.

Erection of the obelisk.

1) *Hauling the obelisk from the road to the inclined ramp that leads to the upper part of the base.*
2) *Trimming and finishing touches. Attaching the monolith to the counterweights.*
3) *Propping up the "base side" of the obelisk in preparation for rotation.*
4) *Rotation of the obelisk rigidly "hinged" at the base side and guided by ropes from the ground and at the summit.*
5) *Positioning of the obelisk guided and oriented by the draft ropes. At the base a "box" of sand, compressed between the struts of the hinge, acts as a cushion for the final settling.*
6) *Behind the pylon, the many large baskets of counterweights slide down and pull up the obelisk. They are gradually replaced by ever lighter ones as the obelisk approaches its vertical position.*

Types of columns and capitals.

a) Palm capital.
b) Proto-Doric.
c) Campaniform or bell capital.
d) Lotus bud or papyrus bud.
e) Hathor capital.

Parts of the temple.

1) Adjuncts to the pylon: obelisks and enthroned colossi on either side of the portal; standing colossi and pennons or flagpoles with standards and banners.
2) Great portal with a terrace on top.
3) Massive lateral pylons with stairs and rooms on several floors.
4) Large court with porticoes of some kind at the sides.
5) Great hypostyle hall.
6) Offering room.
7) Separate depositories for offerings of food and drink.
8) Vestibule around the sanctuary.
9) "Sancta sanctorum" with the tabernacle of the God.
10) Chapel of the sacred bark.
11) Chapels, sacristies, cells of the priests of the sanctuary.
12) Uncovered corridor between the temple and the outer walls.

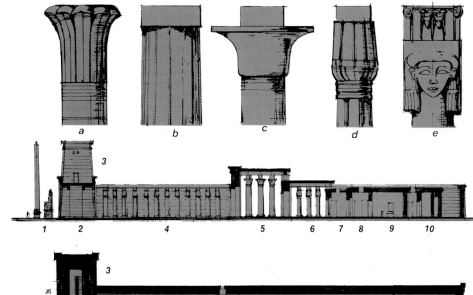

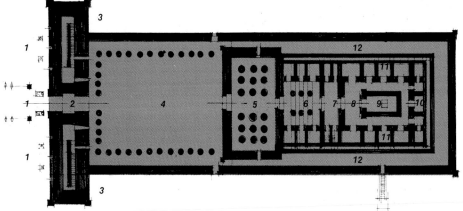

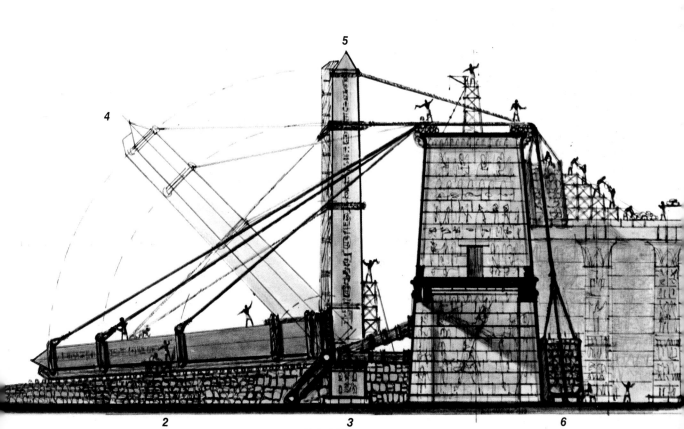

Luxor

The great city of Thebes, for centuries capital of the empire, famous the world over and called by the Greeks "Thebes of the hundred gates", began its decline in 672 B.C. when it was sacked by Ashurbanipal. In 84 B.C. the city was almost completely destroyed by the Ptolemies, the new rulers, in their attempt to quench the nationalist feeling that had risen in opposition to them and their new capital, Alexandria. By Roman times Thebes was a sea of ruins. In the early centuries of the Christian era, Coptic churches sprang up amidst the ruins, followed by mosques, with the formation of new villages. Luxor rose on the ruins to the south of the canal which had divided the old capital, and the small village of Karnak came into being to the north. In Luxor the only conspicuous sign of the past is the temple called "South Harem of Amon" by the Egyptians, a temple almost entirely built by Amenophis III, enlarged by Thutmosis III and completed by Ramses II. A striking singularity in the ground plan is that of a second larger hypostyle hall, now nothing more than a colonnade, set after the temple court.

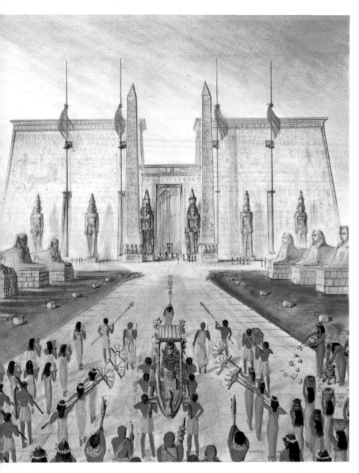

Reconstruction of the entrance to the temple of Luxor.

Shown are the enthroned granite colossi and the two obelisks which flank the portal, the pennons with standards and the four statues in pink granite. These elements have all been derived from ancient depictions and the still visible remains. In the foreground, the arrival of a procession from Karnak.

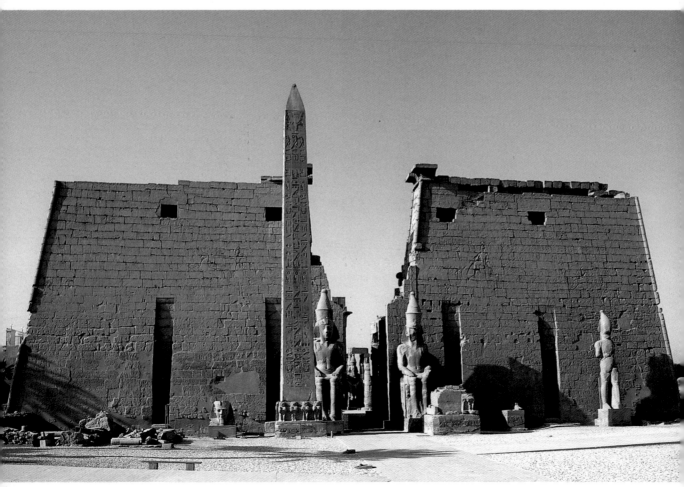

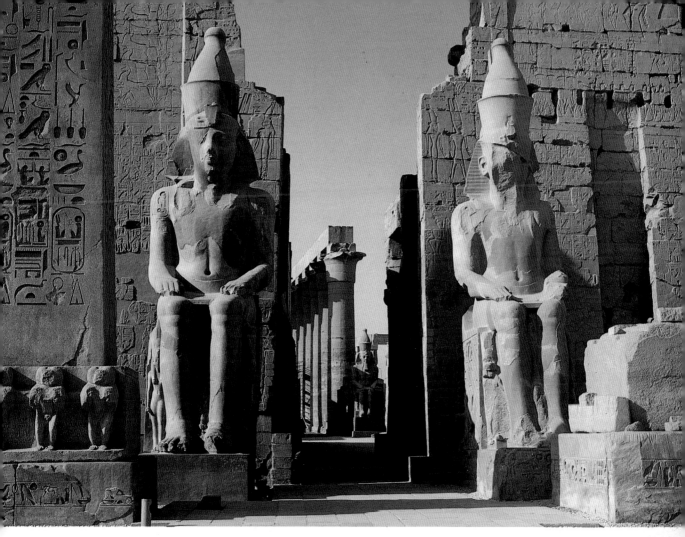

The entrance to the temple of Luxor, with the court of Nectanebo and the pylon of Ramses II; the two colossal statues of the pharaoh set against the pylon; detail of the first court of Ramses II, with the portico of the temple of Thutmosis III.

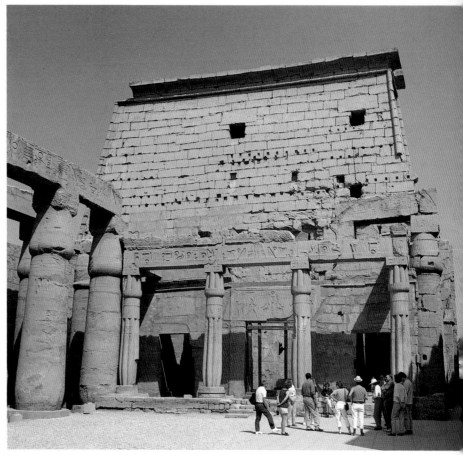

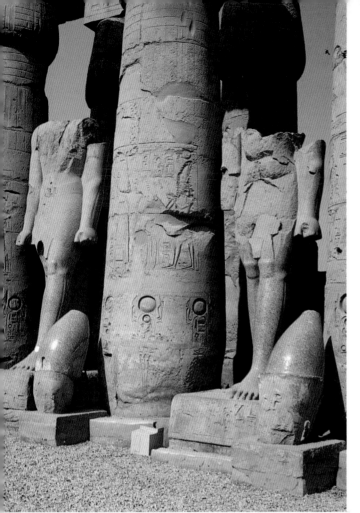

The principal elements constituting the temple of Luxor, beginning with the North entrance, towards Karnak, are as follows:
Avenue of the Sphinxes (the sovereigns of the 30th Dynasty humanized their features); girdle wall and gate of Nectanebo, now almost completely destroyed; Great Pylon of Ramses II with the Colossi and obelisks; Great Court of Ramses II which includes the triple shrine of Thutmosis III: on the unroofed sides, a double row of papyrus-bud columns; in the intercolumniations at the back, Osiride statues; at the exit at the back flanking statues of Ramses II and Nefertari; on the walls decorations with religious scenes. Pylon of Amenophis III with the entrance room reduced in size by the half brother of Alexander the Great; great colonnade with three aisles (length 52 m, ht. 16 m) with fourteen campaniform columns, probably the beginning of a gigantic hypostyle hall with the walls decorated by Tutankhamen and Horemheb. Second great court with a double row of lobed capitals with papyrus-bud capitals; hypostyle hall with 32 columns like those in the court on which it opens; tetrastyle offering chamber, on the left, chapel of the birth of Amenophis III. Sanctuary created by Alexander the Great; vestibule and "Sancta Sanctorum": with scenes of Amenophis presented by Horus and Aten to Amon Ra.

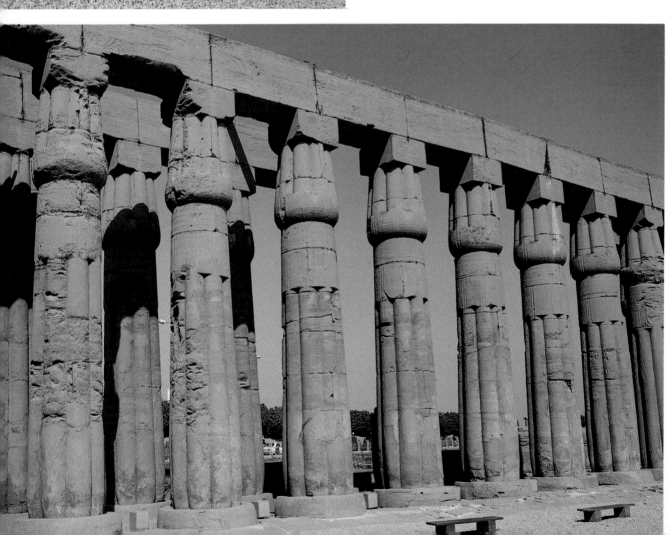

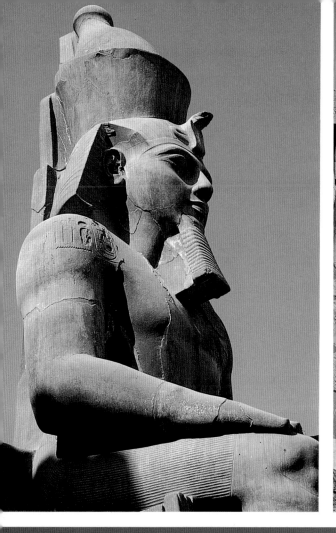

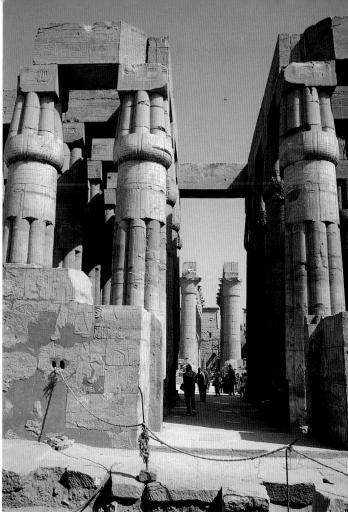

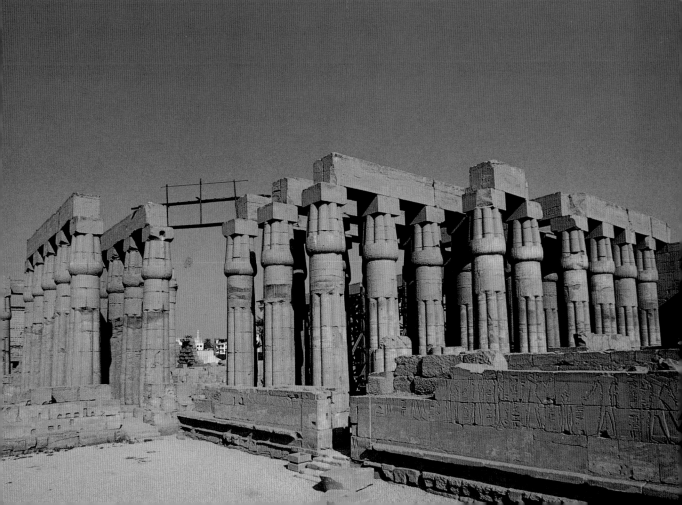

There is more to Luxor than just the temple of Amon-Ra: it is also a delightful and highly colored market which attracts and enthralls the tourists.

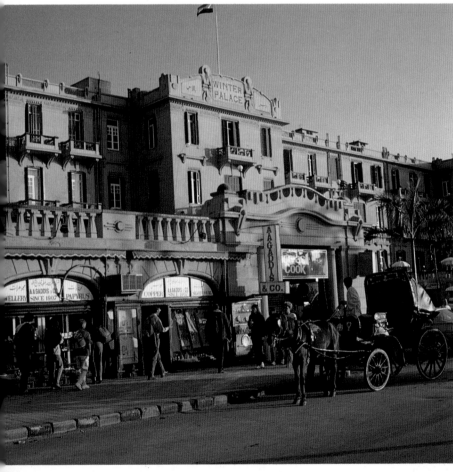

The famous Hotel Winter Palace along the Nile in Luxor.

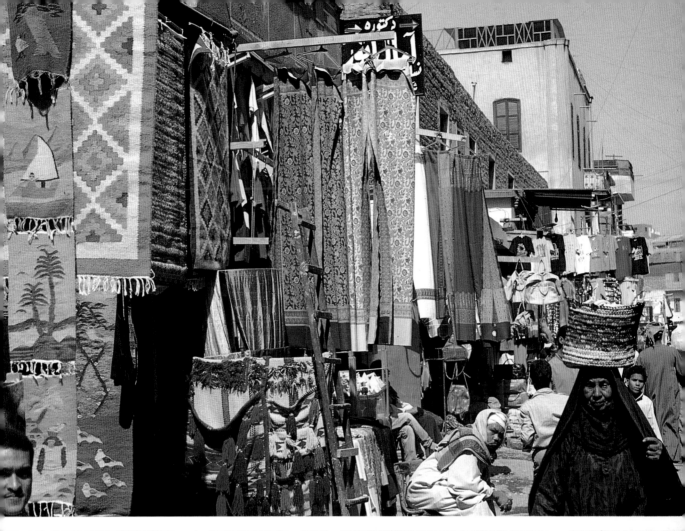
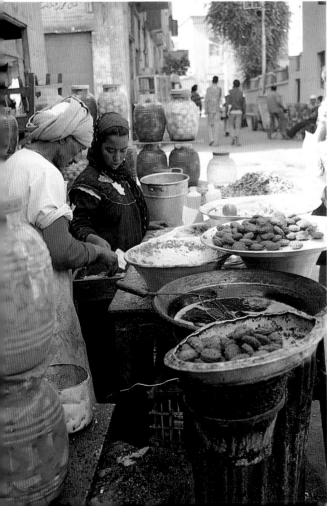
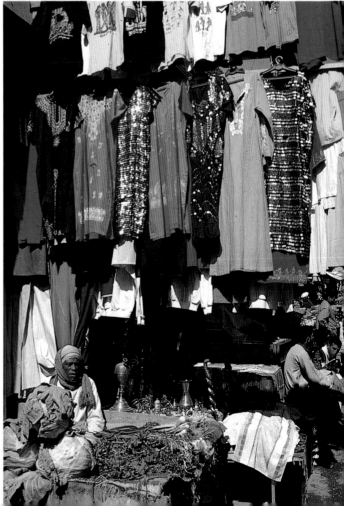

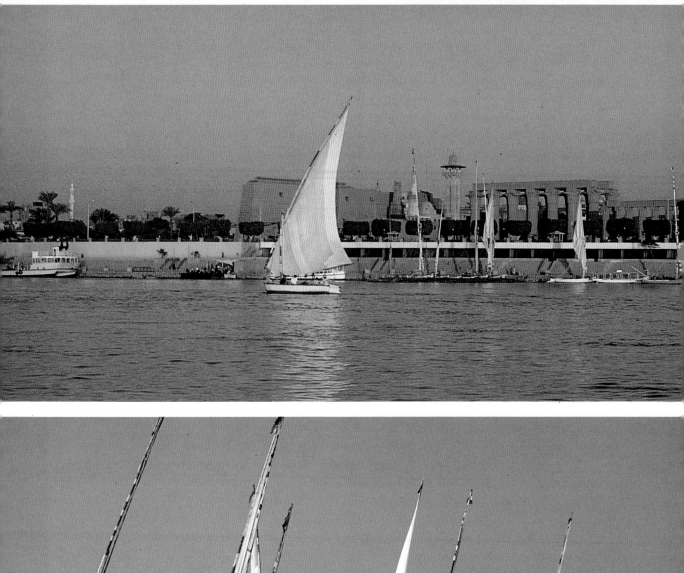

Karnak

The immense monumental zone known as Karnak lies about three kilometers north of the temple of Luxor and is divided into three distinct large enclosed areas. The largest one at the center, about thirty hectares in size, is best preserved, in part thanks to continuous restoration projects. It is dominated by the complex dedicated to Amon, oriented on a southeast and northwest axis. This trapezoidal area is enclosed in a mud-brick wall and has eight entrances, three of which are to the north. On the left, almost contiguous with that of Amon, is the sanctuary of Montu, also with a mud-brick enclosure wall. It is the smallest (about two and a half hectares) and square in shape. Only a few ruins remain, still suffocated by piles of earth, and the fine portal to the north. On the right, three hundred meters distant, lies the zone of Mut, only half explored, trapezoidal in form and with a mud-brick wall which surrounds the approximately nine and a half hectares of the area.

Sanctuary of Amon.
1) Landing stage and Avenue of ram-headed Sphinxes.
2) First pylon.
3) Shrine of the Theban Triad.
4) Kiosk of Taharka.
5) Temple of Ramses III.
6) Second pylon.
7) Great hypostyle hall.
8) Third pylon.
9) Fourth pylon.
10) Fifth pylon.
11) Sixth pylon.
12) Sanctuary of the sacred barks.
13) "Festival Hall".
14) "South propyleia" (7th, 8th, 9th and 10th pylons).
15) Depositaries for offerings.
16) Sacred lake.
17) Temple of Thutmosis III.
18) Temple of Ramses II.
19) Eastern Gate.
20) Osiris chapels.
21) Treasury of Shabaka.
22) Temple of Ptah.
23) Temple of Khonsu.
24) Pylon of the Temple of Opet.
25) South gate.
26) Avenue of Sphinxes.

Sanctuary of Montu.
27) Temple of Montu and shrine of Maat.
28) North gate and avenue of sphinxes.
29) Ptolemaic temple with Saite chapels.

Sanctuary of Mut.
30) Gate of Ptolemy II Philadelphus.
31) Temple of Mut.
32) Large sacred lake.
33) Temple of Ramses III.
34) Temple of Amenophis III.

Above, the temple of Luxor that faces the Nile; below, the traditional feluccas and the modern boats.

1960-1100 B. C.

950-600 B. C.

380- year 0

Reconstruction of the Temple of Amon-Ra at Karnak, assonometric section.

1) Landing stage with two small obelisks of Seti I.
2) Avenue of ram-headed Sphinxes of Ramses II.
3) First and largest pylon (113 m wide, 15 m thick) with decoration, perhaps of the last dynasty.
4) Shrine of Seti II with three chapels dedicated to Amon, Mut and Khonsu.
5) Colonnade with papyrus-bud columns.
6) Large kiosk of Taharku where the proccessional barks were kept.
7) Colossus of Pinudjem (15 m high).
8) Pink granite statue of Ramses II.
9) Columned portal known as the Bubastite Portal.
10) Vestibule with offering scenes of Horemheb and Seti I. Ptolemaic portal almost 30 m high.
11) Second pylon.
12) Temple of Ramses III, pylon with statues of the pharaoh; court with Osiride pillars and procession for the god Min on the walls; hypostyle hall with offering scenes; chapel of Amon's bark flanked by those of the barks of Mut and Khonsu.
13) Large hypostyle hall (102 m by 53) with 122 papyrus-bud columns, 23 meters high. The central aisle was built by Amenophis III. Horemheb began the side aisles, continued by Seti I and Ramses II and then finished by Ramses IV.
14) Third pylon with vestibule of Amenophis III, subsequently completed by Imhotep.
15) External wall with scenes from the battle of Kadesh.
16) Court of Amenophis III.
17) Obelisks of Thutmosis III in pink granite (now destroyed).
18) Obelisks in pink granite of Thutmosis I (only the one on the left is still extant.
19) Fourth pylon of Thutmosis I: entrance to the heart of the temple of Amon.
20) Vestibule of the temple with the obelisks of Hatshepsut in pink granite. The one on the left is still standing. It is 30 meters high and weighs about 200 tons.
21) Fifth pylon of Thutmosis I.
22) Sixth pylon of Thutmosis III.

23) Vestibule of the sanctuary and two pilaster stelae with the symbols of Upper Egypt (the papyrus) and of Lower Egypt (the lotus).
24) Sanctuary of the sacred barks built in pink granite.
25) Sanctuary of the Middle Kingdom.
26) "Festival Hall" of Thutmosis III.
27) Room consecrated to Sokar.
28) "Botanical Room".
29) Shrine of Ank-Menu with seven Osiride pillars and, once, two obelisks of Hatshepsut.
30) Sacred lake for ritual navigation (120 by 77 meters) surrounded by storerooms, living quarters for the priests and an aviary for acquatic birds.
31) "Taharka's house of the lake".
32) Gate of Ramses II.
33) Seventh pylon of Thutmosis III.
34) Peripteral chapel with alabaster shrine and offering scenes of Ramses II.
35) Eighth pylon of Thutmosis II and Hatshepsut.
36) Ninth pylon of Horemheb.

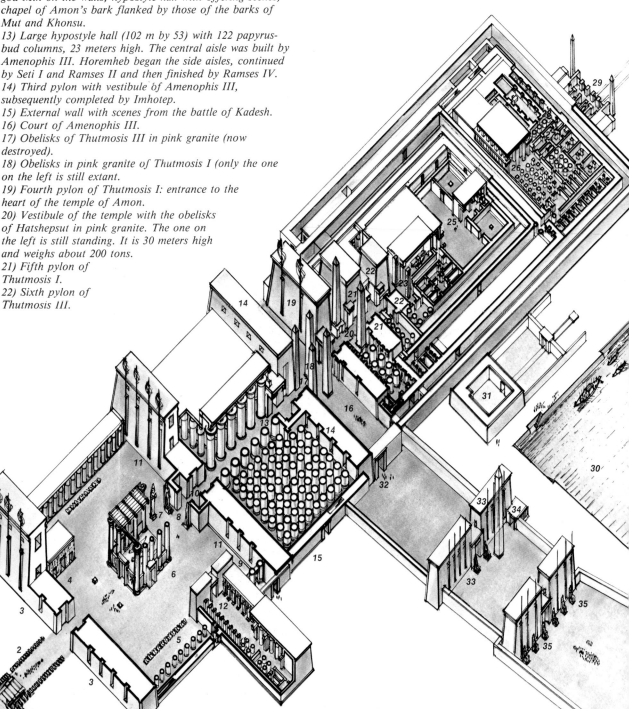

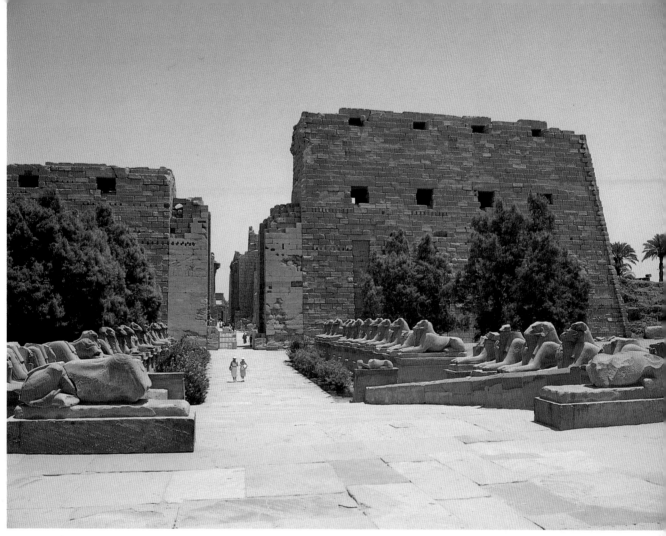

The majestic avenue of ram-headed sphinxes which leads to the first pylon of the temple of Karnak. The ram-headed sphinx is a symbol of the god Amon (identified with the ram) who protects the pharaoh, shown between the beast's front paws.
There were three avenues of ram-sphinxes, one of which linked up with the avenue of human-headed sphinxes which came from the temple of Amon in Luxor.

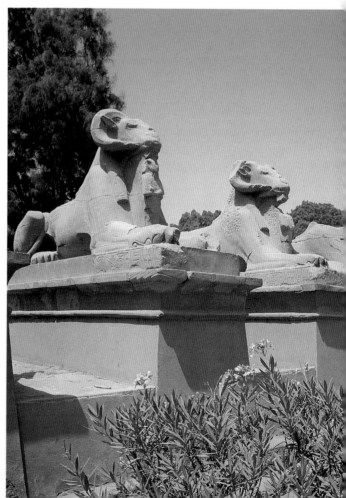

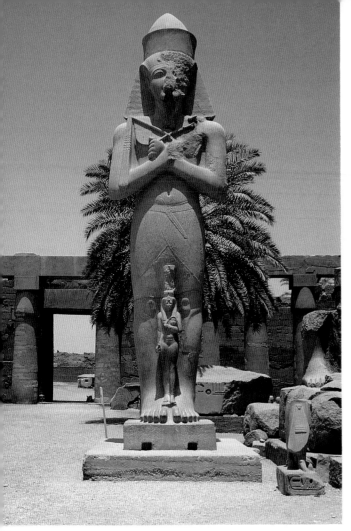

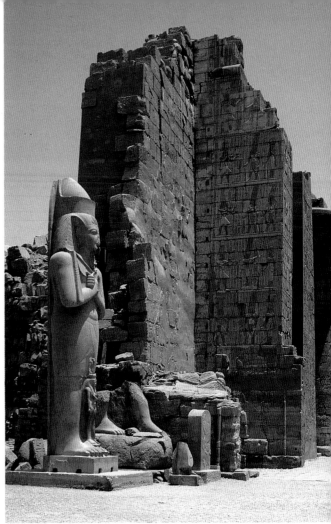

The colossal statue (15 meters high) of Pinudjem, High Priest of Amon at Thebes and pharaoh of the 21st Dynasty known as «Tinita»; a view of the court of the temple of Ramses III, surrounded on three sides by Osiride pillars where the pharaoh is shown in his Jubilee vestment.

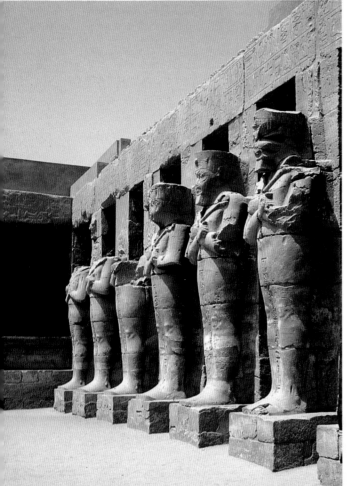

The hypostyle hall, considered one of the finest examples of Egyptian architecture: the 134 columns are 23 meters high, with open papyrus capitals with a circumference of about 15 meters. The central gallery, begun around 1375 B.C. by Amenophis III who conceived it as a simple colonnade in the direction of the sanctuary of Amon, differs in height from the side aisles: and it is just this which made it possible to insert «claustra», wide openwork windows in stoneware, to create a subtle play of light and shade inside.

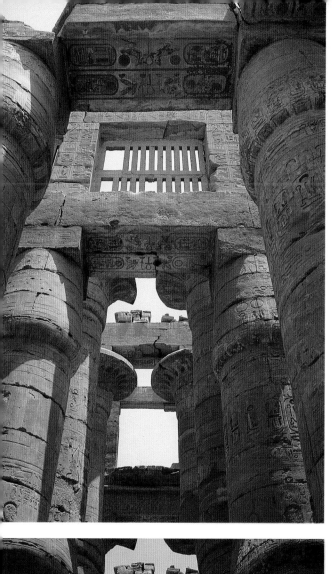
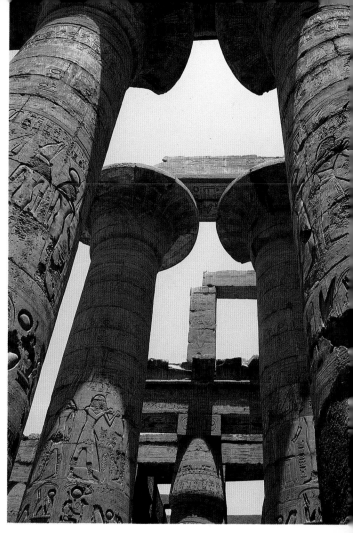
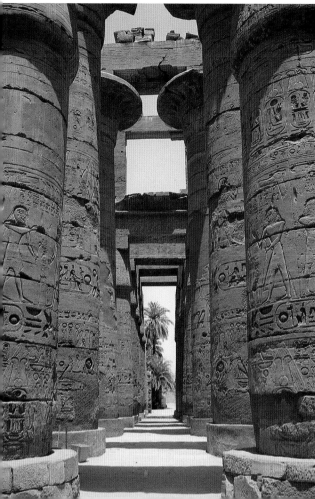
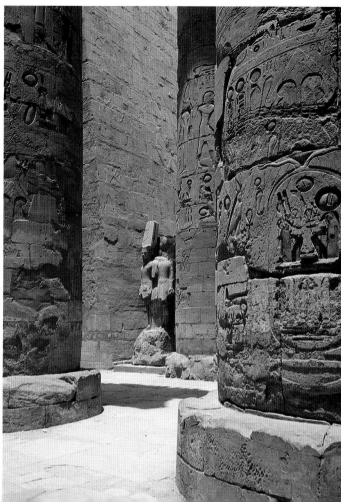

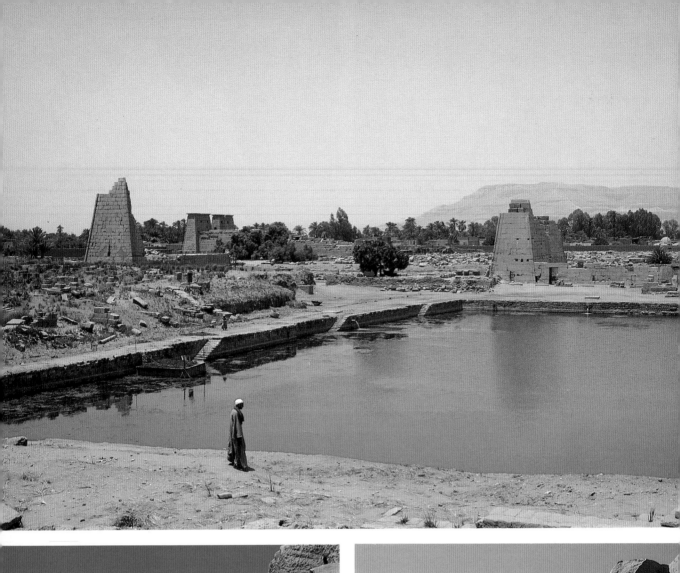

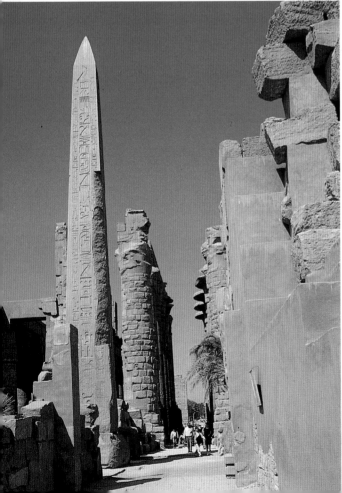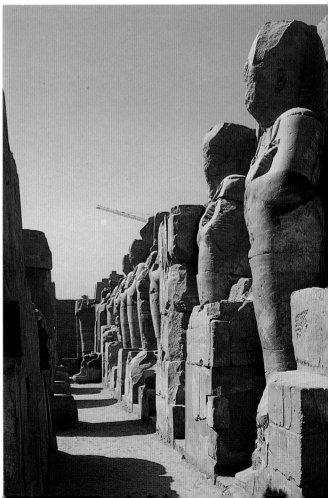

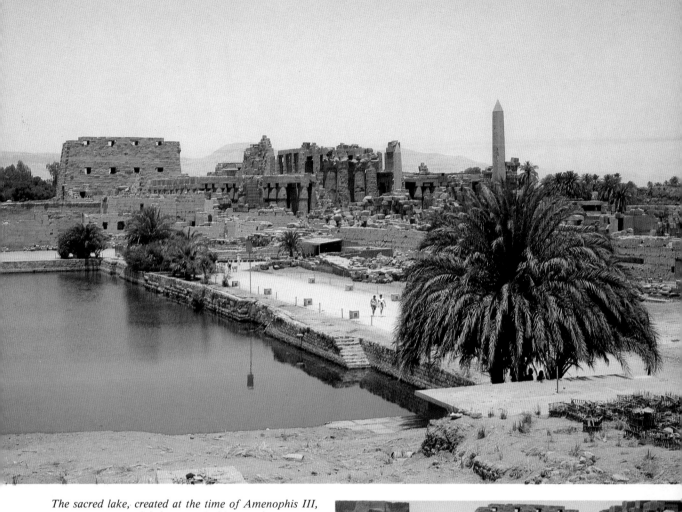

The sacred lake, created at the time of Amenophis III, where the priests did their ritual ablutions four times a day. Preceding page, below: the obelisk of Hatshepsut and one side of the temple with the Osiride pillars.

An obelisk with the cartouche of Amenophis III and the gigantig scarab which the pharaoh himself dedicated to the god Khepri.

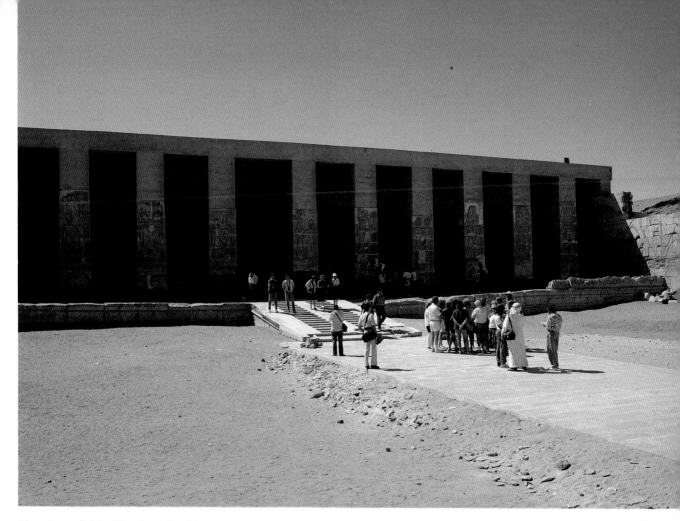

Two shots of daily life along the Nile. Sugar cane is still transported by camel.

The portico of the second court is now the facade of the temple of Seti I: it consists of twelve pillars with rectangular bases and a wall which originally had seven openings, four of which were closed by Ramses II.

Abydos

Abydos is the name given by the Greeks to This (or Thinis), one of the oldest cities in history and seat of the principal sanctuary of Osiris. It was here that the head of the god, the most important relic, was preserved. At least once in their lives, every Egyptian had to make a pilgrimage to Abydos. It was the Holy City where all aspired to have a mortuary chapel or at least a commemorative stela. Almost nothing of the ancient city remains and a few ruins mark the site of the sanctuary. The ruins of the temple of Ramses II further south tell us more for they give us a precise idea of the temple: two pylons and two courts (the second clearly visible) set before two hypostyle halls each of which has eight pillars, and three sanctuary cells. In the rooms are fine scenes of battle and religious ceremonies. Still further south, better preserved and with a splendid picture gallery, is the temple of Seti I. Built to commemorate the pilgrimage of the pharaoh to Abydos, it was still famous in Greek times and Strabo praised its "marvelous construction". His son

Ramses II more or less completed the decoration that continued up to the time of Ramses IV. The building follows the lie of the land so that the two courts with their respective pylons (the first has been completely destroyed) constitute two steps and the temple in turn is set on two other steps. The facade consists of the typical pilaster portico. Then come two broad hypostyle halls with two rows (in the first) and three rows (in the second) of twelve columns. At the back there are all of seven chapel-shrines; then comes a smaller room from which another four chapels open off. On the left another building with colonnaded halls and deep chapels is attached. Some of the chapels were decorated by Ramses II and others are unfinished. Behind the temple is the Osireion, a monumental tomb or cenotaph of Seti I. The concept embodied here is highly interesting and recalls what Herodotus had to say about the mysterious tomb of Khufu. It is in fact a large hall measuring 30.50 by 20 meters, with eight granite pillars and small chapels all around. It simulates the "island" surrounded by the primordial "lake", with hollows for the sarcophagus and the canopic jars.

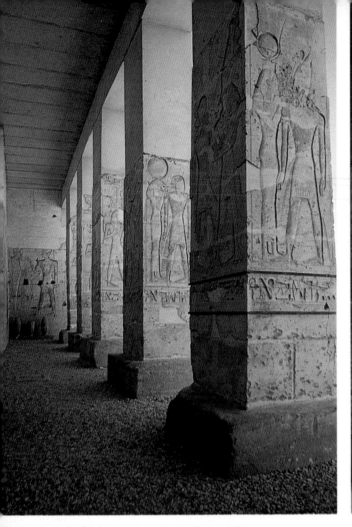

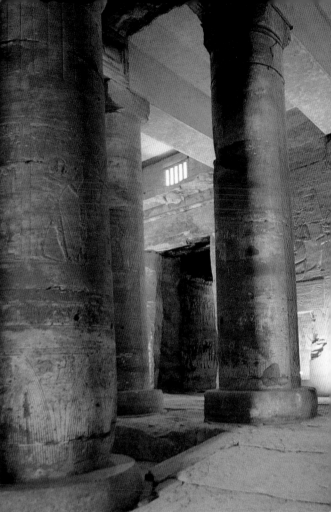

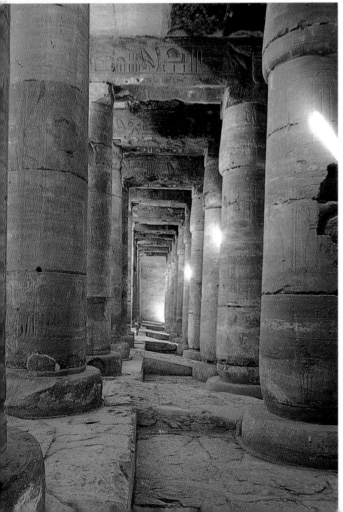

Decorated pillars and columns in the hypostyle hall of the temple of Seti I.

Fresco which shows the pharaoh offering a feathered Zed to the goddess Isis. The Zed pillar is the symbol of the backbone of Osiris and symbolizes stability.

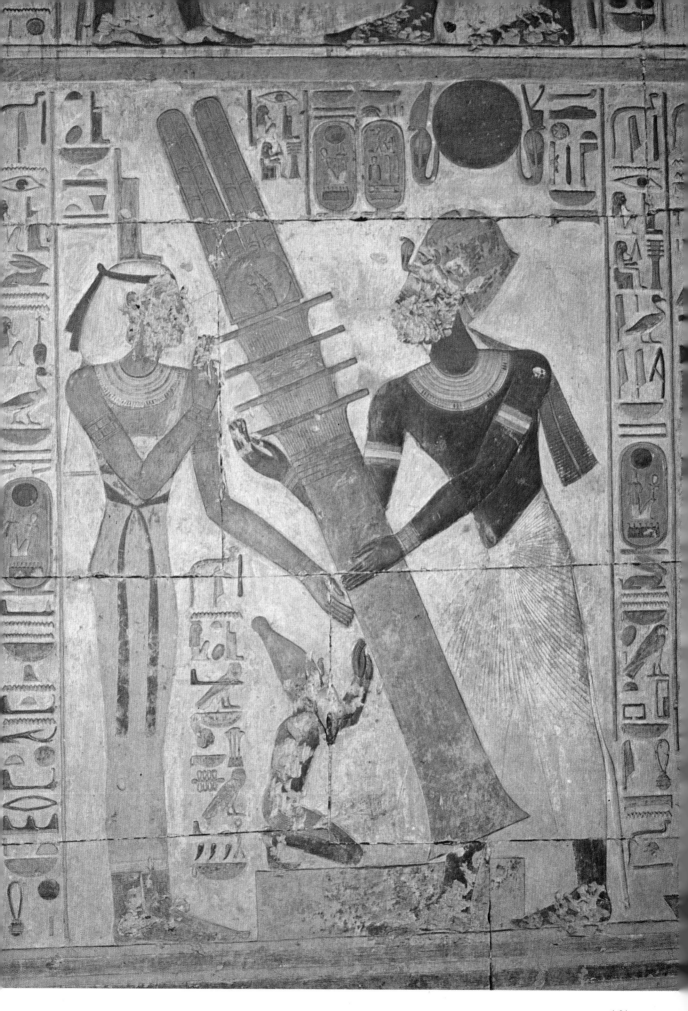

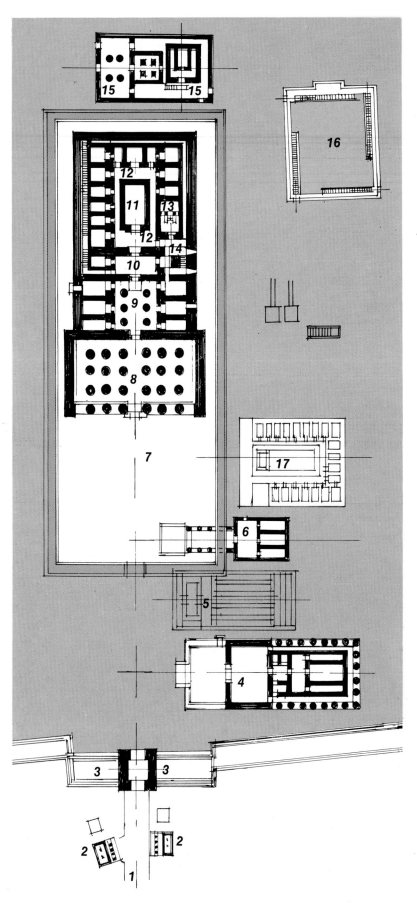

1) A paved avenue leading from the Nile to the Sanctuary.

2) Monumental Roman fountains.

3) Massive wall and North Gate.

4) "Mammisi of Augustus": peripteral temple with Hathor columns. The head of the god Bes, protector of women in labor, is included in the decoration. Scenes of the birth and nourishment of the divine infant Horus, modelled on those in the Mammisi of Nectanebo, appear everywhere. The building was begun by Nero and decorated by Trajan, Hadrian and Antoninus.

5) Remains of a fifth-century Christian-Coptic church.

6) "Mammisi of Nectanebo". Scenes of the gods and Amon creating the Divine Child, born to and nursed by the goddess Hathor, are shown. (The goddess can also be interpreted as Isis and the child as Horus).

7) Sacred enclosure of the Temple of Hathor.

8) Hypostyle Hall (opening onto the court) measuring 25 x 42.50 meters, 18 meters high and with 24 Hathor-headed columns. The ceiling is decorated with celestial figures dominated by the goddess Nut, creator of the sun. On the walls, scenes of the foundation and consecration of the temple.

9) "Hall of Appearances". At the sides, various rooms for storage and the preparation of the offerings, with recipes for perfumes and unguents.

10) Hall of Offerings.

11) "Venerable Seat" or sanctuary of the temple, decorated with scenes of processions on the Nile.

12) "Corridor of Mysteries" with eleven chapels decorated with scenes of initiation into the Hathoric mysteries.

13) "Chapel of Sanctity".

14) Stairway leading to the terrace with the kiosk with twelve Hathor columns and the "Tomb of Osiris" consisting of two chapels. Beyond the stairs, a narrow gallery in the thickness of the walls leads to twelve small crypts all decorated with subjects of a religious nature concerning the mysteries.

15) Temple of Isis-Hathor. It consists of two buildings: one with columns and pillars on a transverse axis; the other with a cell dedicated to the birth of Isis.

16) Sacred lake (28 x 34 m) still almost complete.

17) "Sanatorium" with font, basin for the "miraculous water" used for healing baths and small dressing rooms all around.

Dendera

Name given to the ruins of Tentyra, sacred city of the three sanctuaries: the sanctuary of Ihy, son of Horus of which nothing remains but one of the monumental gates; the sanctuary of Horus, almost completely vanished; the temple sanctuary of Hathor with conspicuous ruins and an almost intact temple. The origins of the temple, which was restored by the Ptolemies and partially reconstructed by the Romans, go back all the way to Khufu and Pepi I. The buildings within the extensive enclosure walls of the sanctuary of the goddess Hathor are aligned more or less along an axis from the main entrance, as can be seen in the ground plan.

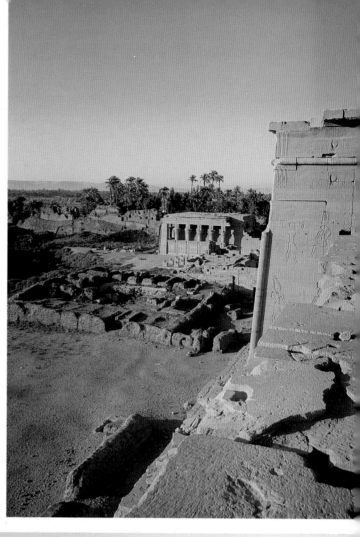

The mammisi seen from the top of the terrace and the front of the temple with the Hathor columns.

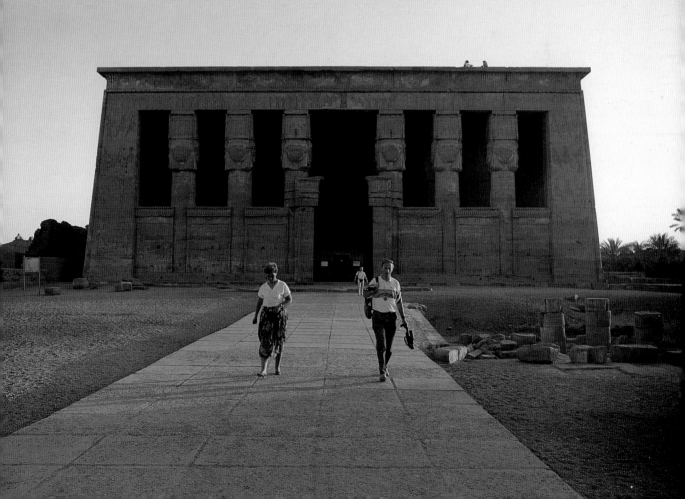

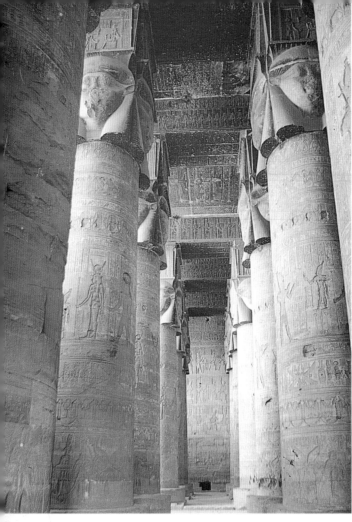

The tall columns of the hypostyle hall with Hathor capitals. Below, the «Chapel of Sanctity» where the mysteries of the birth of the cosmic order from primordial chaos were celebrated, and one detail of a frescoed ceiling.

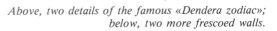

Above, two details of the famous «Dendera zodiac»; below, two more frescoed walls.

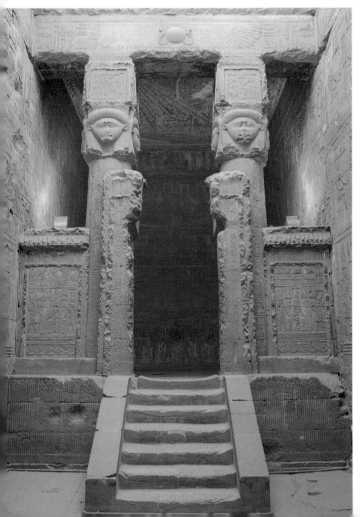

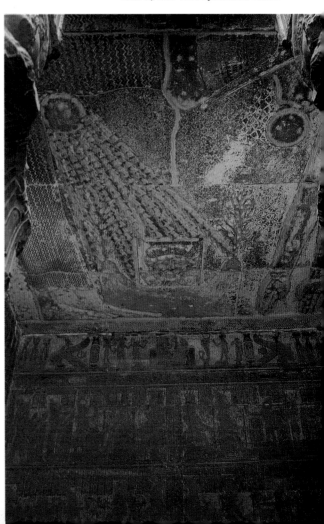

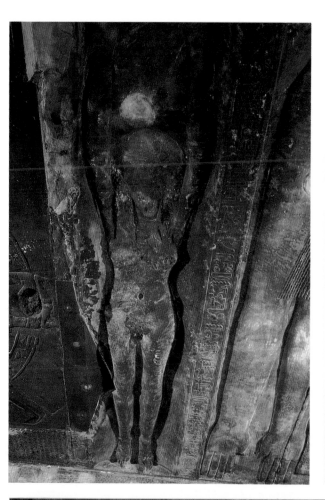

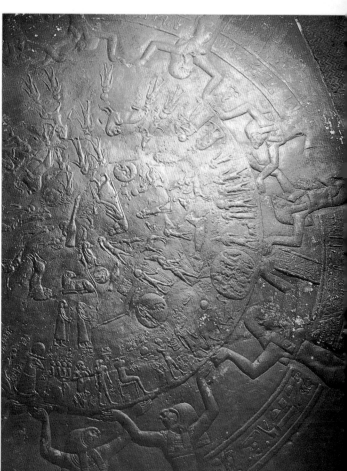

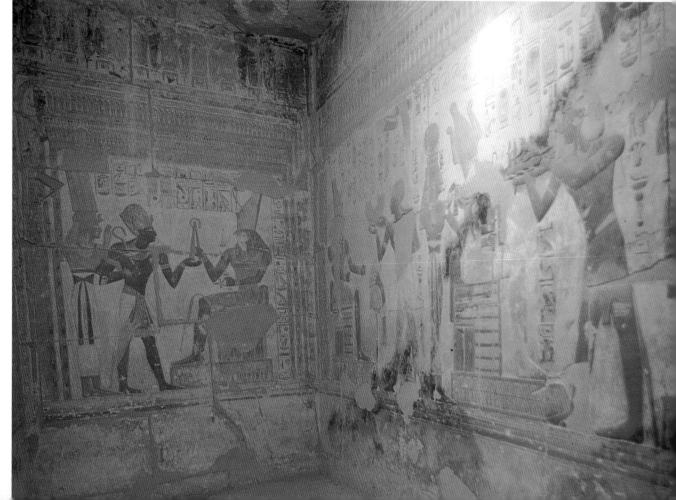

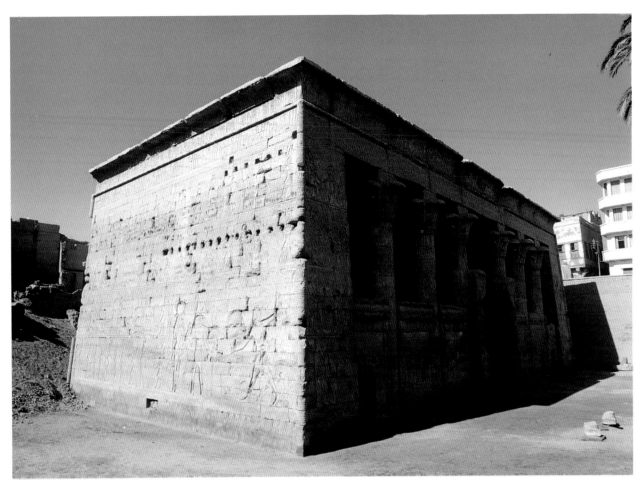

Detail of the tetralobed capitals inside, composed of various sculptural floral motives. This is still another example of the exquisite elegance and fantasy achieved by the Egyptian artists of the later centuries in the field of decoration.

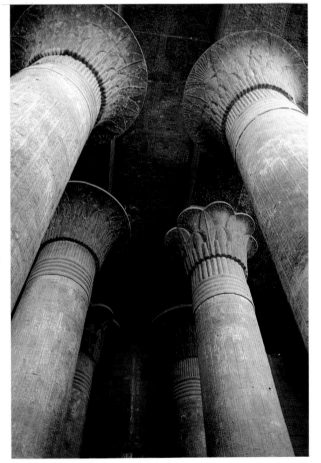

Esna

The town of Esna stands on the site of ancient Latopolis of which only part of the temple of Khnum (similar to that of Dendera), with an almost intact hypostyle hall, still stands. The rest is nothing but foundations or buried under the enormous land fill. The temple is a Ptolemaic reconstruction of an 18th-dynasty temple. The hypostyle hall measures 33 x 18 meters and has 24 columns (13.50 m high) with magnificent composite capitals.

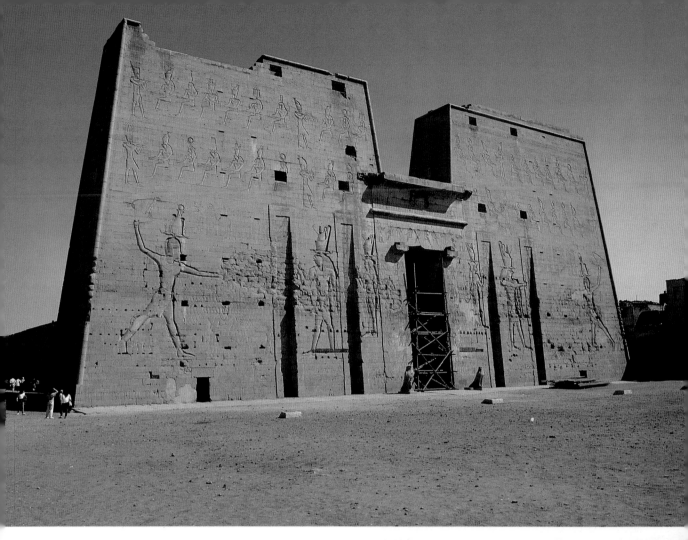

Detail of the exterior of the Great Pylon of the temple. On the walls: adoration of the gods and large figures of Horus and Hathor to whom the last of the Ptolemies offers captives in sacrifice. The tall portal is flanked by two granite falcons and long recesses which were meant for flagstaffs.

The falcon of Horus — a beautiful piece of sculpture in black granite — guarding the entrance to the temple.

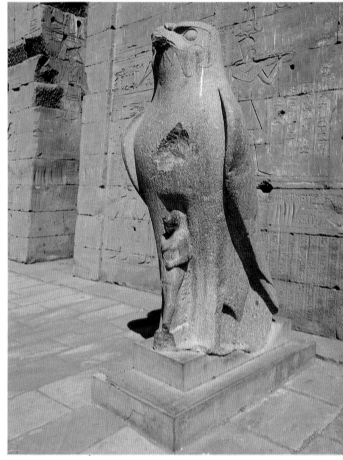

Edfu

The best preserved temple in all of Egypt still stands in the ancient capital of the region, called by the Greeks Apollinopolis Magna. Consecrated to Horus, the temple was built by Ptolemy III Evergetes in 327 B.C. on the much older one built for Thutmosis III by the first priest architect Imhotep. Work was continued by the successors of Evergetes, up to Cleopatra VII, the last queen of Egypt. The structure is typical of Ptolemaic temples and almost identical with the one in Dendera. In front stood a large solid pylon with a falcon in black granite on either side of the entrance. Inside, the pylon was subdivided into four stories of rooms. Next comes a court surrounded on three sides by columns with various types of capitals. At the back, the facade of the Great Hypostyle Hall composed of the first row of columns of the hall, with screen walls in between. The Great Hall has three rows of six columns,

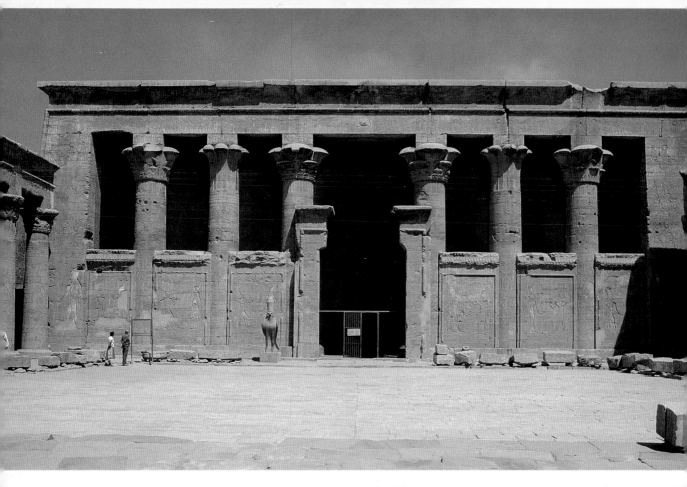

including those on the facade, and the walls are covered with interminable offering scenes. Next comes a lesser Hypostyle Hall with three rows of four columns; a door on one side leads into the room for dry offerings and on the other into one for wet offerings, with an adjacent room for their preparation. Next comes the court of offerings with stairs that lead to the terrace, and then the vestibule in front of the sanctuary. A fine monolithic shrine still stands inside the sanctuary. Ten rooms, each with its specific characteristics, open off the "corridor of mysteries" which extends around the sanctuary. The scenes on the walls facing onto the avenue between the temple and the outer walls are of particular interest: ceremonies for the construction of the temple, mythological scenes with the victory of Horus over the murderers of his father, the birth of Horus, scenes of the cult of Horus according to the hours of the day and the periods of the year. In front of the temple on the left is the Mammisi of Ptolemy III Evergetes, decorated under Ptolemy IX. The capitals with the head of Bes are unusual. Inside, scenes of the birth of Horus suckled by the goddess Hathor.

The term Mammisi comes from the Coptic language and means "Birth House". It indicates the place where the mystery of the birth of Horus, the Divine Son, is renewed daily and is therefore sacred to all those in childbirth and every woman who hopes to become a mother. Initially the room was part of the temple but in the 30th Dynasty it was transformed into an autonomous shrine, set in front of the sanctuary, and became increasingly important with the Ptolemies and the Romans.

The so-called «wide court of the libations», with the columns on the facade joined half way up by intercolumnar walls; the walkway which runs between the external wall of the temple and the circle of walls: to be noted are the lion-headed water spouts, an architectural solution also found in Dendera where however the perimetral walls have disappeared; the fine monolithic shrine in grey granite, four meters high, was made under Nectanebo II and is therefore earlier than the Ptolemaic temple; the majestic black granite statue of the falcon god Horus, wearing the double crown of Upper and Lower Egypt.

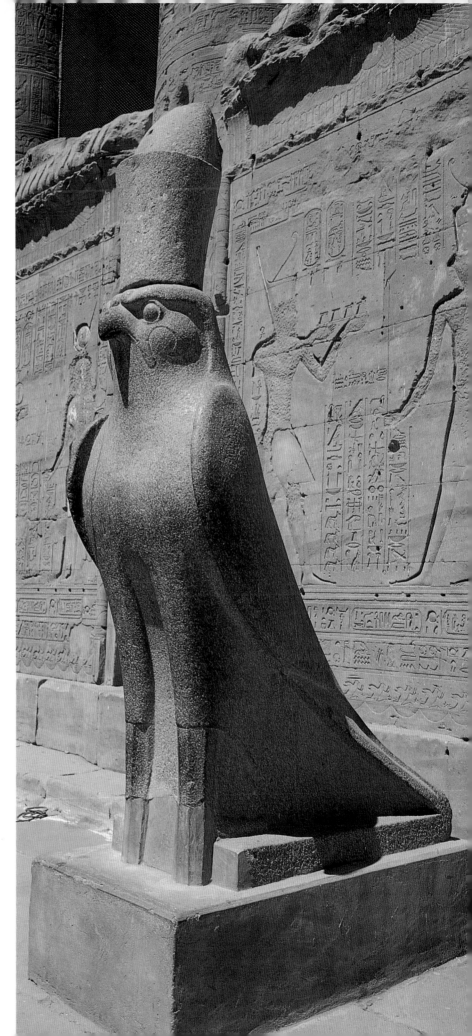

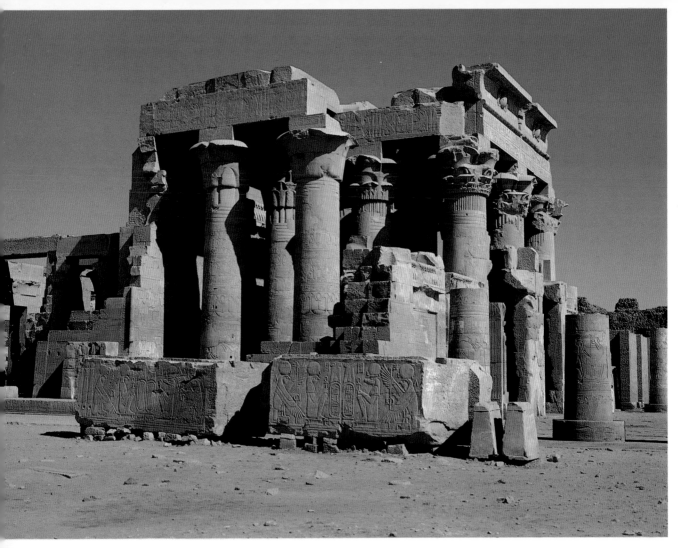

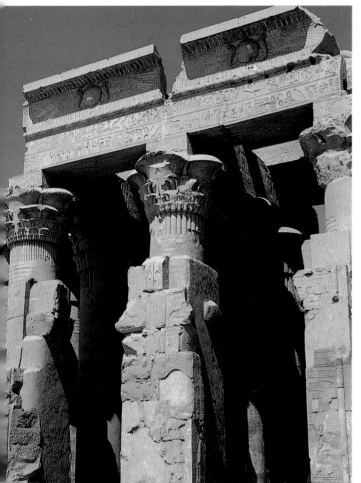

The western side of the temple: the two flanking entrances which lead to the majestic hypostyle hall; details of the reliefs on the columns in the court which still bear traces of the original painting; remains of the Mammisi decorated by Ptolemy VIII Evergetes II, southwest of the temple facade.

Kom Ombo

An unusual temple is to be found near the village of Kom Ombo, the result of the fusion of two temples set side by side. The left part is dedicated to the falcon god Haroeris or Horus the Elder (still another personification of the Sun-Horus), a solar warrior god, exterminator of the enemies of Osiris, represented by the winged disk. With his great wings he protects from evil spirits and harm and is therefore depicted on all the entrance portals. The right side is consecrated to the crocodile god Sobek, a primordial divinity to whom the creation of the world is attributed and god of fertility, exterminator of the enemies of Osiris and

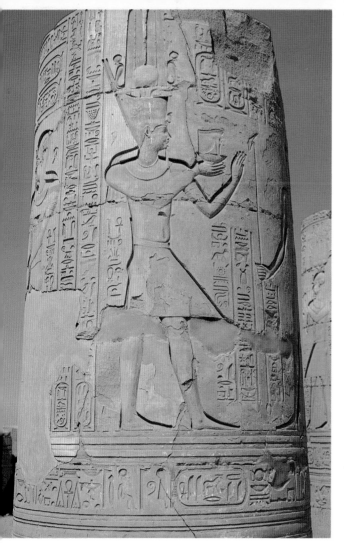

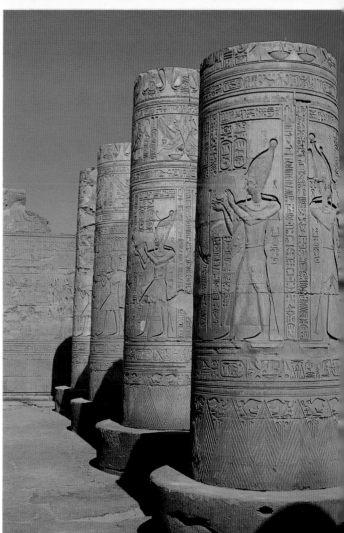

therefore like Haroeris, a powerful enemy of evil.
This too was built by the Ptolemies who completely
reconstructed the temple founded by Amenophis I and
Thutmosis III more than a thousand years earlier. The
temple stood only a few meters from the Nile and was
surrounded by tall walls which started at the gate of
Ptolemy XIII (on the right) and enclosed the Great Temple
and other small temples and chapels. Among these: the
Hathor chapel (next to the Ptolemaic gate), decorated with
offering scenes under the emperor Domitian and still well
preserved; the chapel of Sobek (north of the temple) with
scenes in which the emperor Caracalla appears; the
Mammisi of Ptolemy III (to the left of the temple),
towards the Nile.

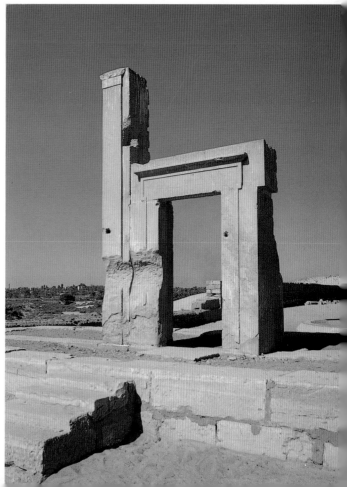

Aswan

Aswan (Assuan), the ancient Syene, lies on the right bank of the Nile, 886 kilometers from Cairo. This is where the Valley of the Nile with its typically gentle landscape ends. This is where Egypt ends and Nubia begins. Gone are the farmlands which accompany the bends of the river, replaced by endless kilometers of desert sands and the majestic still waters of Nasser Lake. The Nile too is transformed and the smooth tranquil waters give way to the sudden troubled waters leaping and eddying around the rocks of the First Cataract.

Trade and barter went on here as early as the third millennium. Nubia, whose ancient name pub (nbw) means «gold», has always been a land of conquest and exploitation. The doorway to black Africa, the only communications route between the sea and the heart of the black continent, Nubia provided the pharaohs with their best soldiers, highly prized woods, precious ivory, perfumed spices, the finest ostrich feathers — as well as gold. Syenite — that pink granite so widely used in Egyptian religious architecture in the building of temples, the sculpting of colossi and obelisks — came from its many rich quarries. It was so abundant that the quarries were still in use in Roman times. Syene was also of basic importance in controlling both the river traffic and that of the desert caravans. The pharaohs maintained an armed garrison there and made Syene the capital of the first nome of Upper Egypt. The Tropic of Cancer, which now lies somewhat further south, originally passed here. Proof is the presence of a well whose straight sides are illuminated by the rays of the sun without shadows only at the summer solstice. This was how the Greek scientist Eratosthenes calculated (with a minimum of error) the length of the terrestial meridian and concluded that the earth was round.

Various aspects of life at Aswan: from the tourist boats and feluccas which glide softly over the water to the brilliantly colored Bazaar where the atmosphere is truly African.

In early medieval times the city was subject first to the incursions of the Blemi, from Ethiopia, then fell victim to a violent outbreak of the plague. It was gradually abandoned and revived only after the Turkish conquest of Egypt. Its modern name derives from the old Egyptian «swenet» meaning «trade», transformed into the Coptic «suan» and then into Aswan.

Nowadays, in addition to its purely historical and archaeological interest, the mildness of its climate has made Aswan an ideal winter resort. Elegant hotels equipped with every imaginable comfort have risen along its banks; cruising yachts by the dozens sail up the Nile and anchor here for days at a time so that the ever growing number of tourists can visit the exceptional surroundings of the city. It is, lastly, the most important departure point for the excursion to Abu Simbel, jewel of the desert.

When evening falls, Aswan is suddenly bathed completely in violet, while the feluccas glide silently over the water, dotting the river with their enormous white sails. No other place in Egypt has the luminosity and silence that reign in Aswan.

The modern monument erected in memory of the commitment shown by all those who worked to construct the High Dam, and whose shape is reminiscent of a stylized lotus flower; the luxurious vegetation on Kitchener Island, known also as the Island of Trees, north of Elephantine; two pictures of the white feluccas which glide over the Nile; the entrance to the mausoleum of the Aga Khan, built in pink limestone on the model of the Cairo mosque of Al-Guyushi. The Aga Khan Muhammed Shah, spiritual head of the Ismailian Muslims, is buried here.

Monastery of St. Simeon.

The Deir Amba Samaan (as it is called in Arab) is one of the largest and best preserved Coptic monasteries in all of Egypt. It was built between the 6th and 8th centuries and the death of the bishop Hadra. It could house up to 300 monks and offer shelter to hundreds and hundreds of pilgrims. After a life of almost five hundred years, the Arabs destroyed it in 1321.

The surrounding wall of stone and unbaked brick flanked by towers two meters high lend it a majestic solemn air which induces respect and awe.

Inside, the convent was conceived of as a real city in miniature. On the first level is the tripartite church with an apse with three chapels. Traces of frescoes depicting the Pantokrator and twenty-four seated saints are still visible. Above each saint is painted a letter of the Coptic alphabet. A staircase leads to the second floor, where the real monastery is, with a long corridor on which the monks' cells face and the service rooms for the community, such as kitchen, bakery, cellar, etc.

If we cimb to the top of the walls, the desert stretches out in all its majesty. At the back of the valley we are struck by the startling contrast of Aswan overlooking the blue waters of the Nile and the white feluccas.

The necropolis of Aswan, on the left bank of the Nile, in a haunting nocturnal vision.

Tombs of Mekhu and Sabni.

These two tombs at the southernmost end of the necropolis are intercommunicating for their owners were father and son. Mekhu's tomb has a vast hall with three rows of six columns each. At the center between two pillars is a block of granite which served as an offering table: to be noted are the symbols for bread and the drainage canals for the ritual libations. Sabni's tomb is divided by twelve pillars arranged in two rows and is decorated with scenes of hunting and fishing.

Tomb of Siremput II.

The tomb, one of the best preserved, belonged to the «Superior of the prophets of Khnum» during the 12th dynasty. It consisted of a first chamber with six pillars, a gallery flanked by six niches each of which contained the mummylike statue of the deceased prince and a second square chamber with four pillars, each of which was decorated with a lovely image of Siremput. After that comes the back chapel which is painted: the prince is shown with his small son rendering him homage before a table set with bread, sweets, fruit, even a duck and bunches of grapes. The adjacent wall is decorated with the figure of the wife of the prince, a priestess of Hathor, also shown seated before a prepared table.

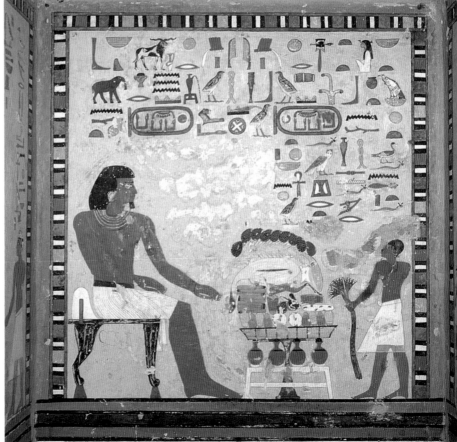

177

The granite quarries.

The ancient quarries which furnished Egypt with granite can still be seen behind modern Aswan. This is where the famous "unfinished obelisk" is to be found. It would have been 42 meters high and would have weighed 1,150 tons, but it had cracked in several places and was never detached from the rock. The notches seen in the photo were made in the granite to extract the blocks.

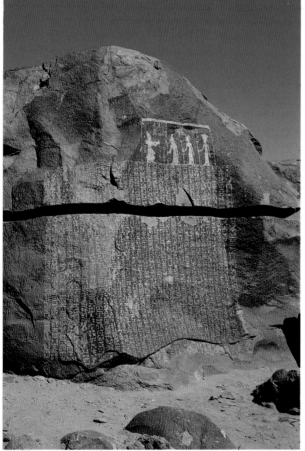

Seheil Island.

The First Cataract of the Nile, an ideal southern border for Ancient Egypt, lies a few kilometers from Aswan. It is a vast area of swirling eddying waters between countless rocks and islets. The most interesting island is Seheil, with blocks of granite piled up in disorderly array, rather like the ruins of two gigantic pyramids. They are sometimes engraved with figures and inscriptions as if they were actual stelae, ranging in date from the 6th Dynasty up to the Ptolemaic period (one from this period mentions king Zoser).

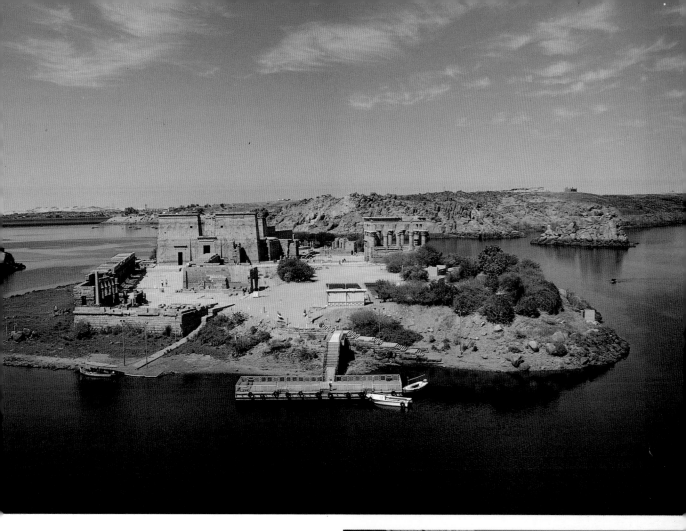

Philae

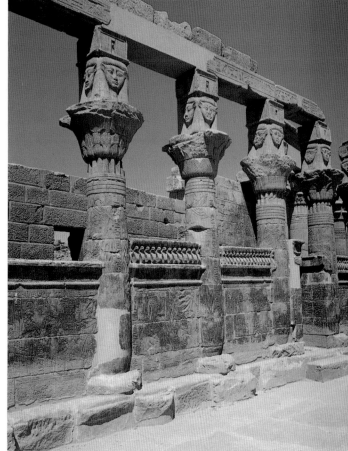

In the midst of a fascinating landscape of granite rocks, the
sacred island, domain of the goddess Isis, raises its columns
and pillars towards the cloudless sky, giving one the
impression of being in a purely imaginary place. The temple
of Philae is one of the three best preserved Ptolemaic
temples, the other two are those of Edfu and Dendera.
Philae was the largest of the three islands at the south end
of the group of rocks that comprise the First Cataract, and
is 400 meters long and 135 meters wide. The name itself
reveals its unique geographic position: Pilak in fact, as it
was called in the ancient texts, meant «the corner island» or
«the end island». For originally Philae was on the east bank
of the Nile, in the corner of a small bay, and also at the
southermost tip of the First Cataract. Of the other two
islets, Bigeh (today partially submerged) was particularly
sacred for it was the place of eternal sleep for Osiris and
therefore out of bounds to all human beings. Only those
priests who came by boat from Philae were allowed there
where they celebrated their sacred rites on the 360 offering
tables which indicated where Osiris was buried. The temples
on Philae were dedicated to his bride Isis who with the
force of her love had recomposed his scattered limbs and
resuscitated him. The cult of the goddess on this island
dates to extremely ancient times and it was a tradition that
at least once a year the Egyptians go in pilgrimage to the

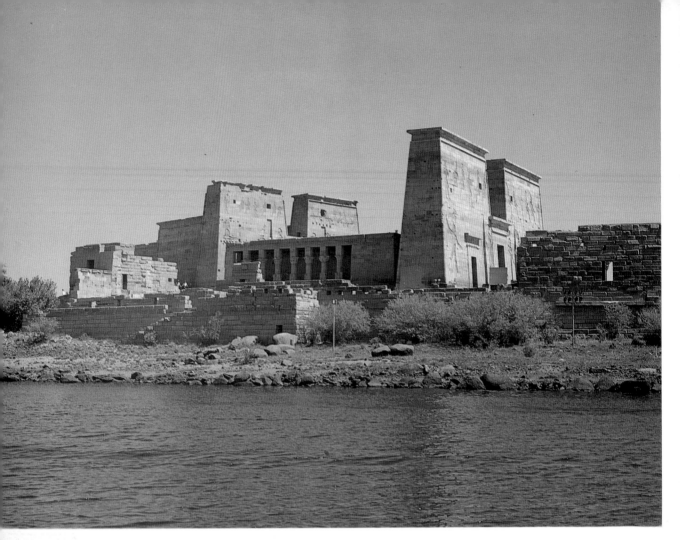

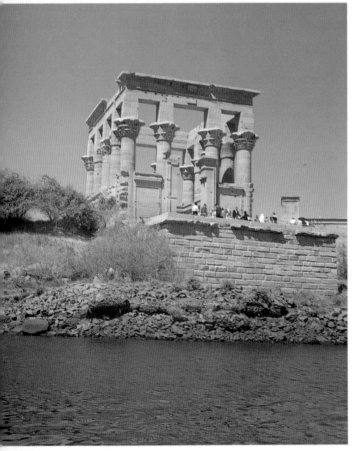

sacred island. It was not until A.D. 535, under the reign of Justinian, that the priests dedicated to the cult were removed.

The third islet is Agilkia: and this is where we can now admire the temple complex which was originally on Philae, barely 500 meters away.

The sacred island, in fact, was above water throughout the year until 1898. With the construction of the Old Dam, it remained submerged by the artificial lake most of the year. Only in August and September when the lock-gates of the dam were opened to alleviate the pressure of the flood waters, did the island emerge from the waters so it could be visited. The construction of the High Dam put Philae in a critical situation: the sacred island would have found itself in a closed basin in which the waters, no longer twenty meters high as before but only four, would have created a continual ebb and flow that with the passing of the years would have inevitably eroded the foundations of the temples which sooner or later would have fallen.

They were, therefore, between 1972 and 1980, dismantled and rebuilt on this islet (where the topography of Philae was recreated) in a position that was higher up with respect to the waters of the lake.

The temple complex includes the pavilion of Nectanebo, the monumental temple of Isis with its annexes, the charming pavilion of Trajan and the small Hathor temple.

While most of the decorations at Philae regard sacred rites and tributes to the gods, there is one that stands out for its

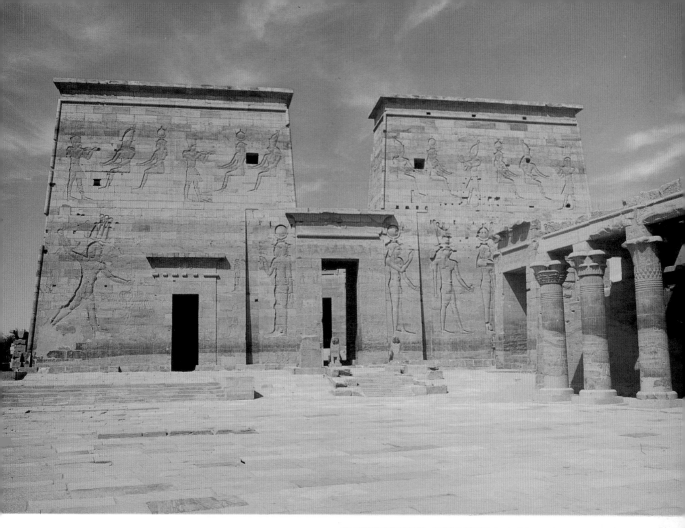

originality and the atypicality of the subject represented.
This is the so-called gate or bastion of Hadrian, an aedicule
that dates to Antonine times and that is situated in the
western wing of the temple of Isis, on a level with the
second pylon. Inside the gate, on the north wall, a relief
demonstrates the Egyptian concept of the source of the Nile.
In fact Hapy, the deification of the Upper and Lower Nile,
is shown in an anthropomorphic and hermaphroditic form.
The god is show in a cave surrounded by a serpent and he
holds two vases from which water flows. In fact, the
ancient Egyptians believed that the source of the Nile was in
the neighborhood of the First Cataract near a mountain
called Mu Hapi (meaning «water of Hapi»). The annual
rites in honor of the god were celebrated by the pharaoh
himself and began in the middle of June when the star Sotis
marked the beginning of the river flood.
Philae represents a perfect synthesis of the Egyptian, Greek
and Roman civilizations: here architecture and design are
one. It suffices to remember that once, before the waters of
the Old Dam washed them clean, all the capitals were
painted in brillant colors — blue, red, yellow and green —
as witnessed by the paintings of those travelers who saw
them before the temple was submerged in the artificial basin
of Aswan. Despite the fact that all the original color has
disappeared, Philae remains that masterpiece of grace and
enchantment, as Amelia Edwards wrote, a marvelous
example of elegance and charm, which led Pierre Loti to
call it the «pearl of Egypt».

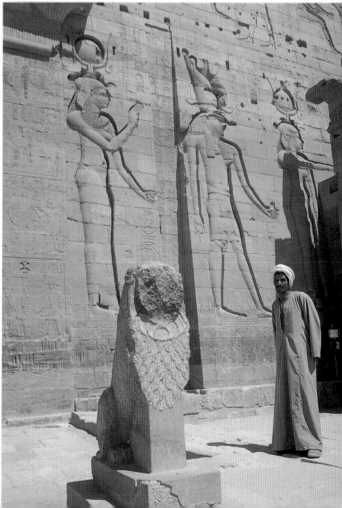

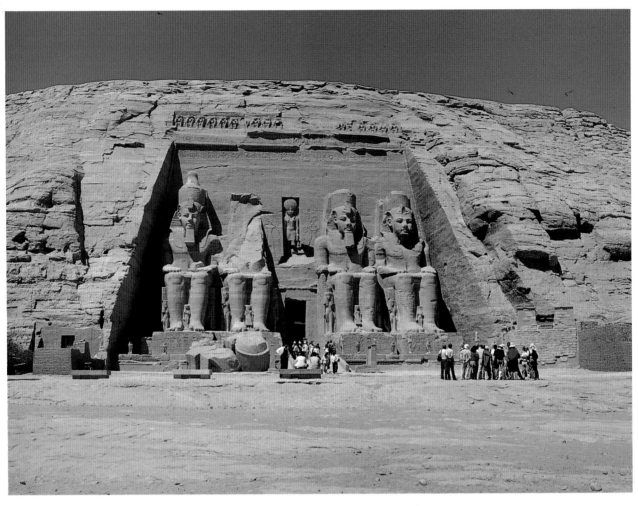

Abu Simbel

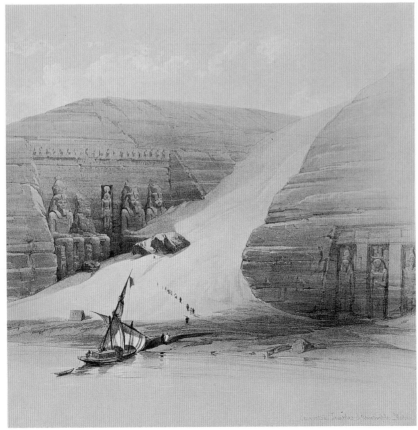

In the heart of the Nubian territory, almost on the borders of Sudan and about 300 kilometers from Aswan, is the most beautiful and imposing construction of the greatest pharaoh in Egyptian history: Abu Simbel, the temple that in theory was dedicated to the triad Amon-Ra, Harmakes, and Ptah, but which was to all extents erected solely to glorify in the centuries its constructor, Ramses II the Great. Abu Simbel is not only one of the most beautiful temples in Egypt — it is without doubt the most unusual and majestic — but is also the symbol of the gigantic rescue operation involving all the fourteen Nubian temples threatened by Lake Nasser. Ybsambul, as it was called, had been long forgotten and once more saw the light of day in the last century when on May 22, 1813, the Swiss Johann Ludwig Burckhardt by chance saw the upper parts of four stone giants emerge almost as if by magic from the sand. On August 1, 1817, the Italian, Giovanni Battista Belzoni, freed the upper part of a doorway from the sand and found the entrance. After

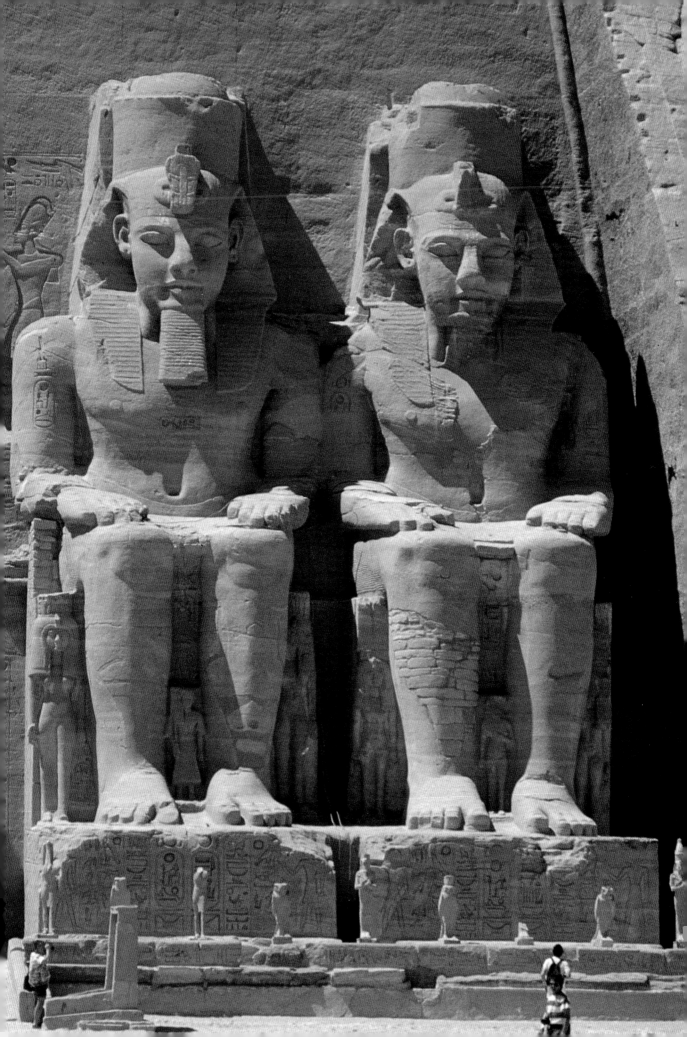

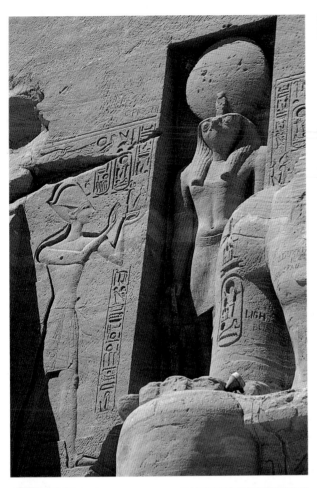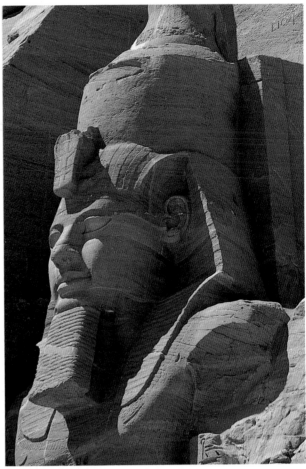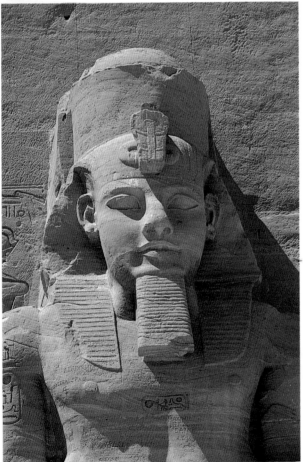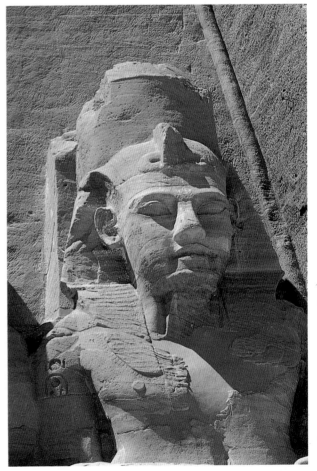

him travelers, scholars, archaeologists, tourists, came by the hundreds to admire the architectural masterpiece of Ramses II, free at last. The danger that it might disappear under the waters of Lake Nasser became a case that echoed throughout the world. While Abu Simbel was the most beautiful and the most imposing of the temples of Nubia, it was also the most difficult to save on account of the material in which it was sculpted, the site and the structure in which it had been conceived. Despite all this, here too man's will coupled with the wonders of technology succeeded in saving the temple with one of the most unbelievable works of dismantlement and reconstruction that archaeology had ever been involved in and in perpetuating its memory throughout the centuries.

The rock-cut temple of Abu Simbel is actually nothing but the transferral into rock of the architectural elements of the Egyptian so-called inner sanctuary temple.

Four colossol seated statues of Ramses II replace the supporting columns of the facade. In their monumentality they perfectly reproduce the somatic features of the sovereign.

A «multitude of workers brought into imprisonment by his sword» worked on this monumental facade, under the orders of the head of the sculptors, whose name was Pyay, as we read inside the temple. The work of the sculptors was followed by that of the painters: in the time of Ramses the temple must have been brightly colored.

The decoration of the walls celebrates the military glory of Ramses II. The most interesting and famous is the one on the north wall, where we can follow the various phases of the battle of Kadesh, including the pharaoh's military campaign against the Hittites in year V of his reign. The long epic poem, written by the court poet Pentaur, is engraved in hieroglyphics both here and on the walls of other temples, such as Luxor and Karnak.

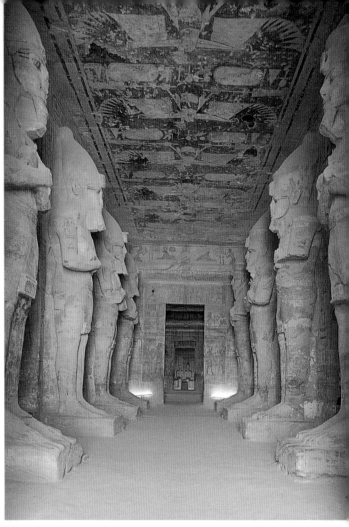

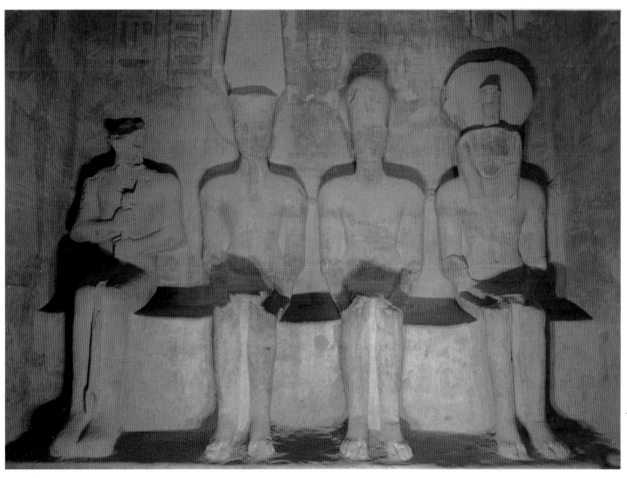

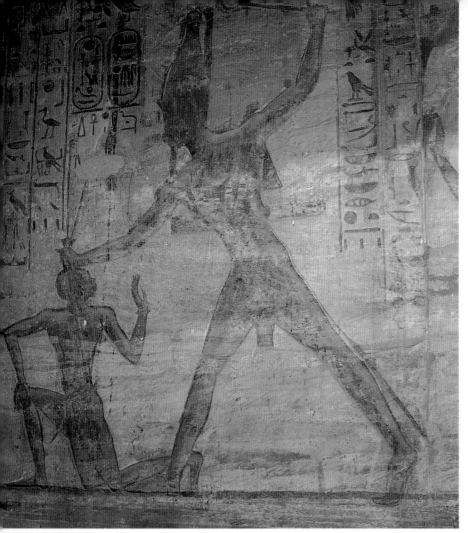

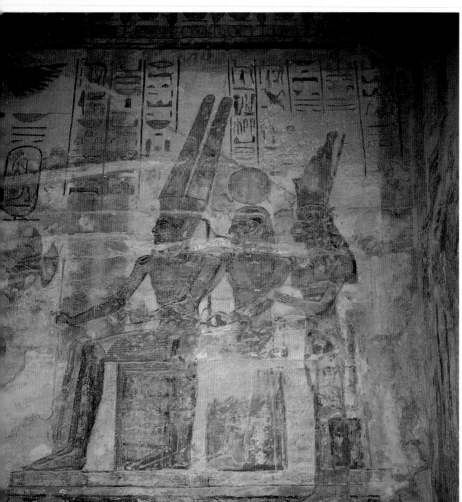

Sixty-five meters from the entrance portal, in the heart of the mountain, is the sanctuary, the most intimate and secret place in the temple, a small room measuring four by seven meters. Here sits the statue of the deified Ramses II, together with the triad of Ptah, Amon Ra and Harmakhis. Regarding these statues, as early as the late 19th century it was realized that the entire temple was built according to a very precise scheme. Various scholars, first among whom François Champollion, had noted what was then called the «miracle of the sun». Twice a year, at the equinoces, the sun penetrates the entire length of the temple and floods the statues of Amon, Harmakhis and the pharaoh with light. After about five minutes the light disappears and it is truly remarkable that Ptah is never struck by the rays of the sun, for Ptah is the god of darkness. Despite appearances, Abu Simbel is more than simply a matter of Ramses II glorifying himself. It suffices to leave the large temple and turn left: the temple of Hathor which the pharaoh had dedicated to Nefertari - his queen - not his only wife but certainly the best loved-strikes our eyes. Never in pharaonic Egypt had the consort of a sovereign been represented on the facade of a temple, as large as the statue of her husband right beside it. For her, for the Great Royal Consort, Nefertari-Mery-en-Mut («beloved of Mut») Ramses had this temple cut in the «fine white and solid stone», small in size and of great harmony.

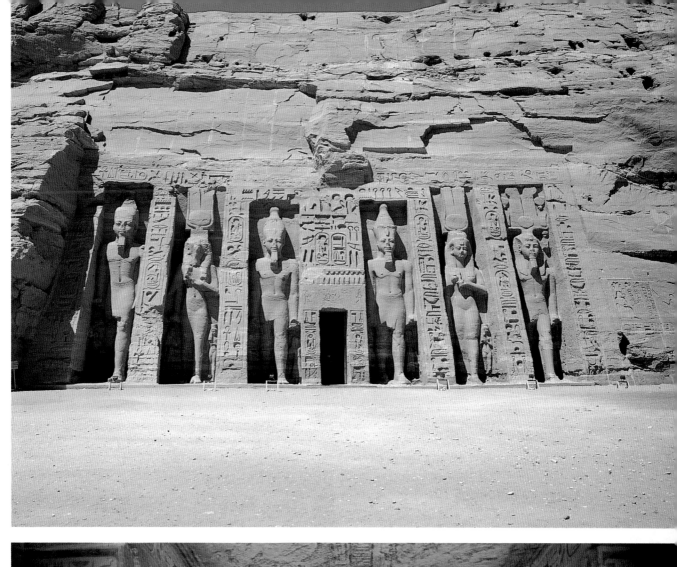

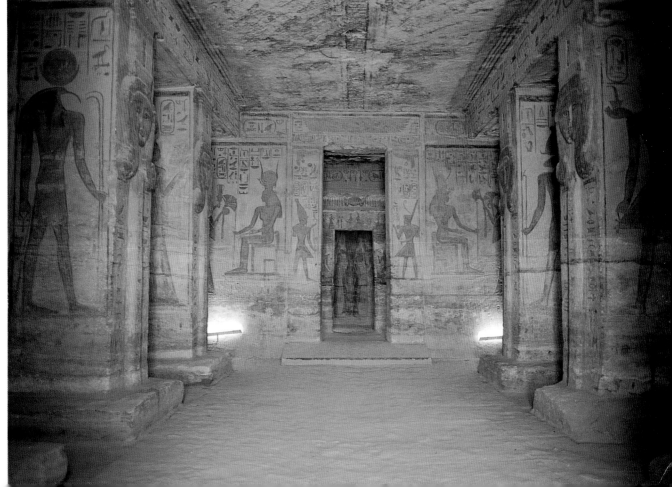

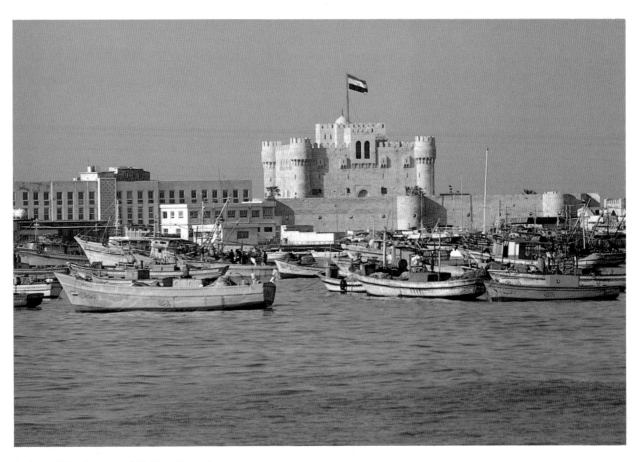

A view of the fortress of Kaitbay from the port.

The entrance to the fortress of Kaitbay.

Below and following page: the so-called column of Pompeius.

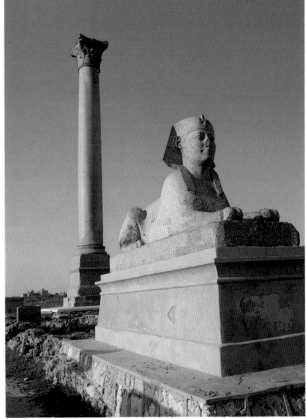

Alexandria

The second largest city in Egypt was built by Alexander the Great on the site of an old fishing village which had a small harbor that was sheltered by the island of Pharos. Alexander realized the potentialities inherent in the site and charged his architect Dinocrates with planning a city. Indeed, at the time there was a lack of important outlets on the Mediterranean and the small ports of Naukratis, Tanis and Pelusco, on the Delta, could not compete with the Phoenician ports.

It was 332 B.C., the year in which Alexander, after freeing Egypt from Persian occupation, had himself consecrated pharaoh in the oasis of Siwa.

But it was under his successors, the Ptolemies, that the city became capital. Ptolemy I Soter built a causeway (the Heptastadion or Seven Leaguer) to link the Island of Pharos to the mainland and thus created two harbors which were in communication thanks to passageways under the two bridges of the Heptastadion. An entire district was set aside for the Jews and subsequently the city was the residence of Demetrios of Phaleron, who founded the famous Great Library, of Euclid, and of Apelles, one of the greatest painters of antiquity. Under Ptolemy II Philadelphus the Great Lighthouse or Pharos was built on the tip of Pharos Island and became one of the Seven Wonders of the World. It was also at this time that the school which attracted the most illustrious intellectuals of the Greek world was founded and the Old Testament was first translated into Greek, the famous Septuagint, by the scholars gathered here.

Thereafter, despite the succession of internal revolts and palace intrigues, Alexandria continued to be a rich trading center, a cosmopolitan capital and a center of intellectual activity. In 48 B.C., during the reign of Cleopatra the last queen of Egypt, Caesar laid siege to the city and the famous Library burned down. Egypt became a Roman province and Alexandria, already intermediary between East and West (Red Sea and the Indies), became the second city of the Empire.

In the year 40 evangelization began (a tradition states that the Evangelist Mark founded the church of Alexandria) and it became a great religious center; in the second century, a school (the Didascaleion) was founded, entrusted to great theologians, but before long bitter controversies arose which later led to the rise of heresies. Nor was there a lack of revolts by the religious and racial minorities which led to repression and persecution. Initially it was the Christians who were the victims (under Caracalla, Decius and Diocletian), and later, after the edict of Theodosius (392), it was the pagans.

In 642 the city was conquered by Amir In El-As, general of the caliph Omar Ibn Al-Khatab, who succeeded in taking all of Egypt from the Byzantines. Cairo was chosen as capital and Alexandria began its inexorable decline.

With the arrival of Napoleon and scholars who brought in modern ideas on how best to exploit the country, but above all with Muhammad Ali and his successors who put these ideas into practice, the city came back to life. With the introduction of cotton growing in the Delta and then with the opening of the Suez Canal trade got off to a new start, industries were opened, the foreign community increased, residential districts were built which gave the city a typically Mediterranean aspect, with hotels, tree-shaded boulevards, casinos, shops. Since the Egyptian Revolution of 1952 all that remains to recall this elegant cosmopolitan high society world are the facades of the buildings that were built for the foreigners and the summer residences of the Cairo bourgeoisie. The area of Lake Maryut has become an industrial zone, the port has been enlarged and new wet docks have been built, but even so Alexandria has continued to maintain its role as the leading seaside resort of the country.

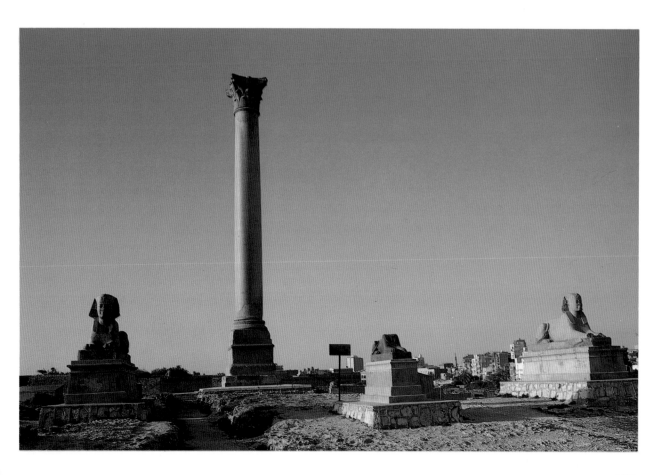

The Sinai peninsula

About twenty million years ago, Egypt, Sinai and the Arab peninsula were united in a single block. Then, huge terrestial devastations led to the separation of the lands, and the southern Sinai peninsula remained isolated, giving rise to two large gulfs: to the west, the Gulf of Suez, whose maximum depth is barely 95 metres, and the Gulf of Aqaba to the east, which instead reaches a depth of 1,800 metres. The latter gulf is a part of the big land fissure — called Rift — which extends from the chain of Taurus as far as Kenya. The great sismic activity of the past and the tremendous eruptive phenomena have given Sinai its characteristic imprint. The most important peaks are the Gebel Musa (Moses' mountain), that reaches 2285 metres, and Mount St Catherine (Gebel Kathrina), of 2642 metres, the highest on the peninsula. The west coast, then, that from Sharm el Sheikh to Ras Mohammed goes as far as Taba, is distinguished by numerous coral reefs that occur in succession, one after the other, creating the ideal conditions for a flora and a marine fauna, the variety and richness of which have no peer in other seas.

Monastery of St. Catherine.

The smallest diocesis in the world is at the same time the oldest Christian monastery still in existence in the world and houses also the richest collection of icons and precious manuscripts.
We can find the first news regarding the Monastery of St. Catherine in the chronicles of the Patriarch of Alexandria, Entychios, who lived during the 9th century: said chronicles tell us how Helena, the mother of Emperor Constantine, remained so impressed by the sacredness of these places that in the year 330 she ordered the construction of a small chapel on the site where the burning bush had been located. The chapel was dedicated to the Blessed Virgin Mary. Emperor Justinian in 530 ordered the construction of a much larger basilica: the one which would be the Church of the Transfiguration. It was than that the monastery took on the appearance of a massive fortification which characterizes it even today.

Wintertime view of Gebel Musa, or Moses' Mountain.

The Monastery of St. Catherine.

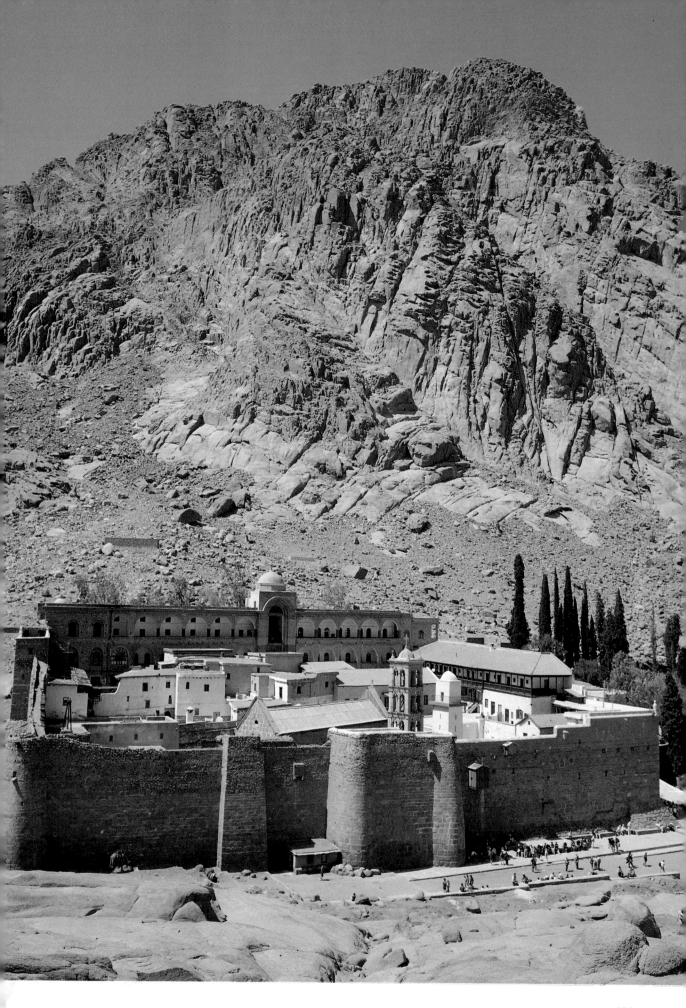

INDEX